EDWARD S. CURTIS
THE LIFE AND TIMES OF A SHADOW CATCHER

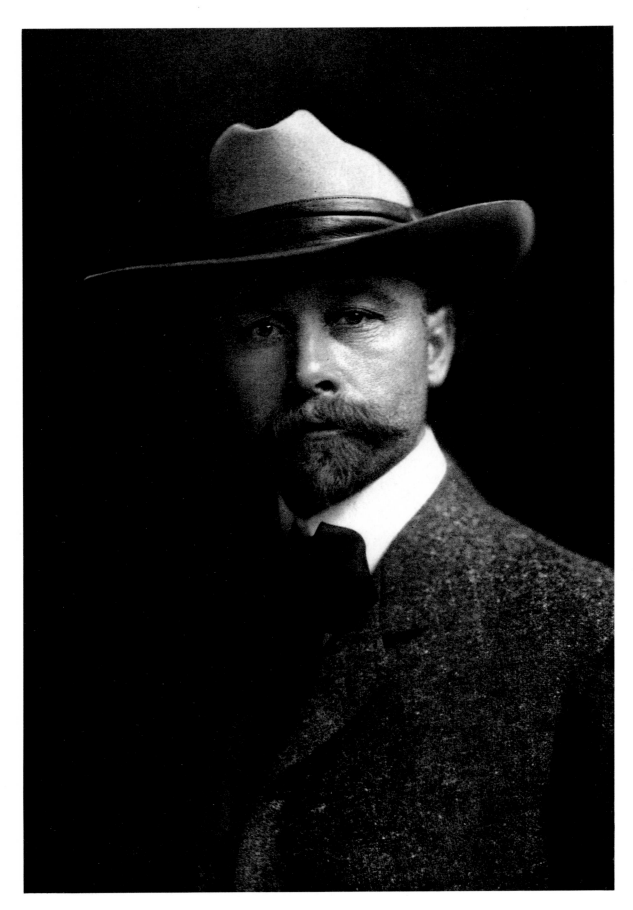

EDWARD SHERIFF CURTIS, 1906.

EDWARD S. CURTIS
THE LIFE AND TIMES OF A SHADOW CATCHER

By Barbara A. Davis

An Appreciation by
Beaumont Newhall

Foreword by
Bill Holm

Chronicle Books

Edited by Suzanne Kotz
Designed and produced by Ed Marquand
Printed and bound in Japan by
Dai Nippon Printing Co. Ltd., Tokyo, Japan

Photographic Credits
We would like to thank Lois Flury, of Flury and Company, for
supplying the bulk of the images reproduced in the gallery sec-
tion. We would also like to thank the following for supplying
photographs:
Lou Daly: 83, 84
Robert Vinnedge: 87
University of Washington Libraries, Historical Photography
Collection: 86A, 86B, 87, 99B, 100, 116, 135, 139, 145,
157A, 157D, 159, 160, 165, 169, 170, 171, 183, 184, 187, 189,
193, 195, 208, 212, 214, 230, 236

Library of Congress Cataloging in Publication Data

Davis, Barbara A.
 Edward S. Curtis: the life and times of a shadow catcher.

 Bibliography: p.
 Includes index.
 1. Curtis, Edward S., 1868-1952. 2. Photographers—
United States—Biography. I. Title.
TR140.C82D38 1985 770'.92'4 85-9715
ISBN 0-87701-346-2

Chronicle Books
1 Hallidie Plaza Suite 806
San Francisco, California
94102

CONTENTS

AN APPRECIATION

Thirty-three years ago when I arranged a large exhibition of Edward Curtis's American Indian photogravures at the George Eastman House in Rochester, New York, his work was almost unknown to the photographic community. The magnificent twelve-by-sixteen-inch plates could still be purchased for a modest sum from a Boston bookshop—if you took the trouble to visit the store and pick out what you wanted from a bin where they had lain for many years.

At the turn of the century Edward Sheriff Curtis began to accumulate a comprehensive record of all the important tribes of Indians in the United States that still retained to some degree their native customs and traditions. He continued this work for thirty years, and between 1907 and 1930 a series of publications unique in photographic history appeared. The work comprised twenty volumes of text illustrated with over fifteen hundred full-page photographic illustrations. In addition to the text, Curtis published twenty portfolios containing over seven hundred photogravures of his magnificent photographs. Photogravure is now rare for commercial purposes because of its laboriousness: the plates must be printed one by one on a flat bed press in a process that involves as much art as craft. In Curtis's day, the publication and research were enormous undertakings which received encouragement from Theodore Roosevelt and partial financing from J. Pierpont Morgan. In a 1907 copy of the *National Geographic Magazine*, George Bird Grinnell, an author and explorer who went with Curtis on the Harriman Expedition to Alaska, wrote of Curtis's work: "The pictures speak for themselves and the artist who made them is devoted to his work. . . . To accomplish it he has exchanged ease, comfort, home life for the hardest kind of work, frequent and long-continued separation from his family, the wearing toil of travel through difficult regions, and finally the heart-breaking struggle of winning over to his purpose primitive men, to whom ambition, time, and money mean nothing, but to whom a dream or a cloud in the sky, or a bird flying across the path from the wrong direction means much."

Though unknown for many years, Curtis is today recognized as one of the most dedicated photographers of the life style, manners, customs, and environment of native Americans. Resurrecting the original hand gravure process, two contemporary printings have made selected images from *The North American Indian* more available to the public. Thanks to these new printings, exhibitions, and a number of books, many people now recognize Curtis's name and his most romantic images. But the full range of his work has yet to be brought to light—hundreds of images are unknown, including many in the documentary style of his time. The twenty volumes of text to *The North American Indian* are still obscure.

As part of an ongoing discussion, the present book restores Curtis's work to the rich context of social, anthropological, and artistic issues of his time. Substantial new information about Curtis's professional and private life is presented, and the illustrations contain many lesser known Indian photographs, some previously unpublished. Also featured are rare examples of Curtis's portrait studio work, landscapes, and still photographs from his years in Hollywood. Old inaccuracies and confusions are clarified; new issues are raised. Both the breadth of images and text should stimulate further interest in and research into Curtis's contribution to art and science.

Edward Curtis's portrayal of Indians was not without its weaknesses, but those are, after all, easy to see, and are far outweighed by the strengths of his multi-faceted achievement. Because of his skill, artistry, and extraordinary perseverance, the lives of modern students of photography and native Americans can be greatly enriched by his work.

BEAUMONT NEWHALL

FOREWORD

Edward Curtis, once the associate of giants of industry, science, and politics and hailed as a photographic master for his portrayal of the "vanishing" Indian, came to be forgotten except by the few to whom his pictures spoke most personally. Only lately has he been recognized once more for his monumental work in recording visually and verbally the world of the tribes of North America. This reborn fame is not without blemish. Even during the years when the name of Edward Curtis was largely unrecognized he was not free of detractors. Many anthropologists were familiar with his pictures and the awesome accomplishment of *The North American Indian*, the forty-volume aggregation of text and photographs that consumed thirty years of his life in its preparation. But they did not universally approve of Curtis's work. I well remember the warnings in the early 1940s by some admired anthropologists of the dangers of relying on the Indian images of Edward Curtis for ethnographic evidence. These warnings were especially emphatic regarding the illustrations of volume ten, on the Kwakiutl tribes: Curtis posed his subjects, he dressed them up, fitted them with wigs, manipulated the images. It was only years later, with more familiarity with the ethnographic literature and the Kwakiutl people themselves, that the importance of Curtis's work began to be apparent to me. Though we can find fault with many of his statements and actions, Curtis was really far ahead of most of his contemporaries in his sensitivity to the people who were the subject of his words and photographs.

A legacy of this earlier criticism remains today. Reviewers and critics are reluctant to accept Curtis at face value, knowing that his work has been characterized by the experts as either romantic, racist, or sexist. Looking back from the vantage point of the 1980s it is easy to criticize Edward Curtis, but when viewed in the context of his time, his mores appear not worse and often remarkably better than we have any reason to expect. Franz Boas, respected as an objective scientist, arranged to have native Kwakiutl dress in archaic clothing and reenact outmoded customs for photographs, which he later prepared for publication by retouching out distracting details. John Muir, the patron saint of the modern conservation movement, set a giant tree in Alaska on fire and gloried in the spectacular forest fire that resulted. Such actions seem unscientific and even appalling to us today, but it is unfair to Boas and Muir (and Edward Curtis) to judge their actions according to rules that were not part of their world.

To understand Curtis we need to understand his setting. The first quarter of the twentieth century, during which Edward Curtis produced the greater part of *The North American Indian*, was a time of social, political, and industrial convulsion in America. Far from being isolated from this tumult in distant Indian lands, Curtis was forced to react to it constantly. The continued existence of his great project required him to campaign unceasingly for support from his backers, all the while continuing to photograph, write, interview, lecture, supervise his assistants, and attend to myriad details that could not be left to others. The incredible dedication and monumental compulsion that drove Edward Curtis can hardly be imagined. It broke his health, ruined his marriage, and left him in debt. Yet he never gave up, and saw his great project to completion. He deserves our profound gratitude for that.

BILL HOLM

ACKNOWLEDGMENTS

There is much to be done in the way of assessment before Edward Curtis's photography and writing will be available to the wide public for whom it was intended. It is my hope that this book will spark continued research and attention to his work.

Previous books on Curtis proved to be valuable resources, and this volume owes a debt to those efforts. I am most deeply indebted to Bill Holm and George Quimby, both of the Thomas Burke Memorial Museum at the University of Washington, and to Mick Gidley, Senior Lecturer at the University of Exeter, England, for their roles in the early stages of serious study of Curtis's work. The inclusion of their publications in the notes and bibliography to this book does not sufficiently reflect the extent to which they served as standard and inspiration.

A different type of debt is owed to Lois and James Flury, who have spent years building their collection of Edward Curtis's photography. Soon after I met them at their Seattle gallery in 1981, Lois and Jim gave me unrestricted access to their collection—a rare opportunity and pleasure. Once this project was underway they provided important practical assistance. Source material on Curtis is still only roughly charted territory, and the sorting out of conflicting evidence would not have gotten as far as it did without Jim's long experience and good judgment. Lois has contributed in a variety of ways to the book, especially in gathering the images, many of which are drawn from their collection. She has also supplied vital information, made suggestions about the manuscript, and secured important permissions to publish. Both of them have my great gratitude, as does their daughter Melissa, who has good-naturedly endured the many added claims on her parents' time in past months.

Many individuals have had a hand in building Lois and Jim's collection over the years. By extension, they deserve my thanks as well.

In the preparation of this book, many people have been of assistance. Florence Curtis Graybill and Harold Curtis provided information about their father and generously gave permission to quote from his writings. Early and important encouragement for a publication came from Anne Kohs, of Anne Kohs and Associates in San Francisco, while vital use of the original copper gravure plates was permitted and organized by Steven Kern, with the cooperation of Kenneth Zerbe.

The staff of the Museum of the American Indian cared for some of the copperplates, and Ron Pokraso pulled the new prints used for this book. Robert Vinnedge made additional photographic prints. Access to some photographs was arranged by Gary Mingus, Head of Special Collections Division of the University of Washington, with additional assistance from Richard Engeman, of the Pacific Northwest Collection, and Stan Shockey, of Instructional Media Services. Permission to reprint one image was arranged by Juanita Pike, of the University of Washington Press.

Other assistance at the University of Washington was provided by the staff of the Burke Memorial Museum, by Gary Lundell, Archives and Records, and by Janet Ness, Manuscript Section. Carla Rickerson, Susan Cunningham, and the rest of the staff at the Pacific Northwest Collection provided valuable suggestions while graciously handling my many requests.

The library and archival staffs of the following museums were without exception cordial and unstinting in aiding my research: the Pierpont Morgan Library; the Southwest Museum; the Smithsonian Institution; the American Museum of Natural History; the Bancroft Library, University of California; the Henry E. Huntington Library; the Library of Congress; the Maryhill Museum, Goldendale, Washington; and the Seattle and Denver public libraries.

Craig Klyver did vital research at the Southwest Museum, as did Myra Davis-Bloom at the Pierpont Morgan Library. Margaret Gaia supplied important leads to information, and kindly shared her fine photograph of the

Curtis Studio. Rod Slemmons also located several wonderful images for our use, while the efforts of Bill Shelly and Esther Holt-Knight have turned up material for future research. Bill Holm, George Quimby, and Frank Porter have taken precious time to read the manuscript at various stages and have offered excellent suggestions.

Ed Marquand has been instrumental in determining the look of the book, and in handling a multitude of production details and arrangements with the publisher, while Suzanne Kotz has been a second right hand in my writing. Both she and Ed Marquand have provided not only expert assistance, but also the benefits of their tact and good humor. The same is true of Theresa Axe, Robert Hutchins, Glory Jones, Paula Thurman, Rain Block-ley, and Nancy Rekow, all of whom have been valiant in the clinch. Our collective efforts have enjoyed the full support and encouragement of the fine staff at Chronicle Books, including Larry Smith, Jack Jensen, William LeBlond, David Barich, Fearn Cutler, Drew Montgomery and Mary Ann Gilderbloom.

NORTH AMERICA

Showing the research areas, cities, and rail routes important in Edward Curtis's life.

Kotzebue

King Island

Nunivak

Haida

Tsimshian

Cree

Bella Coola

Blackfeet

Nootka

Kwakiutl

Bloods

Makah

Kalispel

Sarsi

Nez Percé

Kutenai

Quinault

SEATTLE

Blackfeet

Piegan

Assiniboin

Yakima

PORTLAND

Cayuse

BROWNING

Mandan

Chinookan

Flathead

BUTTE

Hidatsa

GRANTS PASS

Klamath

Modoc

PRYOR

Arikara

Crow

Northern
Cheyenne

Yurok

Paiute

PINE
RIDGE

Teton Sioux

BOSTON

Wiyot

Yuki

Washo

Shoshone

NEW YORK

Hupa

Shasta

CARLISLE

Pomo

Kato

Paviotso

CHICAGO

COLFAX

Ute

CHEYENNE

WASHINGTON

SAN FRANCISCO

Mono

Arapaho

Miwok

DENVER

Yokuts

KANSAS CITY

Havasupai

CAÑON DE
CHELLY

Walapai

Navajo

Jicarilla

Cheyenne

Oto

Osage

Mohave

Hopi

Pueblo

Ponca

Wichita

LOS ANGELES

NEEDLES

GALLUP

Pawnee

Cahuilla

Zuñi

Kiowa

Luiseño

Apache

Comanche

Apache

Arapaho

Papago

EL PASO

INTRODUCTION

In the summer of 1948 the Washington State Historical Society was at a loss as to whether a recent bequest was of great value or an exceptionally elaborate white elephant. The gift consisted of fifteen large and handsome illustrated volumes on Indians and fifteen matching atlas-sized portfolios of pictures. Titled *The North American Indian* the series was on its face an impressive publication: magnificently printed, the text obviously represented long years of cooperative effort by several people, and the many hundreds of illustrations included a rich variety of straightforward ethnographic material and extraordinarily romantic images. Curiously, though, none of the standard references on art, anthropology, and Indian history made any mention of *The North American Indian*. The series seemed to have materialized out of thin air.

The volumes themselves provided some background. The first volume, published in 1907, indicated that the series would include twenty installments "picturing and describing" the Indians of the United States and Alaska. The title page gave credit for authorship, photography, and publication to one man, Edward S. Curtis, although assistance in preparing the text was acknowledged in each volume. A flattering introduction was signed by then-President Theodore Roosevelt; smaller type discreetly credited J. Pierpont Morgan as patron of the field work on which the publication was based.

The author's preface to the entire series outlined his plan to "form a comprehensive and permanent record of all the important tribes... that still retain to a considerable degree their primitive customs and traditions." His inspiration came from what he regarded as the self-evident and urgent need for just such a record:

> The passing of every old man or woman means the passing of some tradition, some knowledge of sacred rites possessed by no other; consequently the information that is to be gathered for the benefit of future generations, respecting the mode of life of one of the great races of mankind, must be collected at once or the opportunity will be lost for all time.

The author sounded as idealistic as he was prolific, and with the support of a U.S. President and a rich banker and art collector, he must have been well connected. How then had such a work slipped through the cracks of public awareness?

A Historical Society member and librarian named Harriet Leitch decided to search for information about *The North American Indian*. Her efforts were rewarded by the discovery of many newspaper and magazine articles dating from the years when the first volumes were published. These praised Curtis's photography and his plan to create a record of the "vanishing race" intended to be as accurate as it was beautiful. Gradually, a few pieces of the puzzle slipped into place: Curtis had been

nationally known, even famous, for his Indian work from 1903 to 1912 or 1913, when the newspaper notices thinned out. Miss Leitch found no mention of him after World War I, when the series had been only half completed. Obviously, a few more installments had been published—the Historical Society had been given fifteen volumes and portfolios—but whether the series had progressed beyond that was still a mystery.

On a tip from someone who had known Curtis when he lived in Seattle, Miss Leitch wrote to a Curtis Studio in Los Angeles, asking for any information about the publication. To her surprise, a letter came back from Beth Curtis Magnuson, Edward Curtis's oldest daughter, saying that her father was "elderly, but very much alive," and that Miss Leitch should write to him to find out more about *The North American Indian*.

Curtis was not only alive at the age of eighty but eager to respond to inquiries about his forgotten work. He maintained an apartment of his own but was often bedridden and under a nurse's care. When he was up and could work at his desk, his first priority was a book manuscript called *The Lure of Gold*. Between being a shut-in and continuing his copious research, he managed to write Miss Leitch twenty-three times during the next three years, filling in parts of the story of *The North American Indian* and telling her about his early years in Seattle. All twenty volumes and portfolios had eventually been published, though it took him until 1930. And the work wasn't entirely lost: many of the 272 sets that had been printed resided in fine private collections and famous libraries. He sent her old clippings, reviews, and publicity material, loaned her the few journals he had written during his years in the field, and even wrote down some of his reminiscences and had them typed for her.

Despite his many health problems, Curtis corresponded with a number of people. He probably didn't always keep track of who had been brought up to date, for he once wrote Miss Leitch almost exactly the same letter on two different days. When he was annoyed by some physical restriction, his letters to her occasionally lapsed into querulousness, a mild enough reaction given his circumstances. In most of his correspondence he was neither complaining nor confused, but so immersed in his research on gold that "everything else is neglected.... Two walls of my room are covered with pads of research notes." He put up a new bulletin board so that he could keep track of random notes, added two hundred books to his library, and even planned to accompany a mining expedition on a cruise up the Amazon River during the spring of 1950. When asked why he didn't write the story of his life, Curtis replied that he wasn't in the physical or financial shape for such a large undertaking, and besides, he questioned being able to find a publisher for the results: "Publishers tell me that there is but a limited market for books dealing with Indian subjects."

Nearly twenty years after *The North American Indian* had been finished, the subject of Indians was still the love of his long life. It had not been his only area of interest, though. He grew up surrounded by the railroads and banks and mines of the "robber barons," the men who had become fabulously wealthy from new technology, public resources, or the cheap labor supplied by millions of immigrants who streamed into the country during the latter years of the nineteenth century. Still young when the last great Indian Wars were fought, Curtis had been living on the frontier when it was announced that the era of the frontier was over; and he came of age just as public faith in "progress" and "cultural evolution" reached its peak. When he started out in photography, it had not yet been accepted as an art; and his involvement with ethnology predated its independence as a discipline. During the 1920s he worked in yet another new field as a motion picture cameraman and still photographer in Hollywood. He knew not only Edward Harriman, Theodore Roosevelt, and J. P. Morgan—three of the most powerful men of their time—but also such diverse people as Gifford Pinchot, Charles Lummis, Buffalo Bill Cody, Geronimo, Gertrude Vanderbilt Whitney, Cecil B. DeMille, and the cowboy star William S. Hart. Curtis made a movie, mined for gold, and rode the trains back and forth across the country at least 125 times. Despite all this, he felt the story of his life could only be classed as an "Indian subject."

For most of the thirty years it took to complete *The North American Indian*, Curtis kept a schedule that would have killed other men. He ruined his health, gave up his family life, and assumed crushing debts. During the course of the project he took more than 40,000 photographs, wrote four books and supervised sixteen others, collected more than 350 traditional Indian tales, and made more than 10,000 recordings of Indian speech and music—a staggering body of work. But in 1948 he knew it was all in rare-book rooms, museums, and warehouses, far from the general public he had hoped to reach.

Harriet Leitch's inquiries on behalf of the Historical Society did not lead to a resurgence of interest in *The North American Indian*. Thirty-five years later, the work still languishes at the edge of public attention. More people may be aware of it, but opportunities to read Curtis's ethnology or to see more than a few dozen of his images are still severely limited. The work continues to be the object of controversy, and, just as in his own time, the criticism is rarely supported by facts. In the meantime, a sense of the issues that shaped Edward Curtis's thinking and the multiple forces of accident and design that came together in his work has been obscured or lost. The work that he created to bridge not only two cultures, but also art and science, is now once again uncharted territory—waiting to be explored.

1

THE LAST FRONTIERS

Her first winter in Chinook there was a lynching. She never forgot it.
She saw Chinook reduced to ruins in two hours in the Big Fire ... and like
a phoenix rise out of the ashes. It made no difference to her that it grew, that
gas and waterworks were built, that a morning and evening paper appeared,
or that horse cars crept up Front Street. To her Chinook was always
the last frontier, the place where anything might happen.
Bertrand Collins on Seattle (1928)

Edward Sheriff Curtis was born in 1868, a bitter year for native Americans. The main acts in the drama of their displacement by white settlers had already taken place, and now they were fighting for survival without hope. The transcontinental railroad was near completion, signaling the disappearance of the bison from the plains, and all over the country tribes were being forced to settle on reservations. On the Washita River in Oklahoma, George Armstrong Custer, an ambitious lieutenant colonel under Gen. Phillip Sheridan, finally defeated Black Kettle and the Cheyenne who had escaped the Sand Creek massacre in 1864. One of the few rays of light in the gloom was that when Red Cloud signed a peace treaty at Fort Laramie, Wyoming, on November 6, 1868, it was with the understanding that the Sioux would receive a giant reservation in South Dakota, including the Black Hills. That same year, though, the U.S. government decided that an "Indian problem" should no longer exist, and a radical policy change subsequently declared that "no Indian nation or tribe ... within the United States shall be acknowledged or recognized as an independent nation or power."

With the Civil War only recently over, the Republicans in 1868 chose as their presidential candidate Gen. Ulysses S. Grant, the victor at Appomattox. Within a few months of his election, Grant's cronies began using their connections for monetary gain, even claiming that their unscrupulous practices were good for the country. At a dinner to honor Junius Morgan, a powerful banker whose son was already making a name for himself in railroad stocks, the master of ceremonies explained the thinking of the time: "While you are scheming for your own selfish ends, here is an over-ruling and wise Providence directing that the most of all you do should inure to the benefit of the people. Men of colossal fortunes are in effect, if not in fact, trustees for the public." The American people made little protest to the wealth and corruption of these moguls, perhaps because they were too war weary to feel indignation. At the end of the Civil War many people in the country, including Edward Curtis's family, were tired and poor.

Johnson Curtis had been both a Union Army private and a chaplain in his Wisconsin regiment. After the war he returned to his wife, Ellen Sheriff Curtis, and to their son Ray, born in 1861. His health ruined by the war, he was unable to resume the arduous life of a farmer and so began preaching for the United Brethren Church. Edward Sheriff Curtis was born on February 16, 1868, followed by Eva in 1870 and finally by Asahel in 1874.[1] Soon after Asahel's birth the family moved west to Cordova, a rural settlement in Le Sueur County, Minnesota, where they would remain more than ten years.

Edward often accompanied the Reverend Curtis on canoe trips along the many small streams and lakes of southeastern Minnesota to visit his widely scattered congregation. Helping with the canoe, portaging their goods, and camping and cooking outdoors, Edward learned habits that would play an important role in his life.

Opportunities for formal education were more limited, and Edward did not go beyond grammar school, a fact that proved no obstacle to his keen interest in photography. With a stereopticon lens his father had brought back from the war and a construction manual that outlined the steps, Edward built a rude camera for himself while still an adolescent. Then, like thousands of other would-be photographers, he taught himself technique from a volume of *Wilson's Photographics*. Written by an Edward Wilson from Philadelphia and first published in 1871, this widely distributed book's subtitle characterized that period's ambitious and thorough self-education courses: "A Series of Lessons Accompanied by Notes on All Processes Which Are Needful in Photography." Despite Mr. Wilson's twenty-five-year career, he disclaimed photography's value in the preface, calling it a "circus kind of business, and unfit for a gentleman to engage in."

Nonetheless, during his years in Minnesota, Edward may have worked for a time in a St. Paul photography studio and may even have had his own unsuccessful photography business. But his father's health continued to weaken, and when Edward's elder brother married and moved to Portland, more responsibility for supporting the family fell to Edward. Over six feet tall before he was eighteen, he landed a job supervising 250 Canadians on the Minneapolis, St. Paul and Sault St. Marie Railroad. Many years later he said, "They didn't understand me, I didn't understand them, but we got the job done."

Thanks to unusually good weather, bumper crops, and the new rail lines' stimulation of settlement and business, the Midwest prospered after the Civil War until 1883. But land speculation had been wild, and most settlers had mortgaged their properties. In 1883 a financial panic caused bank failures,

countless foreclosures, and a widespread loss of confidence in industrial ventures. The winters of 1886 and 1887 were brutal, and the summer of 1887 brought a devastating drought. Many farmers were ruined, as were many small businessmen, and both the desperate and the ambitious made their way west once again, following the frontier's elusive promise of prosperity. In the autumn of 1887, Edward Curtis and his father, by now a semi-invalid, temporarily left their family in Minnesota and set out for Washington Territory.

The Northern Pacific Railroad had reached Portland, Oregon, in 1883, so father and son probably took the train from St. Paul to Portland and traveled north from there by stagecoach. Friends from Le Sueur County, the Sanstroms, had recently moved to Puget Sound and now encouraged the Curtises to settle near them. Though wetter and milder, western Washington was not unlike parts of Minnesota, and many people had come from Minnesota to log the forests, mine coal, or simply to try farming again away from the bitter winters. Puget Sound's labyrinth of waterways reached south into the state more than seventy miles. Heavily forested hills ran down to meet the bays, and on the narrow lowlands in between, many settlements were springing up, often on the sites of Indian villages. Johnson Curtis chose a homestead outside the tiny town of Sidney, near what is now Port Orchard, a ferry ride across the sound from Seattle. From the thick spruce woods the two men cut logs for a sizable cabin, and Johnson Curtis arranged to purchase a nearby brickyard. By the time winter set in, they were sending encouraging letters back home.

With high hopes, Ellen Curtis and the other two children traveled west the following spring in an emigrant railroad car, sleeping in their own bedding at one end and cooking at the other. To Eva, then seventeen, the trip "seemed like luxury and going to the end of the world." But just after the family's reunion, Johnson Curtis fell ill with pneumonia and, despite the care of a Seattle doctor, died within a few days, in May of 1888.

According to Eva, following their father's death "Edward had the full responsibility of the family and he felt the load. There was never any frivolity about him." Edward, then twenty, and his thirteen-year-old brother pieced together an income by chopping trees from their land into cordwood, fishing and digging clams on their beach, growing vegetables and fruit trees, and helping neighbors with chores. This meager living notwithstanding, Edward managed to buy a camera from a man seeking a grubstake for a trip to the goldfields in California.

Though the life on Puget Sound was grueling in many ways, it was exciting too. In 1889, when Washington was made a state, Seattle had been settled for only thirty-five years and had a population of roughly twenty thousand people. Hundreds of diverse businesses had been established. Three hundred telephones were in use, a cable railway carried passengers to outlying neighborhoods, and bicycles and wagons thronged the streets. When fire destroyed the entire business district the

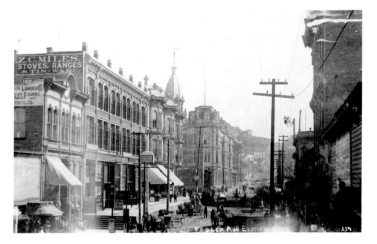

SEATTLE, JUNE 6, 1889. The city as it looked when the Curtis family moved to Puget Sound from Minnesota in the late 1880s. A newspaper photographer made this picture the day before most of the city was destroyed by fire. (Photograph by William Boyd, reproduced by permission of Historical Photography Collection, University of Washington.)

next year, the city was spurred to greater growth by new construction and planning. With its powerful timber and coal industries still expanding, Seattle was a vigorous frontier town and an ideally situated port.

Around the edges of the city, a handful of dispossessed natives still fished or hunted seals in the harbor, occasionally coming into town to sell baskets on the muddy streets. During a boom in hop exports in the mid-1880s, the Indians did most of the hop picking, leaving their canoes drawn onto the flats below the city and the riverbanks in the Rainier Valley. Many tribal leaders had signed the Point Elliott Treaty in 1855, by means of which then-Governor Isaac Stevens coerced the Indians into ceding legal title to six counties. In exchange, the Indians were to keep 48,000 acres divided between four reservations, and they were promised $15,000 to be paid in twenty equal annual installments. Indians who had not been represented in the signing lost title to their lands nonetheless; in the wake of skirmishing, most of the natives around Seattle had been isolated on the Suquamish Reservation across the sound. The treaty was ratified in 1860, but the terms of the payment were never fully met, nor was any land every returned. By the last years of the century the presence of the Indians was taken for granted, and it was of only limited public interest that the lives and cultures of Northwest Coast Indians were the object of scientific scrutiny. Among others, German-born Franz Boas, the man who would revolutionize the study of anthropology, spent many summers in the Northwest studying the Nootka, Haida, and Kwakiutl for several institutions, including the Smithsonian Institution's Bureau of American Ethnology. But the concerns of most people on Puget Sound were with the future, with growth: new inventions, new investments, and the excitement of bringing a transcontinental railroad to town.

In 1891, the year the U.S. Bureau of the Census announced that the frontier was officially closed, Edward Curtis entered

into business in Seattle. His friend from Le Sueur County, Peter Sanstrom, was anxious to sell his two-year-old share in the photography enterprise of Cedarholm, Sanstrom, and Rothi. On $150 borrowed against the Sidney homestead, Edward formed a new partnership with Rasmus Rothi: Rothi and Curtis, Photographers. For the next year, Edward either lived over his new business at 713 Third Avenue or a half-dozen blocks to the north at 1108 Fifth Avenue. Also living downtown at this time, perhaps even at the same boardinghouse on Fifth Avenue, was Clara Phillips, whom Curtis would marry in the spring of 1892. Her family had settled recently in the area, coming from New Brunswick, Canada, via Emporium, Pennsylvania, where the men had worked as loggers. Edward and Clara had met on the undeveloped Kitsap Peninsula where their families lived, but they both soon made the move across the sound into the churning life of the growing city.

Married when he was twenty-four, and Clara eighteen, Edward spent barely a year in his first partnership before he and Rothi parted company, and he entered a new arrangement with Thomas Guptill. Both young men did photographic portrait work, and Edward engraved printing plates for reproducing photographs or Guptill's drawings in local publications. The studio and darkroom for Curtis and Guptill, Photographers and Photoengravers, were at 614 Second Avenue, only a block away from the first business, and were in a small, free-standing building facing the alley behind the Lewelling-Dodge office building. Today used only for deliveries and garbage, alleyways then were home to small businesses such as dressmakers, print shops, shoe outlets, and carpenters, which left the main streets for banks and prestigious businesses. Curtis and his wife were living in an apartment in the studio building when their first child, Harold, was born on November 18, 1893.

A financial panic had rocked the United States that year, and a long depression followed. Seattle was cushioned against the hard times by the arrival of its first transcontinental railroad—James Hill's and J. P. Morgan's Great Northern—and in the city's comparatively healthy economy Curtis's business grew rapidly. Within a few years, he was prosperous enough to move his young family up the hill to a large boardinghouse, where Edward's mother, brother, and sister joined them. Asahel went to work as an engraver for Curtis and Guptill, and Eva taught school, but Edward was still responsible for the household. In 1896 he and his partner's exhibit of portraiture won a bronze medal from the National Photographers' Convention in Chautauqua, New York, for excellency in posing, lighting, and tone. Their submission consisted of 101 images selected from portraits of Seattle citizens made during the previous year, and although a local newspaper reported that their pictures were "full of snap and vigor," Curtis and Guptill were quick to attribute their success to the unusual attractiveness of their female clients. The same article went on to say that

> While Curtis and Guptill are known among the homes of the city as photographers, they are known among the

printers and businessmen as printers also. They make printing photos for modern illustrations, and their business in this line extends all over the Northwestern states and into British Columbia and Alaska. *The Argus* predicts that in a very few years these young men will have the largest engraving plant west of Chicago.... Mr. Curtis being a master of the engraver's art... while Mr. Guptill is a designer and illustrator of more than ordinary ability.... While still in their twenties they have by steady application and straightforward, honorable business dealing, achieved a place in the art and business world often striven for in vain by men of maturer years.[2]

Later that year, the *Argus* called them the leading photographers on Puget Sound and reported that their work could be found in nearly every home in the Northwest. That December 19, 1896 article also drew attention to a new type of "photograph on a gold or silver plaque. This method is original with Curtis and Guptill and... is brilliant and beautiful beyond description." The gold or silver plaque might well have been a forerunner of the goldtone pictures for which Curtis would one day become famous.

Edward's first daughter, Beth, was born May 5, 1896, and the growing Curtis family moved again, this time to a large house at 413 Eighth Avenue. There they would stay for six years, up the hill from the court house and just over the ridge from the red-light district. Harold Curtis, who would be nine years old before the next move, saw a hanging in the court house yard one summer and, down in the neighborhood where he was forbidden to walk, the even more exciting sight of women sitting on their front stoops, smoking.

In addition to Clara and the two children, Edward's household still included his mother, younger brother, and sister; and it had now been increased by three members of Clara's family as well. One of Clara's sisters, Susie, worked as a photo-printer for Curtis and Guptill, as did a first cousin from Bremerton, William W. Phillips. A third Phillips, Nellie, worked as an operator for the newly formed Sunset Telephone and Telegraph Company; off and on in the coming years, she too would work for the studio.

Meanwhile, Edward often worked through the night, taking the streetcar home or walking the six blocks from his studio only when he was satisfied with the prints of all the photographs he had shot during the day. In 1897 Thomas Guptill went his own way, and the business's name was changed to Edward S. Curtis, Photographer and Photoengraver. Apart from the lucrative photoengraving for other businesses and publications, Curtis's stock in trade consisted of fashionable engagement and wedding portraits, dramatic prints of Northwest scenery, and a number of photographs of local Indians.

Contradictory anecdotes date the beginning of Curtis's Indian photography, but Princess Angeline was certainly among his earliest subjects. The aged daughter of Chief Sealth, the Suquamish Indian from whom Seattle took its name, Angeline lived in a waterfront cabin and eked out a living

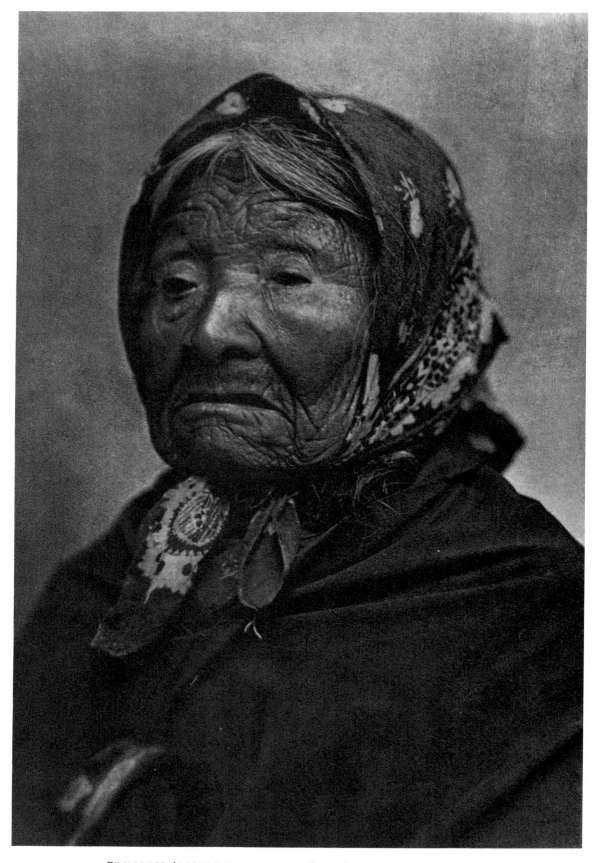

PRINCESS ANGELINE, circa 1895. Shown here in an early Curtis photograph, Angeline was the daughter of Chief Sealth, a Suquamish Indian from whom Seattle took its name. She was well known around town and a favorite subject of local photographers. (Courtesy of Flury and Company.)

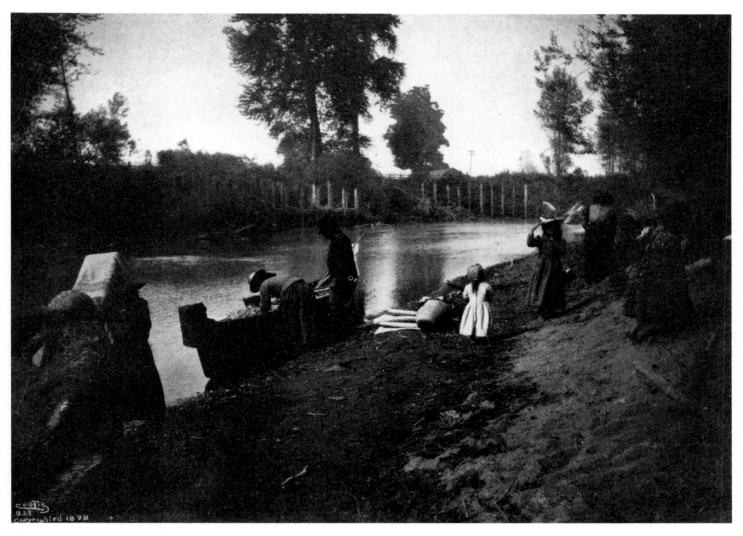

ARRIVAL AT THE HOP FIELDS, 1898. An early Curtis photograph of Puget Sound native Americans beaching their canoes on the way to work in the hop fields south of Seattle. (Reproduced by permission of Historical Photography Collection, University of Washington.)

gathering clams on the tide-flats. Her reputation as a real character was enhanced by the much-circulated story that she threw clams at the sheriff's house when she was drunk. When Curtis gave her a dollar for allowing him to photograph her (probably in 1895 or early 1896), she said, "More easy work than dig clams."

Curtis photographed Indians on the tide-flats, and he spent several days on the Tulalip Reservation photographing an Indian policeman and his wife. He gained the Indians' confidence by treating them as equals. "I said 'we,' not 'you,' " he explained. "In other words, I worked with them and not at them." He and his friend and fellow photographer Duncan Inverarity used to wait for the hop pickers on their way to the Rainier Valley, photographing them as they pulled their canoes up on the beach at the south end of Elliott Bay.

Curtis's studio and engraving plant continued to prosper, and his gentlemanly manners, charm, and good looks made him the premier society photographer in a city with a growing circle of wealthy and socially conscious citizens. But he began to leave the studio in the charge of others, going out alone to search for photographs that pleased him, especially on the slopes of Mount Rainier, which he called "my beloved mountain of mountains." He was fastidious about his composition and lighting and kept a notebook of subjects and arrangement. A few years later he discussed his landscape work in a local magazine column:

In the mountains the morning is almost the only time the atmosphere is clear and free from the blue haze. Every crag and peak casts long shadows, causing the whole to stand out in rugged grandeur. Good pictures are the result of long study rather than chance, and a number of the pictures I worked up in my mind the first season are not made yet. I have not been able to be at the right spot at the right time of day and the proper condition of atmospheric effect.[3]

To explore the mountain, Curtis spent many nights camped on its slopes, packing all his gear as well as his heavy Premo dry-plate camera. Within a few years he became a skilled climber. On July 23, 1897, he joined a large party gathered on Mount

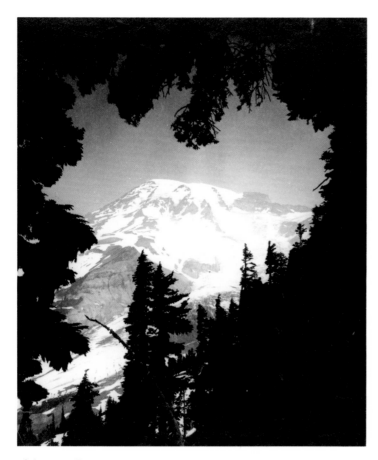

MOUNT RAINIER, circa 1897. Before Curtis dedicated himself to the photography of Indians, he earned much of his reputation and income from landscape photography. He became an expert climber while photographing the Cascade and Olympic mountains. (Courtesy of Smithsonian Institution.)

Rainier for the annual outing of the three-year-old Mazamas Club, a Portland-based organization for "true mountaineers," and only the second such climbing club on the West Coast. From as far away as Dallas and New York, people came to spend a week on Rainier; as everyone arrived, one day passed in conversation in Curtis's enormous Sibley tent.

A practice climb was planned to the steep, rocky summit of Pinnacle Peak. That group of twenty climbers included not only Curtis but his twenty-three-year-old wife, Clara, and a young woman who would become a family friend and "star helper" in the Curtis Studio, Ella McBride. McBride was an experienced climber and member of the Mazamas' executive committee, which asked the nonmember Curtis to head the expedition to the summit.

For the summit attempt, climbers had "to agree to keep in line, to obey orders implicitly, and to use no stimulants while climbing. The ladies were required to wear bloomers." At the ten-thousand-foot level, where the naturalist John Muir had marked the site for a last night's rest before the final ascent, approximately one-third of the group decided not to venture farther. Under Curtis's direction the other fifty-nine climbers pushed on the next morning, and with the aid only of cram-

pons, ice axes, and a life line to which they could cling in an emergency, they reached the 14,400 foot summit at 3:30 in the afternoon—a remarkable achievement for climbers who would be considered amateurs by modern standards. Of that elated group, nine were women, and many were climbers who had just qualified themselves for Mazamas membership, including Curtis.

> Far to the west, in the hazy distance, could be seen the Pacific Ocean, and nearer at hand, Puget Sound, pearly in its emerald setting of firs. We could trace the beds of the Cowlitz, Nisqually, Carbon, Paradise and Stevens Glaciers melting into rivers that radiated to the sea.[4]

Sadly, on the last leg of the descent a climber slipped into a crevasse and was killed, ending the Mazamas' annual outing on a somber note.

When Curtis returned to Seattle, he found the city in the grip of gold fever. Word had reached the West Coast that gold had been discovered in the Canadian Yukon, and the very day after Curtis left for the Rainier climb, five thousand people swarmed over Schwabacher's Dock to meet a ship carrying two tons of gold. Before it docked in Seattle, the ship was completely booked for the return passage north, and people clamored for bookings on the six other departures scheduled that year. Waves of gold fever had swept the frontier before, but nothing so close to Seattle, and the business of outfitting miners headed for the Yukon was a welcome shot in the arm to the city's economy. Harold Curtis recalled standing on a dock next to his mother, and watching a well-known rascal come staggering down the gangplank weighted down by the bulging sacks of gold dust he carried in each hand—a fortune he claimed to have made by ambushing drunk miners outside saloons and relieving them of their "pokes." Asahel Curtis, twenty-three, was still working at the Curtis Studio as an engraver, but his pictures recording the excitement on the docks during these years attest not only to his budding journalistic interest, but to the fact that he too was a skillful and talented photographer.

A newspaper article from the end of 1897 suggests that Edward's conceptions of his photography business were still changing, and that the charged atmosphere was fanning his ambition:

> E. S. Curtis, the well-known photographer, will go into the Alaska view business on the most gigantic scale ever attempted with the coming of Spring. Mr. Curtis will add to his already excellent stock of Alaska views. As soon as is practicable, Mr. Curtis will start a party for the gold field in charge of Mr. A. Curtis. The party will take 3,000 photographic plates and will spend the entire season in the interior, coming out as late as possible in the Fall. Arrangements have been made, however, to forward the plates that have been exposed to Seattle, in order that the views may be put on the market as soon as possible. These views will cover not only the explored portions of Alaska, but it is the intention of the party to take views of sections on which the human foot has never been placed.

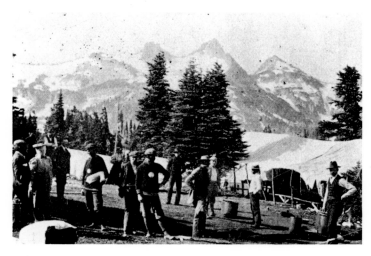

CAMP MAZAMA, 1897. Curtis photographed the base camp for the Portland climbing group, the Mazamas, before an ascent of Mount Rainier. Although not yet a member, Curtis was asked to lead the climb. (Reproduced by permission of Historical Photography Collection, University of Washington.)

This collection of photographs, when completed, will be the largest and best that has ever been attempted of this wonderful country. Mr. Curtis has already received a number of offers from publishers and others for the first choice from this collection.

The Yukon trip represented a great financial risk, not to mention extraordinary physical risk. At a time when the family was spending twenty-nine dollars a month for the rental of their home, the photography equipment alone for the trip cost several hundred dollars. Everyone, Curtises and Phillipses alike, spent weeks preparing dried and canned supplies, sewing a specially sized tent, and making watertight packages for the photographic plates. Before the first of the year, Asahel left for Skagway on the *Rosalie*, loaded down with photographic plates and a year's worth of supplies. He would stay in the north for two years, taking pictures and sending negatives back to his brother, and also working for a time on a claim on the Sulphur River, near Dawson.

In March 1898, the *Century Illustrated Monthly Magazine* published an article by Edward which described the enormous physical obstacles faced by the prospectors and the "wreckage" left after the first rush of 1897. Also credited to Edward were seven of the pictures forwarded from the north. The piece was probably Edward's first published writing, and it was a credible effort for a self-educated man:

> The rush of 1897 can be termed the first shock of a great battle which is now waging between invading Man and defending Nature. Lured from the paths of peaceful employment and routine labor by visions of sudden wealth, men rushed into the North unprepared by any certain knowledge of the country, and by the very nature of their errand antagonistic to any form of organized enterprise.... Men who lift heavy packs over steep hills and rough trails must work slowly and steadily. There is no carrying

Nature's forces by assault. Her resisting strength is immeasurable, and man can overcome it only by using brain as well as brawn. Men who contend hand to hand with nature must protect their health and daily renew their strength; for Nature is just as strong at the end of a day's work as at the beginning.

There is no indication that Curtis himself went to the Yukon at this time. In business for six years, he had a steady clientele for his portraiture and scenic views, a national award for photographic skill to his credit (with Guptill), and he was respected for his talent and resourcefulness. But his reputation—and his challenges—were still very much a local matter. Later that year the vistas of his curiosity and ambition widened unexpectedly after a chance meeting on the slopes of Mount Rainier.

Late one afternoon while climbing and photographing with a female studio assistant, Curtis stumbled on a lost climbing party in the col below little Tahoma. Members of a government commission had been climbing the mountain in two groups, by the Longmire and an alternate route, and the second unit had missed its guide points. Led to Curtis's camp to thaw out, the relieved members of the climbing party turned out to be nationally known: Dr. C. Hart Merriam, naturalist and physician, chief of the United States Biological Survey; Dr. George Bird Grinnell, editor of *Forest and Stream Magazine* and well known as a naturalist and writer on the Plains Indians; and Gifford Pinchot, chief of the Division of Forestry and a pioneer conservationist. Many years later, Curtis said simply that after he set them straight about where they were, he agreed to act as their guide in "giving the mountain the once-over." Having helped them explore the mountain for a few days, Curtis then entertained them in Seattle, showing them hundreds of his photographs of Mount Rainier and the Puget Sound region. Grinnell was sufficiently taken to keep in touch throughout the next year, and in the late spring of 1899 Merriam and Grinnell invited Curtis to act as the official photographer on a scientific expedition to Alaska.

This research cruise for distinguished scientists had originally been planned as a luxury vacation for the railroad tycoon Edward Harriman. Long a gadfly to the seemingly limitless power of steel- and railroad-magnate J. P. Morgan, Harriman annoyed Morgan's associates as well, including James J. Hill and his son-in-law, Sam Hill, a resident of Seattle and friend to Curtis. The previous year Harriman had boldly outmaneuvered Morgan for control of the Union Pacific Railroad, and now, at the height of his powers, he was considered the man of the hour in railroad circles. Flushed with success, he saw an opportunity to turn a vacation ordered by his doctor into a dazzling contribution to the world of science. Such a grand gesture of philanthropy might also improve his social standing: the uneducated Harriman was an outsider to bluestocking business circles.

In March 1899 Harriman went to see C. Hart Merriam at his offices in Washington, D.C., and broached the idea of an expedition to Alaska at Harriman's expense. Merriam plunged

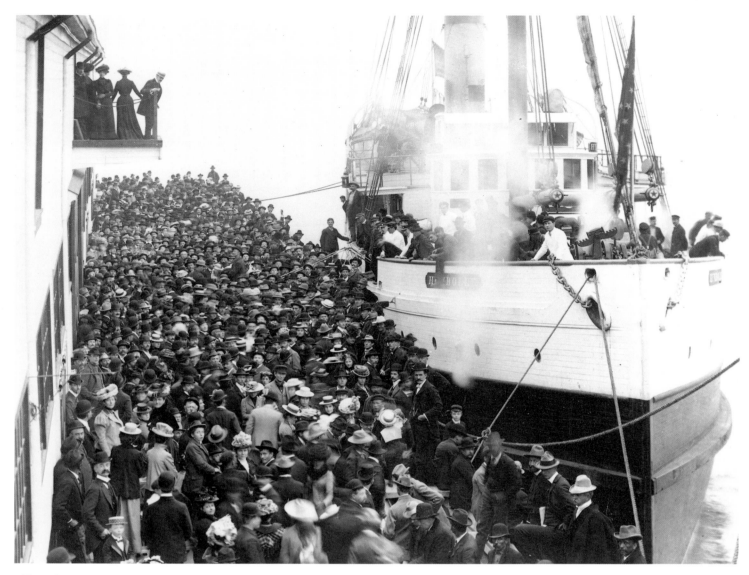

THE GOLD RUSH. On July 4, 1897, word reached Seattle that gold had been discovered in the Yukon, and the arrivals and departures of ships immediately became an important part of city life. This photograph was made by Asahel Curtis, who, unlike his brother Edward, was fascinated with current events. (Reproduced by permission of Historical Photography Collection, University of Washington.)

ahead with the project and in less than a month managed to pull together twenty-three of the country's top authorities in various fields, many of them scientists drawn from the ranks of the capital's prestigious Cosmos Club. Merriam also invited naturalist John Muir, the pastoral author John Burroughs, and three artists, including Robert Swain Gifford, a highly respected landscape artist who had illustrated one of Theodore Roosevelt's early hunting books. These luminaries, the Harriman family, and a total of eighty-nine ship's officers, deck hands, hunters, packers, medical personnel, stenographers, and taxidermists were to spend two months cruising the Alaskan coast.

On May 23, 1899, Harriman and his family met the rest of the East Coast contingent in New York, boarded luxurious private Pullman cars, and spent five days traveling across the country. On two occasions it was necessary for Harriman's private train to travel on Northern Pacific tracks which belonged to his great rival, John Pierpont Morgan. For a short time, the great man himself accompanied them, and when a derailed car threatened to spoil his gesture of courtesy to Harriman, Morgan angrily ordered that the car be pushed into a ravine. Fortunately, it was realigned and the Harriman train went ahead. In Seattle, the party was greeted by Curtis and the friend he had chosen as his assistant, Duncan Inverarity, and by Trevor Kincaid, a brilliant young zoologist from the University of Washington. After lunching at Seattle's posh Rainier Club and doing last-minute errands, the passengers boarded a refurbished iron steamer, the *George W. Elder*, and under the watchful eyes of a curious crowd, 126 adventurers set sail in a drizzling rain.

2

AS THE WEST VANISHED

I knew the railroad was coming. I saw men already swarming into the land. I knew the derby hat, the smoking chimney, the cord-binder, and the thirty-day note were upon us in a restless surge. I knew the wild rivers and the vacant land were about to vanish forever, and the more I considered the subject, the bigger the forever loomed.

Frederick Remington (1898)

The Alaskan wilderness in 1899 was fertile ground for dreams. The gold rush was at its height, and before the summer was over, miners would stampede to a major new gold discovery in Nome. Before the year ended, a new wave of industrialists would arrive from the East, self-proclaimed visionaries who looked beyond Alaska's forbidding climate and terrain to plan the development of her vast resources. Edward Harriman made his trip to assess the possibility of a trans-Alaskan railroad line culminating in a vital bridge or tunnel over the Bering Strait to Siberia. The scholars who went with him hoped to contribute to the virtual explosion of scientific knowledge at the end of the century, and thus to the strength and prestige of the nation. But they too were thrilled to be traveling along the edge of the country's last frontier; they were at once awed and stirred to greater heights of ambition by the grand scale and majesty of Alaska's peaks and glaciers.

Much more lavish and formidable than its predecessors, the Harriman Expedition was the last great nineteenth-century survey to assess the frontier's economic potential. The presence of its ornithologists and entymologists reflected the increasingly specialized and esoteric nature of science. During their two months of work, expedition members recorded in minute detail the smallest of facts through interminable lists, fastidious dissections and descriptions, and enormous collections of specimens.

As the *George W. Elder* steamed north along the coast, John Muir likened the experience to "turning over the leaves of a grand picture book." Sighting an inviting bay or a promising island, the ship would anchor and the expedition members embark in six- or eight-person launches to pursue their separate research interests on shore. Geographer Henry Gannett, minerologist Benjamin K. Emerson, and mining engineer W. B. Devereux were generally considered to be the most valuable members of the expedition because of their ability to get at exploitable resources: minerals, timber, seal and walrus skins, ivory, and fish of all kinds. The glaciologist Grove Karl Gilbert mapped and photographed glacial contours, ornithologist Albert Fisher and bird artist Louis Aggasiz Fuertes trapped and shot bird specimens, and De Alton Saunders studied marine life at the tide line. A shipboard library of five hundred books had been provided, and in the evenings the men lectured in the main salon, recording the progress of their work on the cruise as well

as speaking on their professions in general. Expedition members often referred to the *Elder* during the two-month cruise as a "floating university," and the Harriman children could certainly say, paralleling Herman Melville, "The *George W. Elder* was my Yale College and my Harvard."

But pristine bays and rookeries crowded with rare species of birds were not all that the expedition members encountered. Near Juneau they visited the thundering Treadwell Mine, already world famous for its successful extraction of gold from vast quantities of quartz. The noise of rock being crushed was deafening, surrounding forests had been reduced to scarred fields of stumps to make way for new mining shafts, and even in 1899 the discharge from the mine was noticeably polluting the air. The expeditioners visited two of the fifty-five salmon canneries along the coast, observing underpaid Chinese laborers brought in from San Francisco and beaches covered with stinking salmon parts. Touring an island fox farm east of Kodiak, the Harriman party heard that the male fox population was already so depleted as to slow reproduction, threatening the supply of pelts to the mainland fashion industry.

William Healy Dall, paleontologist and expert on Alaska, pointed out in a shipboard lecture that since the first intrusion by white explorers the territory had been the helpless victim of human greed. In Volume I of the expedition's official reports, John Burroughs wrote that "in places the country looks as if all the railroad forces in the world might have been turned loose to delve and rend and pile in some mad, insane folly and debauch." In the same volume, George Bird Grinnell painted a devastating picture of the ruthless and wasteful salmon industry invading ancient and sacred Indian domains. But in a fatalistic Spencerian turn, Grinnell concluded that "there is an inevitable conflict between civilization and savagery, and wherever the two meet the weaker must be destroyed."

In contrast to its widespread worship in the mid-1800s, nature was now regarded as the storehouse of raw materials needed to speed the march of civilization. Once nature's worshipper, man had now become her architect. The wilderness itself was now considered primarily as a source of irritation and discomfort. Of Pikes Peak, a Mr. J. T. Reister wrote characteristically in the 1870s:

The dreariness of the desolate peak scarcely dissipates the dismal spell, for you stand in a hopeless confusion of dull

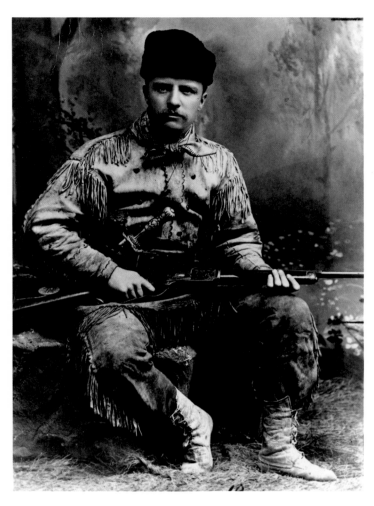

THEODORE ROOSEVELT, 1885. Roosevelt spent two years as a rancher in South Dakota, experience that lent authority to his writing on the West, and to his pronouncements that whites were "more highly evolved" than native Americans. (Photographer unknown, courtesy of Library of Congress.)

stones piled upon each other in odious ugliness, without
 one softening influence, as if nature, irritated with her
 labors, had slung her confusion here in utter desperation.
Even cowboys had not yet come into their own in the 1870s, for then the very term "called up the image of a semi-barbarous laborer who lived a dull, monotonous life of hard fare and poor shelter." Similarly, the Indian of the 1870s and 1880s was not considered a creature of romance, but rather, as the future President Theodore Roosevelt wrote in his *Winning of the West*, a

lazy, dirty, drunken beggar, whom they the frontiersmen
 despised and yet whom they feared; for the squalid, con-
 temptible creature might at any moment be transformed
 into a foe whose like was not to be found in all the wide
 world for ferocity, cunning, and bloodthirsty cruelty.[1]

But in the late 1890s, in a climate of opinion that reemphasized traditional values, the Wild West came to represent a culture before the advent of industrialization—and as such it became both heroic and melancholy. This attempt to revive earlier values actually meant a reinterpretation of them,

with significant change to their content. Within a few years of the official closing of the frontier in 1891, the West was transformed from a wilderness inhabited by "savage" and "barbarous" trappers, backwoodsmen, cowboys, and Indians, into the "true" home of the "strong, self-reliant individual with many estimable traits." The *Nation* had reviewed Roosevelt's writings about the West in 1893 by calling the life of the West "peculiar" and its inhabitants "strange," but by 1897 the magazine's outlook had changed sufficiently to observe that "the days of the cattle kings, the cowboys, and the great roundups may be nearly over, [hence] their story... marks a stage in the development of the country that cannot be ignored." This emphasis on rugged individualism represented an invaluable rallying point for the ambitions of the future and also presented an opportunity to elaborate on the heroism of the past: the more formidable the obstacles overcome in the conquest of the West and the more staunch its pioneers, the more glorious the light reflected on the country as a whole.

This new view struck vibrant chords in the hearts of Americans, and the general public took increasing interest in the poignant image of the vanishing West. A reviewer of Owen Wister's wildly popular novel, *The Virginian*, wrote that the West was an environment which "developed the elemental qualities of manhood," and called "the hero of this tale of the vanished frontier a real man."

The Harriman Expedition was undertaken just as excitement over the reinterpretation of the frontier experience was reaching its height. The expeditioners did not indict business and government for wasting and destroying the wilderness; their confidence in the eventual mastery of science was unshaken, as was their belief in the evolution of civilization. They looked past the pillaging of Alaska in search of principles to secure them in the future.

The group's detachment from the grisly aspects of the trip is mirrored in Edward Curtis's luminous photographs. Of the roughly five thousand images that came out of the cruise, Curtis's are almost exclusively of geological formations. To document the research interests of the expedition members, he photographed mile-long glaciers, towering mountains next to narrowing inlets, and the glaring, undulating surfaces of ice fields. His six-by-eight camera faced many technical challenges, and the detail and clarity of his results attest to his skill and long experience on Mount Rainier. In these expedition photographs he often placed a dark and textured foreground against bands of light and dark receding into the background, where the strange Arctic light played a dramatic part. As a group, these are mysterious and dreamlike photographs.

On the dozen or more occasions that the Harriman Expedition encountered native cultures, it was C. Hart Merriam who made almost all the photographs. In general, photography was still considered to be window dressing for the written studies of other cultures, but in Merriam's disciplined hands the camera became a vital tool for recording data. Working in series, he made detailed photographs of the faces of native people, their

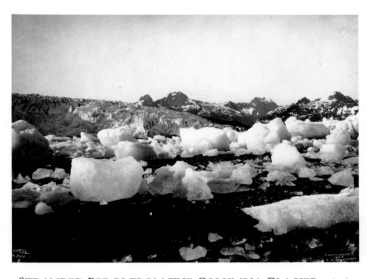

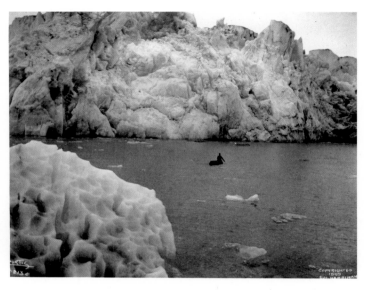

STRANDED BERGS FROM THE COLUMBIA GLACIER, 1898. One of Curtis's dreamlike photographs from the Harriman Expedition. Invited as chief photographer, Curtis returned from the two-month trip with hundreds of images of landscapes and geological formations, and a few pictures of Indians which forecast his later work. (Reproduced by permission of Historical Photography Collection, University of Washington.)

BEFORE THE GREAT BERG FELL, 1898. This Curtis photograph from the Harriman Expedition was made in Glacier Bay, and the man in the canoe is probably Curtis's assistant, Duncan Inverarity. Shortly after this picture was taken, Curtis and Inverarity canoed close to the face of the glacier and were nearly killed when a section of ice broke away. (Reproduced by permission of Historical Photography Collection, University of Washington.)

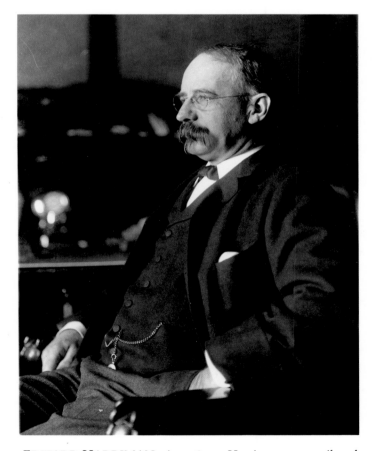

EDWARD HARRIMAN, circa 1890s. Harriman was a railroad millionaire and a rival to both J. P. Morgan and Theodore Roosevelt. Having met Curtis on the 1898 expedition to Alaska, Harriman later provided valuable support and publicity for Curtis's Indian project. (Photographer unknown, reproduced by permission of Brown Brothers.)

DESERTED INDIAN VILLAGE, CAPE FOX ISLAND, ALASKA, 1898. This village was mysteriously abandoned not long before Curtis photographed it. Members of the Harriman Expedition took many carvings and masks from the houses, and pulled down large totems to give to museums and universities. (Reproduced by permission of Historical Photography Collection, University of Washington.)

clothing, houses, boats, tools, and other artifacts. Curtis made only a few Indian images; but since he and Inverarity printed everyone else's work, he would have seen all of Merriam's images and probably discussed some of them with him. Merriam was trained to regard the collection and classification of data as more vital than its interpretation; his precise and consistent photographs reflected all the principles of gathering a systematic visual record of other cultures. In addition, Curtis observed Harriman when he made recordings of Indian speech and songs on wax cylinders, and he heard George Bird Grinnell's shipboard lectures about his twenty years of experience among the Blackfeet people.

Curtis was often free to photograph as he pleased, and his many photographs from the trip suggest that he then saw himself primarily as a landscape photographer. The timing of the expedition, as well as the depth of Curtis's eventual commitment to scientific study, indicate that his two months of study on the cruise crucially influenced his later thinking. The friendships he formed there altered the course of his life: Grinnell would shape his thinking about Indians, and Merriam and Harriman would provide invaluable social and financial connections in the East.

But that was all still in the future. The immediate effects of the Harriman Expedition were to provide Curtis with excellent fundamentals of scientific method and to enlarge his ambitions radically. Self-educated and self-employed in a field still formulating its professional standards, Curtis previously had few opportunities to fully test and assess his own intelligence and capabilities. When he accompanied small parties of expedition researchers to take photographs for them, though, he was

working alongside leaders in various specialties. Taking crash courses in a half-dozen subjects at once, Curtis was learning first-rate field techniques—the same techniques that eventually formed the basis of his study of American Indians.

These men welcomed Curtis as an equal. His intelligence and achievements in photography commanded respect, but his physical strength, adventurousness, and charm undoubtedly played a part in his acceptance into the ranks of this East Coast scholarly fraternity. Most of them were from established old families and came west as young men seeking adventure—scientific pathfinders who saw themselves as frontiersmen as well. Curtis had an edge in being a "real" Westerner and a "rugged individual" to boot. One of the most exciting incidents of the entire cruise came when Curtis and Inverarity were almost killed in Glacier Bay. They had been photographing against the face of the glacier when an unexpected wave nearly swamped their lightweight, canvas-covered canoe. The men on shore thought they would surely be killed, so the duo's showy canoeing and narrow escape were warmly commended.

On the return voyage to Seattle, Curtis was exposed to a darker side of collecting encyclopedic information for the sake of science. One of the expedition members had heard about a deserted Indian village south of Wrangell, Alaska; when the Harriman party put in there to explore they found that the inhabitants' departure had been as abrupt as it was mysterious. Cabins were still filled with baskets, carvings, and ceremonial masks, and children's clothes hung rotting from the rafters. It took a full day to gather and load everything of interest, including two Chilkat blankets that had been on graves. Three magnificent totems were pulled down and tagged for the Field Museum in Chicago, the California Academy of Science, and the University of Michigan. John Muir grumbled about the "robbery" in his journal, but it is unlikely that more than a few expeditioners would have questioned the taking of the pieces for museums, any more than they would have questioned shooting a rare bird to save it as a specimen.

When the *George W. Elder* sailed into Seattle on the morning of July 30, 1899, an excited crowd observed the docking. In the following days the press quickly hailed the Harriman Expedition for its scientific successes. The ship's hold was crowded with specimens: minerals, fossils, birds, animals, hundreds of new species of crustaceans, and stacked crates of Indian artifacts. It would take fifteen years and thirteen volumes to publish all the expedition's findings: two volumes directed to the general public and eleven for professionals which would become standard references. For twelve years C. Hart Merriam directed the publication effort, and he also proofed all of Curtis's prints. In addition, Harriman commissioned a special souvenir album entirely of Curtis's photographs for the expedition members, keeping Curtis busy through the summer of 1900. A fastidious critic, Merriam often returned Curtis's prints, especially for recropping, before he was willing to send them on to be made into photogravures by the prestigious firm of John Andrew and Son in Boston.[2]

Meanwhile, Curtis also printed and sold expedition photographs from his new studio space at 709 Second Avenue. In early 1900 he had sold his engraving business, and with part of the proceeds had taken over Frank La Roche's studio on the top floor of the Downs Building. La Roche had been in business longer than Curtis, making a name for himself by doing portraits of prospectors and "actresses" headed for the Klondike but also making fine photographs of Alaska and of Indians. Curtis inherited not only a larger darkroom but a gallery and well-appointed reception area, and for the first time, a telephone: Blue 281.

The Curtis family was growing as well. Another daughter, Florence, had been born December 1, 1898, so the household at Eighth Avenue now included Edward and Clara, three young children, Edward's mother and sister, and a number of Phillipses that seemed to vary with the seasons. Sue and Nellie were still working for the studio as printers, and during Asahel Curtis's absence in Alaska, William W. Phillips had been promoted from printer to photographer. William began to accompany Edward on his photography trips away from Seattle.

The drama of the Harriman Expedition over, Curtis's life had resumed its old patterns. He managed the studio, printed all his own work, and continued to make lucrative studio portraits and landscape prints. The family was in good health, and with the studio prospering, this seems to have been a happy time. On balmy weekends, everyone in the household boarded one of the "mosquito fleet" boats, ferried across Puget Sound to Port Orchard, and then rowed themselves and their supplies to the beachfront cabin at Sidney. Edward also continued to find the time and energy to climb Mount Rainier. On one occasion, he and Ella McBride led 108 Kiwanis to the top of Rainier; years later he recalled that McBride not only reached the summit unaided but helped him by dealing with "the women who had lied about their physical condition."

In October 1900 he traveled to Portland for a meeting of the Photographers Association of Oregon, which had just agreed to include members from Idaho and Washington. During that first three-day meeting of the new Pacific Northwest Photographic Association, A. L. Jackson of Tacoma was elected president, and Edward Curtis was made vice-president for the state of Washington. This Northwest group affiliated itself with the National Photographic Convention which, in 1898, had awarded Curtis first place in the Genre Class for his Indian images and had given him a diploma for excellence for his portraiture. At the same convention the following year, Curtis again won first-place honors for Indian images, this time for "Evening on the Sound," "The Clamdigger," and "The Mussel Gatherer." Although the West was lightly represented at the convention, another First went to A. L. Jackson for his portrait of a white-bearded gold miner with a corncob pipe. Both his and Curtis's work traveled with the other Grand Prize winners on a two-year tour of foreign countries.

Photographic associations and their salons had sprung up throughout the 1890s as serious photographers sought to defend their work against persistent public condescension, and also against the army of "Button Pushers" that appeared in the wake of the newly invented hand-held camera. Despite the tedium involved in its early technology—and despite the prevailing notion that its products were not Art—photography had become very popular since the Civil War. George Eastman's dry plate had eliminated much of the rigor of the wet-plate collodion process; and the Kodak 1 camera he released in 1888 could make one hundred exposures on a single roll of film. Simplified, photography became a craze in the 1890s—it was the era of "photography by the yard"—and the most cynical opinions about the medium often seemed justified. To distinguish themselves from snapshot takers, professionals and serious amateurs closed ranks, popularizing processes such as the gum print, oil print, and glycerine-developed print because the results were readily distinguished from the work of novices.

In New York, art photographers banded together. Their most influential advocate, Alfred Stieglitz, railed against the damage done to photography's reputation by the new amateurs. In his zeal to influence public attitudes, Stieglitz condemned the work of many dedicated and capable photographers on the grounds that their work was "too literal" and played into the hands of those who insisted that the camera did all the work. Under the banner of nonconformity, Stieglitz allied his forces with the cause of modern painting and established a new category for photographers who were neither hobbyists nor commercial photographers but artists. In 1897 he began a magazine called *Camera Notes* for the New York Camera Club, devoting it to the best artistic photographers or "pictorialists" whose work deliberately resembled painting. Stieglitz's invaluable ally in this promotion was Sadakichi Hartmann, a critic whose penetrating analyses and barbed wit made him "court magician to two generations of intellectuals." Now little known, Hartmann worked tirelessly to legitimize art photography by writing it up in dozens of journals. In 1903 he summed up the New York coterie's view of realistic photography:

> The love of exactitude is the lowest form of pictorial gratification—felt by the child, the savage, and the Philistine—it merely apprehends the likeness between the representation and the object represented. The unforeseen and unexpected effects are those which make the deepest impression.[3]

This position would soon be reversed—and conveniently forgotten in the ensuing years—but until 1904 (and even later, for many photographers) the radical talents of the Photo-Secession group vehemently asserted that the most imaginative pictures were those that did not look like the product of an apparatus.

After the about-face, most pioneers of art photography would favor the "straight" (unmanipulated) print, which emphasized the character of the medium rather than disguising it; "the love of exactitude" would cease to be a sin. But in 1900, the New York set regarded the relatively straight work published by the West Coast journal *Camera Craft* as provincial and uninteresting. *Camera Craft* did carry some pictorialist

Above left, PORTRAIT, 1904; *center,* A DESERT QUEEN, 1901; *right,* THE EGYPTIAN, 1901. Following the Harriman Expedition Curtis was increasingly drawn to native Americans as photographic subjects, but he also pursued commercial portraiture and experi- mented with pictorial fashions. These examples of his work were published in *Camera Craft* magazine. (Reproduced by permission of Historical Photography Collection, University of Washington.)

work, but the treatments were less extreme and impressionistic than those practiced in New York and Europe. The work of many Western photographers looked journalistic instead of picturesque and used a sharp-focus lens, showing their roots in the Western tradition of heroic landscape and engineering-project photography. All in all, the photographers whose work was reproduced in *Camera Craft* were less theoretical and rebellious than the Photo-Secessionists, and the magazine is little known today. But in its own time *Camera Craft* was widely read and had a far greater influence on many photographers than either Stieglitz's *Camera Notes* or the subsequent and lavish *Camera Work*.

During 1899 and 1900, early issues of *Camera Craft* carried Curtis's work on a regular basis and even gave his images prominence as frontispieces and Portraits of the Month. The wide variation in these published photos indicates that he was still experimenting. In October 1900 the magazine featured his three prizewinning images from that summer's National Convention competition; and in December six of his images: three Indian shots, one regular studio portrait and two curious images entitled "The Desert Queen" and "The Egyptian." In the "Desert Queen," a black woman wears a length of cloth draped precipitously around her shoulders and a draped headdress secured by a tiara. The exoticism of "The Egyptian" is just as tenuous: a robust female wears elaborate jewelry, including a wide band on her upper arm, and is presented in profile as though to suggest a bas-relief. These images are fairly typical of the end-of-the-century vogue for picturesque or exotic

subjects, a fashion in keeping with the revival of patterns that characterized much of nineteenth- and twentieth-century art and architecture. The same December issue carried an article and pictures on the Hopi by George Wharton James, a regular contributor whose work was presented formally as science. Respected as an ethnologist, he was not thought undignified for enjoying an enthusiastic lay audience.

Camera Craft's February 1901 issue carried "A Critical Review of the Salon With A Few Words upon the Tendency of the Photographers," in which pictorialist critic and photographer Arnold Genthe observed that "E. S. Curtis's images occupy quite a place by themselves. They are of immense ethnological value as an excellent record of a dying race and most of them are really picturesque, showing good composition and lighting effects." Genthe went on to critique Curtis's submission "The Three Chiefs," a picture of Piegan Indians who had stopped their horses next to a waterhole in the middle of a grassy plain. He found the composition weakened by the parallel arrangement of the horses' heads and suggested that the lead horse's head should have been turned. But in the image of the lifting manes and tails, and the silver undersides of the long grass, the wind could be heard and also felt. It was a monumental image and a sign of the direction Curtis's work was taking.

Late the previous summer Curtis had made a trip to Montana at the invitation of George Bird Grinnell. He went by train to Browning, Montana, not far from the Canadian border, and from there with Grinnell on horseback across a windswept

plateau to a high cliff, where the two men sat looking over a great encampment of Blood, Blackfeet, and Algonquin gathering for their annual sun dance. The camp formed an enormous circle, which sometimes took two days to set up and might reach a mile in diameter. Everywhere were men and women on horses, in wagons, hauling babies, puppies, and camp equipment, sometimes by travois, a simple but effective raised sled of lashed poles.

> Neither house nor fence marred the landscape, and the broad, undulating prairie stretching away toward the Little Rockies, miles away to the west, was carpeted with tipis.... It was at the start of my concerted effort to learn about the plains and to photograph their lives and I was intensely affected.

The sun dance Curtis observed on this trip was the last held for many years; it was outlawed on the grounds of its "barbarous cruelty." Though elements of the dance varied from tribe to tribe, its central feature was sun worship and the formal self-torture of ambitious young braves offering themselves in fulfillment of a vow or in proof of their courage. Curtis described it as "wild, terrifying, and elaborately mystifying."[4]

Curtis returned to Seattle and ten days later left for Arizona to photograph on the Hopi Reservation, an abrupt schedule which suggests impatience to be about his work. But any impression of single-minded interest in Indians is counterbalanced by the publication within weeks of his exotic "Egyptian" and "Desert Queen" pictures and by his columns on composition and lighting for amateur photographers in Seattle's new publication, *The Western Trail*. Although showing that he was abreast of the current arguments surrounding art photography, Curtis's pronouncements were few and reserved:

> Many artists claim that a photograph cannot be a work of art. However, I do not think that even the most radical of them can deny that a photograph can show artistic handling and feeling. After all, it is the finished product which hangs on our wall and not the implements with which it is made.

In this small collection of articles, Curtis repeatedly sidestepped a declaration of his own opinion by quoting someone else.[5] Compared with his energetic writing in the Alaska column two years earlier, his handling of these *Western Trail* pieces is unremarkable and even unsure. He sounds like a fastidious photographer but betrays no hint of exceptional ambition or ability.

Meanwhile, Curtis's Indian images were appearing in local publications, as were those of Frank La Roche and other area photographers, and public interest in the subject of Indians was on the rise. In May 1901, *The Western Trail* devoted a full page to a poem entitled "The Passing of the Red Man," setting the type around an 1899 Curtis portrait of a Nez Percé man. The poem crowds in a remarkable number of stereotypes:

> ... many sons of mighty braves
> are sinking every day,
> Beneath the swells of Saxon waves
> That chill them with dismay.
>
> The smoke from mills and crowded marts
> seem poison to their breath —
> While to engage in peaceful arts
> Is worse to them than death.
>
> They treat all efforts at reform
> With feelings of disdain
> And worship still the burning storm
> And war's wild hurricane!

This poet echoes not only the rising national preoccupation with race comparisons and past history, but also the still-developing idea that the Indian was unable to live in civilization: a "domesticated" Indian could only be one whose spirit had been broken. As the notion took hold that there could be no future for the "true," "wild" Indian, notes of admiration and poignancy intensified in popular depictions of Indians. America's romance with its Western past was about to burst into full bloom.

It is tempting to imagine that Curtis had recognized his calling as a photographer of Indians by this point. When he said to his *Western Trail* readers, "this is a day of concentration and to make a showing you must be a specialist," surely he was thinking of himself as the great recorder of the dying race? Published briefs of Curtis's life have encouraged this notion of his early calling by telescoping the years into one success sweeping into another. That he was photographing Indians early on is clear, but with the exception of Curtis's own later and conflicting claims to have begun "the work" as early as 1895, it seems that his ideas about "a great project" developed gradually. What stands out most about these years is their lack of definition. Almost no trail exists of his activities from 1901 to 1903, and he made no public announcements about his goals until 1904; several years elapsed as he mapped out a course. In the meantime, he learned to use a "motion picture machine" and was fascinated by gold mining.[6] But he was also building a body of Indian photography, and by late 1903 or 1904 he had come to regard his Indian work as a magnum opus in the making.

One incident from this watershed period looms as a troubling omen: Curtis permanently severed relations with his younger brother Asahel. After more than two years in Alaska, Asahel returned to Seattle in 1900 and promptly claimed ownership of the plates that he had sent back from the Klondike and the Yukon.[7] Then, as now, it was accepted practice for a firm to claim the benefits of authorship and copyright from the efforts of its employees. Asahel took exception to this arrangement, feeling he should not relinquish control of his work. The particulars of the falling out are not known, but except for a very few communications between them (usually through someone else), Edward and Asahel had nothing to do with each

31

THREE CHIEFS, PIEGAN, 1900. Curtis failed to win an award when he entered this photograph in a national competition, but it later became one of his most famous. Made on the high plains of Montana, it was a forerunner of his greatest romantic images. (Courtesy of Flury and Company.)

other for the rest of their lives. Their children, all raised in Seattle, were never acquainted.

Like Edward, Asahel was deeply committed to his photography. In the years immediately after leaving his brother's employ, he worked as a staff photographer for both the *Seattle Times* and the *Seattle Post-Intelligencer* and then worked for a year in San Francisco as an engraver, returning to Seattle just before the great earthquake of 1906. After two long partnerships, first with William Romans and then with Walter Miller, Asahel went on his own in 1920 and for the next twenty years advertised his business as "photographs of every kind, taken anywhere in the Northwest." His cumulative body of work far surpasses that modest advertising: a talented and versatile photographer, he documented most of the economic and political developments in the state of Washington for forty years. Working in a plain style then disdained by the *artistes*, Asahel transcended the utility of documentary pictures by

keenly recording many phases of Western life. Richly deserved admiration for his work continues to grow. In addition to his photographic role in the community, Asahel helped found the Mountaineers (Seattle's climbing club), was active in the national park movement during the administration of Theodore Roosevelt, and from 1911 to 1936 served as chairman of the Mount Rainier National Park Advisory Committee.

That these talented brothers created a lifelong gulf between them is a sad testament to both men's determination and taciturnity. Edging gracefully beyond the forceful but often stifling influence of a brilliant mentor is difficult; if that mentor is one's older brother *cum* father, independence is even harder won. The break with Asahel was the first major tear in the net of family responsibilities that enmeshed Edward since he was a child; from now on, ties to his family would bind him less.

3

ON THE RIGHT TRACK

Last night I gave a stereopticon picture talk at the Century Club.
The room was crowded.... The audience was as a whole
breathlessly quiet, but occasionally cheering a picture. When the last picture
went on the screen and I thanked them feelingly for their interest...
the whole roomful of men rose to their feet with a cheer of thanks....
When a gathering like that will show such enthusiasm
one cannot help but feel that he is right in the work.

Edward S. Curtis (1906)

The first few years of the twentieth century in America are popularly regarded as a tranquil period, and compared to what lay ahead for the country, it was a good time for most people. But an extraordinary rise of jingoistic ideas belies the lack of open conflict in those years: Americans were under strain and grasping at a sense of order. President Theodore Roosevelt was raising the powerful rallying cry of Americanism, which he summed up as "the union of strong, virile qualities with steadfast devotion to a high ideal." Americanism became the hallmark of "a new type, a new race," hammered out by the stern land from "the best racial characteristics of Europe." In this highly charged atmosphere of altruism and self-interest, every facet of national history was reexamined to lend strength to the new patriotism. Seizing Texas from the Mexicans was eulogized as "an adventure like that of Norse sea-rovers," and the Texans themselves were praised as "warlike, resolute, and enterprising: [having] all the marks of a young and hardy race, flushed with the pride of strength." The Cuban chapter of the Spanish-American War was recast as a brilliant campaign against the weak Spanish infidels.

After close scrutiny, Western expansion was seen as hinging on the "subduing, displacement, and removal [of] the most formidable, savage foes ever encountered by colonists of European stock." The dimensions of this struggle for the North American continent grew in the public mind until Roosevelt's regular references to it as "the most impressive triumph of the English-speaking race" were regarded as fact. Promoting the valor and ferocity of Indians as opponents—and the "new breed of rugged, individualistic Westerners" who subdued them when the French and Spanish could not—glorified the myth of the winning of the West and the "race accomplishment" it signified.[1]

This backhanded admiration of Indians because of their fighting abilities and fierce loyalty to their "primitive" way of life was fed by a fascination with legends of conquest and loss, and with the contrast between civilized and primitive peoples. During the first decade of this century the demand for images and information about Indians seemed insatiable. An intricate white subculture sprang up around the reservations, particularly in the Southwest, the center of activity for American archeologists and ethnologists. One group worked to supplant old ideas with modern ones about hygiene, jobs, and property so that the Indians might become merged in the American whole as quickly as possible; the other group—ethnologists, writers, and artists—worked to compile records of classical Indian cultures before they disintegrated. This decade represented not only the apex of racial explanations of history and social organization but of public curiosity about native Americans as well.

This final heightening of interest in the West set the stage for Edward Curtis's emergence as a nationally known photographer. The record of his activities in 1903 is sparse, but in July—less than two months after Seattle had welcomed Roosevelt as a war hero and "true Westerner"—Curtis gave his first formal show of Indian photographs. He displayed his prints in the studio gallery and announced them as "the latest images of the Mohave, Zuni, Supia, and Apache," presumably from his second trip to the Southwest made the previous year. A *Seattle Times* article published that November provides a glimpse of public reaction to Curtis's images and to native Americans in general:

> Instead of the painted features, the feathers, the arrows, and the bow, we find him in [the] blue jeans and cowboy hat of semi-civilization. Enshrined though he may be in the weird habits and mysterious rites of his forefathers, the mystery has vanished and the romance has gone in the actuality of the present day.

> And so Edward S. Curtis, of Seattle, found him. For the time being, Curtis became an "Indian." He lived "Indian," he talked it, he became "heap white brother."... He dug up tribal customs, he unearthed the fantastic costumes of a bygone era. He won confidences, dispelling distrust. He took the present lowness of today and enshrined it in the romance of the past.... he changed the degenerated Indian of today into the fancy-free king of yesterday that has long since been forgotten in the calendar of time. [2]

Curtis's pictures were clearly intended to evoke the past. Yet evidence abounds that those "weird habits" were still very much a part of native Americans' lives. Although many Indians wore blue jeans or manufactured dresses, they still dressed in traditional costume for many ceremonial occasions; and on

SPECTATORS AT THE SNAKE DANCE, 1905. At the turn of the century the Southwest was the center of activity for archaeologists and ethnologists. The major ceremonies of native Americans in that region were well known and always drew large crowds, a scene recorded by Curtis. (Reproduced by permission of Historical Photography Collection, University of Washington.)

reservations far from population centers, white ways had made few inroads. For many tribes, real assimilation had scarcely begun.

Early ethnologists chose not to study acculturation and preferred to isolate habits and languages believed to be disappearing in order to record them in as pure a form as possible for future enlightenment about cultural evolution. For this reason, Curtis photographed Indians not on the streets of Seattle in their obvious poverty and mixture of white and traditional clothing, but on the reservations. His work deemphasized whatever acculturation had taken place, usually by highlighting traditional elements of his subjects' dress or habits. He began asking tribes to reenact famous battles or to conduct portions of ceremonies for the benefit of his camera, and he would sometimes remove white goods or tools from his set-ups, though inconsistently; many of his pictures show a large admixture of white culture. In 1905 photography was not a prominent element in ethnological research; suppressing detail in photographs was not the issue it is today. In photographing the Kwakiutl in British Columbia, the fastidiously correct Franz Boas sometimes used blankets to hide settings and even removed distracting figures from some images by retouching—though he, like Curtis, was inconsistent.[3]

It was not Curtis's occasional editing of white influences that set him apart from other photographers of Indians early in the century, but his combination of science and romanticism. Even when Curtis photographed tribes whose lives were still aboriginal, where no reconstruction or staging was needed, his work was distinctly idealized, portraying the Indians as living relics, the embodiment of the vanishing frontier. As the country realized it had a "glorious" past in the West, it would come to

remember that magnificence through Frederick Remington's cowboys, Owen Wister's Virginian hero, and Curtis's splendid Indians.

A few weeks after the newspaper article that contrasted Curtis's pictures with the " 'degenerated' types of today," a reporter for the *Post-Intelligencer* wrote up Curtis's now-famous portrait of Chief Joseph, made when the Nez Percé chief visited Seattle. Then probably the best known surviving great chief, Joseph had worked for years to gain permission for his people to leave the reservation in northeastern Washington and return to their traditional home on the Wallowa River in northeastern Oregon; he had even traveled to Washington, D.C., to enlist aid for his cause. In Seattle he had the support of two friends of Curtis: the powerful Sam Hill, president of the Northern Pacific Railroad and son-in-law to the "empire builder" himself, James J. Hill; and Edmond Meany, an ambitious University of Washington history professor. Joseph came west over the Cascade Mountains to deliver an evening speech on behalf of his people, and the following day he and his nephew, Red Thunder, went to the Curtis Studio to have their portraits made.

The *Post-Intelligencer* published two accounts of Joseph's visit to Seattle, expressing a typical air of racial contempt. The first piece appeared under the headline "Old Chief Likes City, Meets a Famous Indian Artist, Then Takes a Bath." Joseph was described as looking like a "turkey cock on dress parade," Curtis as a "professional Indian tamer;" Curtis was quoted as saying, "I do not consider that Chief Joseph's head is a good type of the Indian, nor is he the best to be found among the Nez Percés."[4] Whatever Curtis said or thought of his model, the two surviving 1903 portraits of Joseph are moving studies, and Curtis would later select one of them for prominence in publication.

In contrast to the fragmented record of Curtis's activities in the previous few years, his career work in 1904 is well documented and clearly pivotal. At the beginning of the year he hired Adolph Muhr to manage his darkroom. Muhr had worked for Frank A. Rinehart, then one of the most famous photographers of Indians, and arrived with impressive credentials in the darkroom and as a photographer in his own right. As Rinehart's assistant, he had been assigned to photograph the 1898 Trans-Mississippi Omaha Exposition, a major Indian congress with delegates from thirty-six tribes; and Muhr's platinum prints and accompanying descriptions had become well known under Rinehart's name. Although Muhr never took any photographs credited to Curtis, Curtis referred to him with singular deference as "the genius in the darkroom" and turned over all his personal printing to him. Between the aid of his new manager and his wife's family, Curtis was now free of most of his responsibilities in Seattle, and he worked away from home most of each year after 1904.

By this time, Curtis hoped that his Indian photographs of the previous few years could form the basis of a vast work: he planned to photograph all of the Indian tribes who "still

KWAKIUTL DANCER AT THE WORLD'S COLUMBIA
EXPOSITION, CHICAGO, 1893. The American Museum of Natu-
ral History brought groups of native Americans to the exposition to
demonstrate traditional ceremonies and crafts for the educational
benefit of the public. Photographs were made of the performers and
craftsmen to supplement field research. Franz Boas was in charge of
Northwest displays, and he probably worked with the photographer
who took this picture. (Photograph by John Grabill, reproduced by
permission of Peabody Museum, Harvard University.)

RETOUCHED VERSION OF KWAKIUTL PHOTOGRAPH,
1897. Franz Boas reproduced this version of an 1893 photograph in
"The Social Organization and Secret Societies of the Kwakiutl."
Early anthropology emphasized the study of traditional native
American cultures over the process of their acculturation. Conse-
quently, it was not considered misleading—as it is today—to remove
"distracting" signs of white culture from pictures of native Ameri-
cans, as Boas did when he had the long fairground shed retouched
out of this photograph. (Reproduced by permission of American
Museum of Natural History.)

HOPI FARMERS YESTERDAY AND TODAY, 1906. Most native
Americans in the United States had been influenced by white culture
by the time Edward Curtis began his Indian photography. He fol-
lowed the lead of ethnologists in trying to salvage a record of pre-
contact cultures, and emphasized the study of traditional ways of
life. But he often referred to the extent of acculturation in his sub-
ject's lives, both in photographs such as this one and in the text of
The North American Indian. (Courtesy of Flury and Company.)

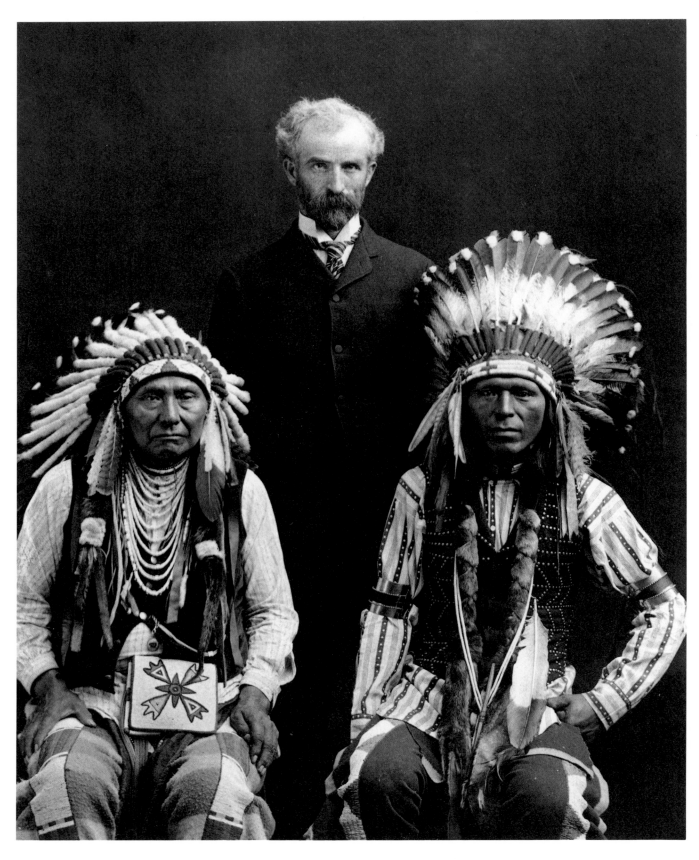

CHIEF JOSEPH, PROFESSOR MEANY, AND RED THUNDER, 1903.
Then one of the few surviving patriot chiefs, Joseph was in Seattle to lecture on
behalf of his people and visited the Curtis Studio to have his portrait made.
(Reproduced by permission of Historical Photography Collection, University
of Washington.)

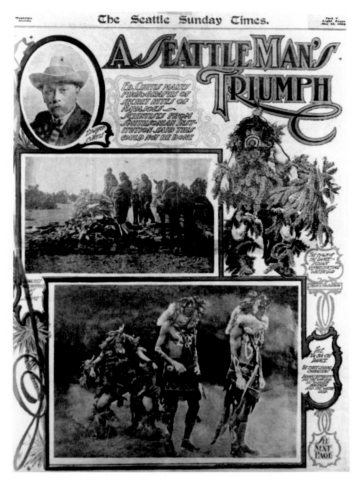

THE ETHNOLOGIST AS EXPLORER, 1904. When Curtis returned from the Southwest in May of 1904 he brought back still photographs and pioneering "moving pictures" of a sacred Navajo dance. Criticized today for having gained information by subterfuge, many early ethnologists saw themselves as explorers to foreign lands whose role was to bring back revitalizing treasures to their own culture. (Reproduced by permission of Historical Photography Collection, University of Washington.)

retained to a considerable degree their primitive customs and traditions." The most enlightened scholarly opinion expected native American cultures eventually to be absorbed into white society and entirely disappear. In wanting to catalogue their ceremonies, beliefs, and habits, Curtis was in keeping with the scientific drive of the day and was especially influenced by his experiences with the Harriman Expedition. From the outset, though, Curtis wanted his work to be both scientific and artistic, to provide new data for professional ethnologists and a beautiful record of pictures and descriptions for the general public, so that the Indian could not "by future generations be forgotten, misconstrued, too much idealized or too greatly underestimated." While his overall conception of his efforts was still taking shape, Curtis set out to make his great project and publication a reality.

Early in 1904, Curtis traveled to the East Coast to discuss his work with Frederick Webb Hodge, then a respected figure at the Smithsonian Institution's Bureau of American Ethnology,

and also with William Henry Holmes, chief of the Bureau of American Ethnology. On the same trip he had an appointment in New York with Walter Page at Doubleday and Company to discuss the possibility of publishing his photographs. Page at first told him there was no point in even attempting to publish his Indian photographs, saying, "The market's full of 'em. Couldn't give 'em away." But according to a newspaper report, Curtis went ahead and showed him several prints—"a nervy thing to do, but Edward S. Curtis was from Seattle." After seeing his work, Page was said to have been interested in printing some of the images in lots of 5,000. The results of Curtis's trip to Washington and his subsequent field work among the Navajo were reported in the *Seattle Times* on May 22:

> When Mr. Curtis was in Washington, D.C., recently, government scientists who have devoted a lifetime to the study of Indians chanced to mention the great Yabachai dance. It seems this dance is hidden among the most sacred rites of the Navajos. It is a ceremony that lasts nine days, all told. ... Smithsonian Institution men told Mr. Curtis that pictures of the dance... would be priceless from the standpoint of the Indian historian. But they also told him that the government had been working to get the views for twenty years without result, and [had] reached the conclusion that it was beyond the pale of the possible.... Curtis started for the land of the Navajo. This trip he took with him a moving picture machine, something he had never carried before. To all questions he answered: "I am going to Arizona. I don't know how long I will be gone." And he went to Arizona, and he stayed just long enough to accomplish that which Uncle Sam, with all his power and authority, had tried for two decades to do and failed.... In addition to individual pictures of the masked dancers and the "fool," Curtis brought back a "moving picture" of the dance itself... something that thrown upon the screen will convey to the onlooker the exact and lifelike picture of a dance that, in its reality, had never been seen by light of day, or had been looked upon by the eyes of a white man.[5]

Years later, the suggestion that Curtis had carried a movie camera in Indian country at this time was dismissed on the grounds that the process had not then been sufficiently developed, a difficulty of which he was evidently not informed. It is not known how Curtis came to use a motion picture camera as early as 1904—only one year after one of the first "story films," *The Great Train Robbery*, had been shown to mystified audiences in New York—but that he did is an indication of his wide-ranging curiosity and eagerness to experiment.

In May 1904, the *Lewis and Clark Journal* published the first major magazine feature about Curtis's Indian work. Based in Portland, where Curtis was well known to naturalists and "progressives" in the Mazamas Mountaineering Club, the periodical stated:

> One of the most remarkable portraits... was that of Double Runner, a Piegan. There is a strange mingling of unconquerable dignity and cynicism in the face; a fine

sarcasm hovers about the thin lips, all the wiliness and immobility of the typical Red Man are there, together with a certain eagle-like grandeur. And yet with that sternly patrician nose and ironical mouth it might also be the face of a Roman cynic. It is indeed the face of a man who, though he belongs to a vanquished race, would die without surrendering the secret of his inner self.

Curtis was described as a Western artist who was making it "his life work to preserve by the aid of the camera the essential characteristics of these vanishing tribal types."

When it is remembered that there are no fewer than 80 tribes now remaining, and these are hastening with fatal rapidity toward total extinction, the colossal magnitude of Mr. Curtis's task will be understood. He has the encouragement of the leading scientific institutions of the country. "This thing is too great for any of the institutions to attempt," they say to him, "but if you can carry it along the lines which you are now attempting you will have accomplished one of the greatest things of our century, and the work when completed will be something which every scientific institution must have.[6]

After more than five years of study and exploratory work, Curtis at last had publicly stated his ambition, one vastly more complex and ambitious than anything he had previously attempted. He had already had some publicity and some encouragement from scientists, but to complete a project on this scale and see it distributed, he would need outside support. Six years earlier, when he had reached the limits of local possibility, he had had a fortunate meeting with George Grinnell and C. Hart Merriam on the slopes of Mount Rainier. Now, with his great plan coming into focus, he again made a powerful ally through an unexpected turn of events.

The previous year the *Ladies' Home Journal* had solicited photographs of attractive children for a contest to choose "The Prettiest Children in America." From the thousands of prints submitted, the portrait painter Walter Russell selected 112 photos for publication in the magazine and then chose a final twelve children to be painted in oil. "Personal taste was not the basis on which I determined my choice of these children," said Mr. Russell. "I considered those which closely approximated perfection." He worked out a system for assessing the size of the head, proportions of forehead to face length, and so on; published over the course of ten months, his choices were accompanied by "objective" statements about each child's "form." Curtis had submitted a photograph of a Seattle girl, Marie Octavie Fischer, who was selected for an oil portrait; when Russell came to Seattle late in the spring to paint her, he and Curtis became acquainted.[7]

Weeks later, just as Curtis was packing to work with the Crow Indians in Montana, he received a telegram from Russell asking that he come immediately to the East Coast to make photographic studies of President Roosevelt's boys for oil portraits. By June 16, 1904, Curtis was in Oyster Bay, New York, and subsequently photographed not only the boys but the

QUENTIN ROOSEVELT, THEODORE ROOSEVELT'S YOUNGEST SON, 1904. Edward Curtis came to Theodore Roosevelt's attention after a Curtis portrait of a Seattle girl was one of twelve winners in a *Ladies Home Journal* contest to choose "The Prettiest Children In America." When Curtis was invited to the East Coast to photograph the Roosevelt family, he and the President became acquainted. (Reproduced by permission of Historical Photography Collection, University of Washington.)

whole Roosevelt family at Sagamore Hill, their estate. The fate of Walter Russell's oil portraits is unknown, nor has Curtis's original contest photo of Marie Fischer ever turned up, but in July 1905 *McClure's Magazine* featured Curtis's accomplished, classic portraits of the Roosevelts.

The acquaintanceship between Theodore Roosevelt and Edward Curtis got off to a good start. Curtis had taken a set of his Indian pictures on the trip, and Roosevelt was known "as a true Westerner to delight in things Western.... then, too, the President has a large number of the Curtis Indian heads and values them highly." Roosevelt's expressed view was that a record of Indian life should be kept as evidence of the valor involved in their conquest. But his views about the "deficiency" of Indians were well known, and he had no qualms about "throwing open to actual homemakers for settlement the surplus land in the reservations," a policy that led to the overrunning of Indian lands and further aggression against many native Americans.

Curtis would soon publish his own general view that "the

treatment accorded the Indians by those who lay claim to civilization and Christianity is worse than criminal." In years to come his observations about white attitudes and government policy toward Indians grew more explicitly accusing. But in 1905 he was still learning about Indian cultures and history and, as he would eventually admit candidly, he was very naive. More than anything else, his friendship with Roosevelt is a sign that he gravitated toward powerful men and that he had some costly political lessons to learn.

After the trip to Oyster Bay, Curtis went to the Southwest for two months, traveling through Arizona, New Mexico, and southern Colorado, taking six hundred photographs. In Oraibi, in northeastern Arizona, he filmed the spectacular Hopi Snake Dance.[8] A dramatized prayer for rain, the Snake Dance lasted sixteen days and attracted hundreds of tourists.

Curtis also visited the Navajo reservation, entirely surrounding Hopi territory, and photographed in the sacred Cañon de Chelly, whose mysterious cliff dwellings date back to the fourth century. Back in Seattle, Curtis wrote on October 13 to his friend Edmond Meany, on the occasion of the death of Chief Joseph:

> At last his long, endless fight for his return to the old home is at end. For some strange reason the thought of the old fellow's life and death gives me rather a feeling of sadness. Perhaps he was not quite what we in our minds had pictured him but I still think that he was one of the greatest men that has ever lived.

About his trip to the Southwest, Curtis said with satisfaction that "In no former trip have I accomplished so much in so short a time."[9]

On October 28, he wrote to Frederick Webb Hodge at the Smithsonian Institution's Bureau of American Ethnology. His letter expressed his growing confidence:

> The longer I work at this collection of pictures the more certain I feel of their great value. Of course, in the beginning, I had no thought of making the series large enough to be of any value in the future, but the thing has grown so that I now see its great possibilities, and certainly nothing could be of much greater value. The only question now in my mind is, will I be able to keep at the thing long enough and steady work [sic], as doing it in a thorough way is enormously expensive and I am finding it rather difficult to give as much time to the work as I would like.[10]

Financial concerns were pressing. In addition to supporting his family and field work through regular studio photography and the sale of individual Indian prints, Curtis also sold some of his Indian images as postcards, and two others were reproduced in the popular *Indians of the Southwest*, a book by George Amos Dorsey, the respected ethnologist who later became curator of anthropology at the Field Museum in Chicago. An early tourist guidebook, it was published by the Atchison Topeka and Santa Fe Railroad to stimulate rail traffic.

Curtis needed a wider audience to support his field work, and his friends in Seattle gave him encouragement. In December 1904 they hired a large hall and publicized a lecture and one-night showing of his work. In addition to Sam Hill and Edmond Meany, Curtis numbered among his close friends the newspaper editor Col. Alden Blethen, his son Joe Blethen, Thomas Noyes, Fred Sanders, Amos Brown, and the Stimson brothers—all prominent Seattleites who lent not only vital moral support but desperately needed financial assistance as well.

Curtis must have been delighted at the response to that first large show and lecture at Christensen's Hall. The auditorium was filled to capacity, the crowd broke into applause every few minutes during the slide show, and his talk apparently won over everyone. One newspaper write-up said that "as an entertainer he was a success... a thing rarely found among artists and historians" and went on to describe him as a "defender of a race [whose] photographs and words dissipate many fallacious and fanciful stories that have gained circulation and belief about the Indian." Within a month he was asked to lecture at the prestigious Rainier Club, of which he was a member; he was honored at a club dinner the evening he spoke and showed more than a hundred slides. Curtis then traveled south to Portland to deliver the same talk under the auspices of the Mazamas Mountaineering Club, which had booked a hall for two nights in response to advance demand. An article about the presentation in the *Portland Oregonian*, subtitled "New and Remarkable 'Motion Pictures' of Snake Dance and Other Mystic Ceremonies," observed that the motion pictures had the effect of exciting the audience's imagination to "fever heat and enthusiasm."[11]

During the autumn of 1904 Curtis corresponded with members of the Washington Academy of Sciences and with his friends the Harrimans and C. Hart Merriam; early in 1905 he went to the East Coast for exhibitions they had helped arrange. The first show was at the Washington Club, whose members were fashionable, well-educated women; from there he moved his photographs to the halls of the Cosmos Club. Then one of the most prestigious clubs in the country, the Cosmos included among its members Alexander Graham Bell, Theodore Roosevelt, and nearly the entire Senate. One of the club's cofounders, John Wesley Powell, had also founded the Smithsonian Institution's Bureau of American Ethnology. Curtis's friends Gifford Pinchot (then Chief of the U.S. Division of Forestry) and C. Hart Merriam—both of whom Curtis had rescued on Rainier seven years earlier—were members, so Curtis was a guest in the club's quarters at the old Dolly Madison home. During his stay, he gave an informal talk at Pinchot's home about the Indian work, lectured and showed slides to more than a thousand National Geographic Society members, and then went before the National Academy of Science to explain his method of obtaining colored effects from a single negative.

Curtis took a train to New York for a few days the last week in February to do advance work for another exhibition and returned to Washington after a long detour to the Indian school at Carlisle, Pennsylvania, where he had an appointment to

photograph the Apache Geronimo and five other chiefs. Other than Chief Joseph, Geronimo was probably the best known of the great chiefs. He had been born in 1829 near Gila Bend, Arizona—by 1905 the site of some of the richest copper mines in the country, but for many years an area fairly free of whites due to Geronimo's efforts. Rebelling against the meager rations on their reservation and the continual attacks by white outlaws, Geronimo had led raiding parties on the settlements until he was finally overwhelmed by more than five thousand U.S. and Mexican troops in 1875 and agreed to peace in 1886. Now he was confined to the life of a farmer on the reservation at Fort Sill, Oklahoma. Francis Leupp, Commissioner of Indian Affairs, had invited Geronimo and the other chiefs to Carlisle and arranged for Curtis to photograph them in honor of the inauguration celebrating Roosevelt's landside victory the previous November.

March 4, the day of the inauguration, was a Friday, and Curtis reported in an interview that while he was at the Cosmos recovering from his hurried trip to New York and Carlisle, he met one of the so-called authorities on Indians:

I was feeling tired and mean... as my trip had been a strenuous one, and I was loafing idly in a comfortable chair at the club, resting up preparatory to the great day, when I was approached by a scholarly appearing old gentleman who evidently knew what I had been doing and who I was. He asked me if I thought it would be possible for him to see those old chiefs as they were to be present at the inauguration.

"I would like to see an Indian and talk to him," said this old gentleman, quite confidentially. "I have written about the Indian for scientific magazines all my life and I have never seen one. I would like to learn of their life and logic."[12]

Curtis was incensed. He wrote that he had to go outside to cool off, but he did it in time to go to the White House for the ceremonies. He photographed Geronimo and the five chiefs on horseback, standing on the White House lawn after they had ridden in the parade, their silhouettes blurred in the rain.

The subsequent show in New York was held in the ballroom of the Waldorf-Astoria Hotel, an arrangement made once again with the help of the Harrimans. Before the show, Curtis was very nervous about the $1,300 fee for the use of the ballroom, but his well-connected advocates had generated the necessary publicity, and members of the city's socially prominent Four Hundred families came out in force. Curtis made a profit on the sale of his prints and gained several new patrons, including Mrs. Jack Morgan (Pierpont Morgan's daughter-in-law), Mrs. Jay Gould (the wife of a railroad rival to Harriman), Mrs. Frederick Vanderbilt, Mrs. Stuyvesant Fish, and Mrs. Douglas Robinson (sister to the President). Then in the flush of success over his reelection, Roosevelt and his strongest campaign contributor, Harriman, were on the best of terms. Just before the Waldorf-Astoria show, Roosevelt wrote to Harriman expressing his support of Curtis's work: "Not only are Mr. Curtis's photos genuine works of art, but they deal with some of the most picturesque phases of the old-time life that is now passing away." A New York critic was more voluble:

We are just waking up here in America to appreciating the big interests of our own country, to a sense of cherishing our original greatness. We are painting our plains, protecting our forests, creating game preserves, and at last—not saving the existence of our North American Indian, the most picturesque roving people on earth, but making and preserving records of them from an historical, scientific, and artistic point of view.

We as a nation are not doing this. Just one man, an American, an explorer, an artist with the camera, has conceived and is carrying into execution the gigantic idea of making complete photographic and text records of the North American Indians so far as they exist in primitive conditions to-day.

Mr. Edward S. Curtis has already been working for six years on this project. The Smithsonian Institute at Washington has known about his purpose, President Roosevelt has kept in close touch with his work, ethnologists and photographers have followed his progress with interest, but until the recent exhibitions of Indian photographs and stereopticon lectures at the Waldorf, New York, the general public has had very little idea of the scope and beauty of Mr. Curtis's achievement. It has already been said in print of this work that "if Mr. Curtis lives and keeps his health for ten years he will have accumulated material for the greatest artistic and historical work in American ethnology that has ever been conceived of." Toward this end, Mr. Curtis already has about fifteen hundred characteristic Indian photographs.... When his records are finished Mr. Curtis expects to have from fifteen to twenty volumes, illustrated with from one thousand to fifteen hundred of this own photographs, the text to be gathered by himself, accurate and interesting, and subject to final editing by ethnological authorities.[13]

The quote about Curtis "living and keeping his health for ten years" was from an article by his friend George Bird Grinnell in the March 1905 issue of *Scribner's Magazine*, then at the height of its readership and influence. Having spent so many seasons on the Montana Plains, the "father of the Blackfeet people" knew what was involved in Curtis's field work: "He has exchanged ease, comfort, home life, for the hardest kind of work, frequent and long-continued separation from his family, the wearing toil of travel through difficult regions, and finally the heart-breaking struggle of winning over to his purpose primitive men."[14] After publishing this highly complimentary piece by the respected Grinnell, *Scribner's* editors approached Curtis about publishing some of his work, and he agreed to write and illustrate four major articles.

At the close of the Waldorf show, Curtis shipped his images back to Portland, where they were to hang in the Forestry Building of the Lewis and Clark Exposition. The enthusiasm

that greeted his pictures there was probably becoming familiar to him, as was the consistency of expectations about native Americans. In a long newspaper article praising the beauties of the photographs, a Portland journalist reminded the public that Curtis was not producing these pictures for

mere art's sake, but as irrefutable records of one of the four races of man, now doomed to inevitable and early extinction. The real Indian type is far removed from the debauched vagabond of the average reservation, and it is this type the photo-historian is seeking out and perpetuating with his camera, his instinct and his knowledge of ethnology.[15]

On March 15 Curtis received a letter from Matilda Cox Stevenson, then on the staff of the Bureau of American Ethnology and well known for her work among the Zuni. She expressed her appreciation for his results and for the difficulties under which he was working. "Only the few will record for future generations the true history of the vanishing race, for without certain qualities it is simply impossible to succeed in obtaining the confidence of the Indians. It is a continual wonder to me that you have in so few years passed within the doors of the inner life of so many tribes."[16]

Back in Seattle by early May, Curtis ingenuously told a reporter of the support he had received in the East: "I can truthfully say that everyone seemed greatly interested in my work and I received help and encouragement from every quarter. The Smithsonian Institute people tell me that this is the first time that an outsider has ever butted in and not been knocked by the scientific people. On the contrary, they seem ready to help me in every possible way."[17]

In fact Curtis would find it impossible to gain the official endorsement of the Smithsonian. The Bureau of American Ethnology, long the most powerful anthropological institution in the country, came under congressional scrutiny in 1903 for its casual administration and brilliant but fragmented research. On the defensive, the Bureau became wary of amateurs who might undermine its credibility as a scientific body, even though many of its own staff members were self taught.

Curtis was oblivious to the difficulties he would encounter as an outsider. His confidence was evidently bolstered by the level of response he was generating. After years of relative anonymity, his name appeared often in the newpapers of 1905. In June he hired a publicist named John C. Slater to sell his work throughout America as well as Europe, and on June 11 Slater set off on a flying trip of the United States with fifty of Curtis's eighteen-by-twenty-two-inch prints. The plan was to generate additional income so that Curtis could engage in field work on a more regular and well-outfitted basis; future photographs from the field would in turn increase the likelihood of supporting the project through sales.

After more than a month with his family, Curtis left Seattle. He and his assistant William W. Phillips (his wife's cousin), Edmond Meany, and Sam Hill were all present on the Colville Reservation for the June 20 dedication of a monument to Chief Joseph. Standing seven-and-a-half feet high, the white marble shaft carried a carved image of the chief on one side and his Indian name, Hin-mah-too-yah-lat-keht, or Thunder Rolling in the Mountains, on the other. On the same day the monument was unveiled, Joseph was reburied. In addition to Curtis and Phillips, two other photographers were present for the ceremonies: Edward Latham, the agency physician for the Colville Reservation, and Lee Moorhouse, a former Indian agent whose pictures had been shown at the St. Louis Exposition in 1904. The older Indians objected strenuously to the presence of the photographers, and it took "two hours of parley" to soothe their annoyance.

A Seattle press report indicated, though, that it took more than parley to reconcile the Nez Percés to the cameras. According to this account, Albert Waters, one of the men hoping to succeed Joseph, walked up to Curtis just as he was about to release the shutter and shoved the camera aside. Edward supposedly turned to the man and said, "Albert, if you lay your hands on that camera again I will feel compelled to punch your face, and if that is not sufficient I will blow the top of your head off." So saying, he reportedly pulled a six-shooter out of his pocket, whereupon Albert Waters retreated.[18]

Journalists' fondness for colorful stories—and for seemingly small embellishments and omissions—was invaluable in building Curtis's popular reputation, and thereby sales. He never went out of his way to avoid being written up, but the free promotion eventually proved costly. Over the years, the press's partiality for tall tales gave him a one-sided "buckeye" reputation. Curtis's own lively writing, on the other hand, always showed great concern for accuracy and for the politics surrounding issues in ethnology. Consequently, it's not surprising that the six-shooter anecdote didn't appear in Curtis's own *Scribner's Magazine* account of the dedication ceremonies.

After Joseph's reburial in the Okanogan Hills of northeastern Washington, Curtis (and probably Phillips) went on to visit the Sioux Indians in southeastern South Dakota. Starting at Wounded Knee, Curtis accompanied Chief Red Hawk and twenty of his people on a ride over their territory to the Badlands, fifty miles north. The site of much of the worst history between whites and Indians (including the tragic Ghost Dance slaughter of 1890), the area had been given to the Sioux in 1868, when Red Cloud signed a peace treaty at Fort Laramie, Wyoming.

Curtis spent nearly three weeks riding with Red Hawk, meeting many men who had lived through the last wars in the Badlands and remembered them vividly. During this trip he also took the picture "Oasis in the Badlands," showing Red Hawk watering his horse on the prairie. Before he left, Curtis promised to return and give the men who had ridden with him a feast. In the same season he spent time with the Crow in Montana and then went on to New Mexico where he photographed at Taos. His original field plans for the year included the possibility of a venture farther south into Mexico, but details of an additional leg of the journey have never come to light.

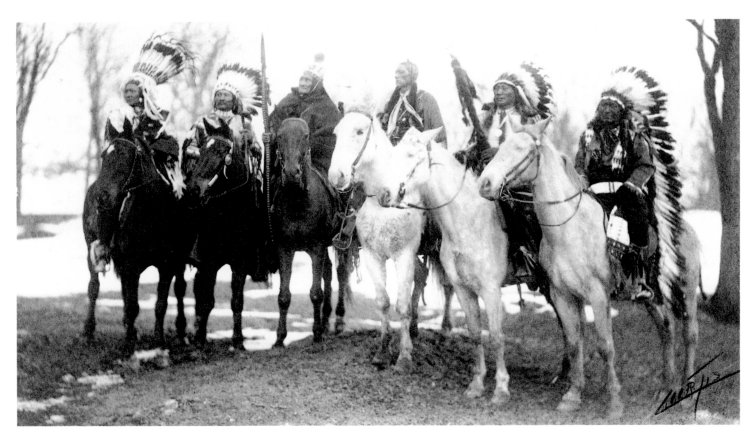

SIX CHIEFS ON THE WHITE HOUSE LAWN, 1905. This rare Curtis image was made after the chiefs had participated in the inaugural parade for Theodore Roosevelt. Geronimo (*third from left*) was then seventy-six years old and had been living on the reservation at Fort Sill, Oklahoma, for twenty years. (Courtesy of Flury and Company.)

By mid-November, Curtis was back on the East Coast. The unknown photographer of the year before was now welcomed as a celebrity. On November 27, a show of the season's work opened at the National Arts Club, then moved to the Cosmos Club, where it remained through December. Curtis's own sales efforts went well, but the income fell far short of the sums needed for field expenses, and the grand John C. Slater sales plan had yet to offer relief. In Seattle, the studio was making only enough to pay salaries and support the family in a skimpy fashion; in fact, Curtis had just been forced to borrow $20,000 from his friends, a loan Edmond Meany had generously organized.

Curtis was making hundreds of prints—photogravures pulled from acid-etched copperplates—of images from the year's work. The gravure process was esteemed for its soft tonal values, but the plates were very expensive to make. Curtis needed excellent prints to attract a wider audience, but he had entered a new league of risk. For all the encouragement he received from various members at the the Bureau of American Ethnology, the Bureau did not help Curtis recover any expenses; and despite earlier expressions of interest, Doubleday and two other publishers declined to make the sizable investment required for elaborate and voluminous printing. The photogravure prints represented an enormous gamble on Curtis's part: unless these beautiful samples of the finished product could attract outside financial assistance, he would have to give up his vision of a complete, accurate, and beautiful record of the lives of North American tribes. A December 16 letter from Theodore Roosevelt, sent to Curtis at the Cosmos Club, makes it clear that Curtis had approached him for a recommendation:

> There is no man of great wealth with whom I am on sufficient close terms to warrant my giving a special letter to him, but you are most welcome to use this letter in talking with any man who has any interests in the subject.

After praising Curtis's work, Roosevelt rested his case about the scientific importance of the Indian pictures on the idea that they documented an early stage in man's cultural evolution:

> You have begun just in time, for these people are at this moment rapidly losing the distinctive traits and customs which they have slowly developed through the ages. The Indian, as an Indian, is on the point of perishing, and when he has become a United States citizen, though it will be a much better thing for him and for the rest of the country, he will lose completely his value as a living historical document. You are doing a service which is as much as if you were suddenly able to reproduce in their minute details the lives of men who lived in Europe in the unpolished stone period. [19]

Curtis soon expressed reservations about Roosevelt's cardinal point that Americanization of the Indians would be the best thing for all concerned. But he desperately needed money, and having received Roosevelt's letter must have encouraged him on the four-day train trip to Seattle for the holidays. He was at home only briefly, but long enough for Edmond Meany to forward a request from Chief Joseph's nephew, Red Thunder, for another "big glass" of his uncle. Less than two weeks after the New Year, Curtis headed east again, this time with Clara in tow, and on January 20, 1906, delivered a "stereopticon picture talk" at the Century Club. He lectured before the National Geographic Society, just as he had done the previous year, and again drew a crowd of more than a thousand. This year's patrons during his one-week show at the Waldorf-Astoria included not only his friends the Harrimans, George Bird Grinnell, and Mrs. Douglas Robinson, but also Mrs. Stanford White, wife of the architect from the fashionable firm of McKim, Mead, and White; and, perhaps most important, Mrs. Herbert (Louisa) Satterlee, Pierpont Morgan's favorite daughter.

The year before, the great man's daughter-in-law had purchased some of Curtis's work, and it was probably the combination of these connections, as well as Roosevelt's letter, that gave Curtis the idea of approaching Morgan for financial assistance.[20] In any event, Curtis obtained an appointment for January 24. On the 23rd, in the thick of preparations for the Waldorf show, Curtis wrote him the following letter:

As you have been so good as to give me an opportunity to bring my matter before you, I take the liberty of writing you and sending you an outline of the work, previous to my coming. In that way you will have the matter before you briefly and concisely. Then when I call to see you tomorrow afternoon, as arranged, you can see what I am like, and if you are interested in the subject I can give you any additional information which you might desire. As to the scientific accuracy of the work I can give ample endorsement. As to its artistic merit it must speak for itself, and no one can better judge of that [sic] than yourself. When I call I will bring with me a few pictures. No one can form an idea of the work until he has seen the pictures themselves. I feel that the work is worthwhile, and as a monumental thing nothing can exceed it. I have the ability, strength, and determination to finish the undertaking, but have gone to the end of my means and must ask someone to join me in the undertaking and make it possible for all ages of Americans to see what the American Indian was like.

Whatever may be the outcome of our meeting, let me now thank you for your courtesy in allowing me to bring the matter before you.[21]

With the letter went an outline for the field work and a detailed plan for publishing the results in twenty volumes of illustrated text with twenty companion portfolios of larger images. In addition, Curtis presented estimates for every facet of publication (except the editing) and even suggested ways that a bene-

factor could regain his original investment and gain the greatest credit. Curtis estimated that he had spent $25,000 of his own money thus far, and that if he had $15,000 a year for field expenses he could complete the work in five years.

Nothing indicates Curtis saw any irony in approaching a man whose railroads had played a major role in decimating the bison and uprooting Indian cultures. Nor was he dissuaded by the fact that Morgan's tastes in art ran to artifacts of religious and European royal history, porcelains, and rare manuscripts. Morgan was well on his way to having the most impressive art collection in the country; his purchases were approved by the London art expert Roger Fry, who said Morgan was "not quite a man, [but] a sort of financial steam engine... too much of a God Almighty" and who damned Morgan's artistic choices: "A crude historical imagination was the only flaw in his otherwise perfect insensibility toward art." But even the condescending Fry admitted that Morgan "strikes me as a big man all the same, and too big in his ambitions to be low or mean or go back on his word."

Morgan was famous for sticking to his decisions. His home was the first in the country to be outfitted with electric lights, and despite the inconvenience of incessant breakdowns, he refused to have the system removed. He was equally loyal to his allies—so long as they did not drag him into public scandal. But his loyalty could turn into an equally famous ruthlessness: Morgan's enemies were legion, and they included some of Curtis's most powerful friends. Out of necessity, the President and Morgan were uneasy allies, but the two men disliked each other. Harriman and Morgan, never on comfortable terms, had become even more bitter rivals after their private stock war over the Northern Pacific Railroad set off a serious financial panic in 1901. Another of Curtis's staunchest allies, conservationist Gifford Pinchot, was fervently anti-Morgan on account of the astonishing level of exploitation of Alaskan resources jointly undertaken in the previous few years by the Morgan and Guggenheim families.

Morgan's business exploits, art purchases, and personal quirks were constantly in the newspapers, so Curtis must already have had some opinion of the man. But Curtis needed money and Morgan was known to spend it royally; in the early weeks of 1906 he was arranging payment of $750,000 for objets d'art collected for him in Paris that season, and it was public knowledge that he paid $500 per hour to fish at a private club in Newport. This sixty-nine-year-old Croesus was the most powerful man in the country, and such power exerted a strong influence on Curtis. On Wednesday afternoon, when Curtis left the Waldorf to go to 23 Wall Street for his appointment with Morgan, he set a slow fire to all of his other bridges.

JOHN PIERPONT MORGAN, circa 1903. Edward Steichen made this portrait in the early years of the century, when Morgan was at the height of his powers as a financier and art collector. In 1906 Morgan agreed to give financial assistance to Curtis's great research and publishing project, *The North American Indian*. (Courtesy of Seattle Art Museum.)

4

INTO THE HEART OF THE COUNTRY

I like a man who attempts the impossible.

J. P. Morgan (1903)

At the height of J. P. Morgan's career he was photographed by Edward Steichen, one of the leading Photo-Secessionists. Given just two minutes to make his picture, Steichen had the presence of mind to click the shutter but said later that looking Morgan in the eye had been "like confronting the headlights of an express train bearing down on you." Morgan's size and bearing were intimidating, and his face was often disfigured by the swelling and darkening of his nose—enough to alarm anyone meeting him for the first time. Even the confident Edward Curtis was put off his stride when they met on Wednesday, January 23, 1906. Later, he recounted how he had barely finished nervously explaining his appeal when Morgan cut him off and dismissed him. According to the Curtis family's account, it was only when Edward plunged ahead and opened his portfolio to show the Indian images that Morgan relented and agreed to give him what he asked: $15,000 a year for five years. It was said to be one of the few times Morgan ever changed his mind.

In the weeks following, Curtis and Morgan met several times (sometimes joined by Morgan's secretary, Albert King) to work out mechanics for the yearly payments and to plan the published materials by which these sums were to be repaid. In general, the publication plan followed the prospectus Curtis had sent to Morgan; twenty volumes of ethnological text would each be illustrated with seventy-five small prints and issued with a companion portfolio of thirty-five large prints. The prints would be photogravures pulled from acid-etched copperplates, a technique that would retain the delicate tonal values of the master photographs.

An engraver himself, Curtis insisted on expensive, fine engraving. Consigned to the firm of John Andrew and Son of Boston (the platemakers for the Harriman Expedition publications), the project's 700 large plates and 1,500 small ones were budgeted at $53,000. The typesetting and printing was to be done by the prestigious University Press, Cambridge. To be consistent with the high quality of the plates and printing, Curtis and Morgan selected two fine handmade papers: a Japanese vellum and a hard Dutch etching stock called Holland Van Gelder, both of which would have a longer life than ordinary papers and produce more subtle prints. Originally, Curtis had specified plain buckram for the binding, but now Moroccan leather would be used to strengthen and embellish the corners and spine of the volumes.

Improving the binding quality was a minor change compared to the decision that Curtis would publish his work himself. Walter Page at Doubleday as well as other publishers had advised Curtis that a publication of such grand scale would

have to retail for about $5,000 and that one hundred sets could probably be disposed of at that price. Although willing to admire his intentions, publishers declined to handle the work on the grounds that its scope and lavishness made the project too large a risk. Morgan convinced Curtis to bring it out himself, and together they established a lower price by trimming much of the profit margin: $3,000 for a set of volumes and portfolios printed on either Japon Vellum or Van Gelder paper. In addition, the press run was tentatively increased from 100 to 500 sets. Most critical of all, funds for materials, editing, printing, binding, and so on were to be obtained by advance sales of the work—a plan that contradicted Curtis's emphatic statement in his introductory letter to Morgan: "It is impracticable to sell a work in parts.... the present date buyer requires the completed work before he will agree to purchase." Determined to publish the Indian work, Curtis forgot his reservations and shouldered staggering administrative and fundraising responsibilities. Before the negotiations concluded, he was convinced that advance sales would generate enough cash to meet publication expenses, even while estimating the entire project—from research through publication—would consume $1.5 million.[1]

In return for his $75,000, Morgan was to receive twenty-five sets, as well as 300 large prints (original photographs, not gravures) and 200 small ones. The $15,000 a year for field work included monies for train travel, lodging, photographic and camp gear, and the services of ethnological assistants, interpreters, Indian informants, and photographic subjects. Of the yearly budget, $1,800 was set aside for motion picture films. But no salary was alloted for Curtis, who, in addition to the field work, would be required to devote a major part of each year to sales and publication efforts. In short, the $75,000 was given under terms that resembled a closely administered loan more than a philanthropic gesture. But Curtis himself had proposed the terms, and $15,000 was a great deal of money for such a project. Most individuals engaged in ethnological research or writing got by the best they could each season and then tried to recover some of their expenses from the Smithsonian's Bureau of American Ethnology or one of the universities. By comparison, Morgan's support of Curtis's campaign to "make it possible for all ages of Americans to see what the American Indian was like" was lavish.

The months began whirling past even more rapidly than before. Curtis lectured at the Waldorf and next at the Astor Gallery; then he and Clara took the train to Pittsburgh to give a lecture and show at the Carnegie Gallery. On February 17, he

was the only photographer invited to the wedding of Theodore Roosevelt's daughter, Alice, to Representative Nicholas Longworth, so Curtis's name appeared with his pictures under society headlines across the country.

News of his new benefactor also appeared in the newspapers: "Mr. Morgan's Help for Indian Photographer" and "Morgan Money to Save Indians from Oblivion." One report claimed Curtis had been at work on the project for fifteen years, another said six, but all agreed that Curtis's text and photographs were critical scientific work. On March 12, the editors of *Photo-Era Magazine* gave Curtis a show in the Boston studio of the fashionable pictorialist photographer John H. Garo, a great tribute for any photographer from the West. The reception was crowded not only with artists and photographers, but also with faculty members from Harvard and Boston University.

Meanwhile, in the gallery and sales office he had opened in New York some months before, Curtis was showing 300 photogravure images printed experimentally on fine tissue, a stylish presentation often used in Alfred Stieglitz's *Camera Work* magazine. The thin tissue allowed the mounting paper to show through the image, heightening its contrast and warming the color of the ink.

Back in New York after the Boston reception, Curtis mailed Morgan a bronze plaque showing the profile of a Jicarilla chief. One of a hundred made by a sculptor named Lenz, the plaque was followed a few days later by Curtis's lengthy memorandum outlining their agreement. For his own records, Morgan filed a companion but much briefer statement to the effect that he agreed to advance a total of $75,000 to Edward S. Curtis "towards carrying on his work in regard to Indian life" and that in return he would receive twenty-five copies of the publication and "three hundred original drawings, large, and two hundred small drawings." Curtis received his first check for $15,000 on March 30, 1906.

On April 11 Curtis gave one last "stereopticon lecture" in Boston, where several hundred of his prints were being shown at the St. Botolph Club. Then he and Clara boarded the train west, arriving in Seattle by the 16th, in time to be interviewed for the next morning's edition of the *Post-Intelligencer*. The article announced the terms of the Morgan agreement, and then quoted Curtis's description of the past winter as a "most successful one.... both Mrs. Curtis and myself have enjoyed ourselves immensely. I have met with encouragement throughout the East.... The last week of my stay in Boston was the most pleasant of the entire winter. The Harvard men have interested themselves in my work, and have become very enthusiastic over it, and have given me much encouragement."[2]

By this time, Frederick Webb Hodge of the Bureau of American Ethnology, had agreed to edit Curtis's work for seven dollars per thousand words. He would begin on the Curtis material as soon as he finished his current project: the editing (and much of the writing) of the first of two large volumes of *The Handbook of the American Indians North of Mexico*, which would be the Bureau's major publication to date. Hodge was also editor of *The American Anthropologist* magazine and had done extensive field work in the Southwest, including accompanying Frank Hamilton Cushing on the Hemenway Expedition in 1886 and spending at least two seasons in the field with the talented photographer A. C. Vroman at the end of the 1890s. Familiar with all of the issues and most of the people involved in ethnology, Hodge was a fortuitous choice as editor.

On April 25, Curtis wrote to Hodge from Seattle to request a copy of the latter's paper, "The Early Navajo and Apache," and mentioned that he was "a little upset" over the loss of a thousand dollars' worth of camera equipment. He had stored it in San Francisco after his last trip to the Southwest, and it was destroyed in the great earthquake there on April 18. Curtis was getting ready to go to the Southwest again to finish the research and photography for the first two volumes and portfolios. He replaced his lost equipment, gathered reference material, and hired a reseacher/stenographer named William Myers, a young man with an English degree who had been working as a reporter on the *Seattle Star*. Besides Myers, Curtis, and William Phillips, the crew would include a Mexican cook named Justo and, for part of the summer, Clara and the three children. In May a wagon outfitted for the field work arrived from the east; and by the first of June, Curtis and his crew were in southeastern Arizona. They set up camp among the White Mountain Apache on the adjoining Fort Apache and San Carlos reservations.

Working within the guidelines of Curtis's previous experience and checking their fresh observations against published studies, the three-man crew (with the help of interpreters) took five weeks to develop a general picture of the "history, life and manners, ceremony, legends and mythology" of the western Apache. Curtis found Myers a great help.

Most times while extracting information from the Indians, Myers sat at my left and the interpreter prompted me if I overlooked any important points.... By writing all the information in shorthand, we speeded the work to the utmost.... Also we knew nothing of labor union hours in our party. Myers neatly typed his day's collection before going to bed. In that way field notes were kept up to the minute.

In addition to his skills as a shorthand writer and typist, Myers soon demonstrated his other verbal abilities. "To the Indians his skill in phonetics was awesome magic," Curtis wrote.

An old informant would pronounce a seven-syllable word and Myers would repeat it without a second's hesitation, which to the old Indian was magic—and so it was to me. We might spend the early part of the night listening to the Indian dance songs, and as we walked back to the camp Myers would sing them.

On June 21 Edward sent expense statements to Morgan and reported that the field work was going well. Francis Leupp, Commissioner of Indian Affairs, joined them in camp on the Apache reservations for a few days; then the work party started

north to Navajo territory. On July 9 Curtis wrote enthusi-
astically to Hodge about the Apache work just completed: "I
think that I can say that [it] has been quite successful—far more
than I had hoped for." As had become his habit, Curtis asked
Hodge to forward one of the Bureau's many publications,
in this instance an article by James C. Pilling on Athapascan
languages.

Curtis soon separated from the rest of the crew and crossed
the state line to Gallup, New Mexico, to meet Clara and the
three children. Harold was twelve, Beth barely ten, and Flor-
ence seven. He met their train in the new wagon, canvas cov-
ered and drawn by four horses, and the family rode back into
Arizona where they camped at a little town called St. Michael's.
Before leaving for the Cañon de Chelly the next morning, Cur-
tis loaded up with supplies at Day's Trading Post, a well-known
layover for all travelers in the Southwest. The trading post was
owned by friends of Curtis's, Sam Day, a retired civil engineer,
and his wife. Curtis had worked here two years earlier, oversee-
ing preparation of the costumes for the filming of the sacred
Yebechai Dance. When the Curtis family set out on the thirty-
five-mile trip to the canyon, they were accompanied by Charlie
Day, one of two sons, who had agreed to act as interpreter for
this chapter of the season's work.

The thirty-mile-long Cañon de Chelly was the dramatic gar-
den spot of the Navajo Reservation. Small streams criss-cross-
ing the canyon floor irrigated the reservation's many
flourishing peach orchards and farms. After rising gradually
out of the desert, thousand-foot-high red sandstone walls tow-
ered over the visitors as they made camp in a grove of cotton-
woods. While Edward took photographs, the children played
nearby, enjoying an idyll to be remembered all of their lives.
They rode a burro, watched Navajo women at their weaving,
and explored the ancient dwellings at the base of the cliffs, being
careful not to "desecrate the places of the old ones," as their
father cautioned them.

One afternoon as they played, an unnatural calm settled over
the canyon. Then, suddenly, up galloped their father and Char-
lie Day. They dismounted and began slinging belongings into
the wagon as fast as they could, breaking camp in a few minutes
and urging the horses through the soft sand. As the wagon
struggled to get out of the canyon, the sandstone cliffs overhead
echoed with the eerie chanting of medicine men. A difficult
childbirth had been blamed on the presence of the white
people, and only after the baby had been safely delivered was
there a short period of relief in which the Curtis party could try
to make an exit. Charlie Day warned: "If it should die now,

CAÑON DEL MUERTO, 1906. The northern fork of the great Cañon de Chelly was the site of a massacre of a band of Navajo by Mexican soldiers. The photographs Curtis made here were unrivaled for dramatic power until the epic Western films of the late 1930s. (Courtesy of Flury and Company.)

correspondence while in camp, and carried files of all his sales, publication, and lecture arrangements wherever he went. Altogether, the loaded wagon weighed close to a ton. Crossing a deep river meant unloading it, removing its wheels, wrapping the wagon bed in waterproof canvas, and floating it across. Sometimes the terrain became too rough even for the wagon, whereupon the party had to make up a pack train which demanded more skill in packing and presented more opportunities for disaster. At one point in the season a mule slipped and rolled down a canyon wall, leaving Curtis's only camera spread out in fragments on the rocky slope. He spent twelve hours rebuilding it, and even then the only way to keep it in one piece was to tie ropes around the outer case.

But Curtis maintained that the weather presented the greatest obstacles in the field:

The rain pours down. What was an arid desert when you made your evening camp is soon a lake. Perhaps in the darkness of the night you have been compelled to gather your camp equipage and carry it to higher ground; or perhaps it is a fierce wind striking your camp, and if strong enough it will either blow the tents to the ground or whip them into shreds. And then comes the sand storm. No horse can travel against it. If en route you can but turn your wagon to one side to furnish as much of a wind break as possible, throw a blanket over your head and wait for its passing. It may be two hours and it may be ten, and when it is passed your equipment is in sorry shape.... At another time it may be the heat, so intense that a furnace seems cool in comparison. I have a keen recollection of a ten day trip through the desert and mountains when each day the thermometer registered 122 or more in the shade, and water was more precious than gold. And, on the other hand, it may be snow storms and cold that will cause you to forget that you were ever warm.[3]

Despite all difficulties, by late September the material for the first volume on the Apache and Navajo was nearly finished. While his crew continued working, Curtis went to Seattle for a few weeks to confer with Adolph Muhr about the prints to be sent to Boston as guides for the platemakers and printers. He wrote to Hodge on September 27, telling him that he had participated in the Hopi Snake Dance and had "in fact [done] everything a Snake man would do except take part in the public part of the Snake Dance. The only reason I did not do that was that I feared newspaper publicity and missionary criticism." Fascinated with the "extraordinary richness" of Hopi ceremonial life, Curtis would go back to photograph year after year. He also mentioned to Hodge that he had received President Roosevelt's foreword for the series. In praising Curtis's "qualities of body and mind" which fitted him to observe the Indians "now on the point of passing away," Roosevelt included some of the same expressions he would use to describe Frederick Remington and his art of the "vanishing West" in an upcoming magazine article.

Leaving Seattle late in October, Curtis went south again,

nothing on earth can save you and your family." The group made a safe retreat, but years later Curtis admitted that he had never felt more helpless. That summer was the first and last time his whole family accompanied him into the field.

By August his wife and children were back in Seattle, and Curtis was working with the crew among the Hopi on the Southwest's high mesas. It was on this trip that a group of young Hopi boys questioned Curtis about his "pneumatic mattress" as he inflated it one night at bedtime; later he discovered he was called "the man who sleeps on his breath." He described the Hopi as having a "sunny disposition"—so long as one did not "presume upon this affability." Actually, the Hopi at Oraibi accepted Curtis to the extent of inviting him to participate in their extraordinary sixteen-day-long Snake Dance, which he had filmed two years before.

Curtis still carried that "motion picture machine" as part of his gear. The field wagon also held several cameras and glass plates, equipment for recording speech and music onto wax cylinders the size of water glasses, a small trunk of books, a typewriter, a tent, all of the team's food for a month, cooking utensils, and personal belongings. Curtis kept up extensive

stopping in Los Angeles just long enough to lecture at the Ebell Club. Then he took a Southern Pacific train northeast across the Mohave Desert and joined the crew in Needles, California, on the Colorado River. Work had begun on the second volume, which was to include information on nine tribes in Arizona, including the Pima, Papago, Mohave, and Walapai. The group did some field work during a five-day trip down and up the river in an unwieldy, homemade steamship. It was the only power-boat on the river, so they had little choice about using it, but the slowness of travel was frustrating, as was the amount of time spent pushing the boat off sandbars. The end of good weather was close, and the team still needed to finish its research. Gradually they worked their way north into the mountains around the Grand Canyon, where they searched for information about the Walapai, or Pine people. In the process they encountered several small groups of Indians not listed on government charts.

The season finally ended when the heavy snow arrived, freezing the crew in their lightweight tents and making it nearly impossible to find a track for the wagon.[4] The group "retired to obscure rooms," as Edward put it, to polish the first volume's text and write the second, so that these volumes could be edited and printed back to back. Not even Curtis's family knew his exact whereabouts that first winter, but he and the crew were probably in the Southwest. The men ate and slept in their rooms, traveled to pick up mail or newspapers one day every few weeks, and worked seventeen-hour days, seven days a week. This punishing schedule lasted until late in February. As soon as the manuscripts were finished, William Phillips took them to Boston and stayed there to supervise the publishing.

In mid-January 1907 Curtis had withdrawn from the final phase of writing and gone to Seattle to work with Muhr on the latest photographs. He delivered a lecture while there, either to a photography club or a group at the University of Washington, and went into uncharacteristic detail about his life in the field:

> To begin with, for every hour given to photography two must be given to the word picture part of this record of the vanishing Indian. True, many of the hours given to the writing are those of the night time, and the light is not a 32-candlepower lamp stand, but most likely two or a half-dozen tallow candles fastened with their own wax to a scrap of plate or grub box. The everlasting struggle to do the work, do it well and fast, are such that leisure and comfort are lost sight of. To the oft-asked question, "What camera or lens do you use?" I can only reply, "I couldn't tell to save my soul—it is enough for me to know that I have something which will make pictures and that it is in working order." And, as to chemicals, I have almost forgotten that they are a necessary part of photography.... [But] for every hour of misery I could tell you of one of delight, and the most stormy days have had glorious sunsets, and for every negative that is a disappointment there is one which is a joy, and for every page of these trials I could write you countless ones of the beauties of Indian-land and Indian life.

You may ask how long the field work will last. When the Navajo does not know the answer, he says "Whoola," which is perhaps the only answer. This I do know. That for six years more the work will be driven to the limits of endurance. After that there will be a little more leisure.[5]

The lengthy speech exuded confidence but for the fact that, one year after requesting assistance for five years of work, Curtis was stating here that he expected the project to run two years beyond his stipend. Whatever his suspicions about the size of the project he had undertaken, though, his determination was unflagging. By March 2 he was in New York, setting up headquarters in the Belmont Hotel and sending Morgan the first batch of master print photographs as part of the repayment plan. In return he received an itemized list of the prints by title, completed by Morgan's glamorous private librarian, Miss Belle da Costa Greene. Previously the under-librarian at Princeton, Belle Greene had come into Morgan's service in 1905, when she was just twenty-two. Her shrewdness and charm gave her great influence among rare book dealers, and she had become Morgan's most trusted advisor in matters concerning his library. Much of Curtis's subsequent dealings with Morgan would be carried on through Miss Greene.

Throughout the spring of 1907 he corresponded with her at Morgan's beautiful new library, as well as with Hodge in Washington about the editing. All the while he also lectured and tried to sell subscriptions. From Seattle, his friend Edmond Meany kept him posted on the University of Washington's progress toward subscribing to a set, finally reporting that the regents were so leery of a large advance debt that they would agree only to purchase each volume as it appeared. One evening before he caught his streetcar home, Meany told Curtis, he had stopped in at the Curtis Studio and found Clara and the "two bright little girls" there, all seeming happy and well.

In the east, Curtis was under pressure. Making advance sales of his series was much more difficult than he had imagined. During his first month in New York, there was a brief but dramatic financial panic. Wall Street blamed it on President Roosevelt, saying he had undermined public confidence in the stocks issued by big businesses. The honeymoon between Roosevelt and the tycoons was over: he had initiated antitrust suits against Harriman's railroads and the Rockefellers' Standard Oil Company, and J. Pierpont Morgan was called in to arbitrate. The public quarrel continued, and business leaders seemed almost determined to go through a slump in order to hold Roosevelt responsible. The real causes of instability were overspeculation, stock-watering, and the flight of foreign capital; so long as those conditions continued, an even more serious crisis was inevitable. Shadowed by the grim news that major companies such as Westinghouse were collapsing, the wealthy were cautious with their money. Curtis sold sets only to friends and patrons, and few of those paid in advance. An edition of five hundred sets rapidly began to look like a pipe dream.

Curtis hired a New York publicist and fundraiser named William Dinwiddie to promote what was by now titled *The North American Indian*. Dinwiddie, himself a photographer,

had once been on the staff of the Bureau of American Ethnology. He was fired, probably unfairly, after a nasty dispute with the flamboyant Frank Hamilton Cushing, famous for his brilliant but erratic work among the Zuni.[6] Dinwiddie still had connections at the Smithsonian, and he solicited an endorsement there in May by sending a letter, sales broadside, and request for an appointment. The Secretary of the Smithsonian, Charles Walcott, wrote back skeptically "It appears that Mr. Curtis's original idea has become very much expanded.... As you are well aware, it will not do to claim too much for such a publication; otherwise it will get the general condemnation of all interested in the subject."[7] Walcott was not convinced by the broadside's claim that Curtis's twenty volumes would constitute a complete record of all of the tribes of North America still living in an aboriginal state; he doubted such a thing could be done in fifty volumes.

At a time when Curtis wanted institutions throughout the country to subscribe, the Smithsonian's lack of public support was a keen disappointment. Unfortunately, he had little influence there. He was far too independent and ambitious to have ever worked on assignment for the Smithsonian, and he had not been involved with the Institution's two-volume *Handbook of the American Indian*, to which dozens of professional ethnologists had contributed. Many of them, finding general acclaim to be at odds with true scientific purpose, regarded Curtis's increasing public notoriety with suspicion. He was discovering that working independently had its price.

A few weeks later, Curtis replied to a complimentary letter from Charles Fletcher Lummis, in Los Angeles, thanking him for his comments: "It is ever the same, you have the happy faculty of saying just the right thing at the right time. Your letter is bully and it seems to cover so many points. Nothing could be better to hit the library people with than this." Lummis was a respected writer and photographer of Indians, then the librarian of the Public Library in Los Angeles. He worked for years to persuade the Archaeological Institute of America to establish a branch in the Southwest, the center of archeological and ethnological activity in the United States. To attract interest in that research, Lummis regularly traveled the country as a spokesman for the Institute and lectured on Indians. He was famous for appearing before audiences who wore evening dress in a loud green corduroy suit and Pueblo woman's belt, a white embroidered shirt open at the neck, and mocassins; he even wore his unconventional costume when he spoke to the National Geographic Society in Washington, D.C. Lummis and Curtis were on close terms, and Edward was frank about his sales campaign: "Confidentially, the fact that the stock market has gone to the bow-wows is making my work a bit difficult."[8]

In early June 1907, just as Curtis was getting ready to leave New York for the season, an issue was raised about his work. According to the account written by Curtis's daughter, Florence Curtis Graybill, and her coauthor, Victor Boesen, Curtis was called on the carpet by President Roosevelt and asked to respond to charges that he lacked professional qualifications for the work he was doing.[9] The question of Curtis's competence is believed to have been raised by Franz Boas, Columbia University's first professor of anthropology, already recognized as the major force in the drive to systematize field work. According to Graybill and Boesen, Curtis presented his field notes and Edison sound recordings as evidence of the caliber of his field work to three experts: Henry Fairfield Osborne, a curator at the American Museum of Natural History in New York; William Henry Holmes, chief of the Smithsonian's Bureau of American Ethnology (and himself a talented artist); and Charles Walcott, Secretary of the Smithsonian, who had recently declined to associate the Institution with Curtis's work. The three men supposedly examined Curtis's work and then conveyed to him their warm approval of his methods in a letter by Osborne—one of the many pieces of correspondence pertaining to Curtis that has yet to come to light. Until it does, the nature and extent of this exchange will remain a mystery.

Like Curtis, Franz Boas was formidable. German-born and educated, he had trained in geography, and his ethnology experience included eight field seasons in the Pacific Northwest. He profoundly influenced American anthropology by establishing systematic field work as the proper basis of study; previously, many ethnologists and archeologists had been content to piece together all their research second-hand, often from the differing perspectives of travelers and scientists trained in other fields. Under Boas's guidance, newly established graduate programs began to dominate the field of ethnology, diminishing the authority of the Smithsonian and other research museums. While Curtis attempted to translate his research into language that the general reader could understand, Boas wrote for other scholars.

Nonetheless Curtis and Boas shared the general perception that changes as a result of white culture hindered ethnological reconstruction of precontact culture. Their interviewing techniques did not differ radically, and both men had their greatest successes in areas where they were well liked. Trust was a crucial factor in field work; nevertheless, both men said candidly that they sometimes learned a great deal by subterfuge, and both had occasion to steal human skulls from their graves "for research purposes."

After being challenged about his work, Curtis left New York several weeks later than planned and went to Pine Ridge, South Dakota, where Clara and thirteen-year-old Harold were waiting for him with the crew. A few days later Edmond Meany arrived to lend a hand with research, and everyone settled down to the summer's work among the many tribes of the Sioux, and among the Mandan, Arikara, Hidatsa, Crow (or Apsaroke), and Atsina. Harold went on horseback with his father to Wounded Knee, and many years later he recalled vividly that on the twenty-mile ride their horses kept shying at the rattlesnakes in the long grass. "All along we saw cattle that were sick and with badly swollen heads from snake bite."

CURTIS CAMP IN SOUTH DAKOTA, circa 1907. The tipi in the foreground belonged to Slow Bull, an Ogalala Sioux. (Photograph by Edward Curtis, courtesy of Flury and Company.)

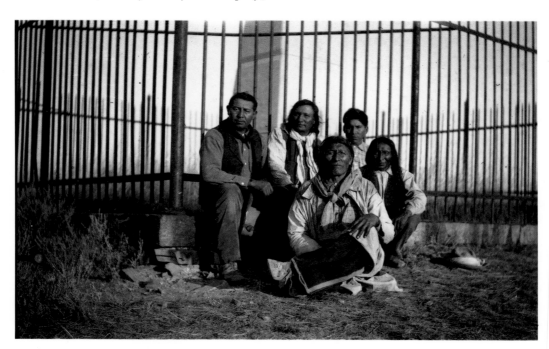

AT THE CUSTER MONUMENT, 1907. Curtis photographed his Crow interpreter, A. B. Upshaw, (*left*) with three Crow scouts who had been with General Custer until the beginning of the Battle of the Little Big Horn, 1876. The fourth man (*upper right*) has not been identified. With the help of the scouts, Curtis wrote a new account of the battle that held Custer partially responsible for its outcome. (Courtesy of Flury and Company.)

At Wounded Knee, Curtis was planning to keep his two-year-old promise to give a feast for Red Hawk and the twenty men who had taken him on the ride across the Badlands. In return for the feast the Indians had promised to act out old battle scenes and ceremonies. But when Edward, Harold, and Edmond Meany arrived, they found not twenty men but several hundred, including at least two chiefs who outranked Red Hawk. Eventually old rites were enacted and some battles restaged for Edward to photograph. But in return, Bashole Washte, or Pretty Butte, as the Sioux called Curtis, had to come up with several more heads of beef than he had originally planned. Next, Edward took Harold with him overland to the Little Bighorn battlefield in southeastern Montana. They rode northwest from Pine Ridge on the South Dakota-Nebraska border, through the corner of Wyoming, and up into the Crow Reservation. It took a week and a half of hard riding to get there, and on the way they saw only one sod house and no fences. On the Little Bighorn River, Curtis was joined by three Crow Indians who had scouted for Custer right up to the battle on June 25, 1876, thirty-one years before. The Sioux made enemies of the Crow when they drove them west off their hunting grounds, and these three—White Man Runs Him, Hairy Mocassin, and Goes Ahead—were among the many Crow who retaliated by aiding the U.S. Cavalry. Day after day, Curtis rode over the area surrounding the battlefield, first with the Crow scouts, then with a group of Cheyenne who fought with the Sioux in the battle, and then again with Red Hawk and Gen. Charles A. Woodruff, who had spent time with Custer in the Badlands and who was familiar with the published facts of the battle. When Meany returned to Seattle, Edward asked him for a general history of Sioux-white relations and any additional information about the last Custer battle his students could scour from the library. Despite his stated intention to avoid writing about all of the wrongs perpetrated against the Indians (he maintained those facts were already well documented), Curtis was becoming absorbed by the discrepancy between what he heard from the Indians and the self-justifying histories published by whites. The official version of the Little Bighorn battle differed from the picture Curtis was piecing together, namely in that the army's account did not place any responsibility for the "massacre" of Custer's five companies on his own decision to advance his troops instead of waiting for other forces as he was supposed to do.

In the Southwest, Curtis had been entranced by the culture of the peace-loving Hopi, but now he was also drawn to the militaristic style of the once fierce and still proud and handsome Crow. Memories of buffalo hunting and bravery in combat still strongly influenced them, and through sympathetic interviewing (and excellent informants) Curtis and his crew obtained an outstanding account of the tribe's four great military societies, including one for men ready to give their lives in battle, "He That Wishes to Become Reckless Dog."

Back in Seattle after five weeks in the field, Meany heard on August 14 that Harold had contracted typhoid. He sent an anxious query to Pine Ridge. Hal had fallen ill on the way back from Montana, and he spent several weeks laid out under a cottonwood tree, too ill to be moved. The crew needed to leave for North Dakota to begin work among the Mandan and Arikara, and as soon as Edward got the money for the trip he sent them on ahead. He stayed behind to help Clara nurse Hal (she had once nursed Edward through his own bout of typhoid). During the ensuing month of worrying and waiting, Edward exchanged letters with Meany every few days.

Meany wanted him to deposit his collection of plates, master prints, and Indian artifacts at the University of Washington for the collection's protection but also with an eye to an eventual bequest, a suggestion Curtis refused outright. He said he couldn't make such a commitment when he still needed more financing for the project, and he described himself as "an unknown man trying by sheer bulldog tenacity to carry through a thing so large that no one else cared to tackle it." He added that he might need to move his headquarters to New York to increase his income, and he worried too that if he died Mrs. Curtis would need income from the collection. Knowing how devoted Meany was to the University of Washington, Curtis softened his stand to the extent of saying that if the collection went to any school it would be the University of Washington. But even that half-promise was made on the condition that arrangements would have to be very careful, "lest some time in the future some local pin head say like that self-made S. B. Jimmy Hoge might become a regent and trade [the material] off for a brass door plate." This was an unusual outburst from Curtis, and, as though to justify his irritability, he went on to say that

> Of late I have had little but swats from my home town and feel in a most disagreeable mood. Most of those who say good things about the work would if I owed them two and a half and could not pay on the dot would kick my ass and say "Get to hell out of this." Yes, I will try to cheer up a bit, but when I think of some of the Seattle bunch I go mad.[10]

Within days, Meany's reply came flying back. "The changing, varying moods revealed in your lines are disturbing, and bring to my heart a tinge of dismay." Meany tried to buck up his friend by reminding him of the tremendous physical hardships he was capable of enduring for his work, and he gently pointed out the foolishness of allowing the indifference of "a group of newly rich members of a Seattle club... to rumble all over your nerves." He reported enthusiastically on the successful sales of Indian images at the Curtis Studio, and then, after all his efforts to cheer, ended his letter on a melancholy note: "In regard to your moving to New York—that just gives me the shivers. I will not allow myself to think of it." Meany had obviously become very fond of Curtis. Since he was also close to Asahel Curtis, perhaps even closer than to Edward, and no one mentioned one brother's name to the other, the friendship must have entailed some strain.

Hal was "an ideal sick boy—as patient as anyone could be," according to his father. Late in August, when he was strong

enough to travel, Edward loaded his mattress into the back of the wagon for the twenty-mile ride to the railroad. Edward flagged down an eastbound train and put Harold and Clara on board for Chicago so they could catch a more comfortable Pullman back to Seattle. Immediately, Edward went north to catch up with the crew in Bismark, North Dakota, and from the Fort Berthold Reservation he wrote Meany the last of a handful of lengthy, intimate letters between them. He began with an affectionate comment on Meany's most recent and chiding letter: "I now feel my bones and none are broken, in fact I'm still alive. Now dear old man let's talk. I likely needed the roast and will in the future try not to be childish. But rather will keep in mind the bigness of my job and try to live up to it." Thanking Meany for his support in one breath, he went on in the next to elaborate on the difficulties that had driven him to let out "the heart broken wail of a lost soul" in his previous letter. Try as he would to be light-hearted in talking about them, several matters were eating at him:

> Your good words in regard to the work and to the poor devil of a worker did me much good. They are about the only good word I have had from anyone in many weeks.... From everywhere comes such a clamour from the cold footed—yesterday brought me eight long letters from Phillips—that you can see some of the things I have had to contend with I am going to save the bunch as an exhibit. Let me mention a few of the things he speaks of he says [sic] "Lack a well defined plan," "I don't think you can succeed in getting through," "if you do you can do more than I think you can." Says the plate makers are "fidgety," "you secured Hodge against my good judgement."... Accused him of deliberately holding back the work to ruin me, wants an immediate change of editors.... He used some 30 typewritten pages to say all these things to me I can't help but think he is *seein* [sic] things. I only tell you of those things so that you may see some of the things I have to contend with. Billy is the best fellow ever but he lacks years. And he has for some time overestimated my dependence upon himself.... if you hear anyone say I am not to succeed tell them they don't know me. I am not going to fail and the sooner the whole "Damn Family" knows it the better.

After this extraordinary rant, Curtis concluded mildly with the news that he was feeling better after an illness, and he asked Meany's forbearance: "Remember I am doing the best I can and keeping 17 helpers from getting cold feet and at the same time getting together something over forty-five hundred dollars a month to pay the bills."[11] The seventeen helpers to whom he referred were the field crew and the publication people spread out between Boston, New York, and Hodge in Washington. Morgan's stipend took care of no more than a third of the expenses, and the printing bills were accumulating more rapidly than subscribers were paying.

While Curtis struggled in camp, his reputation was reaching new heights, due not only to the drum-rolling from the newspapers after the Morgan bequest but also to the success of

Curtis's photography shows, his lectures, and his first two articles in *Scribner's Magazine*. The previous August, *Camera Craft* had published an article by Adolph Muhr on the gum bichromate printing process;[12] and in August 1907 the more fashionable *Photo Era* printed a lengthy Muhr piece discussing his employer's photography and field experiences. In it, Muhr referred to Curtis as "one of the most genial and pleasant of men, [who] is extremely modest and reticent in regard to his personal experiences." After relating a few colorful accounts of disasters in the field, Muhr said:

> These [difficulties] Mr. Curtis considers lightly, and nothing compared with that unknown quantity—the Indian. The qualities so necessary to succeed in dealing with him Mr. Curtis possesses to a remarkable degree: tact, diplomacy, and courage, which combined with a good stock of patience and perseverance, have made it possible to succeed where others have failed.[13]

Also in August 1907, the critic Sadakichi Hartmann paid his respects to Curtis in a major review in *Wilson's Photographic Magazine*. At that time still emphatically modernist and East Coast in his attitudes, Hartmann's review was not entirely complimentary; he found Curtis's prints "muddy," and referred to the Indian as a "gaudy and uncouth subject for an artist that could hardly claim to be as picturesque as, for instance, the Arabian horseman." But he acknowledged Curtis had dealt with the subject far better than most photographers and painters, and he praised his efforts in creating a broad and unified record of the Indian race:

> an undertaking that cannot easily be repeated. The red savage Indian is fast changing into a mere ordinary, uninteresting copy of the white race. And although opportunities for similar records may continue to exist for some years to come, there will probably be no other Curtis to do it. He is an enthusiast and has made it his life's work and none of his occasional competitors will succeed in gathering a more valuable and complete accumulation of the material.

Whatever Hartmann's feelings about Indians as a photographic subject, he acknowledged the inroads that Curtis had made into the photography circles of the East Coast: "Although... it is difficult to tell the whereabouts of E. S. Curtis at this moment, there is no doubt that he is just now the most talked-of person in photographic circles."[14]

Even this irreproachable publicity did not translate into money, however. When Curtis discovered that the manuscripts for the first two volumes were not yet in the hands of the printer, he had a fit. To Hodge, he wrote:

> I must make definite statements to the bank, to fail in keeping my promise there will mean failure, and I do not care at this stage of the game to have the croakers say I told you so. If it is within human effort (and I believe it is) these two volumes must be in the hands of the binders no later than October 15—I know the time is short but this is a time we have 'got to' there can be no 'can'ts.'... [Expenses] are

heavy and these two volumes must be ready for delivery that there can be something there to meet them.

In October, snows drove the crew from the field to a new permanent camp at Pryor, Montana, on the edge of the Crow Reservation. There, in a cabin built for them in the foothills, Curtis, William Myers, A. B. Upshaw (an invaluable Crow interpreter), Levin, a young researcher from Seattle, and Justo the cook all settled down for another punishing winter of writing. Phillips was still in Boston handling publication matters, so Curtis hoped to avoid traveling there. But the money situation continued to deteriorate. He wrote to Meany every few days, discussing the latter's attempts to convince Seattle banks to advance money on the strength of promissory notes Curtis had received from wealthy benefactors. But the entire country was sliding into a panic again, and so long as one wealthy man after another continued to be ruined in New York, the Seattle banks refused to extend credit. By the last week in October, the panic was out of control in the East. Long lines of depositors trying to withdraw their money crowded the cities' business districts, fifty major firms were on the verge of collapse, and New York City was in danger of defaulting on loans. Apparently feeling that he needed to mollify his creditors, and also perhaps to ascertain which of his advance subscriptions could still be counted on, Curtis took the train to New York at the end of October. By the time he wrote to Meany on November 5 his anxieties had been somewhat assuaged: "Things here in New York are strictly Hell and what the future is to be no one seems to want to guess. The book binding, however, is moving along nicely."

He also wrote Morgan on November 5, on the brown letterhead of the "Publications Office, North American Indian, 437 Fifth Avenue," asking whether Morgan might care to have the gravures for some of his twenty-five sets printed on tissue, at an additional cost of $825 a set. He noted that he was leaving samples of both tissue prints and regular ones on Van Gelder paper with Miss Greene, and then said that the "finances of the book building [have] caused some blood sweating, but I am glad to say, no delay." Curtis ended his letter in an uncharacteristically humble fashion: "I hesitate to trouble you with even the briefest letter in hours like these, when you seem to have the burden of the whole land to carry, and let me say what millions know and would like to clasp your hand and say to you: you have saved the country when no one else could."

Curtis's awe was entirely warranted. J. Pierpont Morgan had singlehandedly done more than any group of people, including Roosevelt and the U.S. Treasury, to calm the panic. In the middle of the crisis he issued a warning that any member of the Stock Exchange who sold short and helped promote the panic would be "properly attended to at a later date." Then he strong-armed his allies into joining him in assuming part of the risk for those in immediate danger; over $100 million in interest-free cash was handed over to threatened institutions so that they could meet their short-term obligations and stop the public's fearful run on their resources. Briefly, Morgan's

unpopularity was forgotten, and he was once again a symbol of power and hope.

For nearly six weeks Curtis attended to sales and publication details. Then, as the end of 1907 approached, he turned west again. On his way through Chicago he called on Edward Ayer, a self-educated authority on Indians and the man who had convinced Marshall Field to build a museum for the many fine collections left behind after the Chicago Exposition of 1893. A close friend of Hodge, Ayer was highly respected in ethnological circles, and Curtis was anxious to have his support. Writing to Hodge after their meeting, Curtis described Ayer as having been "extremely friendly and most enthusiastic over the pictures. However, he was frankly skeptical as to what the text would be... he thinks I have attempted too big a task for one man, saying, 'It looks as though you were trying to do fifty men's work.' He thanked Hodge at length for his "splendid help in rushing through the final editorial work" and said he would soon mail him a check.

Curtis went to Seattle to spend a precious few days with his family at Christmas and to confer with Muhr at the studio. Clara and Hal had spent most of the summer with him in South Dakota, but once again Edward had been home for only six weeks out of the year. In his absence the studio was fairly prosperous. Muhr's reputation had grown along with Curtis's, and he attracted a number of talented assistants to his darkroom, among them a young woman named Imogen Cunningham. An ex-chemistry major at the University of Washington, she worked at the Curtis Studio for over two years, learning the intricacies of platinum processing under Muhr by day, and printing her own work in the darkroom of her close friend, Asahel Curtis, in the evenings. Another "star helper," as Curtis referred to a very few people, was Ella McBride, the photographer and mountain climber from Portland. She worked both in the darkroom and in the front office with Clara's sister, Sue Gates.

The studio still had an excellent reputation and loyal clientele, but far too many darkroom hours went into preparing the Indian prints for publication for the business to show a profit. The drain was neverending, and after the staff was paid, Clara and the children were left with only enough for essentials.

As adults, the Curtis children's memories of their father would be mostly of the excitement and pride they felt during his rare visits, and of their delight in the attentions he carefully paid each of them. Their early contentment and sense of security despite their father's absences suggests that he was very affectionate and that their mother did a good job of adapting to her difficult situation. Clara not only dealt with her charming and handsome husband's many absences, doing without a great deal for the sake of his work—she also had to contend with her family's open criticism of Edward's "unreliability." But eight years after her husband had first left her alone with two small children and a seven-month-old baby so that he could go on the Harriman Expedition, the strain on Clara was becoming apparent. She now preferred a steady round of civic and charitable

activities over her plain and sparsely furnished home on Queen Anne Hill; in her absences, Harold took on responsibility for his little sisters and became an adept cook.

The strain was telling too on Clara's cousin, William W. Phillips. He had worked as an assistant for nine years, but he was worn down by what he obviously regarded as erratic behavior on Edward's part, and during times of stress he seems to have thrown the Phillips family's disapproval in his employer's face. Within a short time, William gave up his role on *The North American Indian* and entered law school.

Edward Curtis's response to all problems was to redouble his efforts. Even when he was in Seattle with his family, he worked every day. His first concern was invariably for the project, which, at the end of 1907, was floundering from a lack of cash. Just as the first volume and portfolio were being released, Edward had to write Hodge again without being able to send a check for his editing services. In that letter of December 26, 1907, a worried Curtis returned to the subject of Ayer's skepticism or, more precisely, to the dilemma of needing to keep the work in the limelight for the sake of sales, albeit at the risk of endangering its credibility as a serious undertaking.

> I have read with considerable interest your words in regard to how the serious minded look at the Indian book.... What I felt was, that they took it for granted that I was trying to do original work, but questioned my being able to do so much.... I think like you, that newspapers and well-meaning friends have rather over-stated the case. You can readily understand that when a newspaper starts to do a thing, they are much inclined to over-do it. Unfortunately for our feelings at times, this book must be sold. The majority of the buyers of it are the ones who may be influenced by more or less of a glowing account of the work, while this same thing would cause a feeling of resentment on the part of others, and those then being the ones that we want the good will of more than anyone else.... It will not be necessary, of course, to explain to them that this work is not intended wholly for the scientific reader, but rather to make a lasting picture of the Indian, showing as much of the beautiful of his life as we can.

Not only were local newspapers guilty of over-stating the case: the *New York Herald* called the work "the most gigantic undertaking since the making of the King James edition of the Bible."

By now fully aware that "thrilling" advertising could undermine his efforts, Curtis was careful not to claim too much in his general introduction to the series:

> The task of recording the descriptive material embodied in these volumes, and of preparing the photographs which accompany them, had its inception in 1898. Since that time, during each year, months of arduous labor have been spent in accumulating the data necessary to form a comprehensive and permanent record of all the important tribes of the United States that still retain to a considerable degree their primitive traditions and customs. The value of such a work, in great measure, will lie in the breadth of its treatment, in

its wealth of illustrations, and in the fact that it represents the result of personal study of a people who are rapidly losing their aboriginal character and who are destined ultimately to become assimilated with the "superior" race.

> It has been the aim to picture all features of Indian life and environment—types of the young and old, with their habitations, ceremonies, games, and everyday customs. Rather than being designed for mere embellishment, the photographs are each an illustration of an Indian character or of some vital phase in his existence.... the accompanying pictures show what exists or has recently existed (for many of the subjects have already passed forever), not what the artist in his studio may presume the Indian and his surroundings to be....

> While primarily a photographer, I do not think photographically; hence the story of Indian life will not be told in microscopic detail but rather will be presented as a broad and luminous picture. And I hope that while our intended observations among these brown people have given no shallow insight into their life and thought, neither the pictures nor the descriptive matter will be lacking in popular interest.... The years of a single life are insufficient for the task of treating in minute detail all the intricacies of the social structure and the arts and beliefs of many tribes. Nevertheless, by reaching through the surface by a study of his creation myths, his legends and folklore, more than a fair impression of the mode of thought of the Indian can be gained. In each instance, all such material has been gathered by the writer and his assistants direct, and confirmed, so far as is possible, through repetition by other members of their tribe.

Although the introduction was cautious, Curtis made it clear that he regarded his work as essential: "The passing of every old man or woman means the passing of some tradition, some knowledge of sacred rites possessed by no other; consequently the information that is to be gathered, for the benefit of future generations... must be collected at once or the opportunity will be lost for all time. It is this need that has inspired the present task." He made a case for the rich context in which he photographed ethnographic material, saying that it not only did "not do injustice to scientific accuracy" but that to neglect "the marvelous touches that Nature has given to Indian country... would be to neglect a most important chapter in the story of an environment that made the Indian much of what he is."

Curtis hoped his long field experience and excellent relations with many tribes would yield raw material for professional ethnologists. As he put it in an interview, "My task was that of the harvester, not the miller."[15] But his introduction makes it clear he intended his pictures and text to form a "broad and luminous picture" for nonprofessionals as well. All in all, he rather neatly defers to the "superior insights of the experts," while also implying that the field of Indian studies was still evolving.

Curtis was not always deferential to the "experts." When James Mooney, a colleague of Hodge at the Bureau of

American Ethnology, objected to the word "warrior" in the title of a Curtis image, Curtis defended himself ably in a letter to Hodge.

> It [the title of warrior] does not necessarily imply that the man is engaged in battle, or at the instant of going into the fight. An Indian of the old days was a warrior 365 days of the year, a very small part of which would be spent in actual fight.... I appreciate Mooney's knowledge of the Plains Indians too well to resent his criticism, but I think that in this case he has taken a super-critical attitude, presuming that the title meant to say 'This picture is of a chief dressed for the final conflict of battle,' while as a fact the same title could have been used for the same man while in his lodge smoking a pipe."[16]

By this time, Curtis was thoroughly disabused of his early, naive notion that he could work independently of the major scientific institutions and "not get knocked as an outsider." Meanwhile, he was facing the grim realities of attempting to fund an expensive project by advance sales. From New York he heard only that people were slow to pay up; and after an unsuccessful round of the Seattle banks, he went back to base camp at Pryor after less than a week with his family. He set the goals of completing the text for volume three by the end of February, volume four some six weeks later, and both photography and text for volume five by midsummer. The group settled into the draining schedule of long days and seven-day weeks. To Meany he wrote in January 1908, "The work on the Sioux volume has gone like a whirlwind, and consequently happiness reigns among us." But when the Morgan check for the season had come and gone and promised loans from the banks fell through yet again, his letters to Meany turned rueful: "I find it rather hard to do good work on this book and puzzle over how I am going to pay my bills at the same time." The trusty Meany, already busy writing the Sioux history, was still trying doggedly to find a bank that would accept the two promissory notes from Curtis's supporters. When the situation became desperate he convinced ten Seattle men to put up a total of $20,000 in cash.

Tided over by this loan, Curtis went to New York in April, in time for delivery of the first two volumes and portfolios to subscribers. The first printing was far smaller than planned: no more than 175 first volumes and portfolios, if that. But within two weeks of his arrival, Curtis had two new subscribers, Cleveland Dodge and Andrew Carnegie. Meanwhile, the first installment had been released and the compliments and glowing reviews flooded in.

In reviewing the work, J. H. McGhee, former head of the Bureau of American Ethnology, observed that "Our conquest [was] the most striking in history; near a thousand distinct languages have given way before the conquering Anglo-Saxon speech and the force of the press.... Lowly as they were, our original landholders deserve a monument; cruel as our conquest was in some respects, it deserves a record; and your great book forms both. I do not know of any other general picture of the American Indian so faithful as yours.... Indeed, none other

is so vivid and accurate." Francis Leupp, Commissioner of Indian Affairs, observed that "In other published works, more pretentious than this on their strictly scientific side, are gathered stores of information about our American aborigines. But Mr. Curtis's harvest has passed far beyond the statistical or encyclopedic domain; he has actually reached the heart of the Indian and has been able to look out upon the world through the Indian's own eyes."[17]

One of Curtis's congratulatory letters was from C. Hart Merriam, who, eight years before, had been his firm and effective critic during the preparation of the Harriman Alaska Expedition photographs. At the time of the expedition Merriam headed the U.S. Geological Survey; since then he had worked for Harriman on the expedition publications, a position that may also have closed doors to him. Harriman had publicly humiliated Roosevelt by disclosing his large campaign contributions in 1903, and Roosevelt hated him for it. But Harriman was ill and had recently lost ground to both Roosevelt and Morgan, his two worst enemies, both friends of Curtis.

There is some doubt that Curtis's friendship with his first patron survived this mixing of loyalties. Merriam's position as lifetime employee of a failing and out-of-favor tycoon probably diminished his usefulness to Curtis for sales, but his fastidiousness and experience in ethnology gave substance to his approval of Curtis's work:

> The appearance of the first volumes of your sumptuous work on American Indians prompts me to express my appreciation of what you have accomplished. While for years admiring your annual take of photographs, and your courage in attempting such a prodigious piece of work, I must admit that I have had misgivings as to the eventual results. But now that you have actually brought out two volumes with accompanying atlases of superb photogravure plates... your success is an accomplished fact.... every intelligent man will rejoice that ethnology and history have been enriched by such faithful and artistic records of the aboriginal inhabitants of our country.[18]

From George Bird Grinnell, Charles Lummis, Harvard's Frederick Putnam, H. C. Bumpus at the Museum of Natural History in New York, and many others, the compliments were all generous. In general, the press was much more dignified than in the past, concentrating more on Curtis's work than on his dramatic experiences. Most striking about the reviews is the uniformity of attitudes they expressed; ethnologists and photographic critics alike anticipated that Indians would soon be wholly assimilated into white society, and that the recording of their "vanishing" cultures was a most important task. Dr. Charles Kurtz of the Buffalo Fine Arts Academy reviewed the work:

> It has seemed strange to the writer that American artists have paid so little attention to the representation of Indian life and character. The opportunities these people offer the artist are exceptional. They are picturesque in the extreme. ... They are peculiar to our own country. They are rapidly

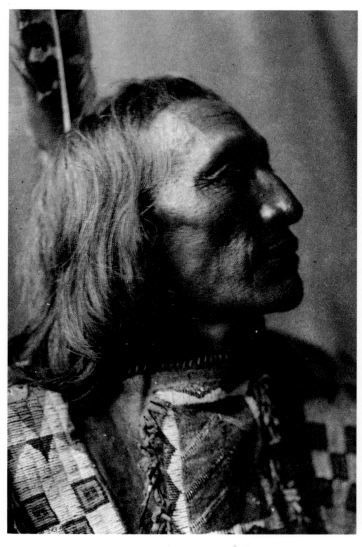

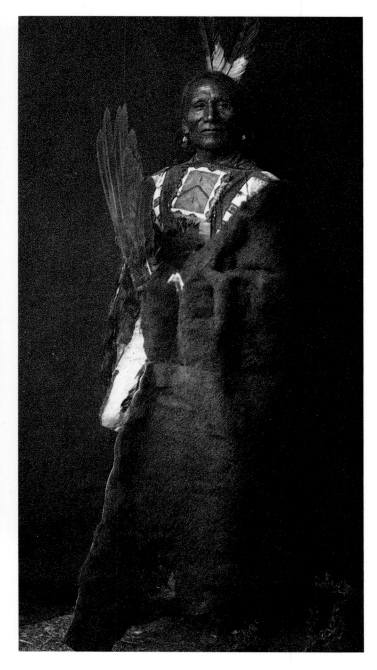

Above left, LITTLE DOG—BRULE, 1907; *right*, GREY BEAR—
YANKTONAI, 1908. These two men are wearing the same Sioux-
style fringed and beaded shirt, which Curtis used on sixteen indi-
viduals of three different tribes while photographing for *The North
American Indian*. Curtis has often been criticized for supplying
props for his Indian sitters, but out of 2,200 published photographs,
this is the only clear example of a costume furnished by Curtis.
(Courtesy of Flury and Company.)

passing away... by dying off or by amalgamation with
other races.... It remained for an artist working with the
camera to avail himself of the opportunity... almost at the
last moment but still in time—and to make a series of pho-
tographs covering almost every tribe.... Many of these
photographs have the qualities one finds in paintings.[19]

E. P. Powell, writing in *Unity Magazine*, called Curtis a "poet
as well as an artist. If it ever comes our turn to vacate the conti-
nent may we have as able an interpreter and as kindly and
skilled an artist to preserve us for the future." Several reviewers
found *The North American Indian* reminiscent of John James
Audubon's *Birds of America*, published between 1827 and
1838; both works combined science and art, and both were
splendidly manufactured. It was an apt comparison. Both men

were genuinely obsessed with their great cataloguing projects,
both were unrecognized for years; and both virtually aban-
doned their families for long periods in favor of their work.

Despite the reviews that greeted the first and second vol-
umes, subscriptions were no easier to sell, and Curtis's harried
shuffling from coast to coast to raise money and stall off bills
became a permanent routine. As it became apparent that his
brutal schedule would never slow down, normal family rela-
tions began to break down. The first major change came in the
summer of 1908 when Edward arranged for Harold to spend
the season with a Mr. and Mrs. Morris on Long Island Sound.
Well-heeled members of the Washington Square set, they were
friends of Edward's through Roosevelt, and a childless couple.

Curtis stayed in the field until the fall, working among the Sioux, Arikara, Mandan, Cheyenne, Atsina, Yakima, Klickitat and Umatilla. William Myers regularly led separate research parties (Phillips seems to have withdrawn by this point) and took on more of the writing, freeing Curtis to spend more time on the photography.

Curtis continued to supervise preparation of the text and often played an active role in both research and writing. In addition, he retained full responsibility for the introductions and image captions. But after the first two volumes (which Curtis wrote), Myers assumed most of the responsibility for both research and writing.[20] Curtis acknowledged him in each of those volumes by setting the younger man's name alongside that of Adolph Muhr. As his financial burden grew oppressive, Curtis relied heavily on each of them.

Even after the first year, the Morgan money was not enough to pay for the field work. Curtis found himself forced to use the Morgan cash to keep the publication wheels turning, leaving only subscriptions to pay for the rest of the field season. In 1908 he couldn't pay Hodge until July, explaining that "collections had been heartbreakingly slow. Of fifty thousand dollars that should have been paid during June, I received less than twenty thousand, and just at the present time I am walking the floor trying to keep the banks from growing peevish." All summer long he sent wires to Meany, asking anxiously for the Sioux history, so that the next volumes could be wrapped up, printed, and distributed to generate some cash. Curtis and Meany also discussed by post Curtis's donation of a set of *The North American Indian* to the University of Washington in the names of those who had loaned him $20,000; Curtis also repeatedly reassured Meany that where Meany's history left off and Curtis's account of the Custer Battle picked up, Curtis had been very guarded. "Don't have a cold chill when I say I brought in my material.... While giving a great deal of new and interesting information, I have said nothing that can be considered a criticism of Custer."[21] But for every letter about the field work, Curtis wrote three about funds. The situation was agonizing, and it made all the difficulties of camp life, research, and Indian relations seem pleasures in comparison.

By late August, Myers went east with the manuscripts for volumes three, four, and five. Curtis went to the Southwest to photograph for a few weeks, then to Seattle where Hal had returned to school for the winter. He was back in New York by November 11. Several lectures and exhibitions were planned for the season, but his main campaign was sales. It had long been evident that Curtis was the only person who could sell the sets, and even for him it was arduous. People often admired the work, but they either couldn't afford it, or, according to Curtis, "they looked the other way and exclaimed, 'Oh! That is Mr. Morgan's affair and let him do it.'" Curtis found that his greatest obstacle was not scientific skepticism but the attitude that if Morgan was receiving the lion's share of the credit, he should simply dig into his own bottomless pocket and pay for the entire project, distributing the sets to museums and universities

across the country. While coming to the bitter realization that many potential benefactors' doors were permanently closed to him because of Morgan's association with the project, Curtis suffered another aggravation: an imitation of his work by Rodman Wanamaker, a department store owner, who was assisted by a Dr. Joseph K. Dixon. (Curtis referred to Dixon as a "yellow cur.") After the Rodman Wanamaker Expeditions of 1908-09, these two men published halftone reproductions of their Indian images (a format strikingly similar to Curtis's), and gave lectures and slide shows using what Curtis called "fakey imitations" of his work. Eventually they even published a book called *The Vanishing Race*.[22]

Curtis didn't return to Seattle during the winter of 1908-09. He lectured, wrote an article on the Hopi for *Scribner's*, and mounted shows at the Plaza in New York and the Shoreham in Washington, D.C. In Cambridge, Myers was working on the texts with the typesetters; and he, Curtis, Hodge, the platemakers, and the printers all kept in touch by mail as the press time for the next three volumes approached. In the midst of everything else, Curtis visited the President at the White House in April, and the *Washington Post* reported that

Curtis said there had never been any foundation to the report that he was to accompany the President on the latter's trip to Africa. He said that he would very much like to take such a trip, but that his labor among the North American Indians was the work of his life and that he was going to start immediately for the West to resume that duty.

Curtis joined Myers and the crew in eastern Washington, and after a few weeks went to Seattle where his five volumes—three of them fresh from the bindery—were being exhibited at the Yukon-Pacific Exposition. He was particularly pleased with volume four, which covered the Apsaroke (or Crow) and Hidatsa, on which he had been "fortunate indeed [to have] the services of Hunts to Die, a veteran of unusual mentality," as well as those of Myers and A. B. Upshaw, the Crow interpreter of "unusual mental ability." To friends, Curtis wrote only that he was pleased with the volumes, not mentioning that his thirty-five-year-old wife was seven months pregnant. After this visit, Curtis's address in Seattle would always be the Rainier Club.

It was probably at this time that final arrangements were made for Harold to move permanently to New Haven, Connecticut, to live with the Morrises. Harold recalled looking out of his kitchen window into the Alaska-Yukon-Pacific as he sat studying for his entrance exams at the Hill School. "I didn't see my sisters again for years. I never came home because there wasn't really a home after that." By the time Katherine Shirley Curtis was born on July 28, 1909, her father had been to Montana and New York, and back to Montana again to resume his summer's work among the Piegan and then the Kutenai, Kalispel, Nez Perce, and Flathead.

Despite family worries, money worries, and mad whirling from coast to coast, Curtis managed to keep his research moving forward and to take beautiful photographs. In trying to

relieve his financial burden, he came up with a plan to encourage sales in England, where great curiosity had been expressed about his work and where Morgan's name would not eliminate other patrons. Knowing that his friend Lord Northcliff, owner of the *London Times* and other newspapers, would arrange placement of a good review, Curtis began casting about for a suitable reviewer. With no introduction, he wrote to Alfred Cort Haddon, reader in ethnology at the University of Cambridge and one of the most distinguished anthropologists in the world. Curtis may have gotten Haddon's name from the English-born Hodge, or from Meany, who knew that Haddon had been invited to lecture at the Yukon-Pacific Exposition that summer. In any event, Curtis invited Haddon to join him in the field—an invitation that caused Haddon to query his friend Clark Wissler, curator of ethnology at the American Museum of Natural History in New York: "By the by, who is Mr. Edward S. Curtis?... He has offered to take me on some Expedition and I don't know who the devil he is and what the devil he is doing." Wissler wrote back, describing Curtis as "an enthusiastic photographer who has a great deal of interest in the ethnological side of Indian life.... While he is primarily an artist, I believe you would enjoy spending a day or two with him."

And so Haddon found himself first on the Frazier River in British Columbia with one Curtis crew, and then probably with another one among the Kutenai on the U.S.-Canadian border. As the days stretched into weeks, Haddon declared himself "much attached to Mr. Curtis" and said he intended to have a "thoroughly delightful trip" to Montana to make observations. An unpublished memoir by Haddon contains a lyrical description of the broad Montana plain in August, covered with "blooming flowers, dwarf roses, marguerites, blue lupins, daisies and goldenrod.... and the air is redolent with the scent of sagegrass." He had apparently worked with George Dorsey (one of Curtis's critics) among the Pawnee in 1901, and so he was not unfamiliar with the sort of field experiences to be gathered among the American Indians. After he and Curtis entered a sweat-lodge with a very old Piegan named Tearing Lodge, Haddon described it as a "novel sensation to be one of seven nude men squatting closely side by side in the dark, steaming with perspiration, and being continually parboiled by puffs of steam."[23]

Back in New York by November, Curtis unsuccessfully tried to convince Morgan to give Haddon a set of the volumes for his personal use. Curtis wrote Haddon in December with the good news that Hodge had been promoted to director of the Bureau of American Ethnology at the Smithsonian, and that Morgan had agreed to advance him an additional $60,000 toward the Indian work. But then Curtis came to the "heartbreaking" part of his news: "I have no means of knowing why, or anything about it, but Mr. Morgan declined to send you the books." Even though Belle Greene supported the request, Morgan was not persuaded, and Haddon's influential review never materialized.

Despite this disappointment, Curtis was enormously relieved by the infusion of money from Morgan, who had agreed to capitalize a corporation for *The North American Indian*. He was hopelessly behind schedule: the five-year arrangement with Morgan would last only one more year, and only five volumes had been published. But those five had been a success, the field work and photographs were completed for three more volumes, and once again the project had been saved from disaster. In December, a new book called *Flute of the Gods*, written by Marah Ellis Ryan and illustrated with Edward Curtis's images, charmed its reviewers with accounts of the southwest's ancient cultures. Curtis even cleared up accounts with Hodge, sending him a check for $2,037 two days before New Year's. In high spirits, he undertook the four-day train trip to Seattle in mid-January 1910.

During the preceding five months, Myers had done research in the Rio Grande and Idaho, working there with a Professor Strong among the Nez Percé. He returned to Seattle to join Curtis; and with a cook named Noggie and a new researcher named Edmund August Schwinke, the writing team was complete. They settled down in a cabin in Waterman, on Puget Sound (not far from the old homestead). When Curtis wrote Hodge on January 23, he was positively lighthearted: "I wish I could steal you from your office for two weeks and keep you here in our cabin. We are entirely shut off from the world, and our weather is anything but wintry from your point of view. Our camping spot is certainly as cheerful as one could wish in this weather, which is the sort well adapted to ducks."

Curtis must have been on fairly good terms with his wife, for the writing group was staying in a cabin built for the family by her father. Edward went to see his family two Sundays a month; otherwise it was the old grind of long days, no newspapers, and only one mail delivery a week until the end of March. Toward the end, Curtis was so worn out that he had to correct proofs in bed, but by April 3 he was well, and the crew was ready to start the season's field work.

The crew worked its way up the Columbia River as far as Pasco and made an exciting return trip in a small, flat-bottomed boat. Traveling by wagon, they then worked with the Indians around Willapa Bay and Lake Quinault and "became quite well acquainted with Tait who was a Quinault doing some work for Boas.... he has helped a great deal in outlining our British Columbia trip." (Curtis probably referred to James Teit, a Tsimshian, and regular field assistant to Boas in the Northwest.)[24]

Back in Seattle in June, Curtis purchased a boat: forty by eleven feet at the beam, the *Elsie Allen* had both an engine and sails; she had been built by an Indian for salmon fishing. Curtis, Myers, Schwinke, Noggie the cook, and an Indian contact man named Henry Allen sailed to Alert Bay and the Kwakiutl country on northern Vancouver Island. Curtis described the field work as a "season of hard work with good results"; but before the Kwakiutl work was very far under way, financial problems again became acute.

THE ELSIE ALLEN, circa 1910. Built by an Indian for salmon fishing, this boat was used by Curtis and his crew during field work in the coastal villages of British Columbia. Curtis purchased three boats during phases of research along the Pacific coast, usually sailing them himself. (Photograph by Edward Curtis, courtesy of Flury and Company.)

In the four years since the project formally began, the costs of the handmade papers and the photographic plates had soared. Morgan's $60,000 was disappearing at an alarming rate, so Curtis let the cook go and took on those duties himself, on top of handling the boat and all his photographic equipment. Within a few weeks of the first bad news about money came word that the new salesman—"the noble-appearing English animal named Bell"—had disappeared from New York without making a single sale. Curtis could not find enough new subscribers or sell enough prints to generate the money he needed, and the new volumes wouldn't be ready until well into the next year. The manuscripts would be delayed even longer than usual since Hodge was doing field work in the Southwest for a month and had put off the editing until he got back to Washington. Curtis stayed with the crew on Vancouver Island until the end of October, and while photographing and helping with the research he planned new ways to raise money. He outlined an intensive lecture tour for the next year; and he, Myers, and Schwinke laid long-range plans for a feature film on the Kwakiutl.

After the season was over, an exhausted Curtis kept to his bed at the Rainier Club for ten days and afterwards remained in Seattle until the end of November, his longest stay in his hometown for more than six years. By early December he was back on the grueling sales and lecture circuit in the Northeast, though he did take time at Christmas to squire his seventeen-year-old son around New York. Harold came in from New Haven to stay at the Belmont with his father and was taken to see the Morgan Library, to meet Miss Greene, and to have tea with Mrs. Douglas Robinson. To Harold's surprise, his father was something of a social lion whose friends included not only the French Ambassador J. J. Jusserand and the British Ambassador James Bryce, but also Buffalo Bill Cody and Henry Cabot Lodge. Curtis's close friends were always generous about providing him with letters of introduction that might lead to sales of *The North American Indian*, but subscribers still numbered well below two hundred. The five-year arrangement with Morgan was at an end, and Curtis faced the task of raising funds for any further field work and publication. He carried his "disheartening effort" to secure orders well into the summer, giving up all hope of an active field season for himself. Except for a few weeks in the field, he struggled alone in New York to keep Myers and Schwinke at work in a "half-supported sort of way." Myers worked both in British Columbia and with the Hopi in Arizona, while Schwinke was probably working with the Makah at Neah Bay.

In the fall of 1911 a new series of lectures, or "picture musicales" as Curtis called them, began in earnest. Curtis engaged the services of a coordinating agent, a veteran theatrical producer named Charles Rice; a booking agent; and even a small orchestra. H. F. Gilbert had transcribed Indian music from the Edison wax cylinders and arranged a score to support the slide show. Curtis thought the music very successful, "particularly the bits which are composed to accompany the impressive dissolving views." The musicales were booked in major cities all over the country, and Curtis hoped to keep up a pace of nine lectures a week. To Meany he wrote: "I passed through seventeen kinds of hell in getting this thing underway." And to Hodge: "I have carefully watched all printed matter bearing on our tour and tried to weed out anything that might be offensive to the critical.... Publicity is absolutely necessary, but I aim to make it dignified. ... Everything depends upon the success of this winter."

5

GOING THE DISTANCE

Many times, my dear friend, I have grieved over the personal sorrows
which have crossed your path.
Edmond Meany to Edward S. Curtis (1924)

By November 1912, when Curtis presented his picture musi-
cale to a delighted audience in the Metropolitan Opera in
Seattle, he had performed his role hundreds of times, and knew
that the 1911-12 tour had been a financial disaster. The Seattle
stage was set with woven grass mats and totems, a twenty-two-
piece orchestra played the H. F. Gilbert score, and the hand-
colored slides and half-reels of motion pictures enthralled the
audience (though an otherwise complimentary review men-
tioned that the field films were "not nearly so clear as the mod-
ern studio product"). As he came out of the opera house a
waiting crowd welcomed him as a local hero. No more than
thirty feet away from the opera house entrance was the old alley
studio where he had struggled fourteen years earlier to estab-
lish himself in business. Few people present knew that he was
still struggling.

As a "sophisticated evening entertainment" the musicale had
been a success. Curtis had presented his program to record
crowds at both Carnegie Hall and the Brooklyn Institute,
where theater patrons in evening clothes responded with an
enthusiam "quite out of the ordinary." Unfortunately the road
expenses ate up any profit and the tour never got out of the red.
Within weeks of their first 1911 booking, orchestra members
insisted Curtis's crippling schedule of nine lectures a week be
cut back to four or five. This meant bringing in even less cash,
and the average daily loss exceeded $300. Matters improved
somewhat during the winter, when the musicales were booked
in major cities; but by March 28, 1912, Edward wrote Freder-
ick Hodge: "Things are fearfully discouraging, but I am always
hoping for the best." The best never materialized. Curtis had
managed to get into the field late in the summer, but only by
taking out a second mortgage on the home he and Clara owned
in Seattle, an arrangement about which he apparently neglected
to tell his wife.

Meanwhile, Curtis had embarked on an even more ambi-
tious fundraising venture. Early in 1912 he formed the Conti-
nental Film Company, proposing to make a series of motion
pictures on Indian life. In promotional material intended for
prospective stockholders, Curtis estimated that "shorter" pic-
tures should pay annual profits of $25,000 to $50,000 and a
moderately successful full-length picture at least $100,000. In
fact, Curtis would make only one film—*In the Land of the
Headhunters*—and it is unlikely that he ever saw any proceeds
from its distribution.

In late July, Curtis and Schwinke joined Myers on Vancouver
Island for a productive field season among the Nootka and

Kwakiutl Indians. They were assisted by a man named George
Hunt, a talented Indian who had been an interpreter and
informant for Franz Boas for nearly twenty years and a pivotal
figure in other important Kwakiutl research projects as well.
Curtis later described him as "the most trying yet the most val-
uable interpreter and informant encountered in our thirty-two
years of research. He was tall, powerful, rawboned, grizzled by
the passing of more than sixty years of hard knocks, intrigue,
dissipation, and the efforts of the 'short life bringers'." Hunt
was invaluable to Curtis not only in the collection of data for
volume ten, but in planning and detailing the feature-length
film on the Kwakiutl, which was shaping up as a great story of
love and war. At first, Edward had emphasized the ethno-
graphic character of the film, describing it to Charles Walcott at
the Smithsonian as showing "all the important activities... and
of inestimable value if properly done. If carelessly attempted I
would consider it a calamity."[1] But he rapidly concluded that
building the film around a story line would be the best way to
reveal the powerfully dramatic nature of the Kwakiutl and to
present details of their lives to the general public. Hunt organ-
ized not only the acquisition or creation of all of the masks,
canoes, costumes, and sets for the film, but also contributed
substantial portions of the film's story about young Motana's
spirit quest, marriage to Naida, and eventual triumph over the
evil Yaklus.

Worked on over several seasons, the film was finally finished
in 1914, and newspaper reporters and friends were invited to
the Curtis home for the first screening of a negative print. A
positive print, about ten thousand feet long, was made in
November and booked first for the Casino Theater in New
York, later for the Moore in Seattle. Just before it opened at the
Casino, Curtis sent tickets to Clark Wissler, curator of eth-
nology at the American Museum of Natural History, and
included some for Herbert Spinden, another prominent eth-
nologist. Curtis had discussed the film with Wissler during its
planning stages and described the results as a "compromise
between what I would like to make, if I was in a position to say
'the public be damned' and what I think the public will sup-
port."[2] The first screening in New York was a great success.
Calling it a "gem of the motion picture art," Stephen W. Bush
reviewed the film glowingly in *The Motion Picture World*, and
the poet Vachel Lindsay gave it high marks in his book *The Art
of the Motion Picture*, published in 1915. But it was an anony-
mous review in *The Independent*, titled "Ethnology in Action,"
that went to the heart of the film:

FILM SET ON DEER ISLAND, circa 1913. This photograph shows the artificial village constructed by Kwakiutl craftsmen for the filming of *In the Land of the Headhunters*. Made between 1911 and 1914, Curtis's film was well received but then disappeared for many years. The film has recently been restored under the title *In the Land of the War Canoes*. (Courtesy of Flury and Company.)

It was thought to be a great educational advance when the American Museum of Natural History and the Smithsonian set up groups of Indians modeled in wax and clothed in their everyday or gala costumes. But now a further step of equal importance has been taken by Edward S. Curtis.... The masks and costumes of the eagle and the bear which seemed merely grotesque when we saw them hung up in rows in the showcase at the museum become effective, even awe-inspiring, when seen on giant forms on the prow of a canoe filled with victorious warriors.... Mr. Curtis appreciates the effectiveness of the silhouette and the shadow and he is not afraid to point his camera in the face of the sun, contrary to the instructions of the Kodak primer. The scenes that elicited most applause from the audience were after all not those of Indian combats, but those of waves and clouds at sunset, the herd of sea lions leaping from the rocks and the fleet of canoes being driven swiftly forward.[3]

Despite its successful release, *In the Land of the Headhunters* was not immediately booked again. Curtis soon discovered that his promoters (and co-stockholders) had little or no experience in motion picture distribution.

He had undertaken the film production to raise money for the larger project, and he had continued his field research and publication work during the filming. In 1913 the ninth volume (concerning the Salishan tribes of the coast) was being published, and that February he read a report to the annual meeting of the North American Indian Corporation, covering not only his work of 1912 but also a brief review of the work as a whole. Stating that it was Morgan who had convinced him to publish the work himself, he identified his two great problems: the initial lack of adequate capital and the difficulty of making sales.

Frankly, being young then, I did not properly discount the enthusiastic commendation and gush; and further, the earlier orders were taken preceeding the great financial crash of 1907. The difficulty of making sales since then has been many times harder than before, and it is safe to presume that had the publication matter not been started previous to the changed financial condition of the country, it would not have been considered a possible publication enterprise.[4]

On March 21, 1913, Curtis wrote to Belle Greene, expressing his fears that the project might have to be given up.

It is with considerable hesitation that I speak in this way,

MAKING THE MOVIE, circa 1913. Curtis wrote the screenplay for *In the Land of the Headhunters*, and used his regular field assistants to produce the film. Edmond Schwinke was the cameraman for much of the filming and took many still shots as well; in this Schwinke photograph Curtis is behind a camera and George Hunt is directing with a megaphone. (Reproduced by permission of University of Washington Press.)

LIFE-GROUP EXHIBIT; "THE USES OF CEDAR," AMERICAN MUSEUM OF NATURAL HISTORY, circa 1904. Designed under the supervison of ethnologists, such exhibits were considered the most effective way to educate the public about native American cultures. The exhibits were extremely popular during the first quarter of the century. (Photographer unknown, reproduced by permission of American Museum of Natural History.)

but it is only fair that you have knowledge of the situation. I so deeply appreciate Mr. Morgan's assistance that the desire to succeed for his sake is the uppermost thought of my life, and I assure you that I have made about every sacrifice a human being can for the sake of the work, and the work is worth it.... that the men for whom Mr. Morgan has done the most and made the most for turn their backs and let the undertaking languish, for the lack of comparatively paltry dollars is maddening, and causes me to have a good deal of contempt for man as a whole.

Without warning, John Pierpont Morgan died at the Grand Hotel in Egypt on March 31. Still a vigorous man at the age of 76, he had been vacationing with his daughter Louisa and her husband Herbert Satterlee. All purchasing arrangements for art were entirely suspended upon his death, and further funding for Curtis's work from the Morgan fortune appeared doubtful. For ten years, until the bulk of his father's art collection could be sold to meet the demands of the estate, Jack Morgan's cash expenditures would be severely limited. For a time, Belle Greene was afraid that he would even close the library, though her enthusiasm soon won him over. According to the Graybill-Boesen account of Curtis's life, it was at this time that Jack Morgan extended additional assistance to the project—a version thrown in a doubtful light both by Morgan's circumstances and by the fact that Curtis's activities in this period reflect no new infusion of capital. In addition, a rumor circulated around the publication office, bank, and library that Curtis had wasted some of the money he had already been given. When he heard about it, he fired off a letter to Miss Greene in which his usual deference to her went slightly acid:

... the trouble with the undertaking is not in the extravagant use of such money as we have had, but rather that we have had so little. The fault has been the fearful difficulty of securing orders for the work.... The attitude of letting Mr. Morgan do it has been a difficult one to overcome.... According to the original plan the expense of research and publication was roughly estimated at one million and a half dollars.... Mr. Morgan's subscription was seventy-five thousand dollars, leaving to be raised one million, four-hundred and twenty-five thousand dollars. This is no small task when confronted with the fact that the majority of the logical supporters insisted that the one doing the most do it all. ... The fact of the case is that both in the furthering of the work and in the support of my family the most rigid economy and pinching care has been necessary. When I say this I do so with the fact before us that we started out to do... a real piece of investigation and publish a real book, not a pamphlet at 'six bits.' As to the effort I have put forth to do the work, few men have been so fortunate as to possess the physical strength I have put into this; and year in and year out I have given to the very maximum of my physical and mental endurance in my effort to make the work a worthy one.

I am enclosing an extract from my annual report of January, 1913. In this I briefly review the situation. I wish you would take the little time necessary to read that material.[5]

It is likely that what funds were available for field work in 1913-14 had come from the cash receipts of volume nine. Curtis stayed in New York until late summer, trying to sell subscriptions and earn money by lecturing. There were scaled-down versions of the grand musicales, but Curtis was no longer being booked as an evening's entertainment: he spoke primarily to women's groups, which may explain how he came to write an article about names for pets for *Animal News*.

At the end of a short field season in 1913, he received word in British Columbia that Adolph Muhr had just died in Seattle. "It came at the end of a day's work at the end of the week," Curtis wrote Hodge on November 24, 1913. "I... returned as quickly as possible and for the balance of the year I must remain at the studio and get affairs in such shape that I can be comparatively free of the studio burden." The management now fell wholly to Ella McBride who lived with Clara and the girls at 934 Twenty-second North, and to Beth, just seventeen years old but already showing the Curtis "business energy and perseverance." Their first crisis came in March when the studio had a bad fire, but by that time Edward was in New York.

William Myers spent the winter of 1913 in library research at the University of California with Alfred Kroeber, who had taken over the new anthropology department there when Frederick Ward Putnam retired in 1909. In April Myers and Curtis joined up in Phoenix for a month's work among the Hopi; then they went north to British Columbia for the final season of work on the film and volume ten.

That summer, Curtis and Belle Greene made up their differences over the rumors of Curtis's extravagance. She had written to inquire about "the personal cast" of his stinging letter to her, and he replied from camp in Port Hardy, British Columbia:

The magnitude of the undertaking is such that the field work, the preparation of the text and pictures, and then the fearful struggle to make sales have kept me too busy to give much time or thought to telling my friends about it. Also I have taken it for granted that they would know I was doing my very best. Perhaps in this I made a mistake. No doubt I should have tried to keep closer in touch and explain more fully the problems confronting us. My theory has always been that people do not want a tale of woe from a worker as to how hard it is to do a thing, but rather they want results from a worker who managed to keep a smile most of the time.... When I get back to New York in the winter I would like to go over the whole situation with you.

Over the years Curtis's letters had indeed taken on a personal cast. Having sent her a copy of his just-released *Indian Days of Long Ago*—a small book telling the story of a young boy of the Flathead tribe—Curtis wrote to her when he was back in New York that autumn:

I am more pleased than you can quite realize that you like the little book. I really think that it is a valuable addition to the available reading matter for the younger generation.

I do want to call and have a chat with you and within the next two or three days I will get in touch with you by telephone and let you suggest the time I can come in. I have with me a few proofs of some of the later work and think you will like them. Looking forward to seeing you.[6]

When not using the brown cotton letterhead from the publications office, Curtis either typed his letters on plain white paper or used a fountain pen on a heavy but simple cotton sheet. This note to Miss Greene, however, was written on a large and magnificent sheet of handmade paper bearing a "Barcelona = Catalunga = Spain" watermark that showed his stylish (if sometimes illegible) handwriting to advantage. In all of Curtis's available correspondence this is one of the most personal gestures—and, combined with its tone, the letter could be construed as flirtatious. If indeed Curtis was slightly smitten by Miss Greene, she seems to have been indifferent to his pains. Among the many men who pursued her were the peripatetic Bernard Berenson, and an unidentified rich western lumberman who threw himself and his checkbook on her mercy. After doing "luncheons, dinners, theaters, joy rides, all the museums," she wrote to a friend that she made him buy a "Reynolds, a Raeburn, a Gainsborough ... and also a private railroad car." After he returned to the West, the man made her "a screamingly funny proposal of 'honest marriage'.... After he had been back about a fortnight, along comes a telegram— 'When will you marry me? ... Reply pd.' I sent word that all such proposals would be considered alphabetically after my 50th birthday."[7]

Even though Miss Greene seems to have ignored the note of flattery that crept into Curtis's correspondence, she was not unfriendly. She was famous for her valuable support to artists and especially young bibliophiles. Though her taste, like Morgan's, ran to the rare manuscript, she encouraged Curtis and wrote to him over the years. He valued her friendship. But after his note late in 1914, and an acquaintaince of eight years, his correspondence to her lapsed.

In New York for the premier of his Kwakiutl film in December 1914, Curtis stayed to work on the publication of volume ten on the Kwakiutl. He was given a show at the American Museum of Natural History—his first major exhibition in several years—and he hoped the added publicity would sell subscriptions. He wrote to urge Hodge along in the editing, saying "the thing is dragging so much that it is proving exceedingly trying in a financial way." Once his proofs for volume ten were completed, Curtis didn't write to Hodge again for fourteen months.

He was, however, stepping up his letter writing in other directions. Probably encouraged by the warm initial reaction to *In the Land of the Headhunters*, he began laying new plans for films and described them in a February 1915 letter to Schwinke in Seattle:

I wish you would immediately shape up your books and other affairs in Seattle so as to be able to leave on the shortest possible notice. I may ask you to go into the field and do a month's motion picture work and scenic stuff. That is, going out quite by yourself, and instructions will probably come by wire, so lose no time in getting everything in such shape that you can pull out for a trip of a month or six weeks.

I will probably have you use the motor camera. Please see our repair man and learn if the Pathe Camera can be adjusted to conform to register with our motor camera.... I think it is in good shape aside from the fact that the present lens is worthless.[8]

Curtis had contracted with *Leslie's Magazine* for photographs to be made during a "picture tour of the scenic spots of America" with plans for "fifty-two weeks of a scenic picture a week." In April 1915 Herbert Smith, a former editor of *The Forester*, the journal of the U.S. Forest Service, approached him about combining his work for *Leslie's* to obtain pictures suitable for "lantern slide illustrations, transparencies, bromides, etc." for the Forest Service.

Also in April, Curtis became acquainted with Robert Flaherty and his wife, Frances, and gave a special screening of *In the Land of the Headhunters* for them in his New York offices. The year before, Flaherty had begun filming on Baffin Island, recording Eskimos building igloos, hunting seals, and performing conjuring dances. He also filmed a caribou hunt by mounting his camera on a sled and shooting while being pulled along "by galloping dogs," but despite his adventurousness his first attempts proved "too crude to be interesting." The Flahertys went twice to the Curtis headquarters; and after showing them the film, Curtis joined them for lunch, giving them "the benefit of his own experience in the moving picture world."

In 1921, Robert Flaherty made his classic film, *Nanook of the North*, at Cape Dufferin on Hudson's Bay. Like Curtis, he selected special actors and put women to work making traditional clothing to replace the Scottish woolens then worn by the Eskimos. A snow house was constructed and a portion of the roof cut away to make room for the motion picture camera. Flaherty also carefully removed all tools, weapons, and utensils of the white man. Curiously, although completed eight years after *In the Land of the Headhunters* and closely following many of Curtis's leads, it was *Nanook of the North* that became a classic for its reconstruction of an earlier phase of an aboriginal culture.[9]

Curtis began his "picture tour" for *Leslie's* in the summer of 1915, though not with the aid of Edmund Schwinke, his cameraman for *In the Land of the Headhunters*. On May 4 Curtis wrote him a long letter itemizing the equipment Schwinke should bring when he met Curtis at the Grand Canyon on the 24th:

The motor camera and its accompanying equipment
Both motion picture tripods. Have old one given any
repairs needed, and if I am right, there is no tilting head
to it.
The small red dark tent
The 6 x 8 camera and accompanying holders, etc.
One small brown tent
Light blanket equipment for yourself, no blanket or
bedding for me.

We will first be making a thousand-foot motion picture of
the Grand Canyon. I will work with you a few days in start-
ing it and then leave you to finish. You will next join me at
Yosemite and there you will have two or three days with me
and again it will be up to you to finish the picture.... After
leaving you at the Yellowstone, I return to Albuquerque
and join a Congressional party there, covering certain
conservative projects in Arizona, New Mexico, through
California, Nevada, Colorado, Oregon, Washington, Mon-
tana, and Idaho. You will touch with me when our party is
in the Yosemite.

Schwinke immediately resigned, saying tersely that the pro-
posed undertaking did not appeal to him. "The heart of the
matter is that I simply cannot afford to stay longer. I have put in
over five years at this work, and have not got anywhere, and am
probably less fitted to hold down the ordinary, everyday sort of
position than I was when I started. It is time for me to change."
Schwinke later wrote Myers that he had had enough of motion
picture photography to "last [him] at least three lifetimes." The
previous year Schwinke and Ella McBride proposed buying the
Curtis Studio, an offer Curtis declined.

Undaunted by Schwinke's disaffection, Curtis found a new
assistant and went to Yosemite, then to the Grand Canyon or
Yellowstone (perhaps both) where he was "furnished an army
mule for his camera equipment.... and he and his "helper made
enough motion picture footage for an evening program and
enough still pictures to fill several magazines."[10]

After Schwinke's resignation, it took some time for Schwinke
and Curtis to sort out their affairs. Schwinke was instructed to
send on all cash-books, ledgers, statements, and receipts to the
publication office in New York, signaling Curtis's resolution to
move his headquarters there. Schwinke was not only owed
money for his services to Curtis, but he had put money into *In
the Land of the Headhunters*.

Asahel Curtis was also owed money: $130 for printing serv-
ices rendered to Edward during the Seattle showing of *In the
Land of the Headhunters*. Perhaps loathe to approach his
brother, Asahel pressed the issue with Schwinke, saying he was
badly in need of the amount. The debt was undoubtedly a sore
point for Asahel.

Edward's mother and sister Eva had for the most part lived
with him and Clara until 1905 or 1906, then made one or two
moves within as many years, and finally settled into a little
house on the east slope of Capitol Hill. Ellen Sheriff Curtis died
on December 11, 1912, after apparently being somewhat ill

THREE GENERATIONS OF MAKAH, 1916. Basket sellers were
still a common sight on Seattle streets when Asahel Curtis took this
photograph. Though his work has never been as well known as his
brother Edward's, Asahel Curtis took many excellent Indian pho-
tographs. (Reproduced by permission of Historical Photography
Collection, University of Washington.)

during her last years. The responsibility for Ellen's care seems
to have fallen to Eva, Asahel, and his family, and the medical
expenses primarily to Asahel. Eva never married. When their
mother died she went to live with Asahel and his wife; she
worked in Asahel's studio as a retoucher, a job requiring con-
siderable artistic ability. Though well established, the Curtis-
Miller Studio was not as well known as the other Curtis studio.

In 1916 the Curtis Studio was moved from the Downs Block
to a new location on the southwest corner of Fourth and Uni-
versity, two blocks away. Plans for the lovely Olympic Hotel
were already under way across the street, making the studio's
corner space an excellent commercial location and one that
only a successful studio could afford. It was here that Curtis
goldtone prints began to be produced. Also called Curt Tone or
orotone, the name "goldtone" referred to the color and special
iridescent effect obtained by printing a reversed image on glass
and then sealing or backing it with a viscous mixture of
powdered gold pigment and banana oil. A sales catalogue for
the new studio had this to say about the Curt-Tone process:

The new Curt-Tone finish of the Indian studies is most
unusual in its depth and lifelike brilliancy. Of this remark-
able finish Mr. Curtis says:

The ordinary photographic print, however good, lacks
depth and transparency, or more strictly speaking, trans-
lucency. We all know how beautiful are the stones and peb-
bles in the limpid brook of the forest where the water
absorbs the blue of the sky and the green of the foliage, yet
when we take the same iridescent pebbles from the water
and dry them they are dull and lifeless, so it is with the
orthodox photographic print, but in the Curt-Tones all the
transparency is retained and they are as full of life and spar-
kle as an opal.[11]

THE EDWARD S. CURTIS STUDIO, circa 1918. Fashionably located at Fourth and University, opposite the Cobb Building and the site of the Olympic Hotel, this was the fourth and last of Curtis's studios in Seattle. After he was divorced in 1919, he and his daughter Beth moved his headquarters to Los Angeles. (Courtesy of Margaret Gaia.)

RECEPTION AREA OF THE CURTIS STUDIO, circa 1918.

After a plate was printed, the backing was applied by taking the glass in hand and carefully tipping it and rolling an amount of the gold liquid over the surface until it was evenly covered. Any perspiration from the worker's hands that reached the backing mixture would leave fingerprints around the edges. Doing the "flowing" was a tedious and unpleasant job usually assigned to Margaret Gaia, who worked at the studio from 1917 to 1919: "The banana oil stunk to high heaven. On the days that I did the flowing, the German piano teacher in the basement got his students to pound on our floor because it smelled so awful."[12]

The use of a gold backing was a fairly common specialty process: every photographer who used it had his own recipe and technique. But Curtis's goldtones were particularly luminous, and the backing material was more stable than most. Curtis aficionados commonly suppose that Muhr developed the Curt-Tone, but it was more likely perfected by Edwin Johanson, the head portrait photographer after Muhr's death.[13] An old-fashioned perfectionist who preferred to work with glass plates and natural light, Johanson came to Seattle from the well-known Hartsook Studio in San Francisco.

The Curtis Studio's large staff also included a man named Burl Patton, in charge of sales; two Japanese printers, Tay Takano and Harry Koniashi; and a photographer named Nels Lennes who doubled as a retoucher. Ella McBride had left, as had Sue Gates, Clara's sister; it now took three or four women to wear all of the other hats in the operation; one of these was making mounts for the portraits, a task that involved cutting heavy, watercolor-type papers to size and hand-deckling all the edges. At busy times of the year the studio took on more printers. Margaret Gaia, only fourteen when she started working for a salary of ten dollars a week, was the only person at the studio younger than Beth Curtis: at twenty two, the "boss" was already an old hand at managing a busy studio.

In 1916 the Curtis Studio was advertising its portraiture, and, for the first time, that it was "The Home of the Curtis Indians." Helen Keller came there to be photographed, as did Sir Rabandranath Tagore, "The Shakespeare of India," when he was in Seattle to lecture on his poetry and raise funds for his boys school in India. But the North American Indian prints were the studio's moneymakers, especially the Curt-Tones of Edward's best-known images such as "Cañon de Chelly," "The Vanishing Race," and "Wishham Fisherman." At fifteen dollars for an eleven-by-fourteen-inch print in a gilded frame with ornate bat-wing or bow corners, the goldtone was a moderately expensive and stylish wedding gift, and within a few years several thousand of them were sold.

After Muhr's death, Curtis was even less involved with the studio. While filming for *Leslie's Magazine* he was in Seattle and climbed Mount Rainier, but his visit was brief and he was back in New York the winter of 1915-16, working to publish volume eleven. By June 1916 he was in the Southwest and wrote to Schwinke that he was suing his promoters for *In the Land of the Headhunters*. Their distribution of the film had

SIR RABANDRANATH TAGORE, 1916. A Nobel Prize-winning poet from India, Tagore came to Seattle on a lecture tour and was photographed by Edwin Johanson of the Curtis Studio. Head portrait photographer for the studio, Johanson probably perfected the "Curt-tone" or goldtone process. (Courtesy of Flury and Company.)

been completely inadequate. But the country's drift towards war also made the film seem less timely—it was "Hate the Hun" movies that were in demand. Whatever the reasons, Curtis's movie was already dropping out of sight, and his investment was going with it. Because of desperate financial circumstances, Curtis wasn't certain he would be able to join Myers for any field work that summer. Meanwhile, Myers was working alone in northern California and southern Oregon, collecting information for volume thirteen and probably going without a salary and paying his own expenses.

The project now relied entirely on its nearly two hundred subscribers—who were slower than ever to pay—and print sales, which brought in only a trickle of cash. The sinking of the *Lusitania* had brought subscription sales efforts to a halt, and a fire in the printer's office destroyed almost the entire stock of Van Gelder paper. Because of the war and an embargo, the paper could not be reordered from Holland, stalling the printing of volume twelve.

Curtis's correspondence seems to have ground to a complete halt along with the publication, and his movements during the

next few years are shadowy. To all queries about his whereabouts, his secretary in New York, Lewis Albert, could say only that he was "still in the West."

Clara Curtis filed for divorce on October 16, 1916, but Edward would not come to Seattle so that the action could be concluded. He was finally cited for contempt for his failure to appear, and the contempt and divorce actions were to be heard simultaneously in June 1918. Not settled until 1919, the divorce action awarded Clara everything—including the studio and all Edward's negatives. In getting the business ready to be turned over to her, Curtis's assistants printed many, many goldtones. But afterwards Mr. Lennes and Margaret Gaia carried all the glass-plate negatives across the street into the basement of the Cobb Building where they broke them— whether by Edward's order or Beth's was not clear. Beth announced she was moving to Los Angeles to open a studio so she could be closer to her father, and the rest of the staff soon moved on to other employment.

When the divorce was final, Clara destroyed a trunkful of letters from Edward. From then on, she and her sister, Sue Gates, managed the studio. With a new photographer, they offered portrait services and sold goldtones until the studio was sold (along with the remaining goldtones) to Joseph E. Gatchell in 1927. Katherine, or "Billy," Curtis grew up working around the studio, even though she had never known the man whose name it still carried.

A new Curtis studio was soon established at 668 South Rampart Street in Los Angeles, and Edward and Beth set out to build a new clientele for portraiture, printing, and Indian images. The presence in Los Angeles of prints from glass-plate images suggests that duplicate negatives on celluloid had been made from the original plates before they were destroyed. Legally, the negatives were Clara's—the income the Los Angeles studio derived from them caused continued ill feeling on her part.[14] But though the studio was in Edward's name, Beth was in charge. Edward worked alongside his daughter at the studio for long stretches of time, but whenever he could afford it, he took to the open country again to continue photographing for *The North American Indian*. His actual whereabouts are mostly unaccounted for.

During these years Curtis had the staunch and invaluable support of William E. Myers, who carried an equal work load. And though he was closest to Myers, Curtis had the no less consistent support of Frederick Hodge, under whose supervision Myers had become a careful and competent researcher. It is only through the letters from Myers to Hodge that the slow progress of the research can be traced. By this time Hodge had left the Bureau of American Ethnology to head the Museum of the American Indian in New York, and from 1918 to 1923 he spent each field season in the Southwest, his favorite place. Hodge had never been paid for his editing on volume ten, but he was generous enough to continue working on the proofs for volume twelve, and to correspond with Myers about research questions. On rare occasions, there are glimpses of Curtis. Preparing to leave Gallup, New Mexico, for work in Polacca, Myers wrote that he had been waiting there for Curtis, "who, by riding on work trains and carrying his luggage across arroyos contrived to come from Winslow in three days."[15]

In July 1920 Curtis was in Seattle. When his old friend Edmond Meany heard of it, he went straight to the Rainier Club, only to find Edward had left just minutes before. He then sat for more than an hour in the King Street train station, but Edward never came. He sent a brief letter in care of the Hotel Stowell: "My good friend, I certainly wish you more happiness than has been your portion of late." There was no answer. A year later Meany had a little more success. Meany's and Curtis's old friend Sam Hill, the railroad man, had once sent the French Ambassador J. J. Jusserand to visit Curtis's camp in Montana; and now, years later, Hill and Meany hatched the scheme of having Curtis give a "tour" of a few reservations for Marshal Joseph Joffre, commander of allied armies in France during World War I. Curtis's first letter to Meany in more than six years was brief: "I fear this is not possible.... It was good to get your letter for it brought up memories of some delightful days we have had together." A month later, fearing that he had given offense, Curtis wrote again: "Mr. Hill, always having an ample bank account at his command, is scarcely in a position to realize the situation where one has to produce something today or not eat tomorrow and we are making the best of things."[16]

The North American Indian remained in limbo. The tissue editions of volume eleven were finally printed, indicating that paper was again available; but no new printing was undertaken.

After a six-year lapse, volume twelve was published in 1922. Most likely Jack Morgan supplied the money for printing expenses: his father's estate was now settled, and subscribers had started to inquire at the bank about the rest of their sets, wondering what they could do to get the thing finished. At this time Curtis's publication office in New York was closed; all further arrangements for the North American Indian Corporation were made out of an office at the Morgan bank. The Suffolk Engraving Company was the new platemaker engaged for volume twelve, and their work was not quite up to the old mark. Despite the noticeable paleness of the new engraving, the subscribers seemed happy with the beautiful Hopi images, selected from the large number Curtis had taken over the course of fifteen years. Although Jack Morgan had renewed his association with the project, nothing indicates he provided any money beyond the printing costs.

But at least the work was being published again. Curtis rounded up his daughter Florence to assist him for the summer of 1922, and the two of them went to photograph among the Yurok, Karok, and Hupa in northern California and southern Oregon. The groups were small and scattered, and in California, isolated in the mountains. The Curtises criss-crossed the coastal range six times and nicknamed their automobile Nanny after it took them through a number of close shaves on the mountain trails. On one occasion the car started to roll over.

Gunning the motor, they shot far enough to come to rest against an oak tree. Curtis wrote to Meany that he could have

> tossed [his] still burning cigarette two hundred feet down to the first ledge of the gorge.... I assure you that the snowy slopes of our beloved Mt. Rainier never gave me thrills surpassing my gasoline trip this season.... From what I have said you may feel that Northern California has no roads other than goat trails, but such is not the case. The main highways are fine, and oh the joy of coming down out of the mountains and the bypaths and striking a road wide enough for two cars to pass. Then you step on the gas just for the sheer joy of going.

Curtis was elated at being able to work on the project for the whole summer, and this long letter of September 22, 1922 was filled with happy details about his and Florence's travel. In the end, though, he could not refrain from touching on the treatment of the California Indians by the early settlers of the state: "The principal outdoor sport of the settlers during the 50s and 60s seemingly was the killing of the Indians. There is nothing else in the history of the United States which approaches the brutal treatment of the California tribes."

In general the project's second phase was carried on in relative isolation. Little public interest existed in Indian work, and in many ways Curtis had been entirely bypassed by practicing ethnologists. Not only were many newcomers to the field rigorously trained by Boas or Kroeber or Robert Lowie, but their work now emphasized the study of individual groups rather than cross-cultural comparisons. Edward's powerful allies among the old guard were either retired or dead, or had lapsed into a conventionalized nostalgia about the "vanishing West." Roosevelt, infirm and almost blind, had made a pitiful attempt to revive the spirit of the Rough Riders through a volunteer regiment in 1917, meeting only with polite disinterest on all sides. Curtis had survived the titans who brought him into the limelight, and their passing deprived him of not only encouragement and valuable introductions but also his primary means of getting his work into educational institutions and public libraries. Without wealthy patrons in the habit of making bequests, Curtis had to rely on the purchasing channels of the institutions themselves, and that meant relying on the good will and respect of ethnologists and anthropologists, many of whom Curtis had long ago alienated. After his first unsuccessful appeals to many universities and museums for financial support, he never sought close ties with any of them. His independence had cost him dearly. Committed to the format and direction of the publication, Curtis and Myers did not alter their research and writing. As they fell behind developments in anthropology, their work was less often cited in journals and books; its potential value to young ethnologists was obscured by its anonymity.

Throughout this dark period in his life, Curtis continued to photograph for the project during good weather. The rest of the year he worked in the studio; and having given up attempts at further subscription sales, he turned his energy to new proj-

ects. After the war Harold Curtis came west and finished his degree in mining engineering while working in the gold mines in Colorado. Edward, his own interest rekindled, progressed rapidly through a sophisticated correspondence course in metallurgy and mining and regularly exchanged letters with Hal on their progress.

About this time Edward developed an ingenious device he called "the concentrator:" a box, a chute and a tray of mercury, it utilized mercury's property of attracting gold. Curtis designed the device to be used among the many abandoned placer mines in California, whose old tailings dumps contained gold too fine to have been caught in the original washing process. No great amount of gold could be collected with the thing at any one time, but it worked well enough to give Curtis a little income. At some point during the 1920s he took out a patent on it.

In addition to his fascination with gold, which he called "the only thing that endures," Edward's interests took a turn toward a more "circus kind of business"—the movies. The first film studios had arrived in Hollywood only a decade earlier, drawn by the sun, the space, and the freedom from the patent-company thugs in New York who collected a $2 weekly "license fee" on motion picture cameras. Los Angeles and its little suburb Hollywood lay in the Cahuenga Valley, and in those early days Hollywood was such a small place that the streets "ran up into the foothills, and the foothills went right up into the sagebrush."

One of Curtis's first Hollywood projects was basic biblical research for The Ten Commandments, which was still on the drawing boards. In the same period he made still photographs of Elmo Lincoln as Tarzan. Lincoln had appeared in both of D.W. Griffith's masterpieces, Birth of a Nation and Intolerance, and he made his last two Tarzan films in 1920 and 1921. Curtis's next known involvement in films was as a still photographer for Cecil B. DeMille's Adam's Rib, released in March 1923, he was later employed both as a still photographer and second cameraman in The Ten Commandments.

Early in 1923 Curtis received a letter from Pliny Earl Goddard, curator of ethnology at the American Museum of Natural History, asking whether he would sell a print of In the Land of the Headhunters. "I have a strong feeling that your film ought to be preserved in some institution like our museum and besides we can make excellent use of it for our lecture work. You know how public institutions are. They are often out of money.... [but] if you will give your price I will do what I can toward securing it."[17] Curtis wrote back on March 1, 1923—just before leaving for Seal Beach to film the flight of the Israelites for The Ten Commandments—to say he would be willing to sell his Kwakiutl movie. In the same letter he mentioned having found interesting material for pictures in northern California and southern Oregon the previous summer and lamented the fact that there had been no money for a motion picture camera.

It must have been disheartening for Curtis to realize that the loss of the $75,000 or so that had gone into his film had been

TARZAN, circa 1921. As the screen's original Tarzan, Elmo Lincoln starred in three features and one serial in the early 1920s. Lincoln began his motion picture career as a blacksmith in D.W. Griffith's *The Birth of A Nation*. (Courtesy of Flury and Company.)

one of the crippling blows to the larger project. Now he was working for someone who spent more on an entertainment film in a few months than he had spent on his entire project over twenty years.

Four other still photographers worked on *The Ten Commandments*, so not all surviving stills can be assumed to be Curtis's work. But among the blue-toned silver prints that have turned up in cardboard mounts from the Edward S. Curtis Studio, Biltmore Hotel, a few images need no identification: they show the same powerful structure and monumentality that characterizes his greatest Indian images.

However exciting the Hollywood work, Curtis's income from it was limited, and he was trying to undertake more field work while still in straitened circumstances. On February 22, 1924, he wrote a weary but still determined note to Edmond Meany: "About the only thing my friends can do is to hold a little belief in me. I am working hard and trying to justify such faith as my friends may have. The problems are many, however the real work moves on." Curtis was tired indeed: twice in the letter he misspelled his old friend's name. Soon afterward, their correspondence lapsed again.

After a year of negotiations, Pliny Earl Goddard wrote on January 17, 1924 to say that the American Museum of Natural History had no funds with which to purchase *In the Land of the Headhunters* in its entirety, but that he had showed it to Professor Franz Boas who thought "several sections of it should most certainly be preserved as a record.... What I really want is a negative of about 1,000 or 1,500 feet of the film covering in particular the dances and boat scenes. This negative could be made from a fresh positive, hardly from the positive I have here." He went on to suggest a joint purchase with George Heye, founder of the Museum of the American Indian, where Hodge was director. Goddard and Boas were probably after the footage of the film's beautiful set pieces; under George Hunt's dirction, the Kwakiutl had made house posts and a magnificent canoe especially for the film. Those pieces represented most of Curtis's budget. The museum would not have been interested in the "made-up" portions of the film: imposition of the story line supposedly marred the ethnographic accuracy of what was being shown. Ironically, when Boas made his own film several years later, he asked the Kwakiutl to perform dances, boat scenes, and games for his camera.

Whatever Curtis might have thought about the museum's request for only a portion of *In the Land of the Headhunters*, he needed money. For $1,500 he shipped off his uncut master print and negative on October 16, 1924, relinquishing all rights to his work.

In the next few years, Curtis worked as a still photographer on DeMille's *King of Kings* (released in April 1927), and in 1936 he went to South Dakota to work on *The Plainsman* which starred Gary Cooper. In addition, his entries for the 1924 and 1926 editions of *Who's Who in America* included membership in the Screen Writer's Club.

Whatever other work he may have done in Hollywood, by 1924 he and Myers were again working heavy summer schedules on *The North American Indian*. Volumes thirteen and fourteen on the many smaller tribes of northern California and Oregon were published in 1924; volume fifteen on the southern California groups was readied for printing (Myers had actually written most of the text years before); and the two men worked a long field season in the Southwest. They were working simultaneously on the Pueblo volumes, sixteen and seventeen, and moved about from Zuni and Acoma to the Eastern Keresan and Tanoan pueblos. They were hampered by a cattle quarantine and the fact that whites were less welcome in those parts than ever due to the interference of religious and philanthropic groups in such issues as Indian education and the religious use of peyote. Myers wrote to Hodge that "considering the difficulty of the field" they had done remarkably well.

In the spring of 1925, Curtis went back to New York—probably his first trip there in ten years—to arrange permission from the Canadian government to conduct field research in central Canada during the upcoming season. Myers visited his mother in Springfield, Ohio, and he wrote to the corporation office at the Morgan bank asking to have his expenses covered from there so that he could travel to consult with Hodge about the best locales for the summer's work and also have assistance in compiling the best research bibliography of the area. The request was turned down. With few exceptions, Jack Morgan was covering only the printing expenses; even after Morgan reentered the financial picture, it took Hodge at least two years to get paid for the editing he had done in 1914.

On the first of August, 1925, Curtis and Myers met on the Piegan Reservation in Montana and went north to Sarsi and Cree country. On November 1, Myers wrote Hodge that the two of them had had a "satisfactory season in Alberta. The outlook was discouraging at first, but as we went farther north it became more promising. We were lucky to find a very good source of information for Cree and Chipewyan, and pumped it dry." On the heels of the successful field season, Myers found himself in a bind: instead of holding all further printing until the field work was done (as had been agreed), Curtis asked Myers to prepare the manuscripts for the Pueblo volumes as quickly as possible. Myers confided to Hodge that he had "promised Mrs. Myers a winter across the pond. I have not as yet accumulated the courage to impart the sad news; and when I do I shall have to offer a compromise in the form of a winter in any place or places in the U.S. she may select. And at that I'll be lucky to get off with my life."

Four months later, in April 1926, as Curtis was preparing for an early start on the year's work in Oklahoma, he received a letter from Myers "like a bolt of lightning out of a clear sky":

It is an unpleasant thing to have to write you that I shall not be able to do any field work this summer. An opportunity has presented itself to make a lot of money in the next two or three years—a real estate transaction. It is one of the kind that rarely occur, and I am getting too old to pass it up in

hope that another will be at hand when the Indian work is finished. It will necessitate my being here from June 1 on. Meantime the bulk of the press work will be done....

It was a great disappointment for Curtis to lose his faithful coworker so close to the end of their long road together. Even the usually taciturn Hodge expressed "distress" that Myers couldn't have held off until he had finished his "excellent work." But Curtis was in full stride again and not to be put off the summer's schedule. Hurriedly, Hodge helped him come up with a new assistant, Stewart Eastwood. He was two years out of college, and able to start at once, but he had only a general grounding in anthropology and no field experience whatsoever. Myers wrote to Hodge apologetically: "It will be next to impossible to get [anyone] to do the field work and prepare the text without insisting that it be published over his own name. That of course is the nub of the whole problem, and the thing that made me hesitate so long before deciding to withdraw."[18] Curtis wrote to Hodge later in the summer, "I never realized how much knowledge a veteran worker had in his system until I worked alongside Eastwood for a few days."

The text for the last two volumes of *The North American Indian* differs in character from the rest of the series, due to both the loss of Myers and unprecedented field circumstances for the last two seasons' work. In Oklahoma, Curtis found it impossible to distinguish aboriginal habits or beliefs; the long crowding together of many tribes on the reservations had blurred culture lines. Forced to base their text on actual circumstances, Curtis and Eastwood concentrated on obtaining the recent histories of the tribes they encountered and especially on the experiences that had brought them to Oklahoma. Curtis's photographs for volume nineteen show the mixture of Indian and white cultures, and the text is characterized by short paragraphs, fragments of vocabularies, and blunt references to tribes whose last member had recently died. Despite an unusual discussion on the spread of the "stomp dance" in 1926, most of the text is still ostensibly concerned with describing the "classic" past; but its very fragmentation makes a statement about the disruptions in the subjects' lives. Curtis had to defend the research to Hodge:

You say the Comanche material is inadequate. I grant you that it does not make a strong showing, but one cannot make something from nothing. We covered the ground with the most intelligent of the present day educated man as interpreter and helper. With his help, we talked to all of the old men of the tribe. Day by day we struggled to get what we thought should exist. Finally, our interpreter, Mr. Tabo, turned to me in some exasperation and stated: "You are trying to get what does not exist."[19]

Due to Eastwood's inexperience, it was Curtis who questioned all of the informants in Oklahoma and turned the field notes into a manuscript. Hodge not only questioned some of Curtis's conclusions but directly criticized Eastwood's portion of the work; Eastwood had, for instance, given no indication of pronunciation stress on any Indian words. Curtis had a difficult time keeping him from quitting. Calling Hodge a "good editor but a bum diplomat," Curtis wrote on May 11, 1927, imploring that Hodge wield the "big stick" only on Curtis himself—he could not afford to lose Eastwood. "The office is expecting us to finish volume twenty this year and to get a new man at this time would be out of the question.... I leave here (Los Angeles) on the 25th. The steamer *Victoria* sails from Seattle on June 2. We go direct to Nome and take a local boat from there to Kotzebue."

The trip to obtain final material for *The North American Indian* was soon under way. The summer's ambitious schedule was made possible only through the assistance of Curtis's least credited supporter, his daughter Beth Curtis Magnuson, who provided all the financing. Close to her father through the years when the project seemed doomed and he had been wracked by depression, she wanted to be with him now that the end was actually in sight. When the *Victoria* set sail for Alaska on June 2, 1927, Beth embarked with her fifty-nine-year-old father on what would be one of his most dangerous and exhausting seasons.

There were warning signs from the first. The *Victoria* took twelve days of precious good weather to break through the ice fields and reach Nome, and once they were there no one was willing to send a charter boat into the Bering Sea. They finally had to purchase a boat called the *Jewel Guard*, forty by twelve feet, and described by Curtis as "an ideal craft for muskrat hunting in the swamp, but certainly never designed for storms in the Arctic Ocean." If it survived the season, its seller—Harry-the-Fish—wanted to buy the boat back. Anxious over its fate, Harry decided to accompany Curtis, his daughter, and Eastwood on their sail to Nunivak, three hundred miles away. Uncharacteristically, Curtis kept a log—a terse and hair-raising account of the storms that beset them from the first day.[20]

They set sail on June 28, and at midnight Curtis made an ominous entry:

Ice thick, headway slow, fog closed down so cannot see two boat lengths. Danger of collision with ice.... Decide to lay to and drift with ice until better visibility. Harry and Eastwood turned in for two hours sleep. I remain on watch. Gloomy night, wind howls through rigging and there is the constant sound of grinding, shifting ice.... Not so good a start.

Curtis had estimated taking three days to reach the island, but after seven days they were still at sea. As another night began, he described the sea as

growing wild and growing worse. It was a sparing [sic] match with one big swell after the other. With full power we could make a mile an hour and each breaker looked as though it might be our finish.

They tried sailing closer to the main coastline, only to strike a sand shoal one night around midnight. The boat stayed solidly aground until six the next evening. Curtis worried that they might have to abandon ship; his hip, injured in an accident years before, was in such bad condition that he could often

barely walk. When they finally drifted free he wrote, "Oh, boy! What a relief to feel her floating free!... All hands are smiling.... We had a celebration supper of eider duck with dumplings, and tapioca pudding with apples." As he had so often before, Curtis cooked for his crew.

But there were more setbacks, and the *Jewel Guard* didn't reach Nunivak until July 10, twelve days out of Nome. Despite the ordeal, Curtis was well pleased with the decision to visit the island:

The natives here are perhaps the most primitive on the North American Continent.... Think of it. At last, and for the first time in my thirty years work... I have found a place where no missionary has worked.... I hesitate to mention it for fear some over-zealous sky pilot will feel called upon to labor these unspoiled people. They are so happy and contented that it would be a crime to bring upsetting discord to them. Should any misguided missionary start for this island, I trust the sea will do its duty .

His delight in the people he met was evident in his warm and charming photographs, among the most beautiful of any in *The North American Indian* series. The researchers were unable to go very far afield in search of more informants, but Curtis had confidence in their interpreter, and the work went well.

Shortly before they started back to Nome, Curtis agreed to transport three ethnologists to the north end of the island. Supposedly working under the auspices of several venerable institutions, including the Bureau of American Ethnology, they disgusted him with their decision to load nearly a ton of human bones on board. "A skull or two as types might be all right but what in hell do they want with tons of the stuff?"

Back in Nome by the end of July, Beth left for Los Angeles, going first by air to Fairbanks with Joe Crosson, who would become a famous bush pilot. Airplanes were still unusual in Alaska in 1927, and Beth was the first woman to make the Nome-Fairbanks flight. Of her father's upcoming sail to the North she wrote in her own log, "I was so fearful that I would never see him again."

Curtis and Eastwood worked first at King Island, where the islanders lived part of each year in remarkable huts on twenty-foot stilts against the cliffs. At Little Diomede in the Bering Strait, they collected many folk tales; and finally they spent three weeks among natives at Kotzebue Sound.

Both the photographs and text for volume twenty are very fluid and confident. But the material was obtained at a terrible cost to Curtis's health. Falling further and further behind schedule, he and Eastwood were still in Kotzebue Sound after everyone else had taken their boats out of the water for the winter. Sailing to Nome they ran into the season's first full-scale blizzard and were forced to work around the clock to pump out their leaking hull and to keep the decks free of ice. "My hunch was that we had about one chance in a thousand," Curtis wrote at one point. "One nice thing about such situations is that the suspense is short-lived. You either make it or you don't." When they finally reached Nome they heard that

the last wireless from the North had presumed them lost in the blizzard. By this time Curtis could barely walk, but his rough season wasn't over quite yet.

He sailed back to Seattle on the S.S., *Alameda*, arriving on Sunday, October 9, and proceeding straight to the King Street train station. Half an hour later, just as he was about to board his train to Los Angeles, he was arrested. "Vehemently protesting," as the newspapers put it, he was taken to the county jail and locked up. It was Clara's doing. She had signed an affidavit alleging his failure to pay alimony for the last seven years, by then a balance of $4,500.

He was released on a $2,000 bond and during the next few days made three appearances in court. After the first day in court, the *Post-Intelligencer* described him as "an international character, friend of Theodore Roosevelt, and associate of the late J. Pierpont Morgan." It went on to tell how he "sat in court, a shabby, hunched, and weary figure—and a stubborn one" who "heard himself berated for refusing to provide for a minor child, and in the same breath lauded for carrying on the great work which he regards as a moral obligation." Curtis claimed he had no money. Clara accused him of purposely refusing to own property or make sufficient income in order to avoid alimony. The battle went on for three days, and it came out in court that since the divorce a total of eighteen suits had been mounted by one or the other of them, apparently over property rights; it also came out that Florence joined Beth in siding with her father. When Curtis insisted that he would get no remuneration from *The North American Indian* because it would be completed at a deficit, the judge asked him why he was doing it. According to the newspapers Curtis broke down:

"Your honor," he gulped, broke—"it was my job. The only thing I could do which was worth doing.... A sort of life's work...[I] was duty bound to finish. Some of the subscribers had paid for the whole series in advance."

And then J. Barnes, attorney for Mrs. Curtis, over the objection of F. E. Holman, defense counsel, spoiled it all by wanting to know something of the Edward S. Curtis Studio in the Biltmore Hotel in Los Angeles. That, Curtis said, was conducted by his daughter Beth. He had no part in it. The rental, he admitted, was something over $300 monthly.[21]

The newspapers lost interest in the painful ordeal when neither party could find the original alimony decree. No decision was ever published.

Curtis limped back to Los Angeles, mortified and physically ill. He set to work on volume nineteen, addressing Hodge's objections and holding his own in their arguments. To Hodge's suggestion that the name "stomp dance" should be changed to the grammatically correct "stamp dance," he replied that "wherever the dance is known it is 'stomp.' We might add a footnote telling the reader that 'stomp' is southern for 'stamp.' " In another case, Hodge contradicted Curtis's statement that Comanche raids had been the principal factor in the decline of the Pecos, saying that the primary reason had been disease. Curtis refused to budge, reminding Hodge that he had

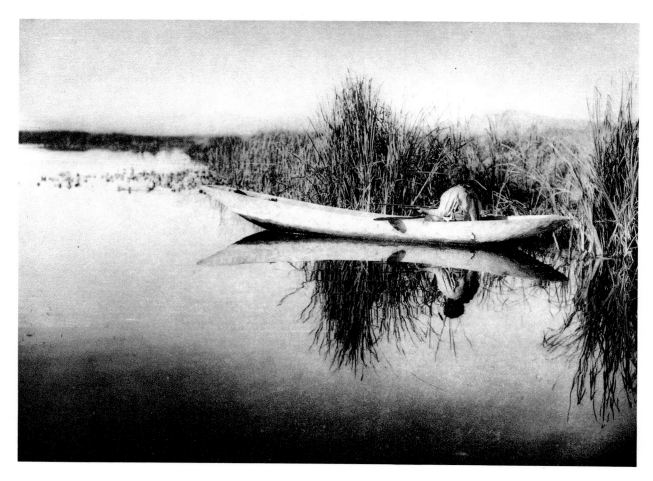

KLAMATH DUCK HUNTER, 1923. During his later work on *The North American Indian*, Curtis was on a severely limited budget and received little public support. His photographs from these years are not as well known as those completed at the height of his fame, but many of them transcend the boundaries between science and art. (Courtesy of Flury and Company.)

gotten his information from many Mexicans of Pecos blood who said that "the last big Comanche raid was the vital factor;" and without missing a beat he suggested that if Hodge checked his own writing in the *Handbook of American Indians* he would see that he himself had put the same thing in print.

Myers was finishing the work on volume eighteen on the Sarsi and Cree, and when he saw the proofs containing Curtis's tribute to him, he told Hodge that it gave him a "heart ache" and ruined the day for him.[22] Volume eighteen was published in 1929; that autumn, after much "cleaning-up" of the texts, the Oklahoma and Alaska volumes also seemed near printing. A final flurry of confusion arose when Hodge lost the introductions to both volumes. Curtis wrote to him on October 15, 1929, from Grants Pass, Oregon (where Florence lived with her husband), saying he was certain Hodge had both of them, and that he should "just go into a trance and think where you have them stored."

Curtis's hip had gotten so bad that he was seeing three different doctors about it and had even commissioned a sort of straitjacket to ease the strain. In the same letter of October 15, he told Hodge that the business with his leg made it "hard to keep

up his courage." At about the same time, he wrote Edmond Meany to thank him for "sending a word of greeting. It came at a moment when I was down in the Deep. Few indeed have thus reached out a hand. I will confess to you that its reading caused me to break down and cry as a child.... Thank you a thousand times for sending the letter. Your old friend, E. S. Curtis." He would not write another letter to either man again for more than two years.

In 1930 volumes nineteen and twenty were published at last. The introduction to the last volume acknowledged the invaluable assistance of the Morgan family, who had by that time spent approximately $400,000 on *The North American Indian*, or about one-quarter the total cost of the publication.[23] Curtis also wrote: "Great is the satisfaction the writer enjoys when he can at last say to all those whose faith has been unbounded, 'It is finished.' " If there were any reviews for the long delayed installments of the series, they were hard to find, as was Edward Curtis, who by that time had dropped out of sight.

EDWARD S. CURTIS, 1951. A portrait made for his eighty-third birthday.
He died eighteen months later. (Photographer unknown, reproduced by per-
mission of Historical Photography Collection, University of Washington.)

6

OUT OF ONE LABYRINTH

*In my sleep I find myself building whole paragraphs in Indian words
which in my normal hours I have quite forgotten. In other cases I am working
out statements, thoughts, names, locations which are unknown to me.
Perhaps it is the worry and pain which causes the strange
wandering of my brain in the sleeping hours.*

Edward S. Curtis (1938)

After more than twenty-five years of work, the publication of *The North American Indian* was finished. Edward Sheriff Curtis accomplished what he had set out to do back in the days when his desire and energy seemed boundless. At the end of the project he was sixty-two years old, half-crippled from injuries and arthritis, in debt, and out of a job. His close friends and family were there to congratulate him for completing the series, but there was no fanfare.

He dropped out sight from 1930 to 1932, his whereabouts and condition during that time a matter of conjecture. By one account he suffered a severe mental and physical breakdown, and was hospitalized in Denver for more than two years. But current evidence suggests that while he was in Denver for two years and was depressed and exhausted, he was probably hospitalized only for a number of months. He was under the care of a well-known osteopath, Dr. R. R. Daniels, at the New Rocky Mountain Hospital, and seems to have begun a self-improvement course for his physical and emotional health. He developed close friendships with both his doctor's wife, Mrs. Olive Daniels, and her brother, Ted Shell, who shared his fascination with mining. Later letters to these friends refer to his depression and ill health while in Denver, but also to socializing, working strenuously on mining claims, and attempting to fund some archeological work in the region.

At the beginning of 1932, Curtis's correspondence began again, and he wrote to Meany, Hodge, Mrs. Daniels, and Shell, seemingly all at once, and often. His first letters to Meany after the long silence pick up as though there had been no lapse; they are brisk and usually written with some object in mind. One letter remarks that he was "in the broke class," and a week later, "Yes, I am certainly broke. Other than that I am not down and out." Just as in the old days, he wrote busily to Hodge, now head of the Southwest Museum in Los Angeles, asking him for a list of subscribers to *The North American Indian*, addresses of old supporters, and a copy of *Hodge's Handbook of the American Indian North of Mexico*. But when it came time to write to his old friend Belle da Costa Greene at the Morgan Library, Curtis had to square accounts:

Much water has passed beneath all bridges since we last exchanged a word or letter. It is years since I have been in New York, and the last time I was there my stay was but for a few days, and to my great regret you were away. It would

have been a real pleasure to have had a chat with you and to express in a feeble way my appreciation of your many kindnesses during some of the trying years of the work.

How many times have I wished that Mr. Morgan might have lived to see completion of the work and know something of its standing as a completed undertaking. Mr. Morgan's generous support of this work was a great service and the world for all time will be indebted to him for making possible this record of the passing of a race.

Following my season in the Arctic collecting final material for volume twenty, I suffered a complete, physical breakdown and for two years was about a 99 percent loss. Ill health and uncertainty as to how I was to solve the problem of the future brought a period of depression which about crushed me. Lacking the courage to do the obvious thing, I fought up and out of the mire of despondency. I am again in a measure physically fit and have much of my old courage back. During the long months of despondency, I could not write to my friends; no one wants to listen to the wail of lost souls, or to the down and outers. I am again writing and hoping that I may do something worth while. Do drop me a line; even a word from my old friends gives me added courage.

Miss Greene noted that Edward Curtis asked no favor of her, but concluded that it was "wiser not to reply," passing the letter on to Kathleen L. Williams, in charge of The North American Indian Corporation. However amicable Curtis's relations had once been with the Morgan family, Mrs. Williams' observations on Curtis's letter reveal that everyone's patience had been strained over money long before the end of the project. According to her, he had written only to open an avenue to Jack Morgan's money. Similar "sad" letters had gotten him nowhere at the bank, and she was unable to "see any other reason he might have written this particular letter."

There's no indication that Miss Greene and Curtis were ever again in contact. He survived this slight, just as he survived the sale in 1935 of the remaining materials for *The North American Indian* to a rare book dealer in Boston. As primary stockholders of the corporation, the Morgan family had invested roughly $400,000 in Curtis's project.

When the North American Indian Corporation liquidated its assets, the Charles Lauriat company bought nineteen unsold

sets, several thousand individual prints, unbound paper, the handmade copper gravure plates, and all copyrights for the sum of $1,000 plus future royalties. The copperplates alone represented an original investment of nearly $100,000. Curtis's original glass-plate negatives, which had been stored in a basement of the Morgan Library, were never shipped to Lauriat, and during World War II they were unwittingly dispersed: some were destroyed, some sold as junk. In Boston, Lauriat found buyers for his nineteen complete sets and then assembled fifty more, supplementing the unbound material with new prints on different paper (mostly for volumes one through twelve), bringing the total number of sets marketed to 291. From time to time, collectors expressed interest in bringing out a new, less expensive edition, but the costs were always too high, and after a time the material was left to sit in the Lauriat basement—just as it had at the Morgan Library.

In the meantime, Curtis needed to support himself. He seems to have worked whenever he wasn't deathly ill, slowing significant improvement to his health. Back in Los Angeles in the autumn of 1932, he wrote to Shell that he had worked so hard in Colorado that he was in very bad shape again: "...seemingly dropped down lower than a snake's belly. Tell the doctor that the condition of my insides is not good but I am now where I can take care of myself and hope to make a real gain." On December 26, 1932, he wrote Shell again, telling him that the President of Mexico had asked him to act as a consulting manager for the government's newly nationalized mining operations in lower California. Admitting that he had been flattered, he thought it best to decline, doubting that he "would be a success in Mexican politics.... I mean to do something in gold mining. I can see no other out.... My gold concentrator equipment has proved a complete success in saving fine gold."

Shell had lived in Seattle until 1924, and he and the Daniels may have known Curtis before his two years in Denver. Curtis and Shell collaborated on several mining ventures: Curtis was to find potentially profitable mines, and Shell to supply the investors. Curtis concentrated his search around Colfax, California, and he spent many seasons there, driving the 450 miles or so north from Los Angeles in his old car as soon as the weather was fine. Whenever he found a new prospect he wrote Shell lengthy, technical, hopeful letters; but time after time something went wrong. Sometimes he went even farther afield, possibly to scout for other mines, and possibly just to do some "hobo wandering," as he called it. An Oregon service station attendant once declined to take his money, saying he was "proud to have filled Bill Cody's gas tank."

Unfortunately, the concentrator was only effective in the tailings dumps of old placer mines, and most of those had been or were then being plowed under or covered up by order of conservation-minded courts. In addition, the gold or zircon mines Curtis found either were purchased out from under him by someone with ready cash or turned out to have structural problems that required the use of heavy and expensive machinery.

He began working on several ideas for publication, including a long article on the history of gold and a popular book about Northwest Coast Indians. But he found himself unable to work as consistently as in the old days. To Mrs. Daniels, of whom he had become very fond, Curtis wrote on December 29, 1932, that he had done no writing since his return to Los Angeles.

Uncertainty, suspense, tummy ache, and the trying state of affairs with friends do not produce worthwhile thoughts.... The first thing I need to do is get something started which will produce the needed food and lodging and conditions being what they are that is not so easy. At least I am not depressed, and am confidant that I will find a way out. Give my regards to Dr. Daniels, tell him I hope some of his patients can pay their bills.[1]

In 1933 the new Commissioner of Indian Affairs, John Collier, publicly criticized some of the statements Curtis made in volume sixteen on the Tewa and Keres Indians, published in 1924. Curtis couldn't afford a trip to Washington to visit the "mad house" but was so concerned about the issue that he spent months writing a defense of his work, strapping his arm to his body so that he could write and type in spite of a new injury to his right shoulder. He did have some belated praise of his work in 1935, when the prominent anthropologist Robert Lowie published *The Crow Indians*:

The only previous account known to me of Crow life as a whole is that by Mr. Edward S. Curtis in his *The North American Indian*, vol. IV, 1909. It is an excellent piece of work and while not written either by or for a professional anthropologist lives up to a high standard of accuracy. The account of the Sun Dance is particularly noteworthy. Unfortunately, the de luxe makeup of the book has precluded wide circulation.

Curtis rarely mentioned *The North American Indian* in his correspondence and even more rarely gave any indication of his feelings about the fact that it had already sunk into obscurity. Writing to Meany about a new manuscript he observed:

Of all books submitted to publishers not one in a hundred are accepted, and of those accepted not one in a hundred prove worth the paper on which they are printed; so why give serious thought to whether a book is published or not? Perhaps its death before its birth would be a desireable outcome—even to the one who wrote it.[2]

Curtis never published another book, nor made any money on any of his mining operations, but "Job with his boils," as he referred to himself, did recover most of his health and good humor. He attributed his improvement not to his doctors but to drinking a special manzanita tea; he gathered the shoots himself in southern Oregon and swore that it stabilized his stomach and intestines after ten years of chronic distress. He didn't dare to tell his doctor in Los Angeles about "the extract. ... he would have just smiled and thought I was nuts."

In 1936 he was well enough to go to South Dakota to work on the film *The Plainsman*, starring Gary Cooper, which, along with a fictionalized Buffalo Bill and General Custer, also featured several hundred Rosebud Sioux and Cheyenne. The film

crew worked in the same area of the Badlands where Curtis had photographed Red Hawk and his men thirty years before as they reenacted battles for *The North American Indian* illustrations. In 1937 and 1938 he spent long seasons working a mine outside Colfax; in the latter year when he and three other men got caught in the woods by the first bad weather, they had to hike the eighteen miles out in knee-deep snow. Despite this and being seventy years old then, he went back to Colfax for at least another three seasons of work.

In 1946 or 1947 he finally settled down on a little farm in Whittier, California, that belonged to Beth and her husband Manford Magnuson. He lived there for a time, raising chickens, ducks, and avocadoes. He was close to all of his children, including his last daughter Katherine, who had come to California after her mother died in 1932.

When Harriet Leitch wrote to Edward Curtis on August 26, 1948, seeking information on *The North American Indian*, he was recovering from a long illness. His letters to her represent the only recorded discussion of his work since it was published—and he indicated he didn't envy anyone the task of "extracting thoughts and information" from the "scrambled data" he provided. Almost as an afterthought, he wrote that the two basic thoughts on which to build his story should be "the value of the published work to posterity and my persistance in carrying on the work."[3]

Edward S. Curtis died of a heart attack on October 19, 1952, at the home of his daughter Beth in Los Angeles. *The New York Times* gave him a seventy-six-word obituary, calling him an authority on the history of North American Indians and mentioning that he was also known as a photographer.

Thirty-three years after his death, the value of his work has yet to be assessed and he has yet to be acknowledged for his Promethean efforts. For the most part, he has been ignored. In 1952 Beaumont Newhall curated an exhibition of images from *The North American Indian* at the International Museum of Photography at George Eastman House—the work's first major show in twenty years—but when Newhall published his definitive *History of Photography* in 1964, he made no reference to Curtis. (He did, however, include him in the fifth edition published in 1982.) The Morgan Library showed 125 of the photogravures in 1972, and yet catalogues of the library's collection do not mention them. The Whitney Museum of American Art owns a set of *The North American Indian*, but when Robert Doty of the Whitney wrote his book on photography he too overlooked the material. No substantial photographic criticism has been undertaken, and Curtis's and Myers' ethnology has gone virtually unexamined and unread.[4] As of 1984, only one master's thesis has been written on Curtis. His name cannot be found in encyclopedias or dictionaries.

Fifteen years ago this astonishing inattention to Curtis's work could reasonably have been attributed to its limited circulation. But many of the images have now been published in other books; and since 1972, when the original copper gravure plates were rediscovered in the basement of Charles Lauriat's bookstore, reprintings have made some of the images available to the public. His work is being purchased by institutions as well as individuals. According to the George Eastman House's *Index to American Photographic Collections*, Curtis ranks seventeenth in the country in terms of the number of collections that own his images. By another yardstick, he is second only to Walker Evans in the number of collections to which his work was added in the 1970s. Curtis has even begun to appear in a few books on photography, motion pictures, and Indian history. Yet despite this increased circulation, he is still overlooked in the organization of major photographic exhibitions, and few commentators seem aware of the true caliber and scope of his efforts.

That Curtis's series has yet to be definitively assessed, or even fully explored, seems now a matter of its staggering dimensions and its intermingling of disciplines. Lost in the gap between art and science, Curtis has not been evaluated for his successes in bridging different worlds but instead has been criticized for not confining himself to one field. In a characteristic reaction, one critic noted, "If Curtis's photographs were true documents, they would more closely resemble Dorothea Lange's photographs of migrant workers in the 1930s instead of proud warriors." Perhaps the biggest difference between Curtis and other photographers of Indians lies precisely here: no one else made Indian subjects look as beautiful, as proud, and as powerful.

He intended his images to be dramatic; he wanted to rouse his future audiences to feel respect and concern for a culture other than their own. In looking at his photographs, one can sense not only the trust between subject and artist but a complicity between them in the creation of a romantic image, some shared dream of pride and freedom. The danger of idealizing native Americans is today far less than the danger they may suffer at the hands of people in a position to help them protect their mineral, water, and timber rights. However illusory Curtis's old dream of Indians, its vitality and power still draws in new dreamers. He insisted that sentiment was no substitute for knowledge, but he of all people knew that it is in dreams that obligation first begins.

PLATES

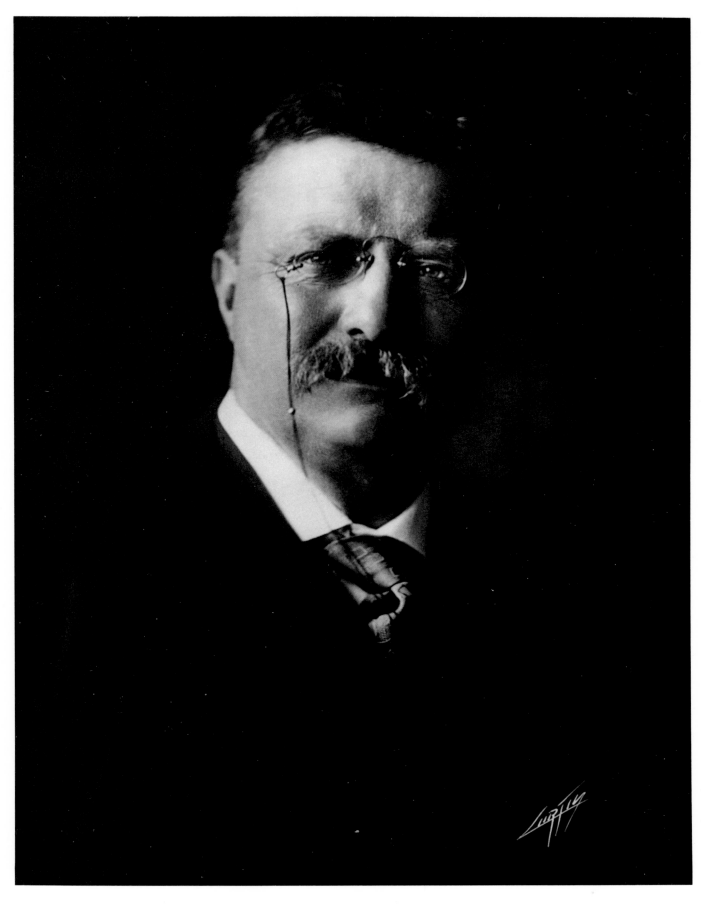

THEODORE ROOSEVELT, 1904.

SOLOMON PECK SMITH, circa 1910. Example of Curtis Studio portraiture.

CLINTON STRONG HARLEY, circa 1910.

HARLEY CHILDREN, circa 1910.

KATRINA HARLEY, circa 1908.

MABEL VICTORIA GARDINER, circa 1910.

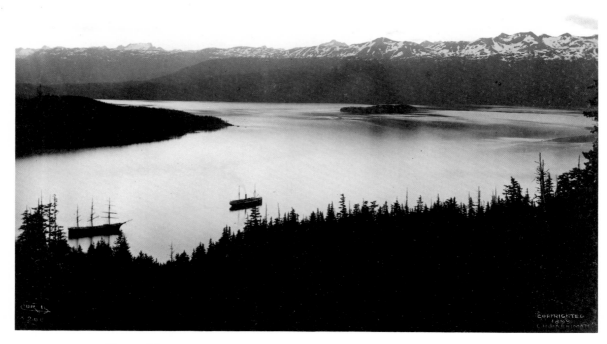

ORCA HARBOR AT 11 P.M., 1898. From the Harriman Alaska Expedition.

ARENARIA—HALL ISLAND, 1898. From the Harriman Alaska Expedition.

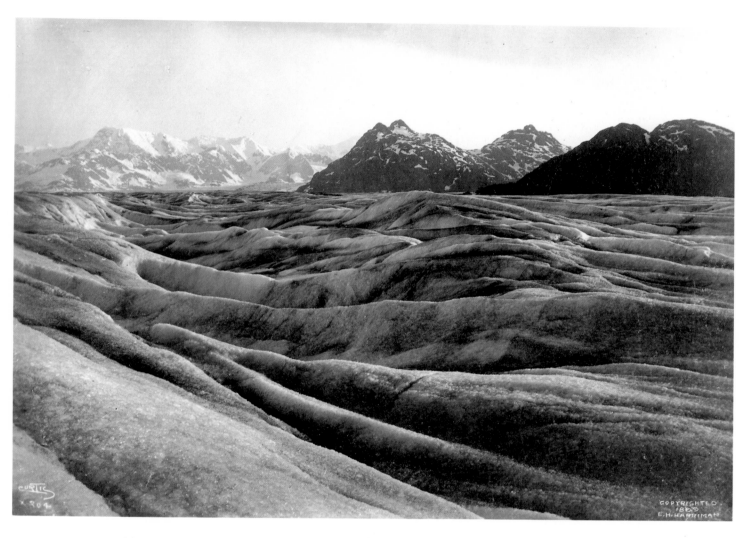

THE WAY TO THE NUNATAK—RIDGED ICE, 1898. From the Harriman Alaska Expedition.

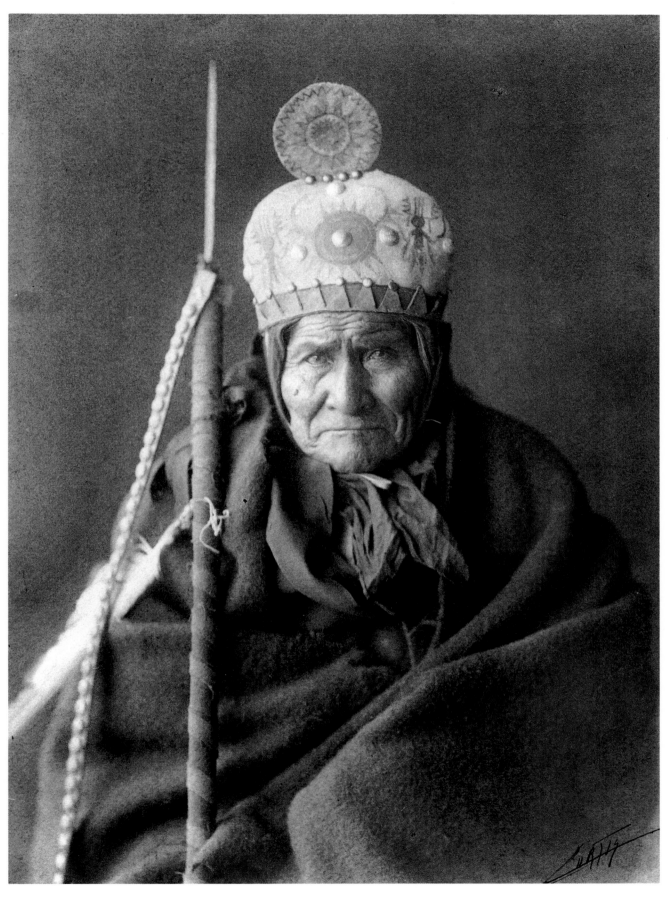

GERONIMO—APACHE, 1905.

THE VANISHING RACE—NAVAHO, 1904.

SUNSET IN NAVAHO–LAND, 1904.

STORY-TELLING—APACHE, 1903.

THE STORM—APACHE, 1903.

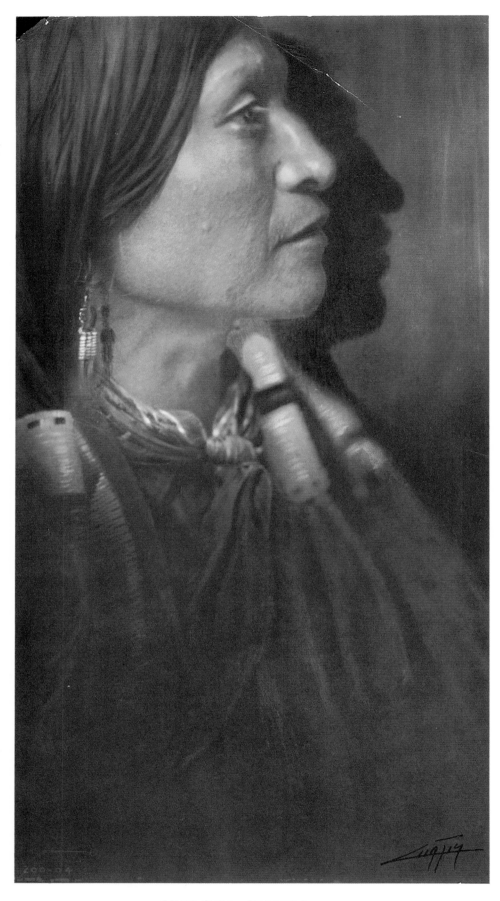

VASH GON—JICARILLA, 1904.

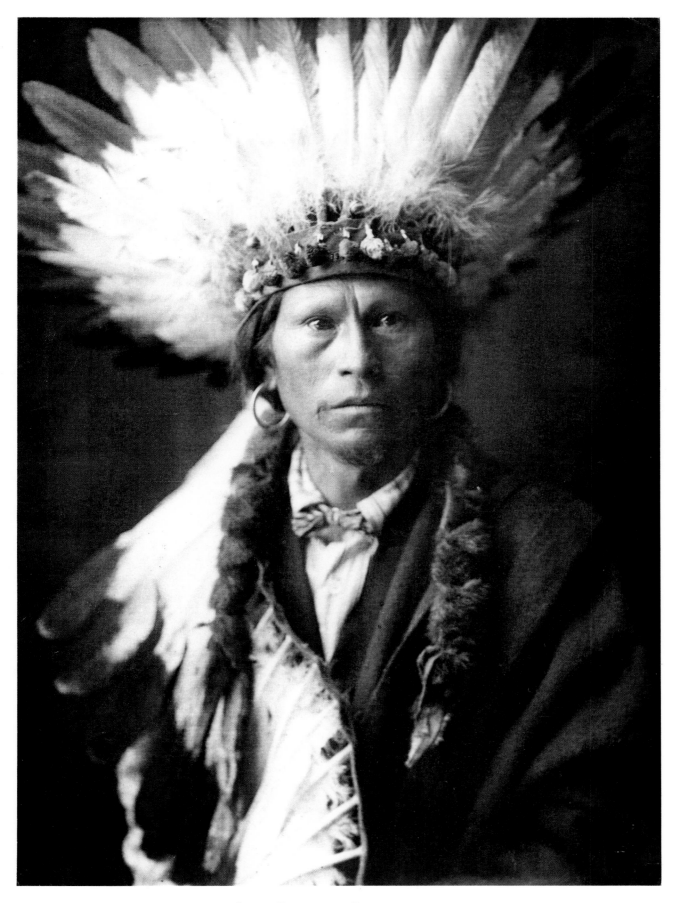

CHIEF GARFIELD—JICARILLA, 1904.

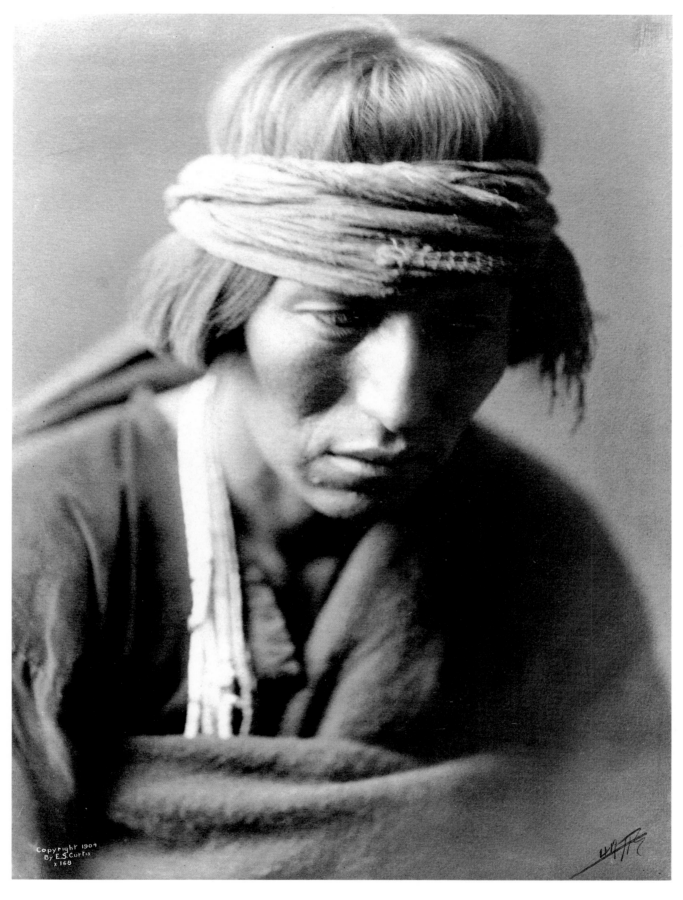

HASTOBÍGA—Navaho Medicine-Man, 1904.

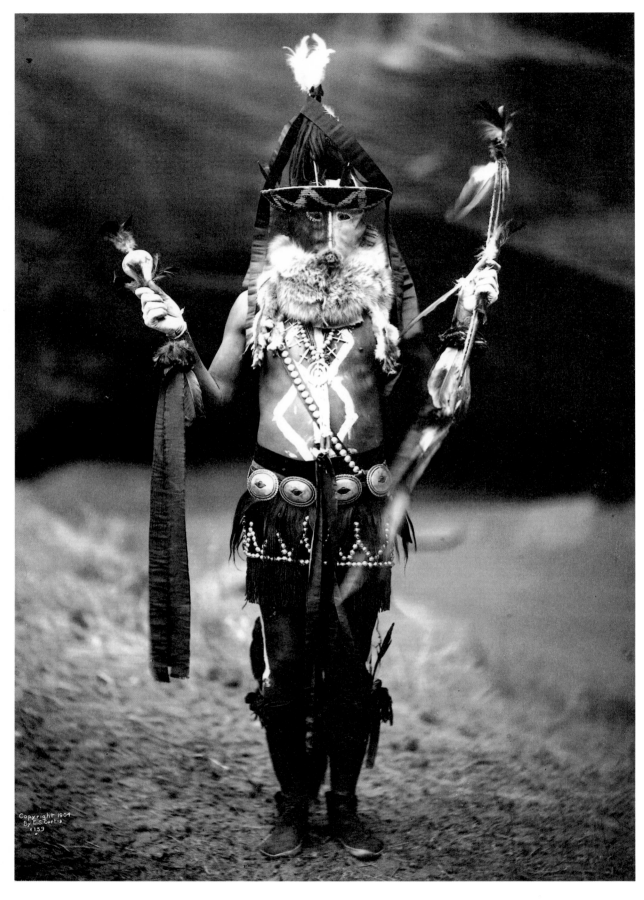

ZAHADOLZHÁ—NAVAHO, 1904. A benevolent spirit that lives in the water.

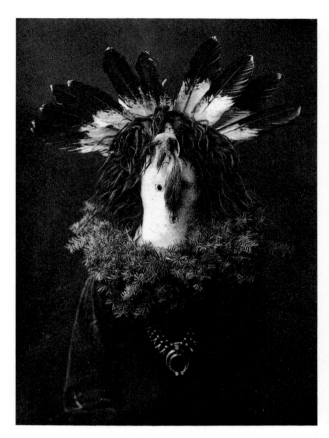

HASCHÓGAN—NAVAHO, 1904. The House God.

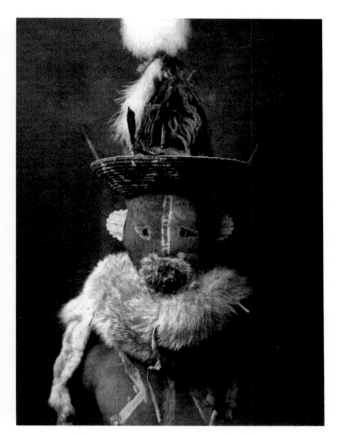

ZAHADOLZHÁ—NAVAHO, 1904.

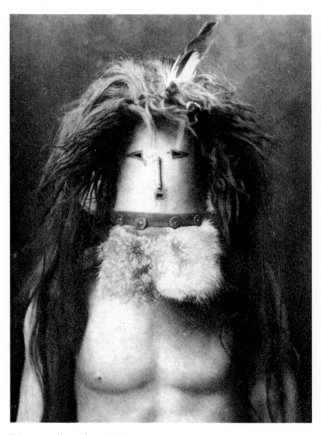

HASCHĔBAÁD—NAVAHO, 1904. A benevolent female deity impersonated by men.

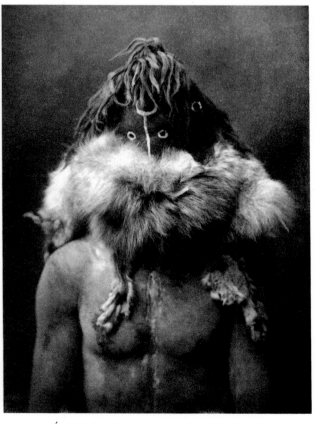

HASCHÉ̆ZHĬNĬ—NAVAHO, 1904. Black God, the God of Fire.

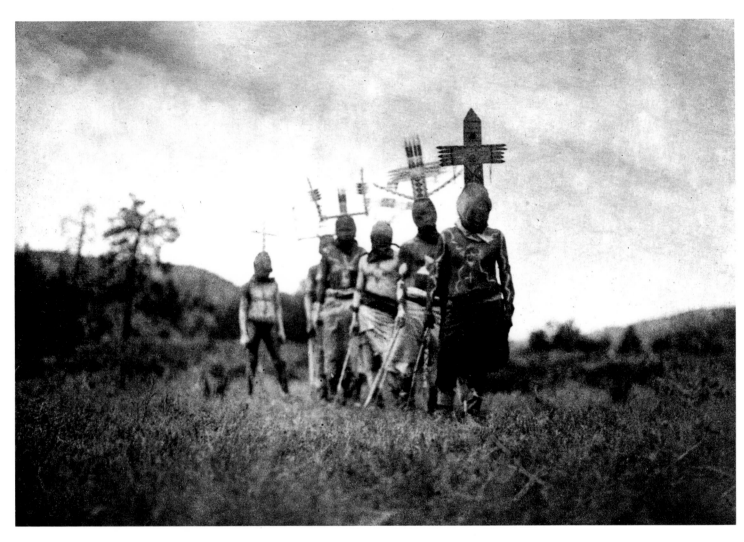

APACHE *GAŬN*, 1906.

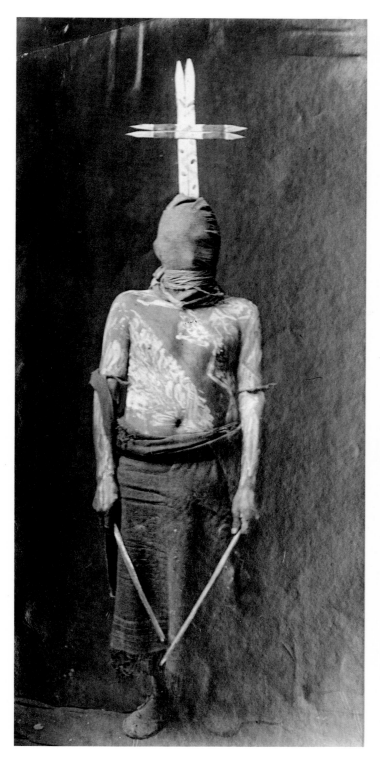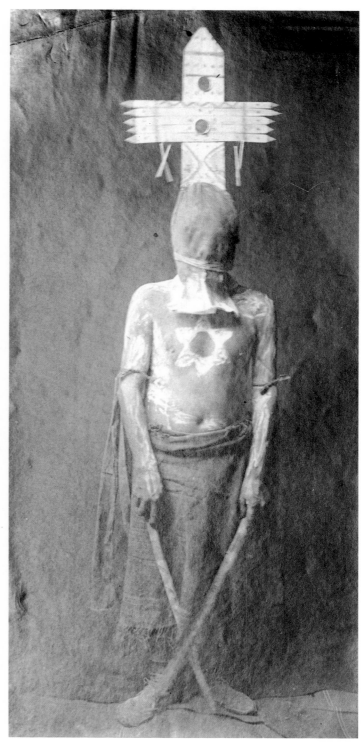

GAŬN DANCERS, 1906.

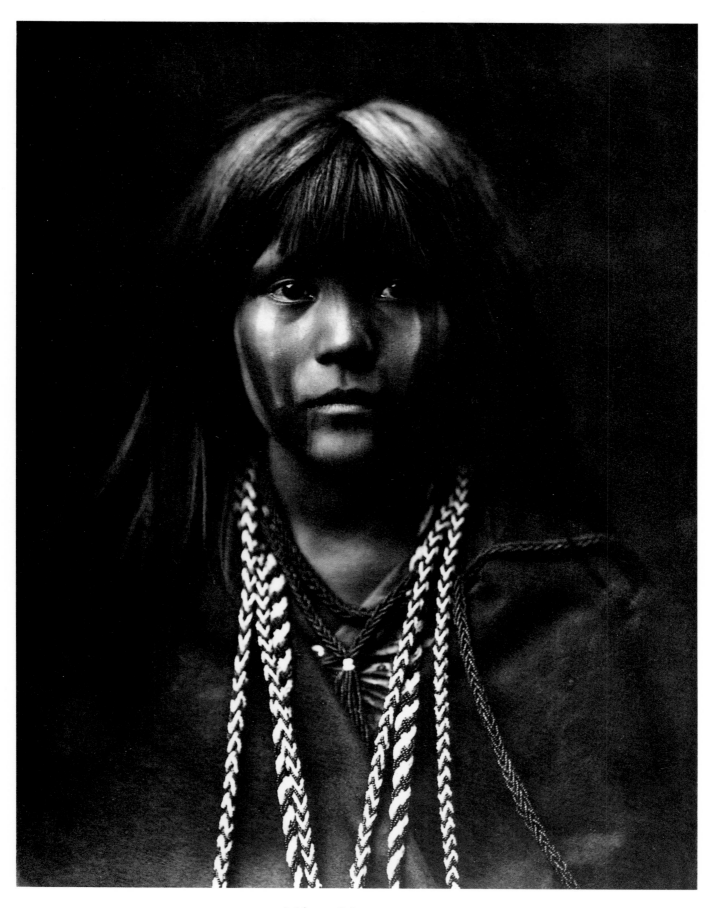

MÓSA—MOHAVE, 1903.

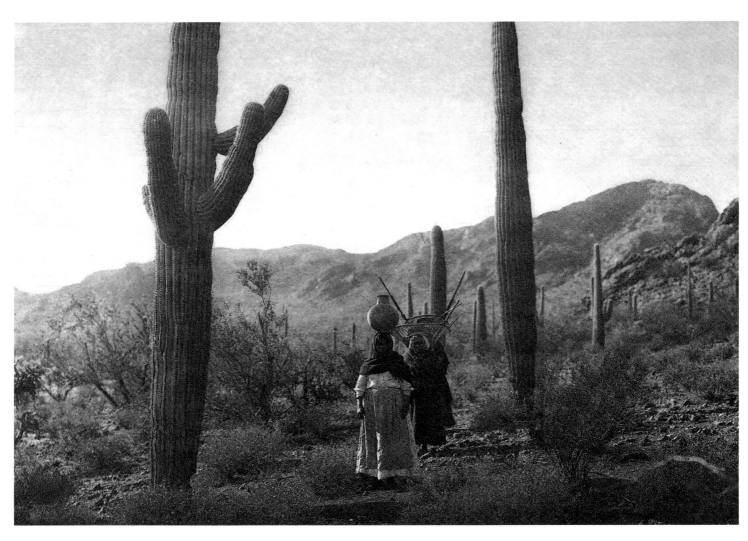

HÁSĔN HARVEST — QAHÁTĬKA, 1907.

PAPAGO PRIMITIVE HOME, 1907.

ELK HEAD, AND THE SACRED PIPE BUNDLE, 1907.

IN THE BAD LANDS, 1904.

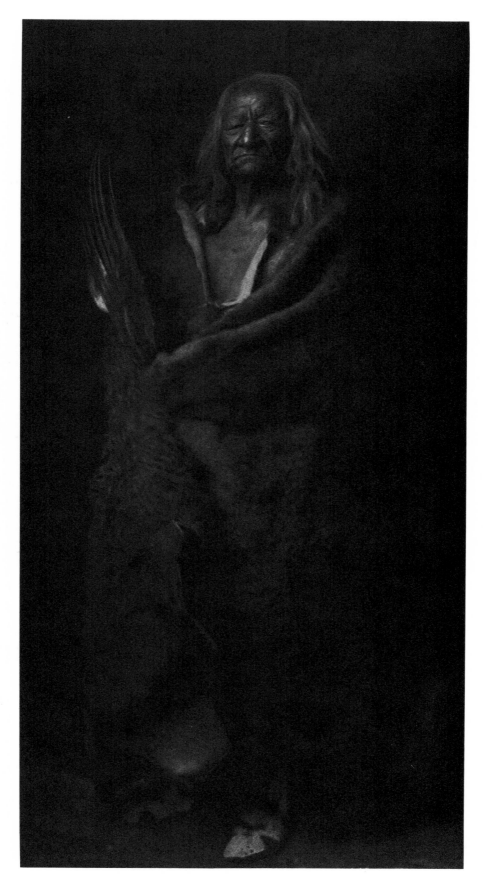

BLACK EAGLE—ASSINIBOIN, 1908.

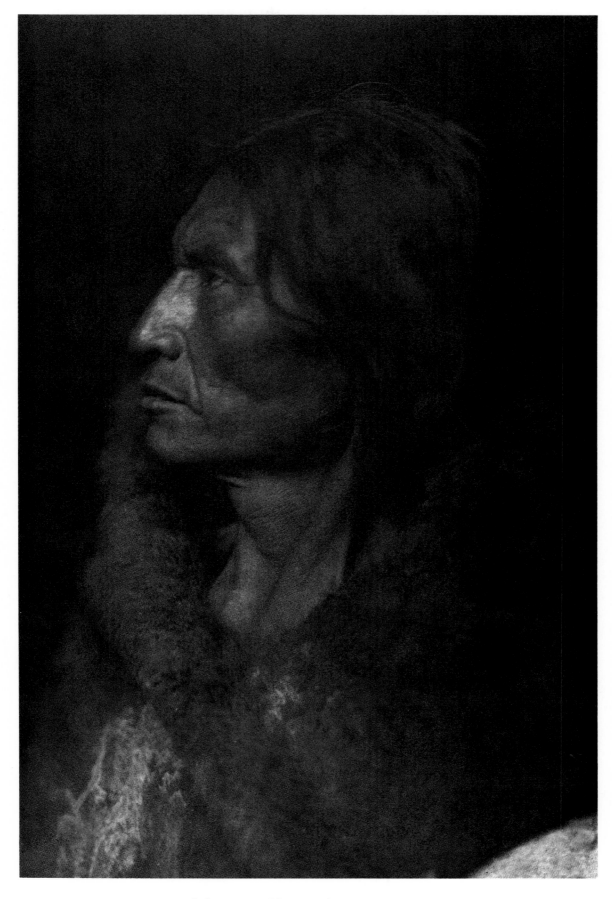

MOSQUITO HAWK — ASSINIBOIN, 1908.

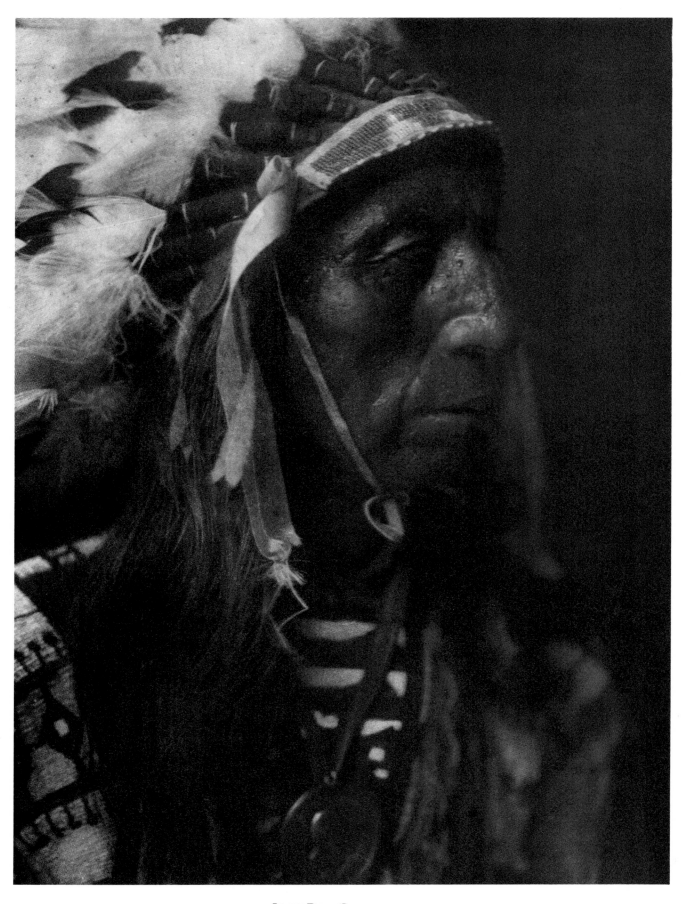

JACK RED CLOUD, 1907.

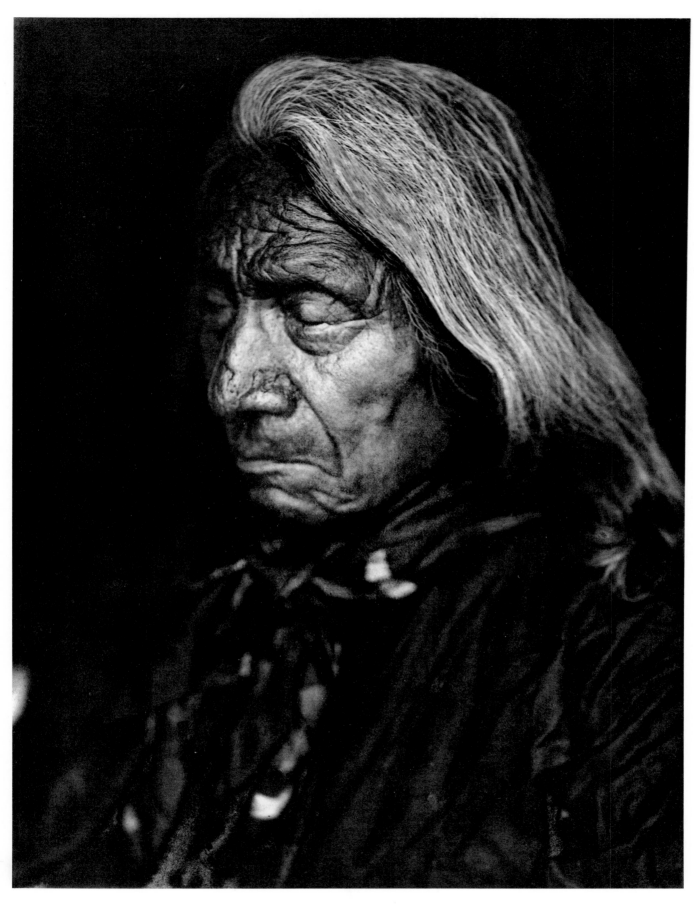

RED CLOUD—OGALALA, 1905.

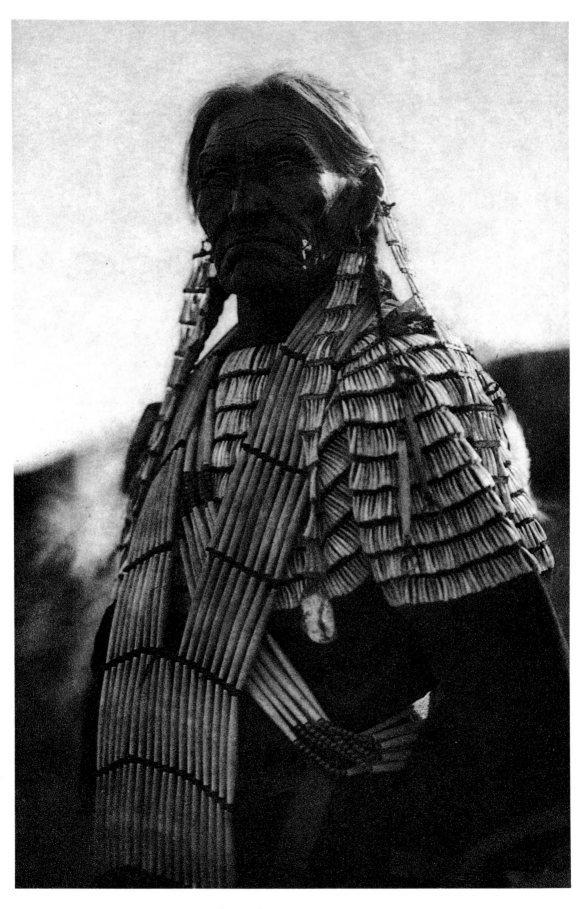

SLOW BULL'S WIFE, 1907.

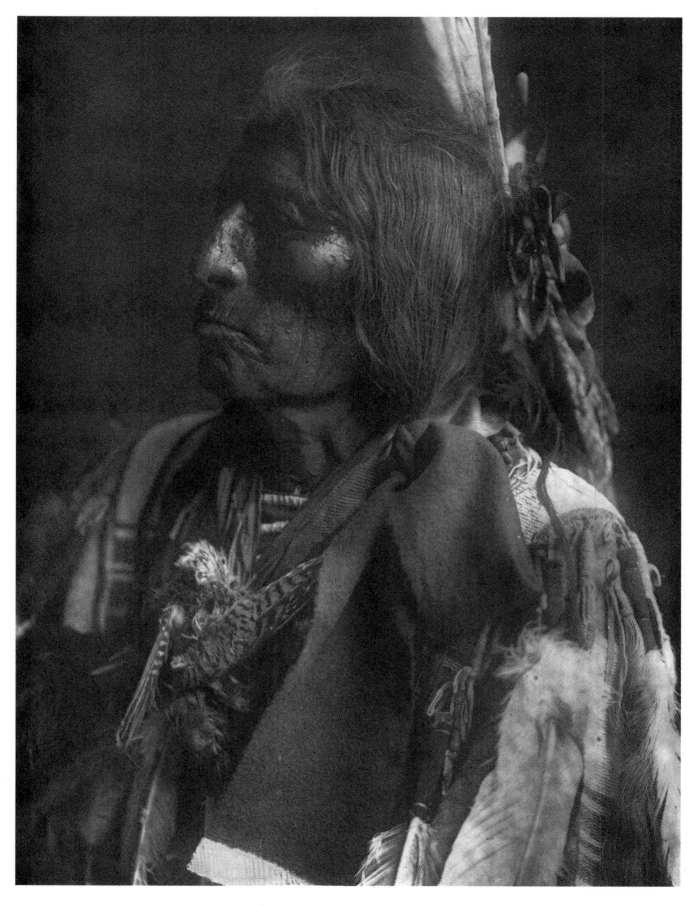

SLOW BULL—OGALALA, 1907.

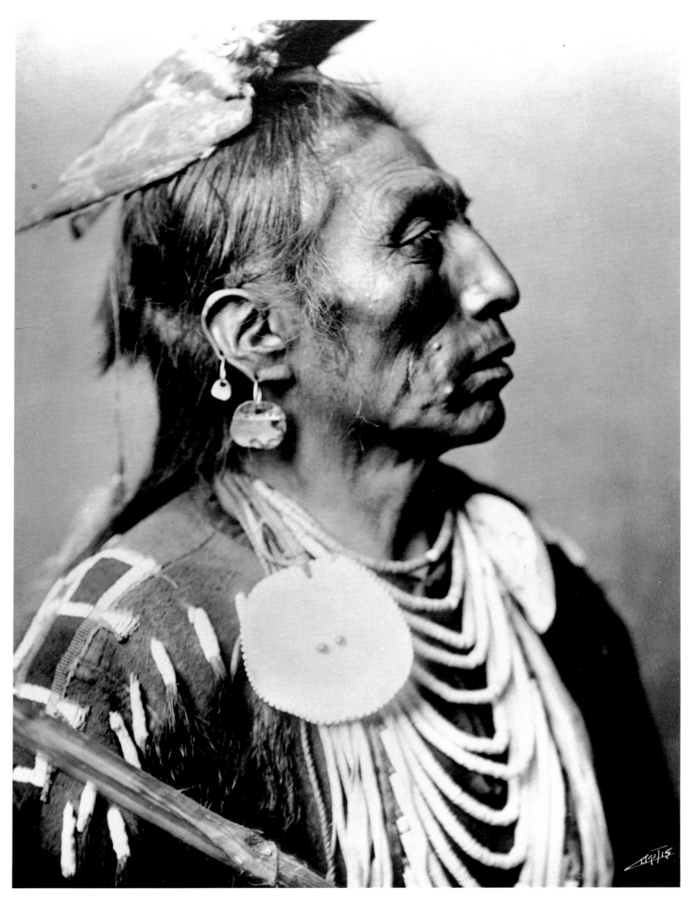

MEDICINE CROW—APSAROKE, 1908.

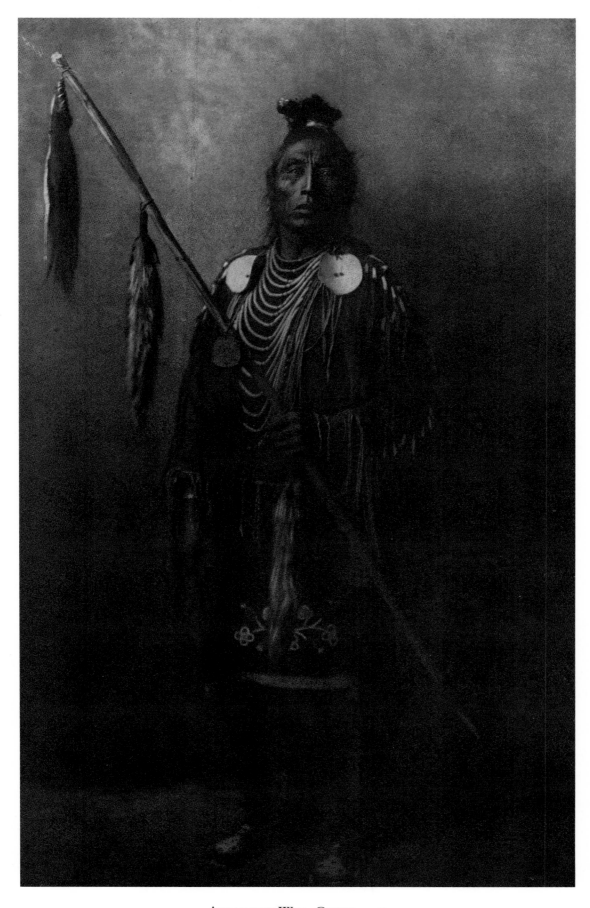

APSAROKE WAR–CHIEF, 1908.

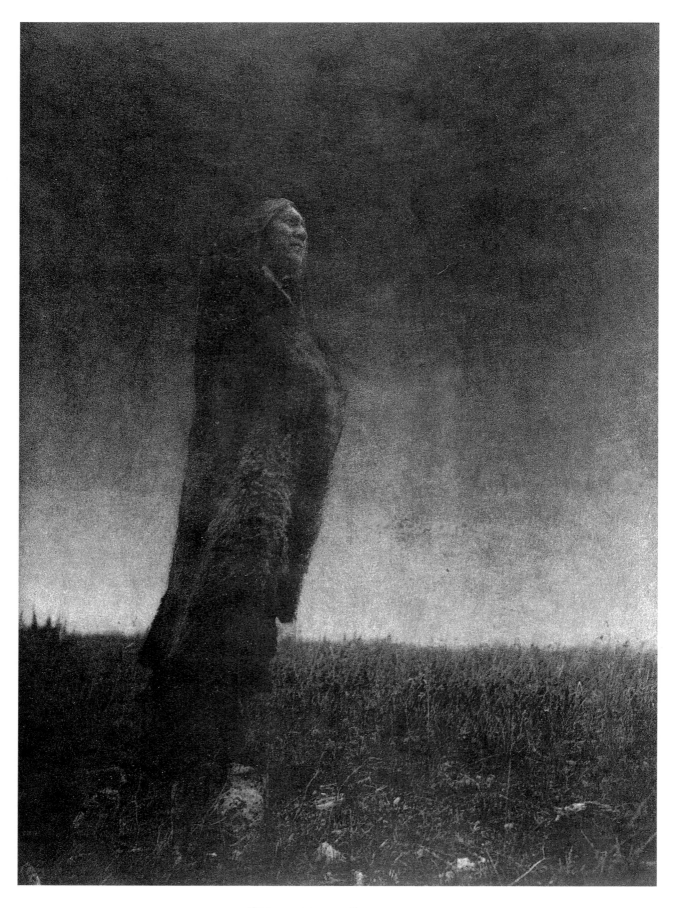

CRYING TO THE SPIRITS, 1908.

WINTER—APSAROKE, 1908.

A Burial Platform—Apsaroke, 1908.

On the Banks of the Missouri—Mandan, 1908.

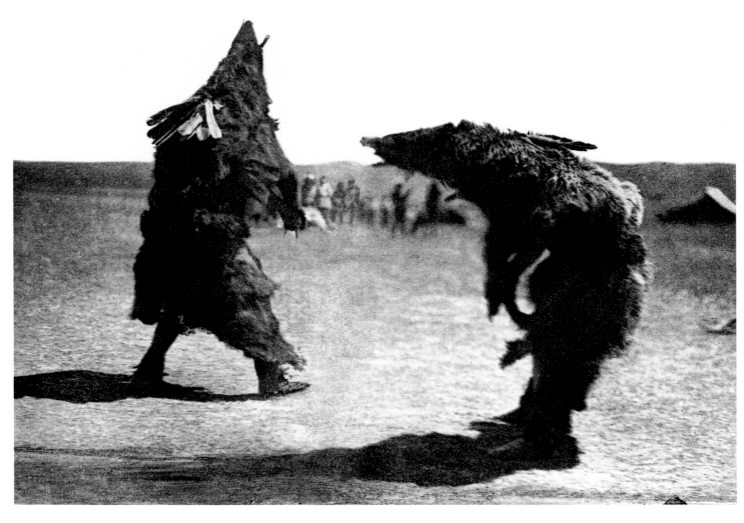

ARIKARA MEDICINE CEREMONY—THE BEARS, 1908.

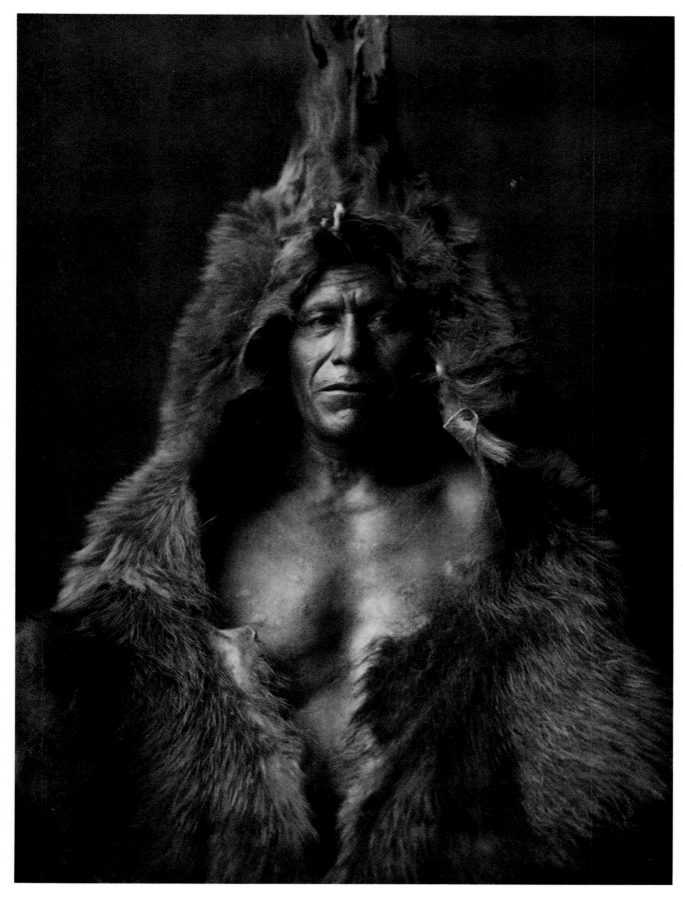

BEAR'S BELLY—ARIKARA, 1908.

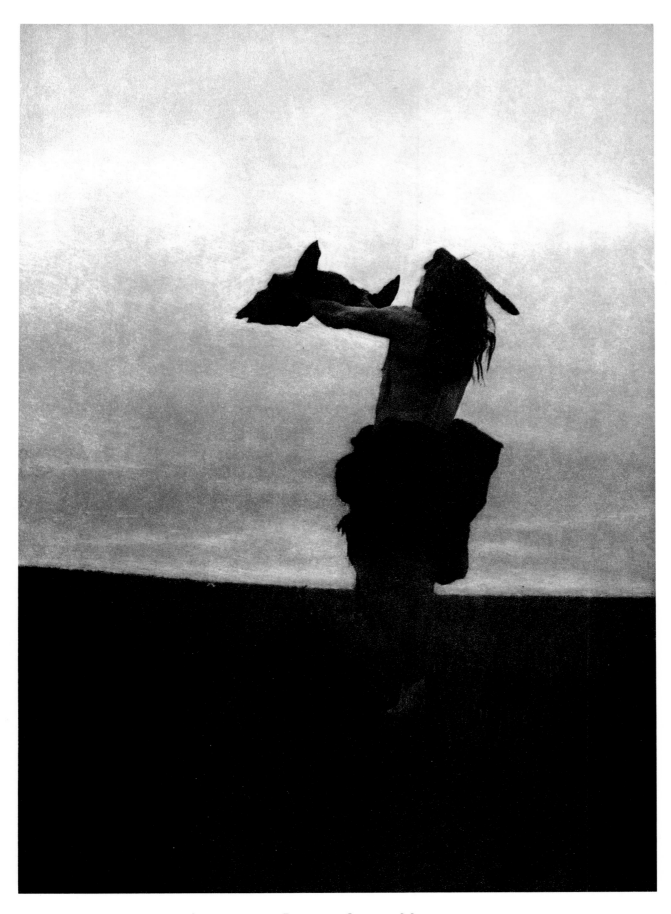

OFFERING THE BUFFALO-SKULL — MANDAN, 1908.

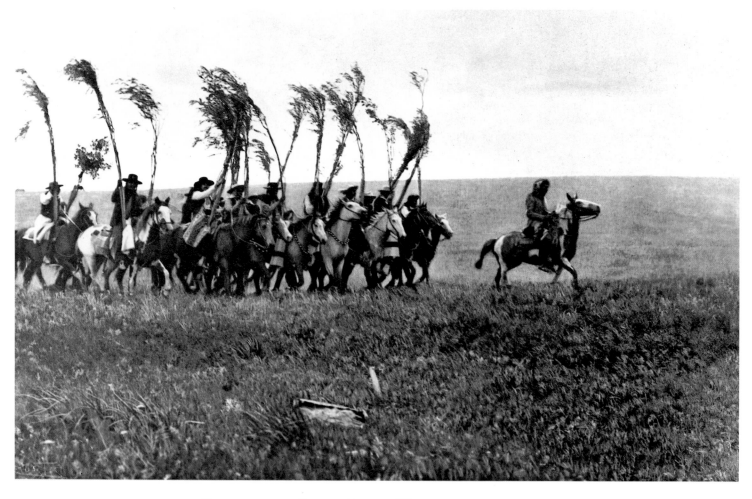

BRINGING THE SWEAT–LODGE WILLOWS — PIEGAN, 1900.

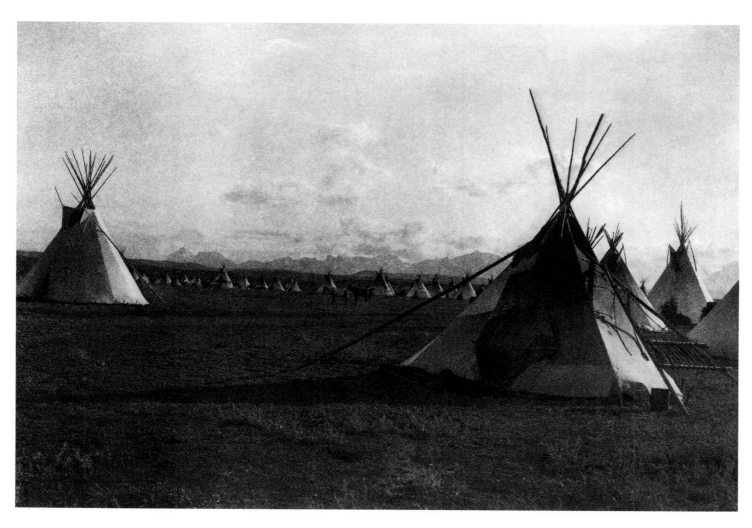

PIEGAN ENCAMPMENT, 1900.

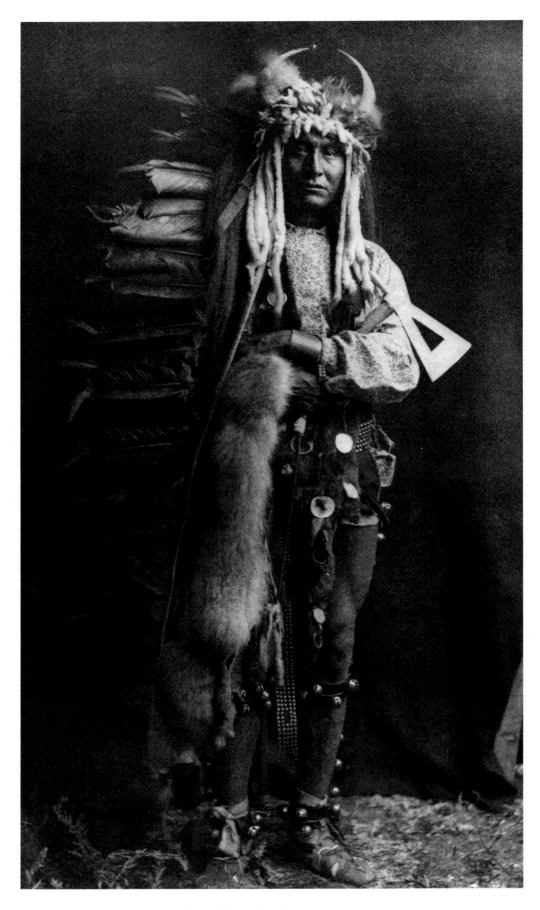

IRON BREAST—PIEGAN, 1900.

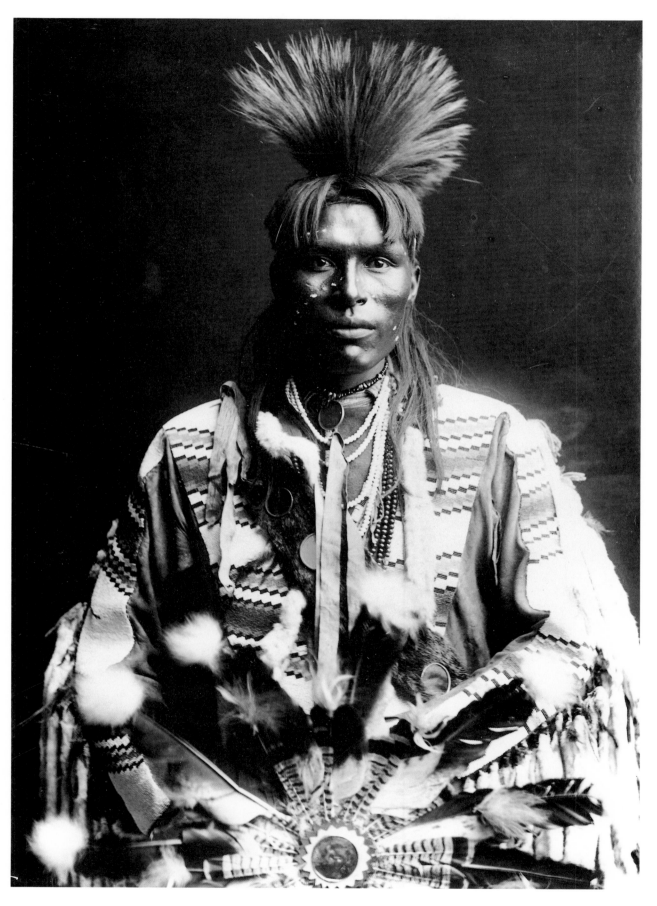

A PIEGAN DANDY, 1900.

WAITING IN THE FOREST—CHEYENNE, 1910.

SUN DANCE PLEDGERS—CHEYENNE, 1911.

TWO MOONS—CHEYENNE, 1910.

KUTENAI CAMP, 1909.

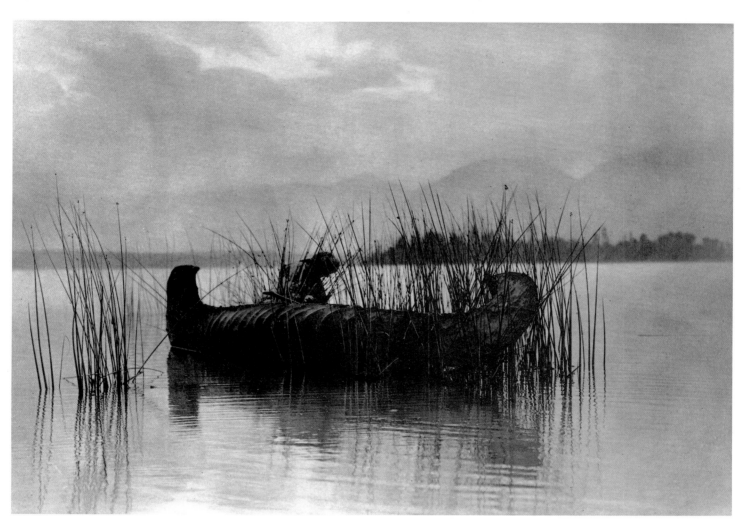

THE RUSH GATHERER—KUTENAI, 1910.

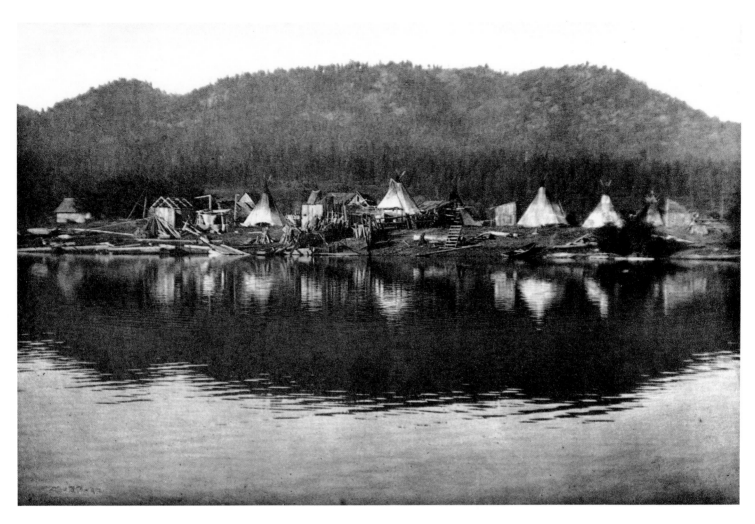

KALISPEL VILLAGE, 1910.

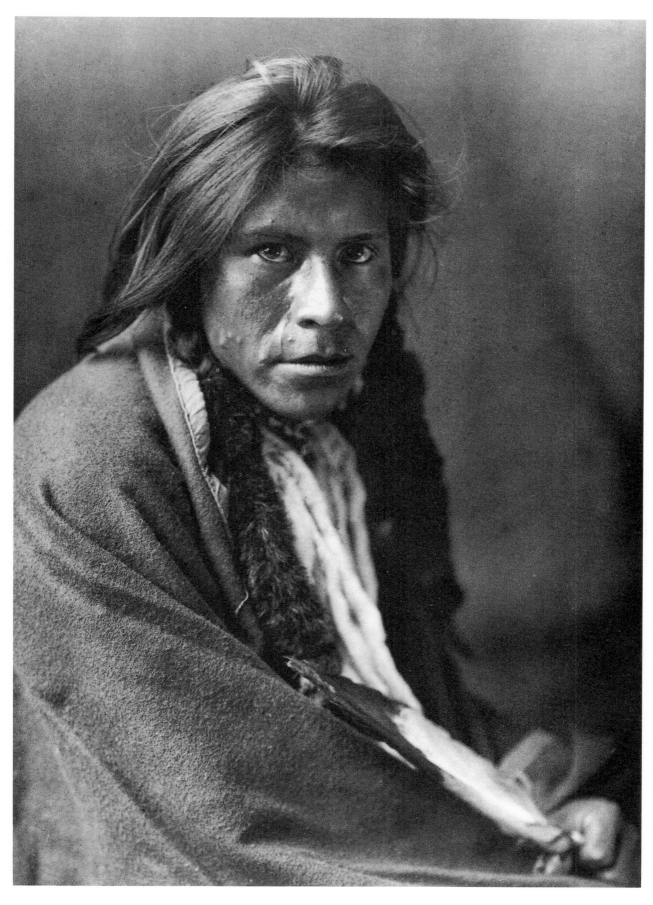

KALISPEL TYPE, 1910.

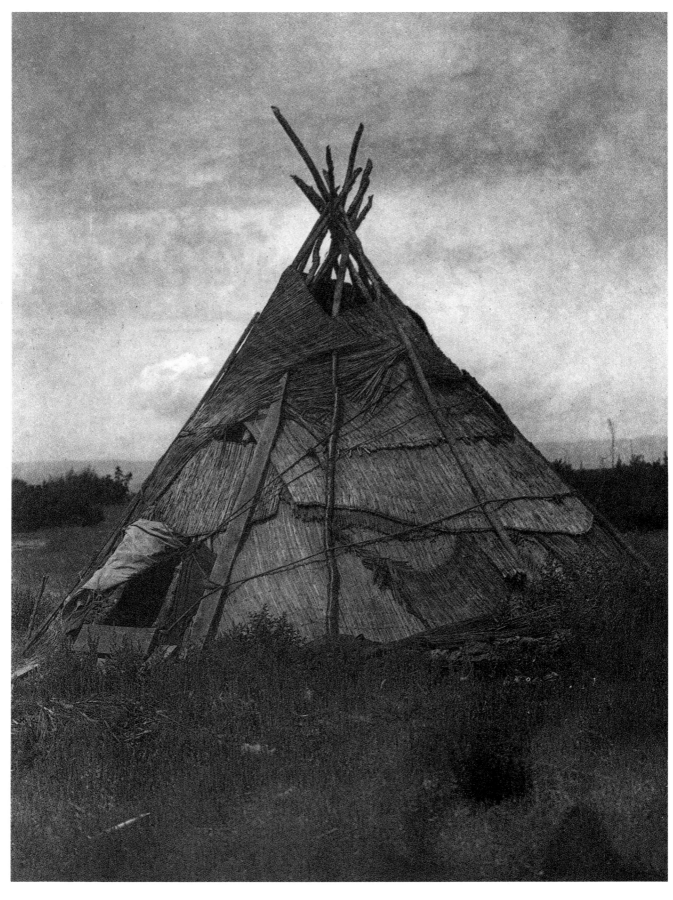

MAT LODGE—YAKIMA, 1910.

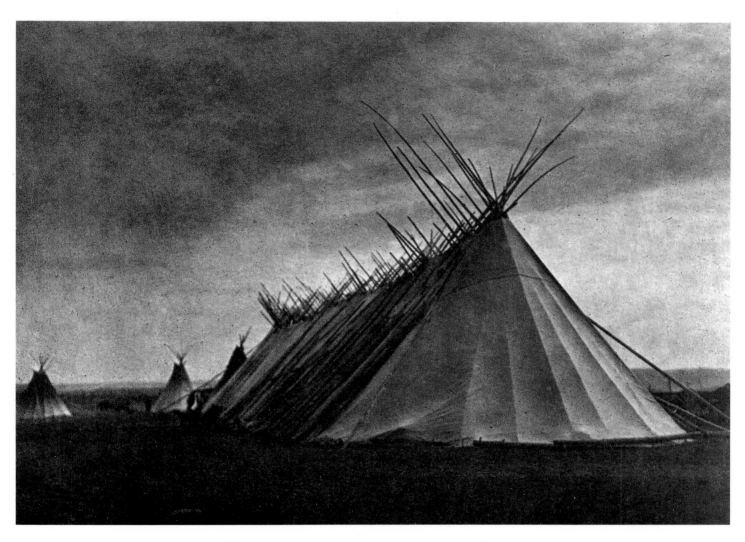

JOSEPH DEAD FEAST LODGE—NEZ PERCÉ, 1905.

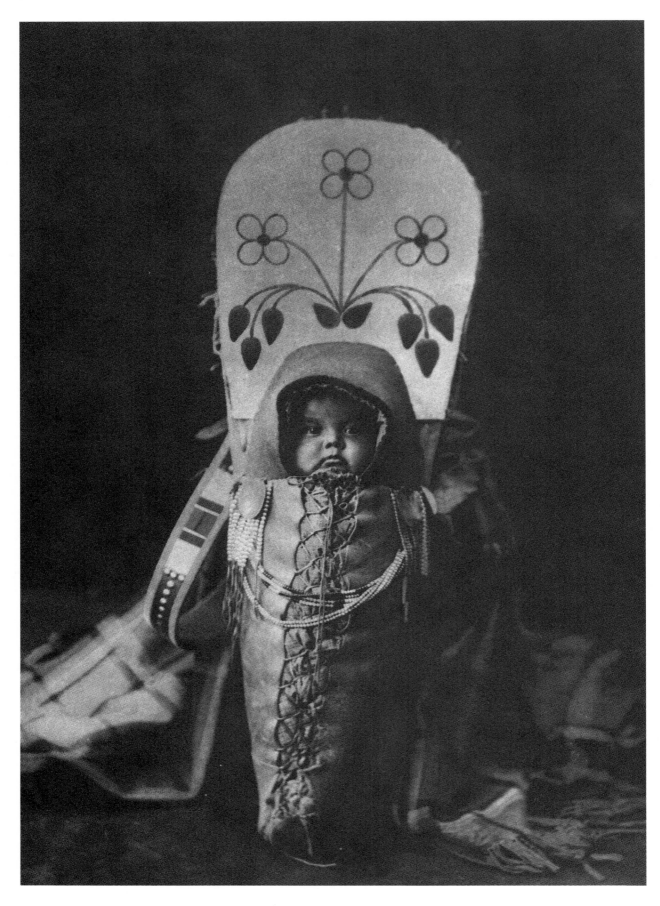

NEZ PERCÉ BABE, 1900.

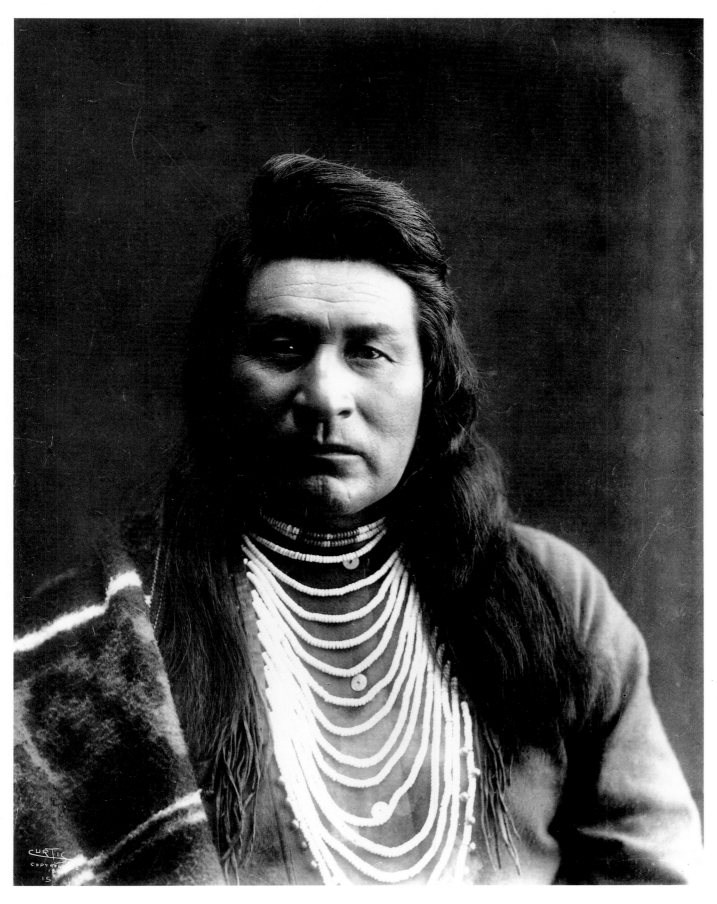

TYPICAL NEZ PERCÉ, 1899.

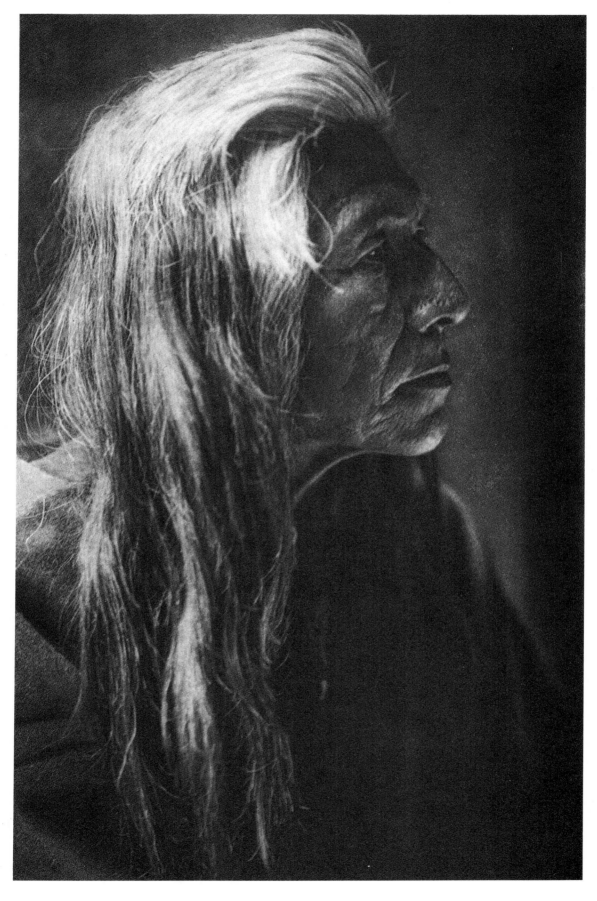

GRIZZLY–BEAR FEROCIOUS — NEZ PERCÉ, 1910.

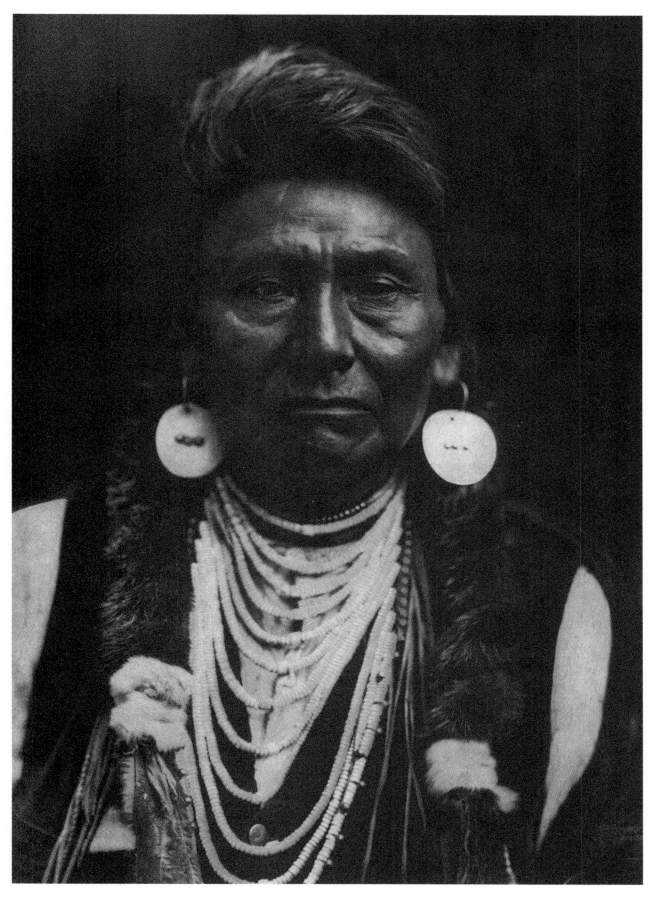

CHIEF JOSEPH—NEZ PERCÉ, 1903.

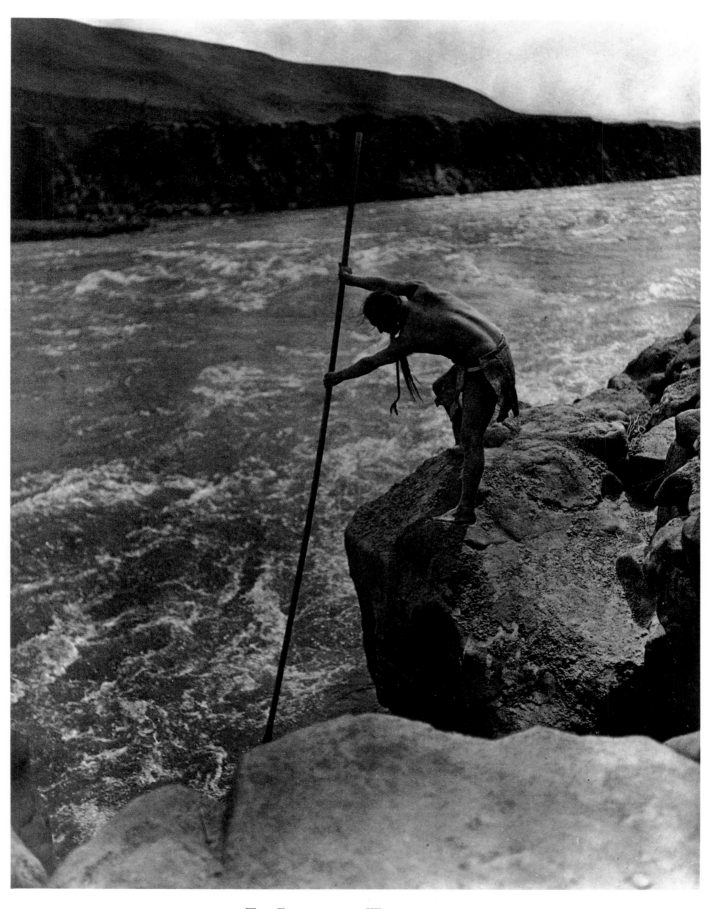

THE FISHERMAN—WISHHAM, 1909.

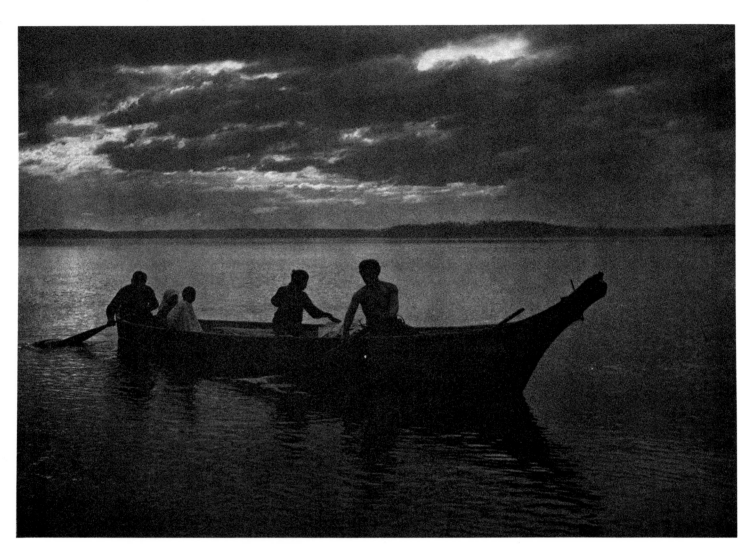

HOMEWARD, 1898.

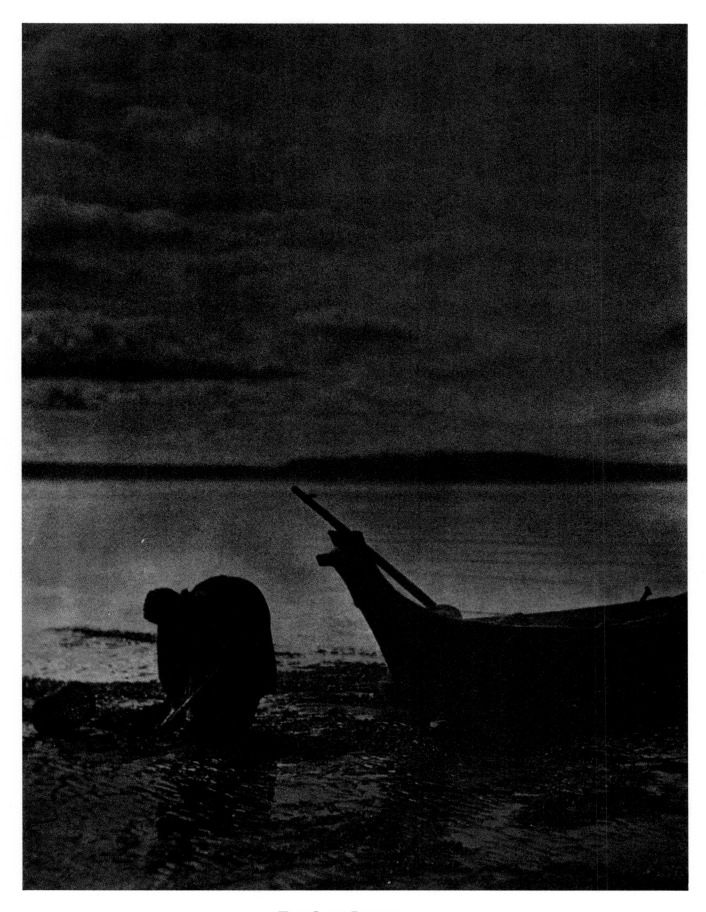

THE CLAM DIGGER, 1898.

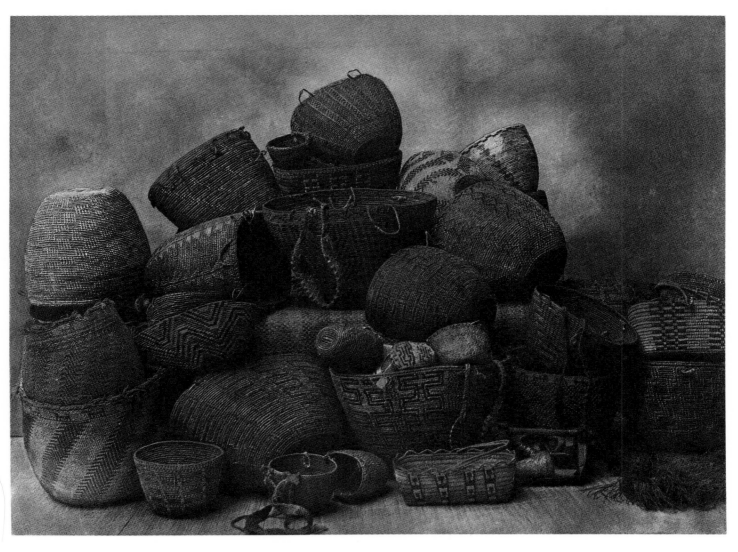

PUGET SOUND BASKETS, 1912.

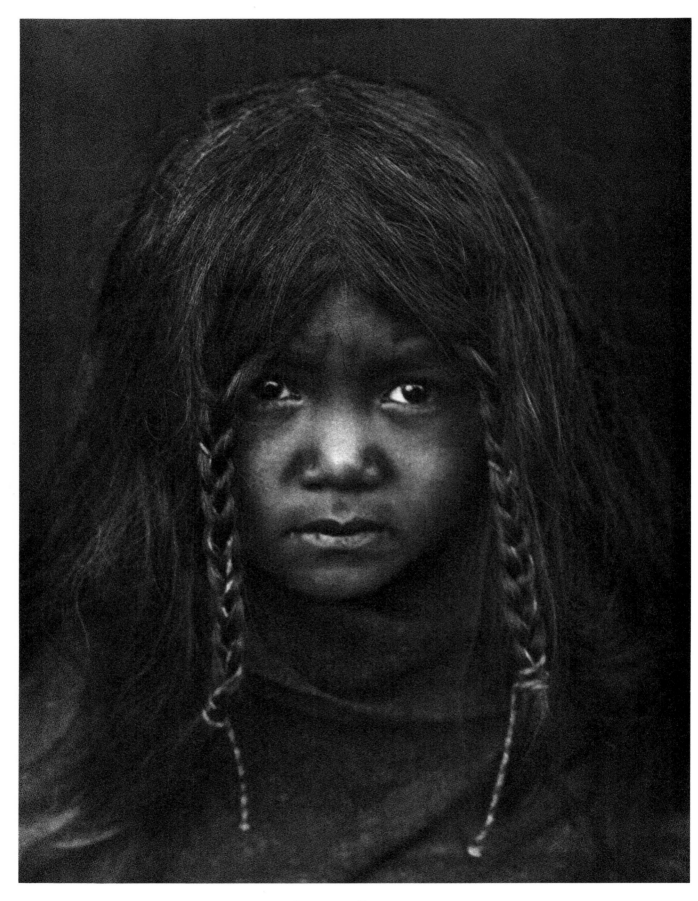

QUILCENE BOY, 1912.

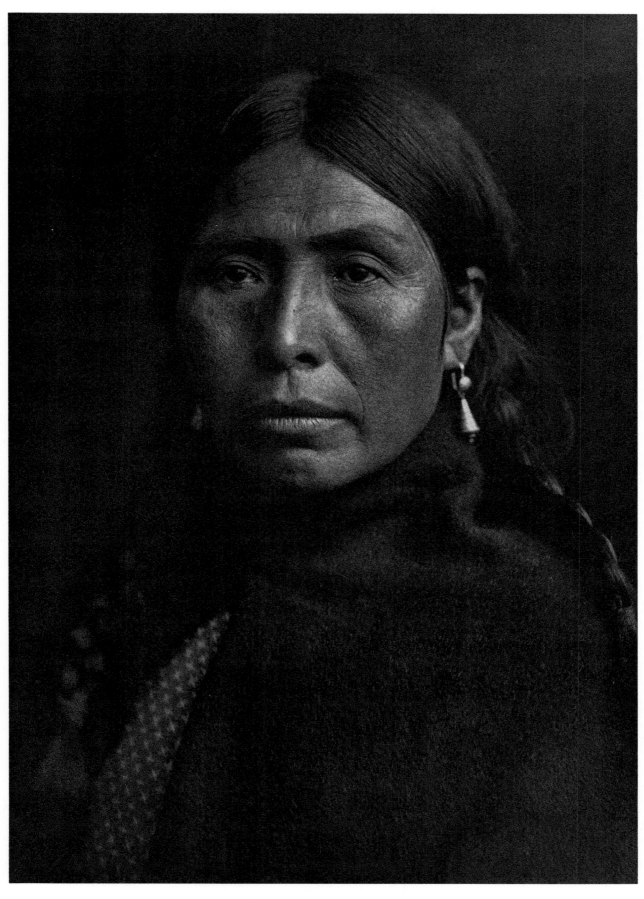

LUMMI TYPE, 1899.

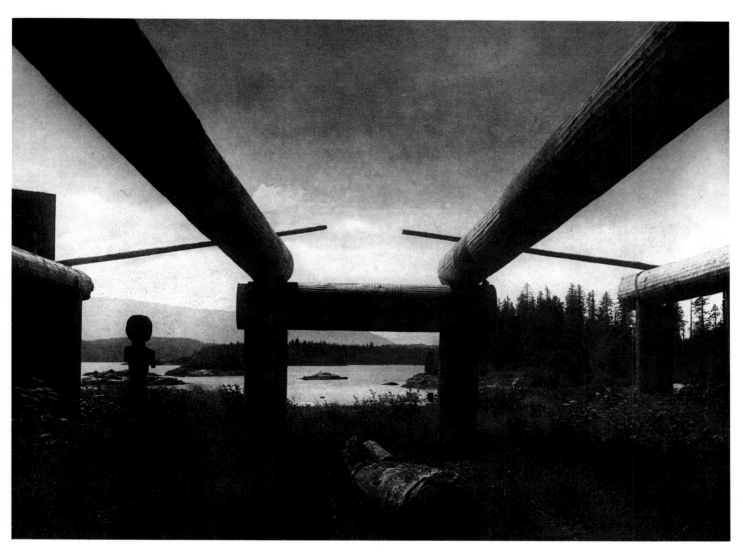

KWAKIUTL HOUSE-FRAME, 1914.

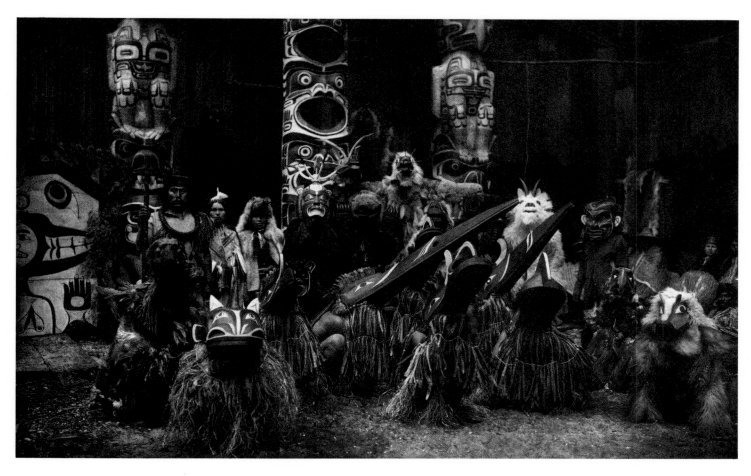

MASKED DANCERS—QÁGYUHL, 1914.

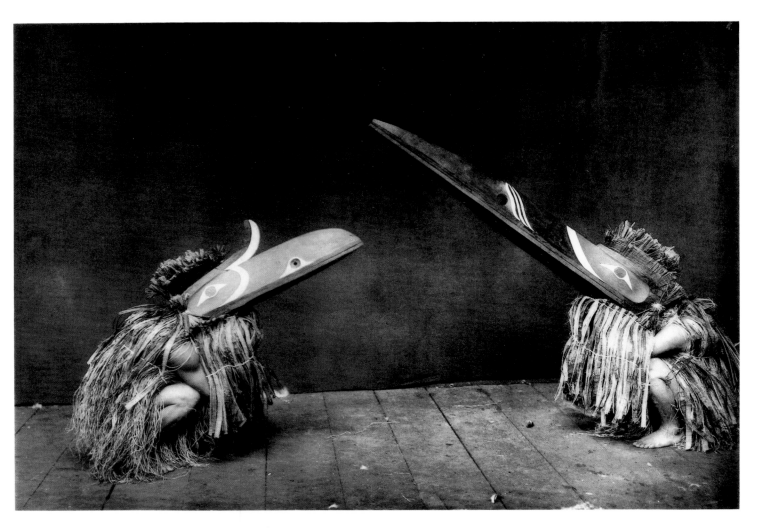

KÓTŜUIS AND HÓHHUQ—NAKOAKTOK, 1914.

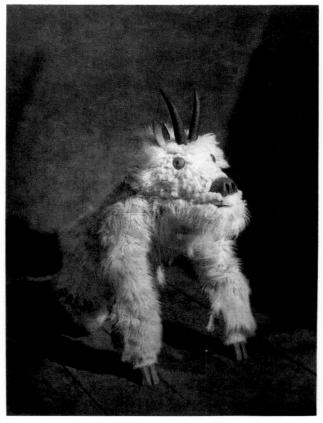

TÁWIH̱YILAHÎL—QÁGYUHÎL, 1914. Mountain goat.

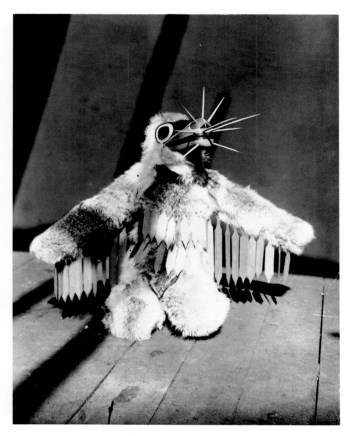

HÁMASĬLAHÎL—QÁGYUHÎL, 1914. Wasp.

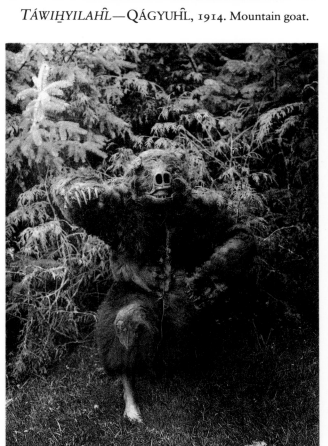

NÁNE—QÁGYUHÎL, 1914. Grizzly bear.

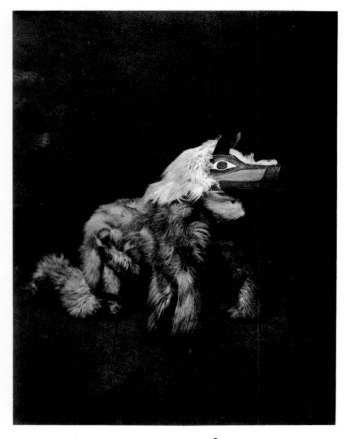

WÁSWASLIKYI—QÁGYUHÎL, 1914. Dog.

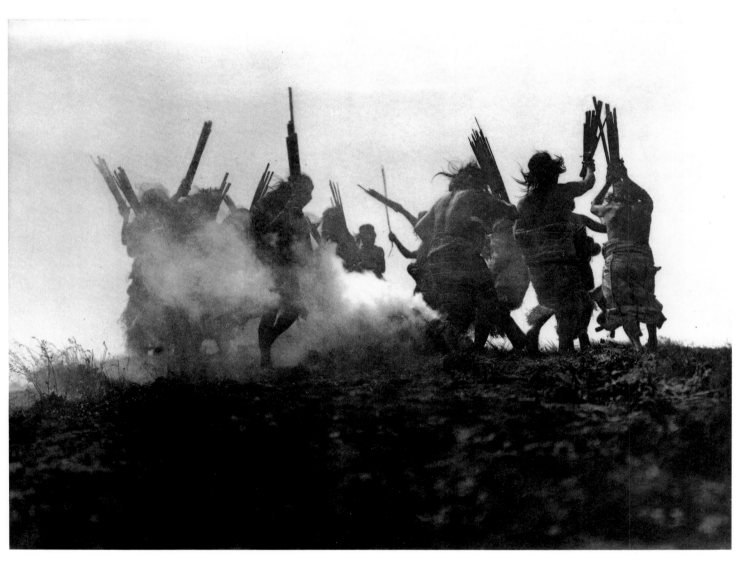

DANCING TO RESTORE AN ECLIPSED MOON—QÁGYUHÎL, 1914.

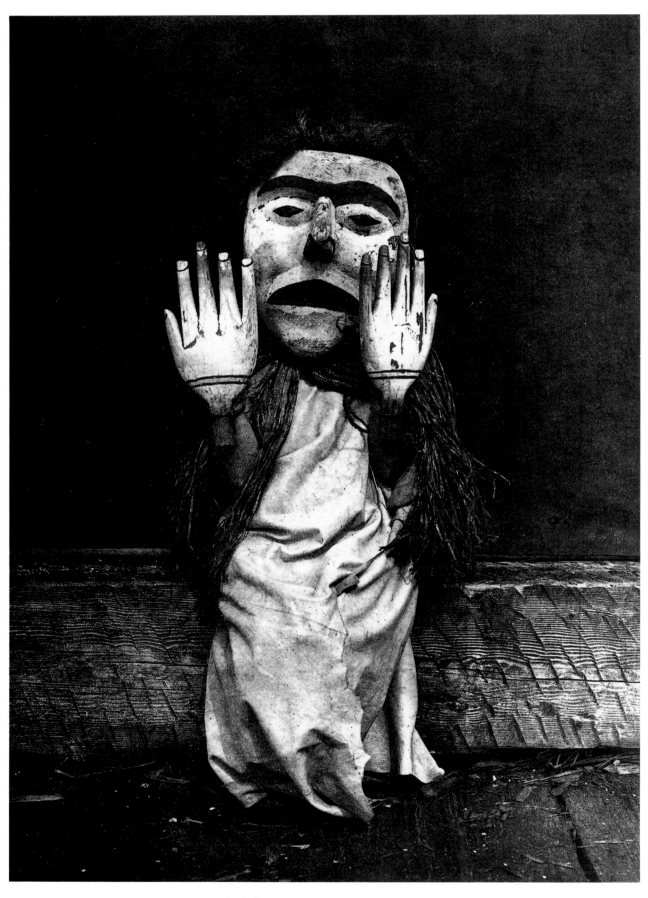

NÚHÎLĬMKILAKA — Koskimo, 1914.

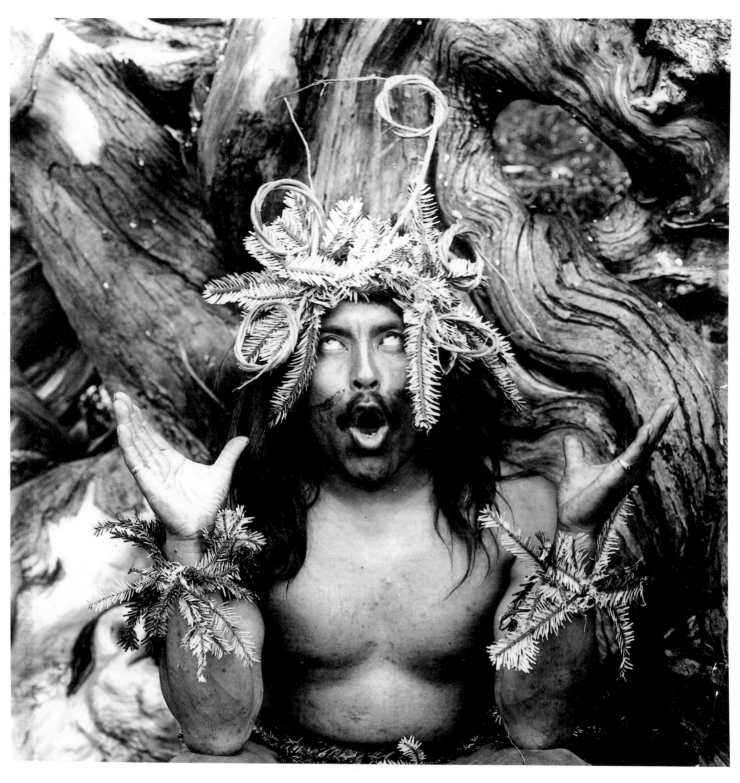

HAMATSA EMERGING FROM THE WOODS—KOSKIMO, 1914.

A HAIDA CHIEF'S TOMB AT YAN, 1915.

OLD HOUSES—NEAH BAY, 1915.

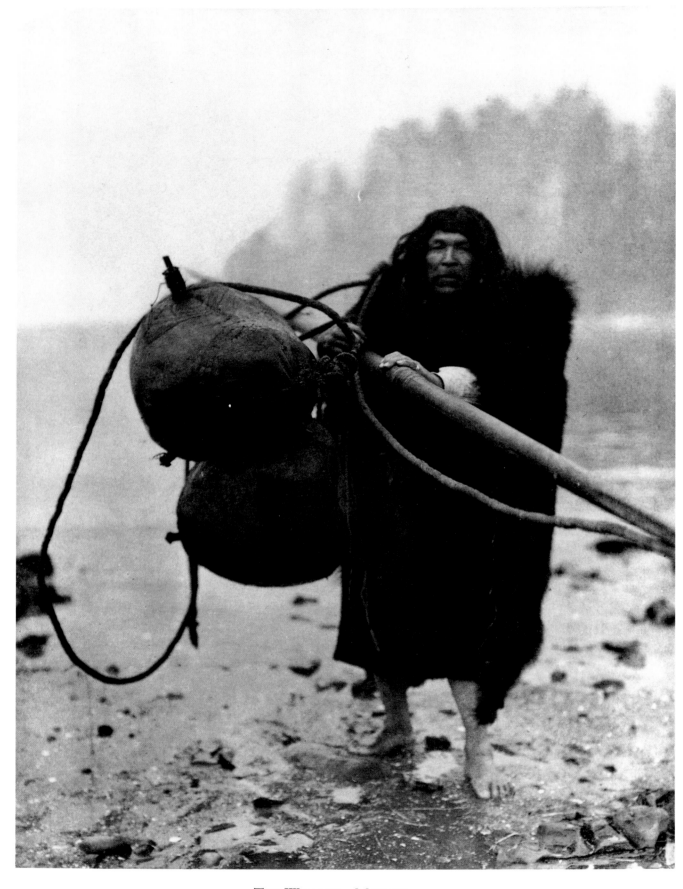

THE WHALER—MAKAH, 1915.

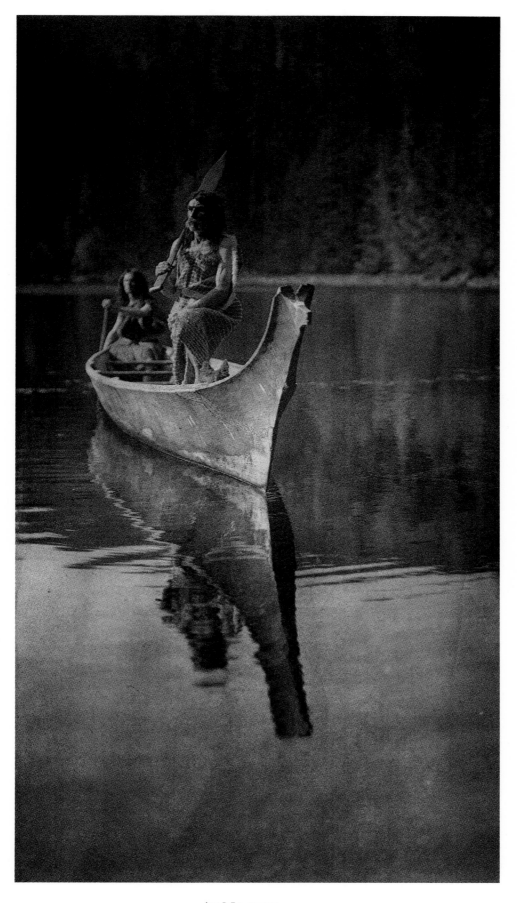

AT NOOTKA, 1915.

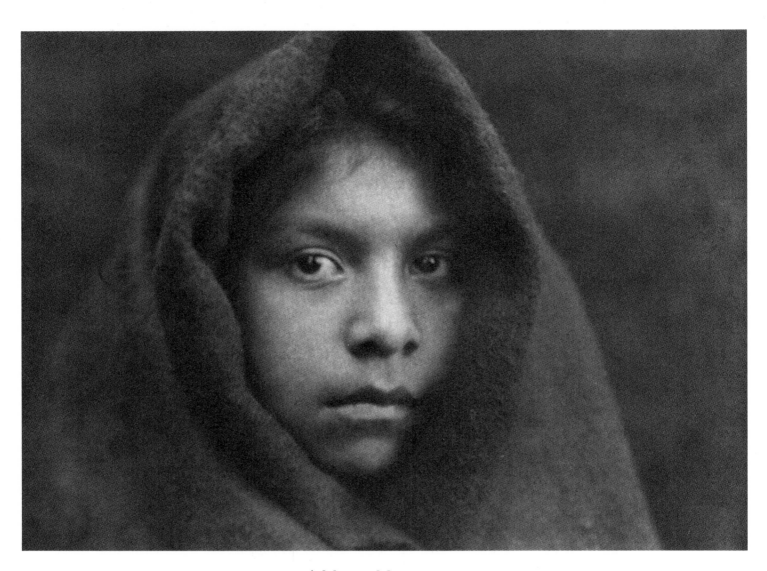

A Makah Maiden, 1915.

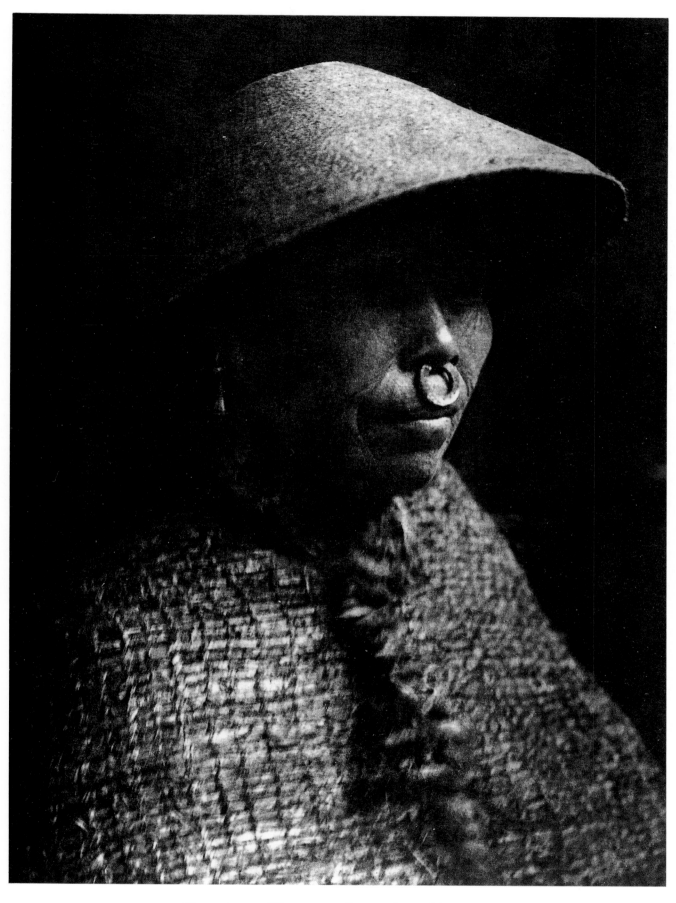

Clayoquot Woman in Cedar–Bark Hat, 1915.

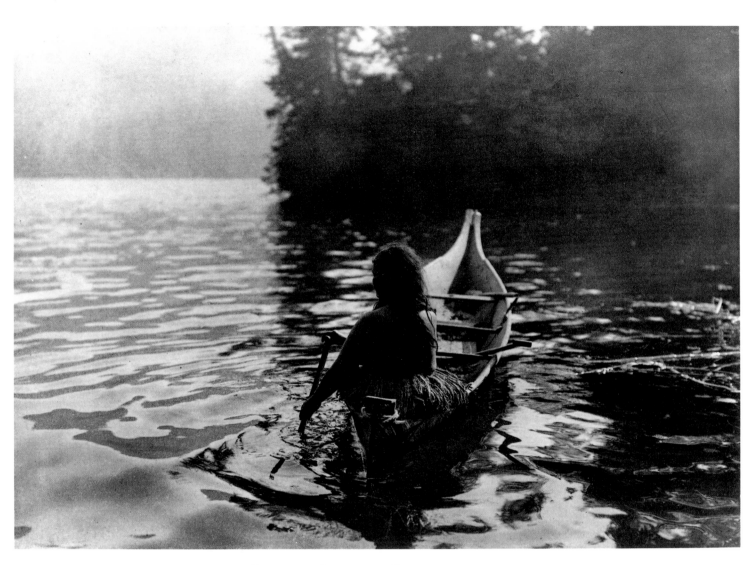

INTO THE SHADOW—CLAYOQUOT, 1915.

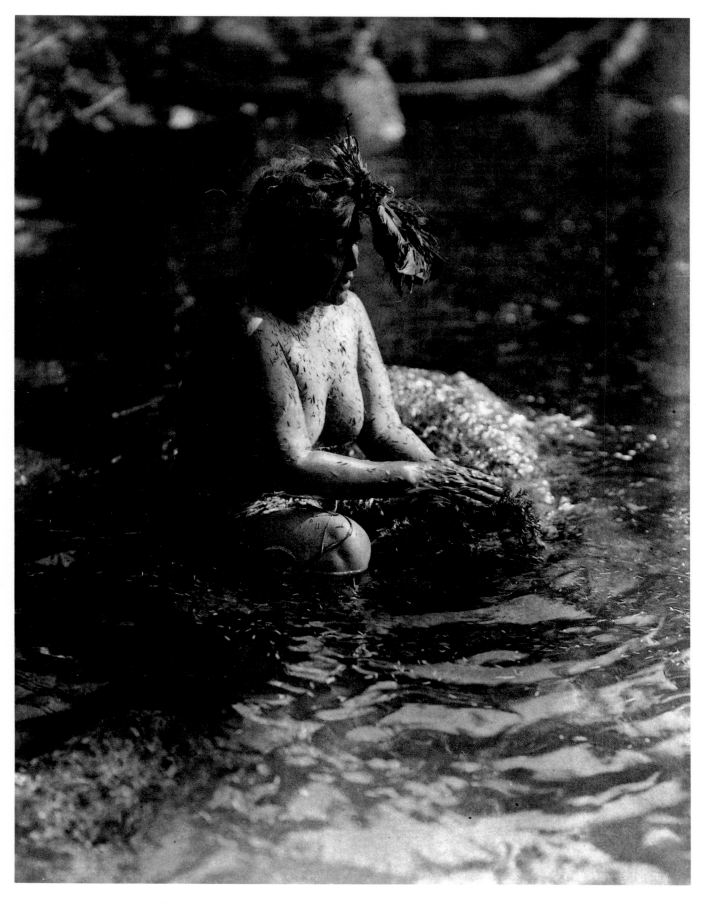

CEREMONIAL BATHING, 1915. A female shaman of the Clayoquot tribe.

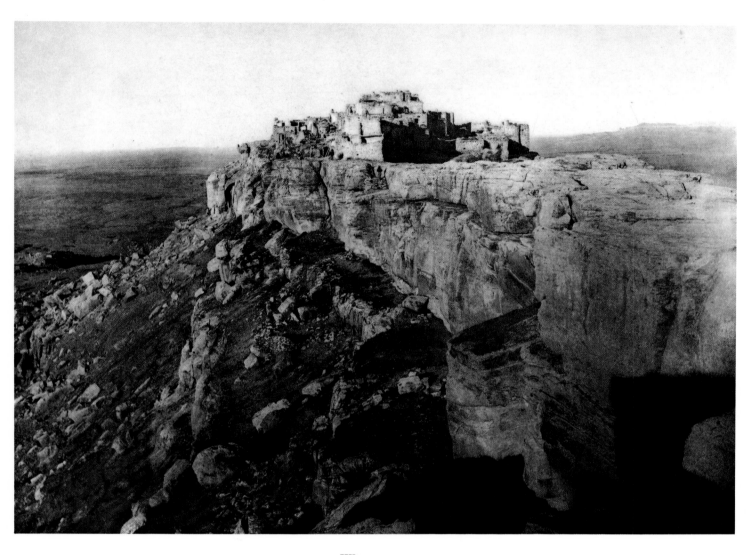

WALPI, 1907.

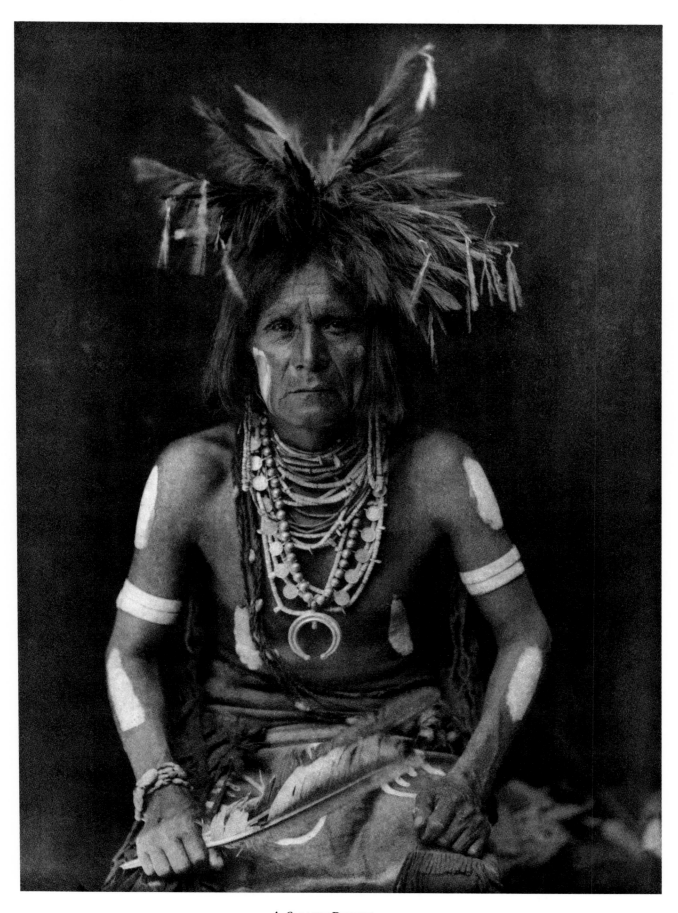

A SNAKE PRIEST, 1900.

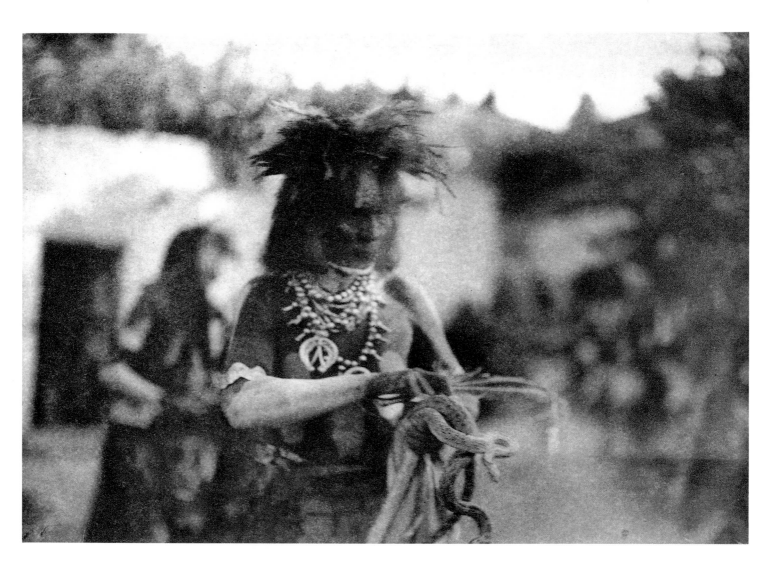

THE "CATCHER," 1906.

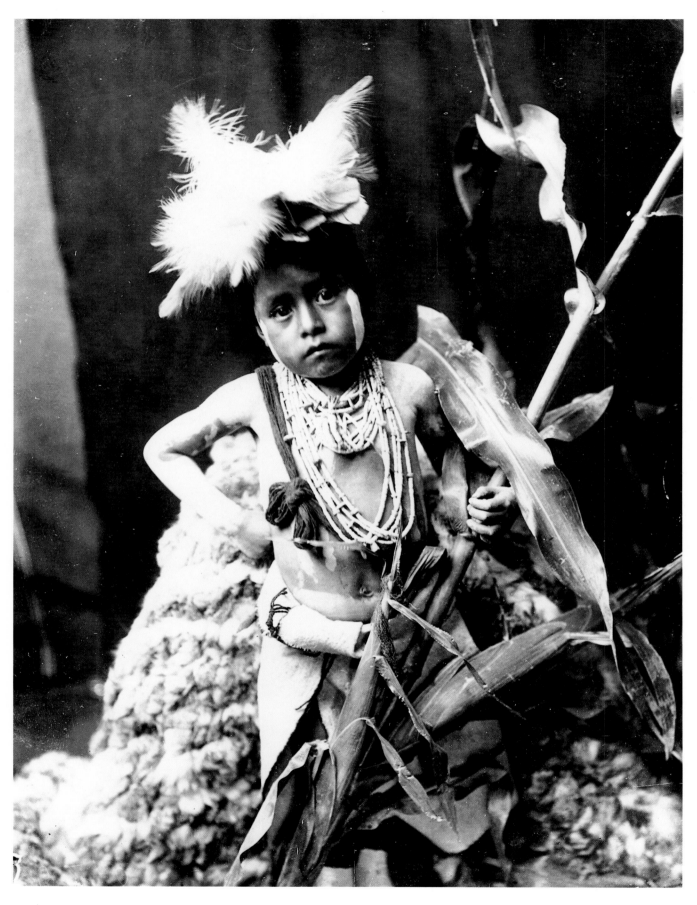

Awaiting the Return of the Snake Racers, 1921.

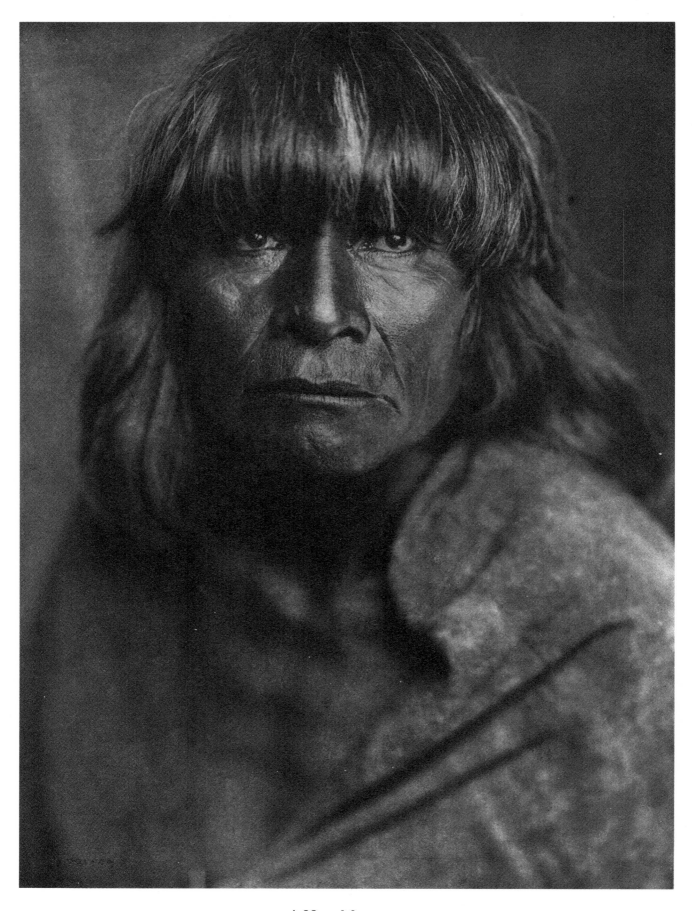

A Hopi Man, 1921.

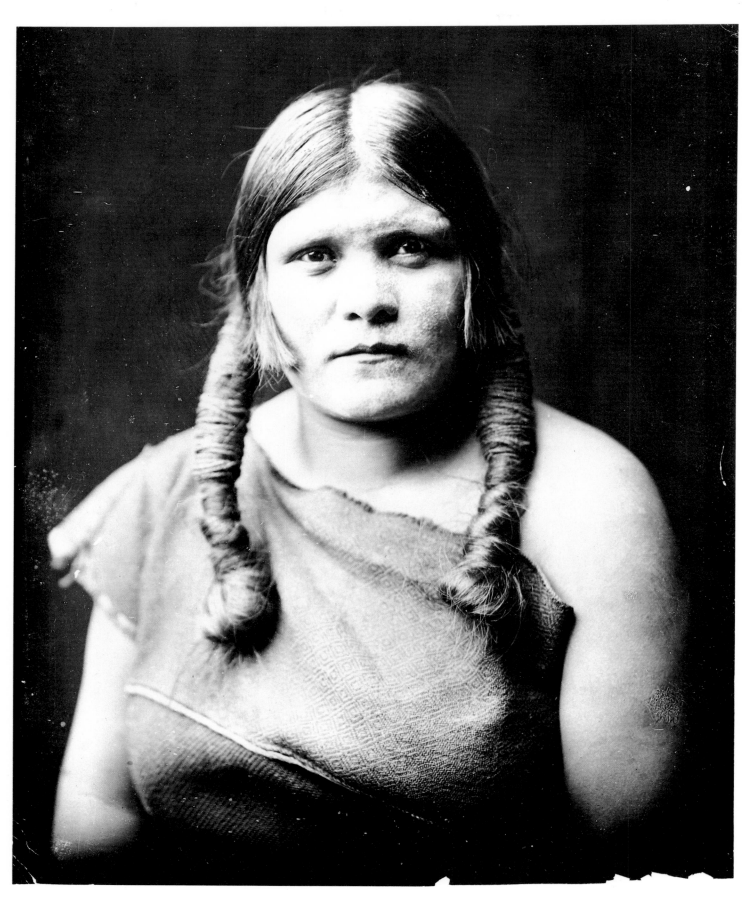

A HOPI WOMAN, 1905.

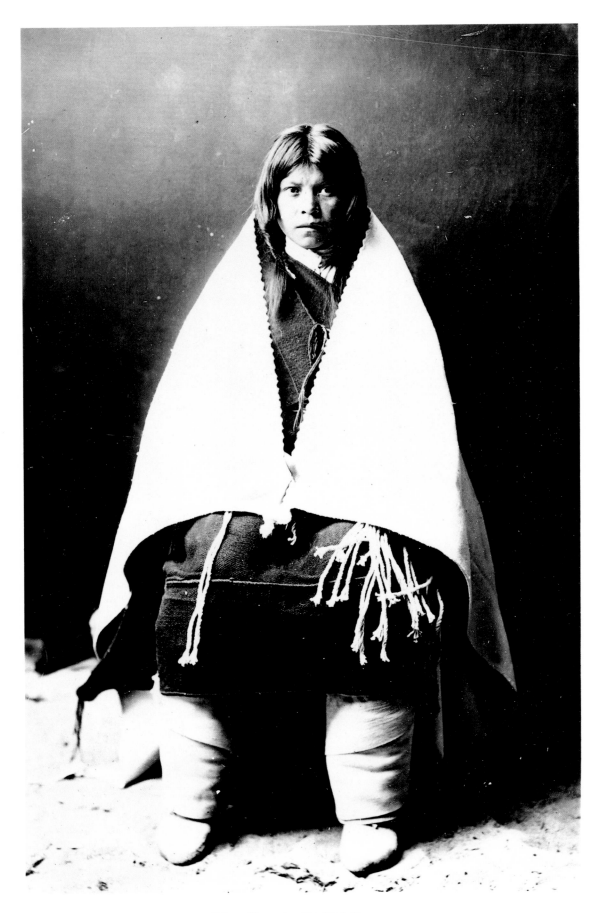

HOPI BRIDAL COSTUME, 1900.

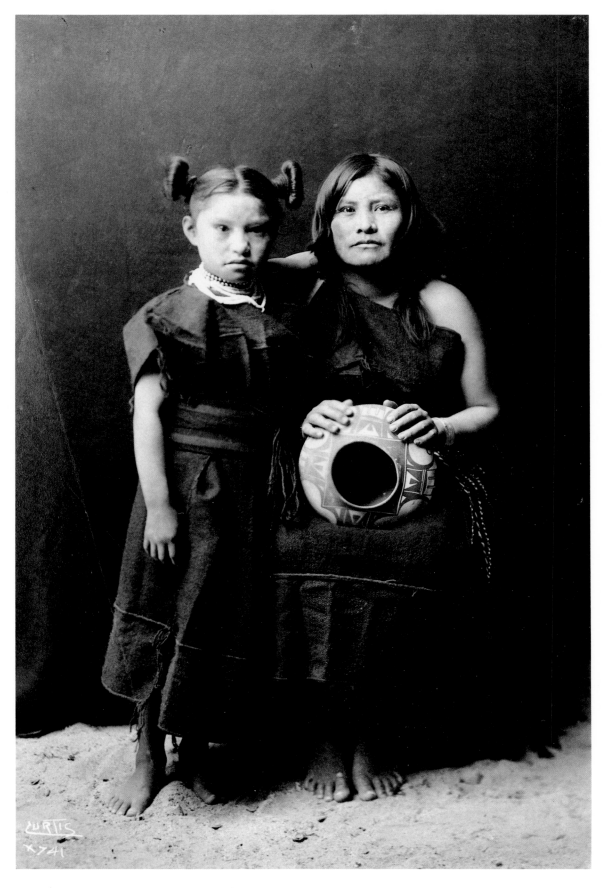

NAMPÉYO AND DAUGHTER, circa 1900.

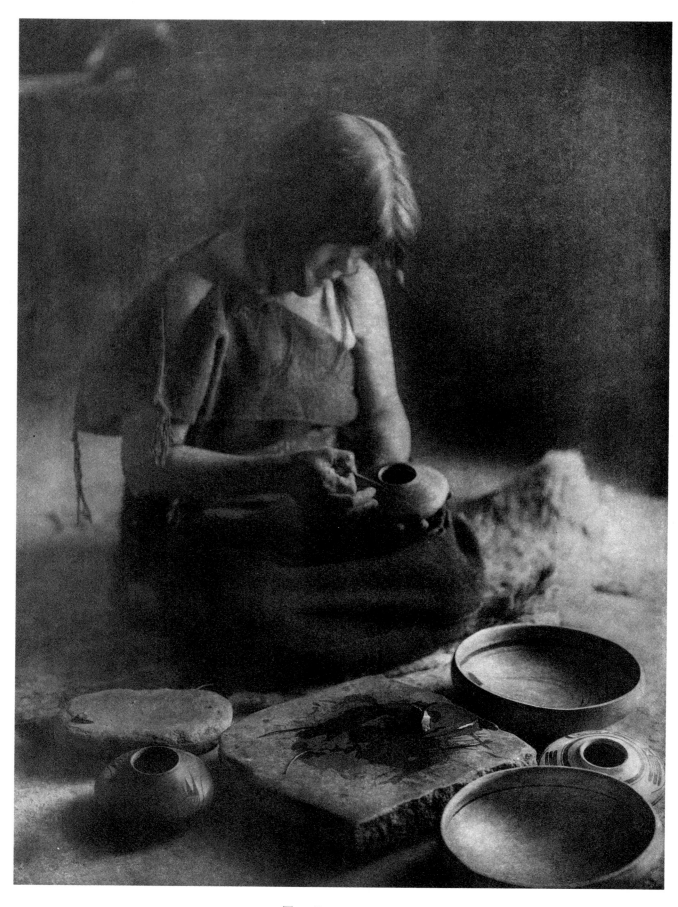

THE POTTER, 1906.

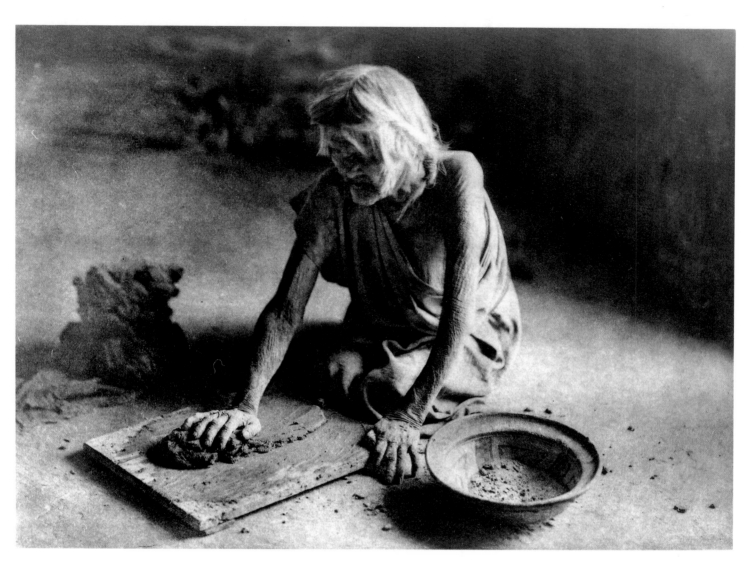

THE POTTER MIXING CLAY, circa 1900.

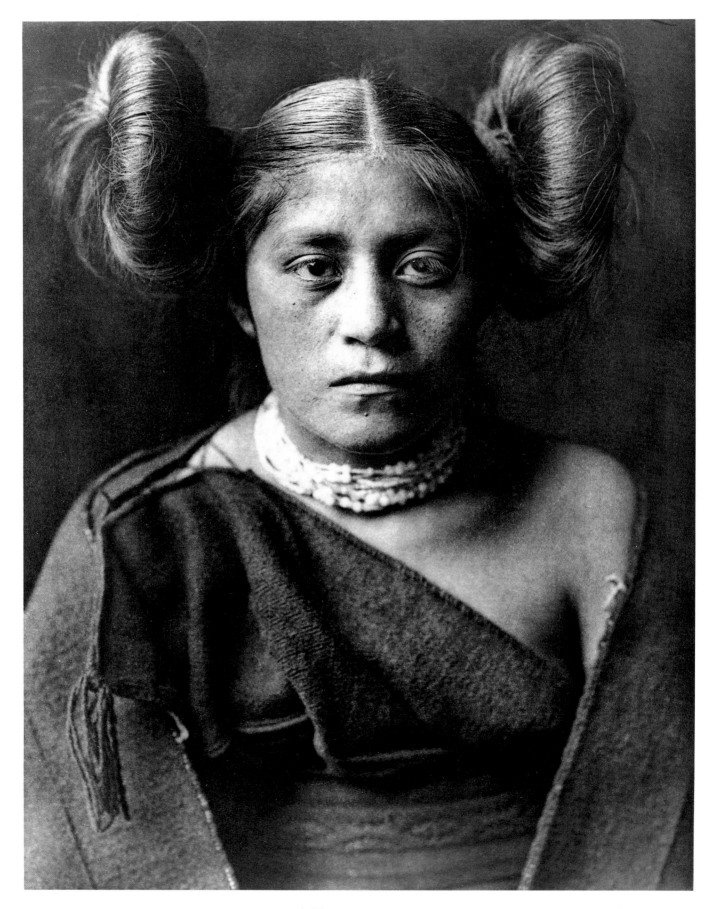

A Tewa Girl, 1921.

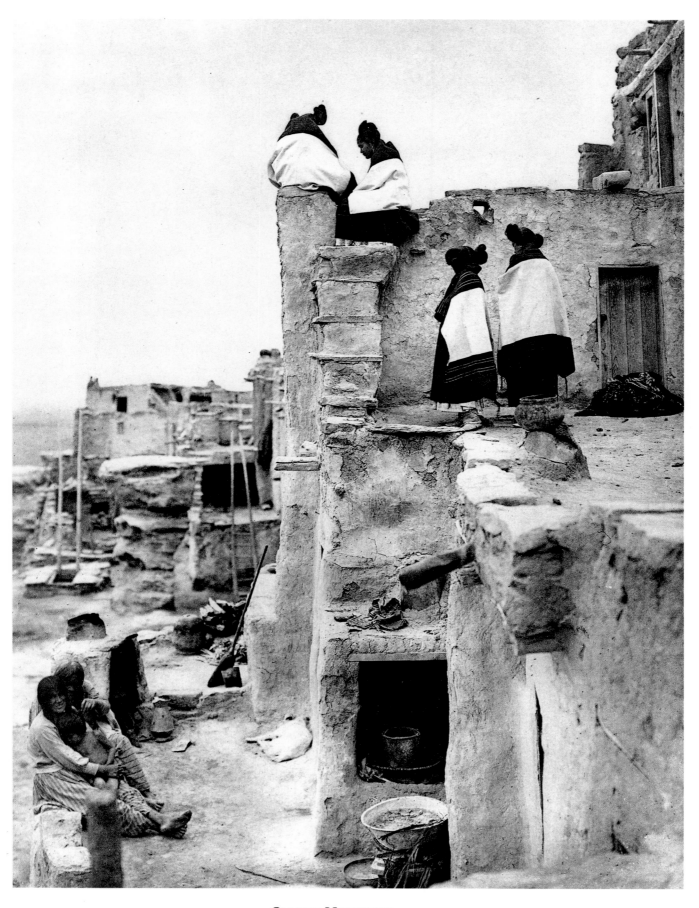

On the Housetop, 1921.

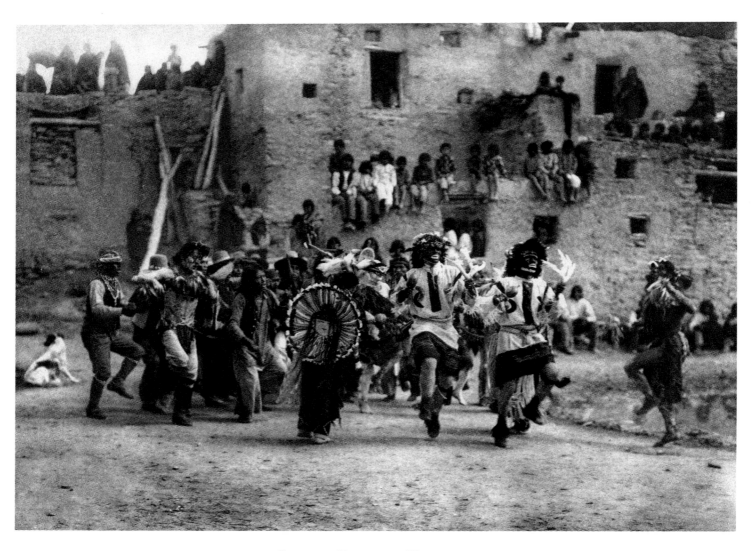

BUFFALO DANCE AT HANO, 1921.

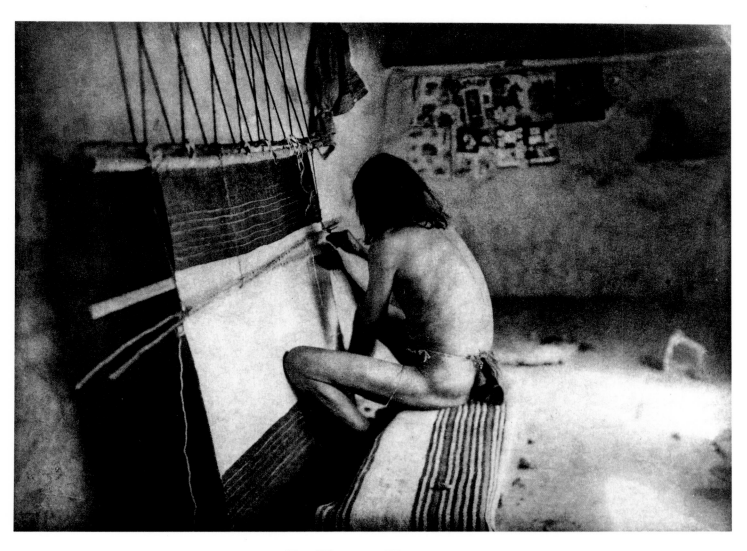

THE WEAVER—HOPI, 1906.

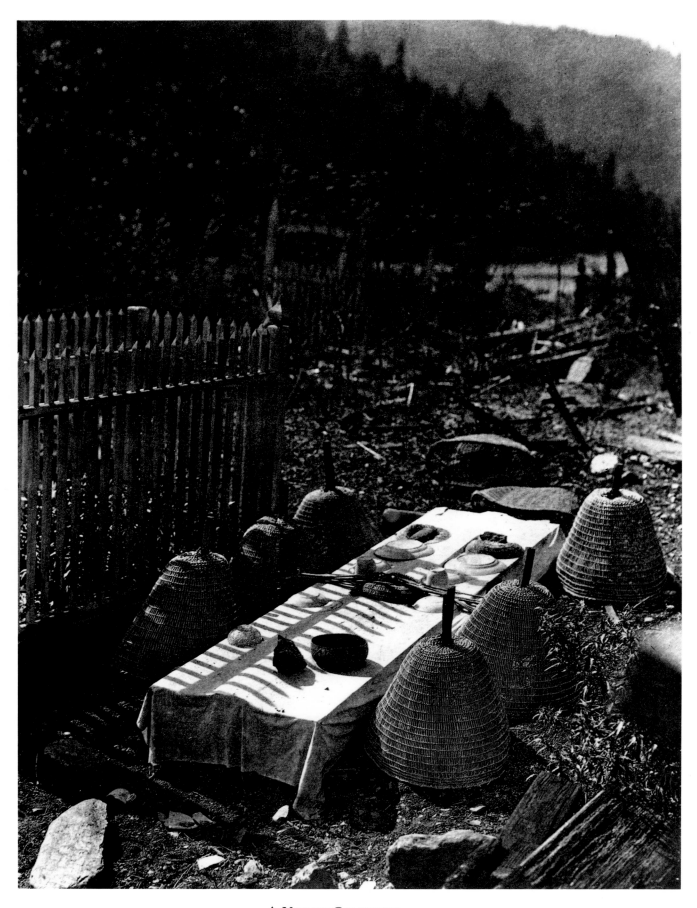

A YUROK CEMETERY, 1923.

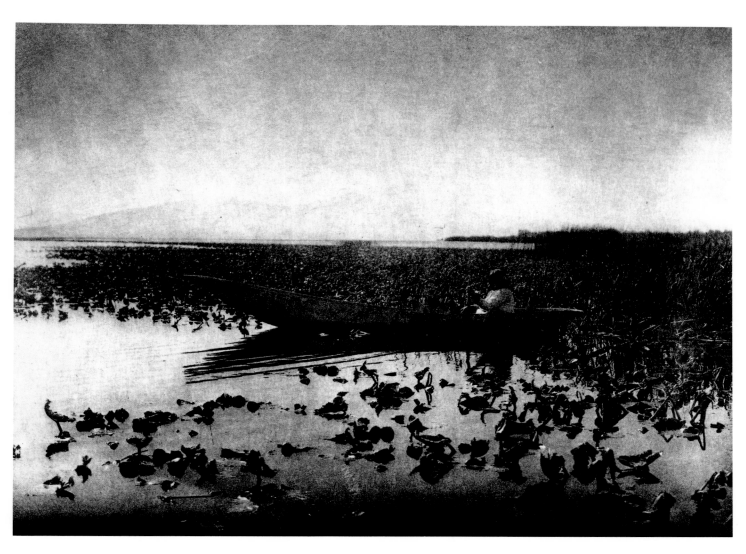

THE *WÓKAS* HARVEST—KLAMATH, 1923.

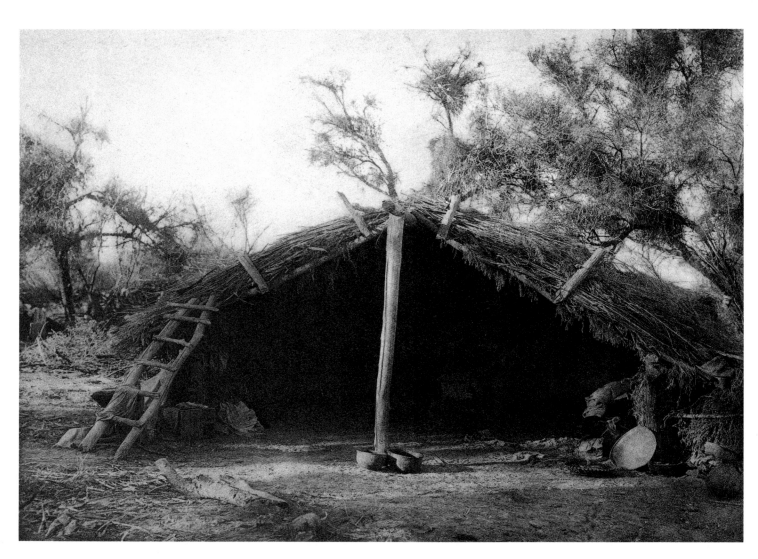

A Home in the Mesquite — Chemehuevi, 1924.

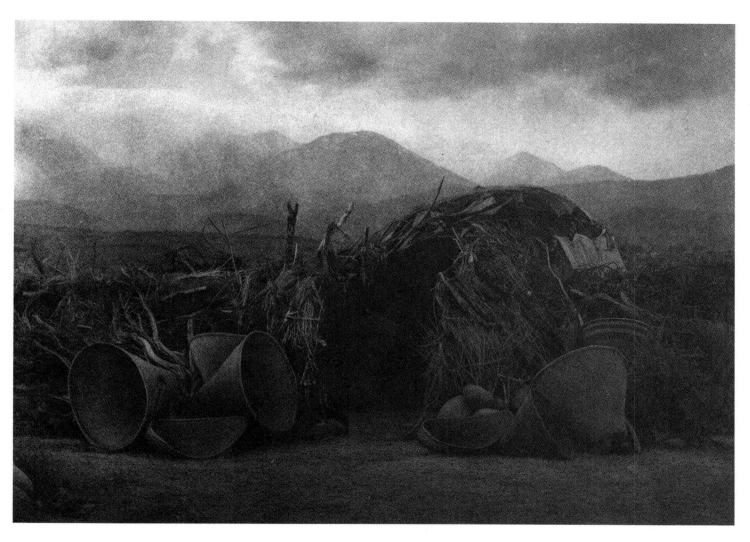

A MONO HOME, 1924.

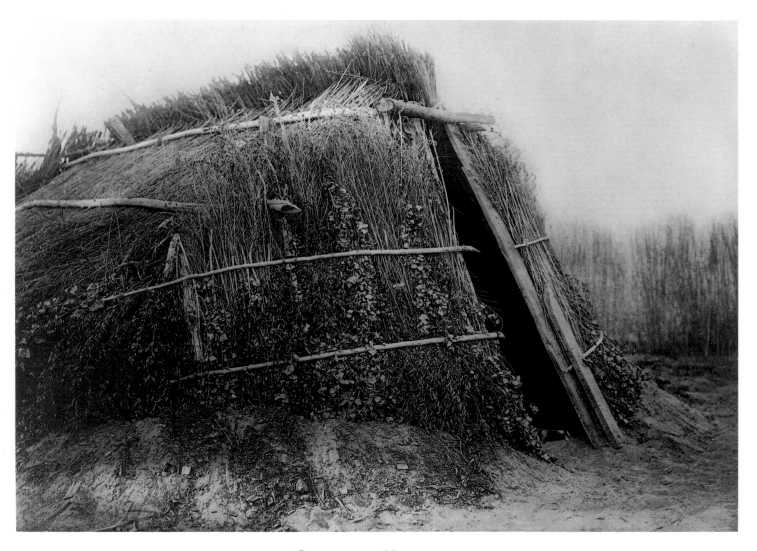

CHEMEHUEVI HOUSE, 1924.

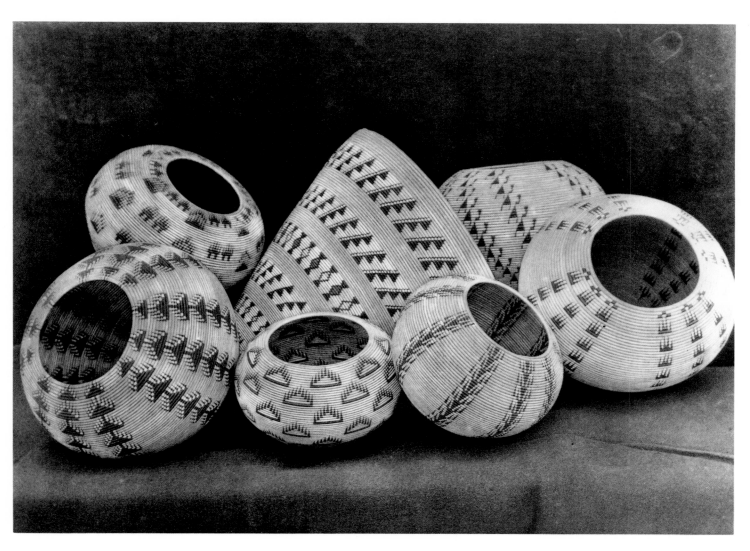

WASHO BASKETS, 1924.

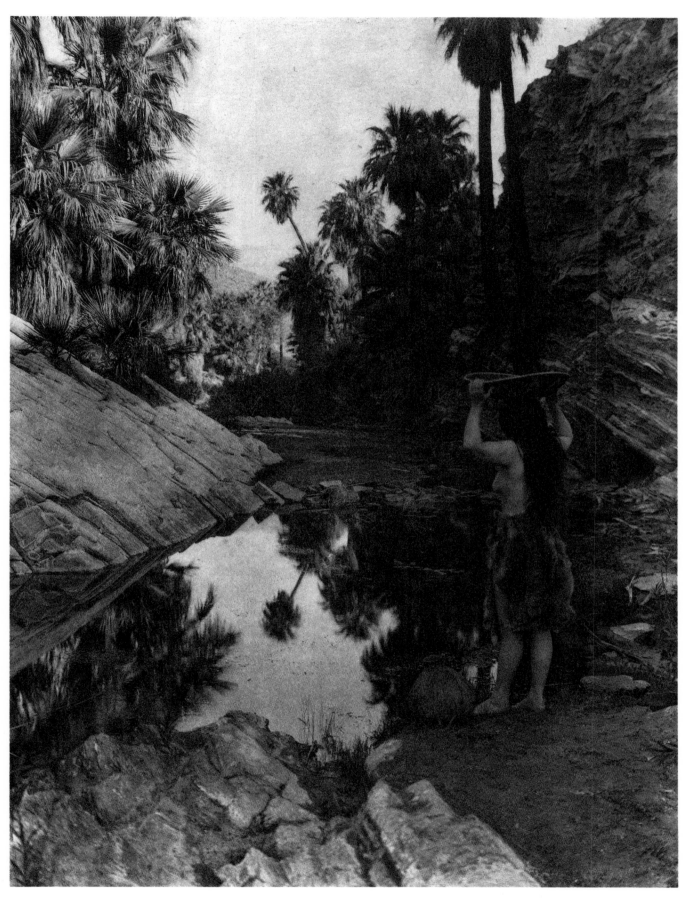

BEFORE THE WHITE MAN CAME—PALM CAÑON, 1924.

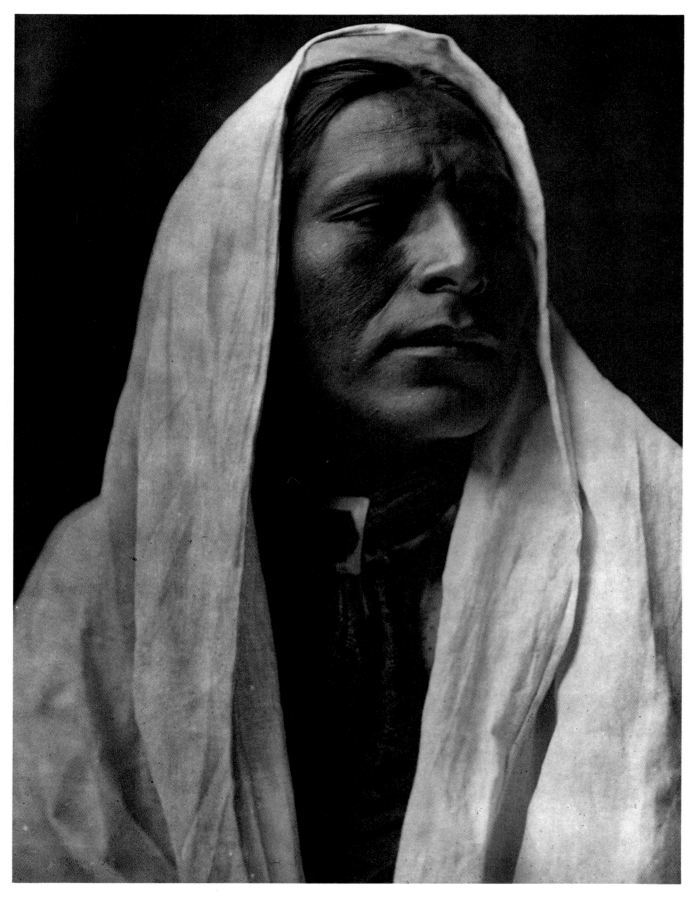

IĂHÎLA ("WILLOW") — TAOS, 1905.

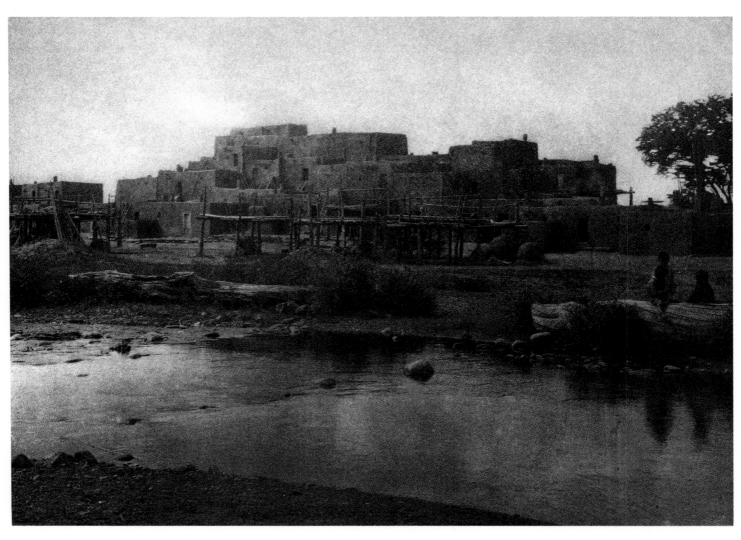

NORTH PUEBLO AT TAOS, 1925.

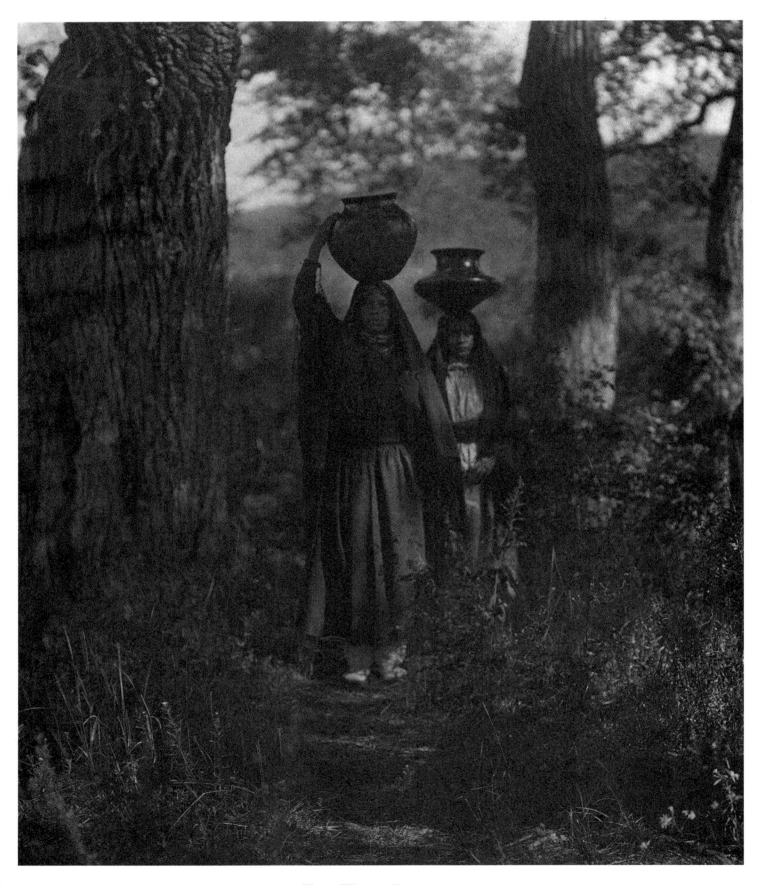

Taos Water Girls, 1905.

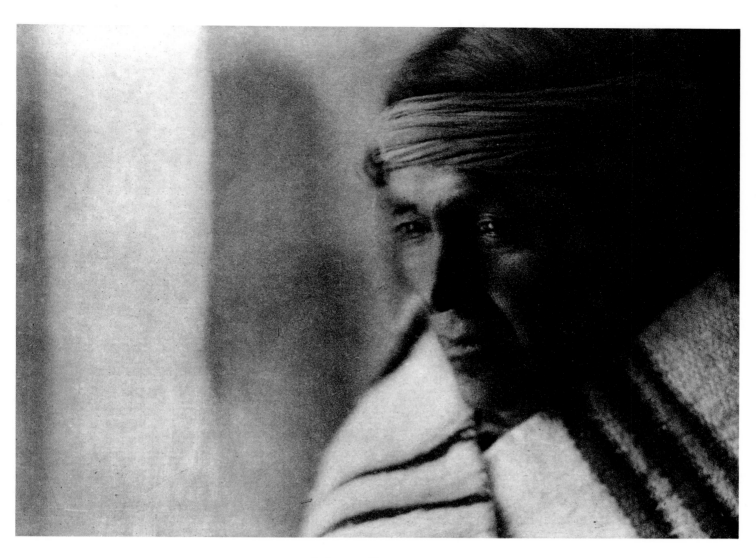

A Jemez Fiscal, 1925.

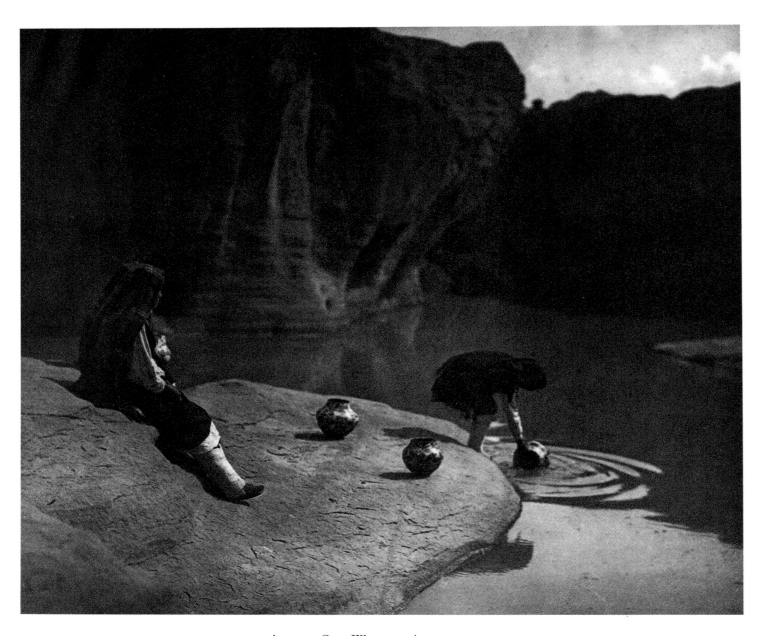

AT THE OLD WELL OF ACOMA, 1904.

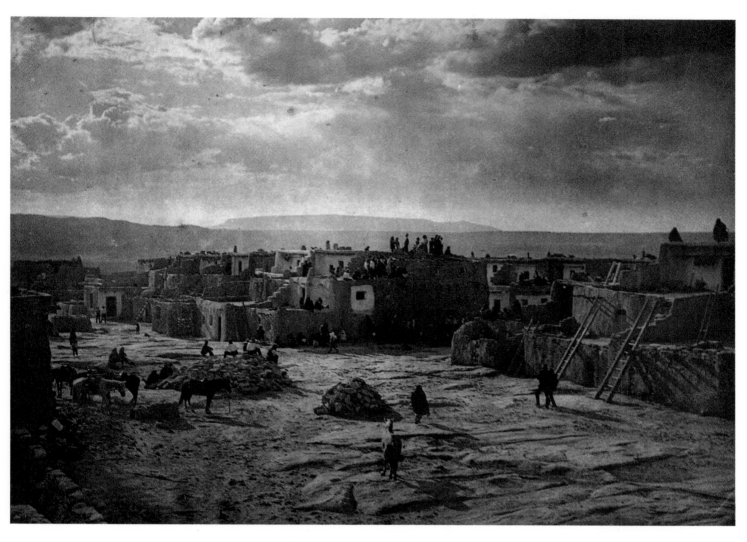

A Feast Day at Acoma, 1904.

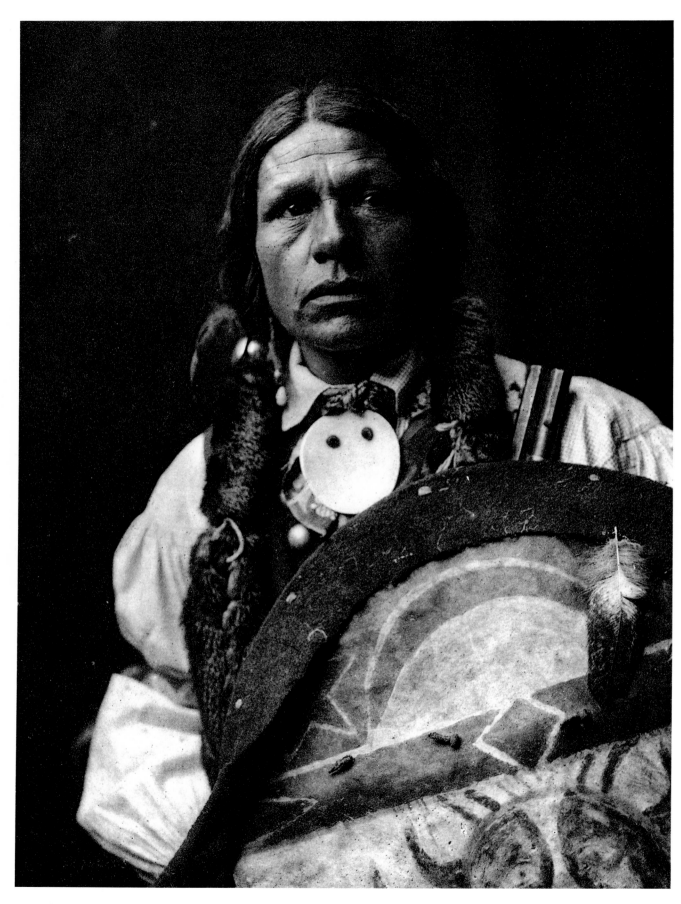

KÓ-PI^N ("BUFFALO MOUNTAIN")—SAN JUAN, 1905.

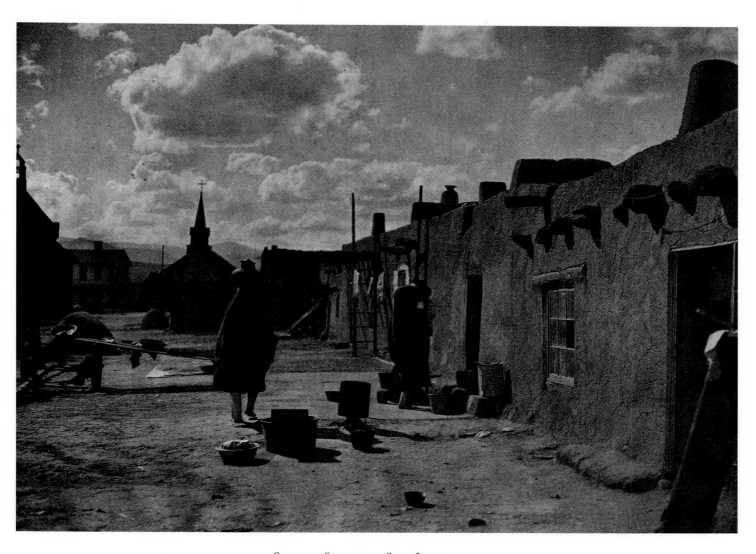

STREET SCENE AT SAN JUAN, 1925.

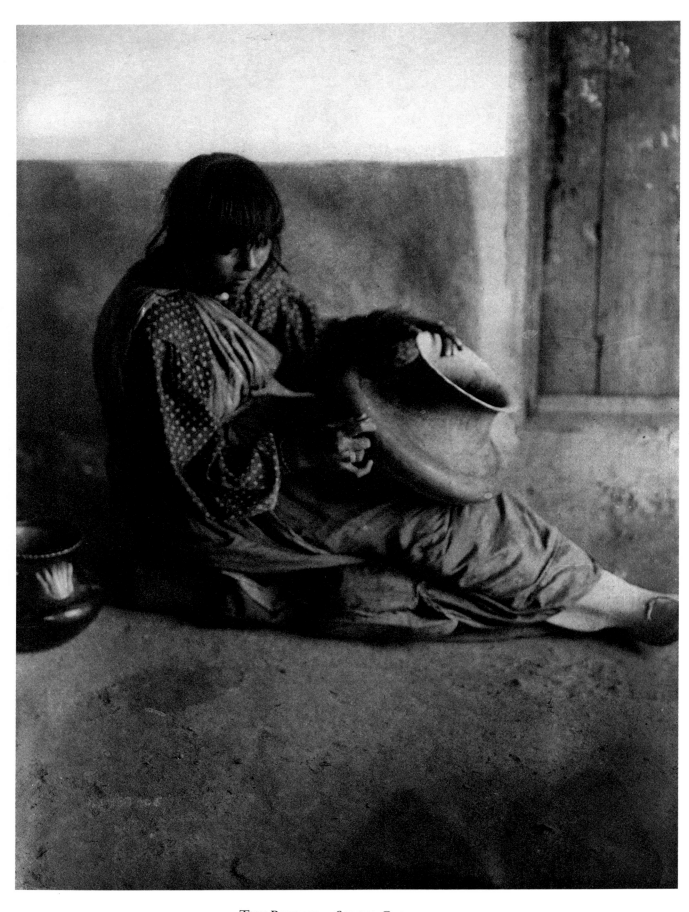

THE POTTER—SANTA CLARA, 1905.

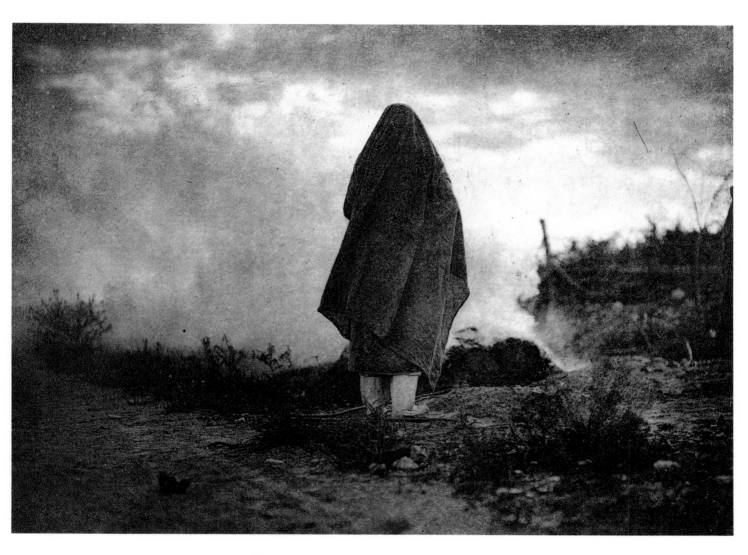

FIRING POTTERY—SANTA CLARA, 1905.

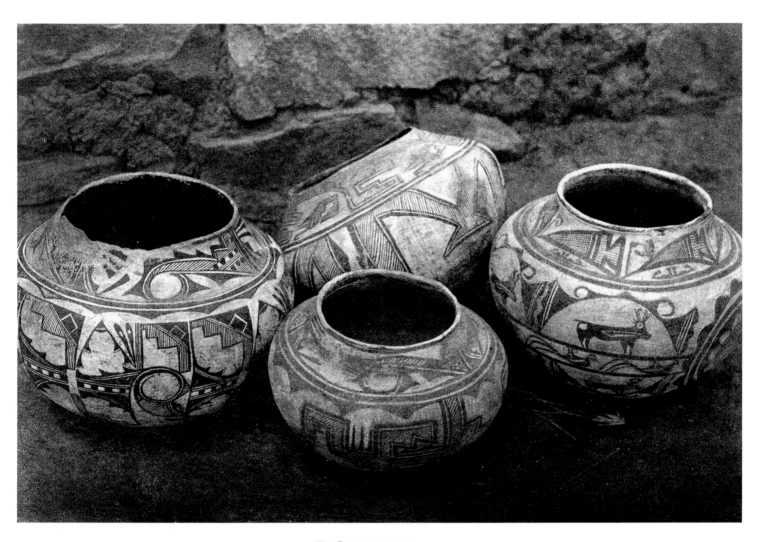

Zuñi Pottery, 1925.

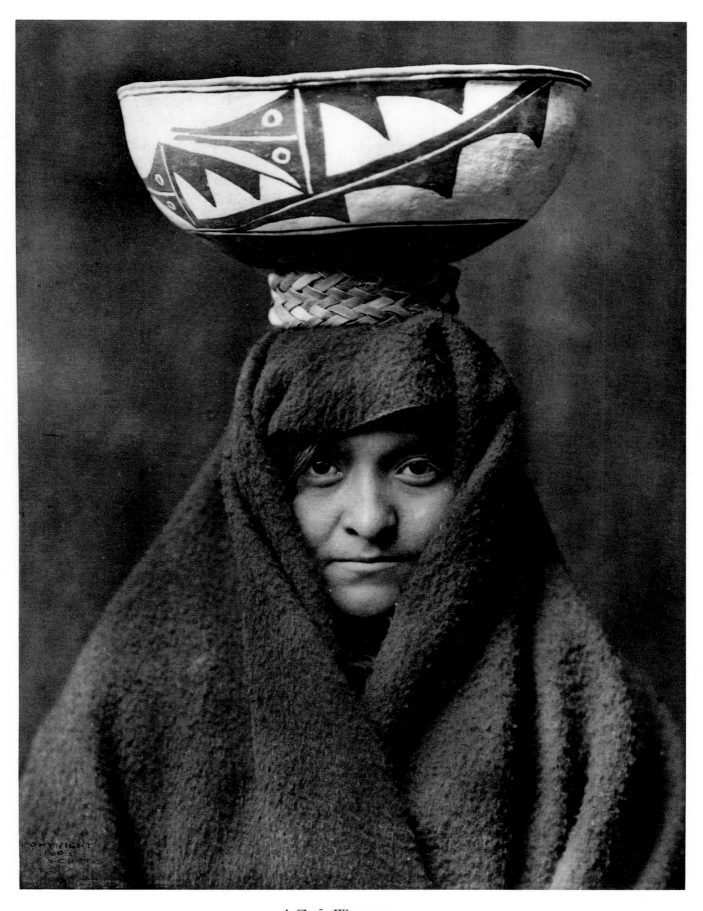

A ZUÑI WOMAN, 1903.

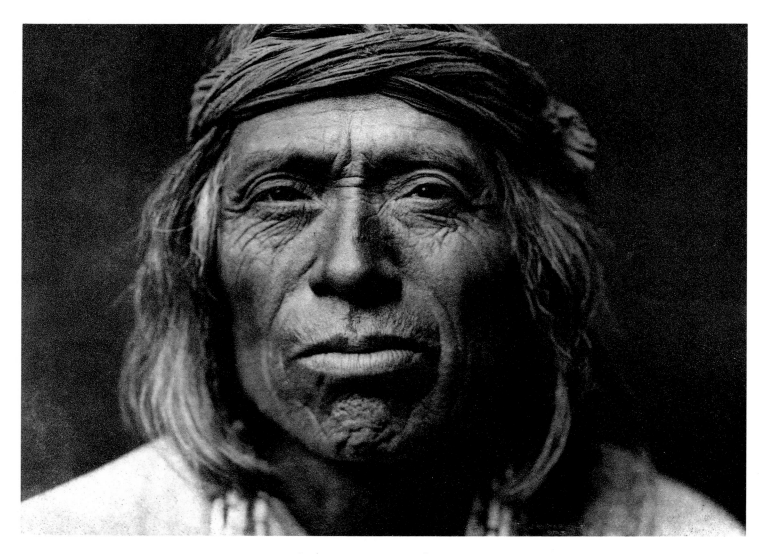

SHÍWAWAṬIWA—ZUÑI, 1903.

GRINDING MEDICINE—ZUÑI, 1925.

BOY AND GIRL COLUMNS AT CORN MOUNTAIN—ZUÑI, 1925.

THE SENTINEL—SAN ILDEFONSO, 1925.

TABLITA DANCERS AT THE KIVA—SAN ILDEFONSO, 1925.

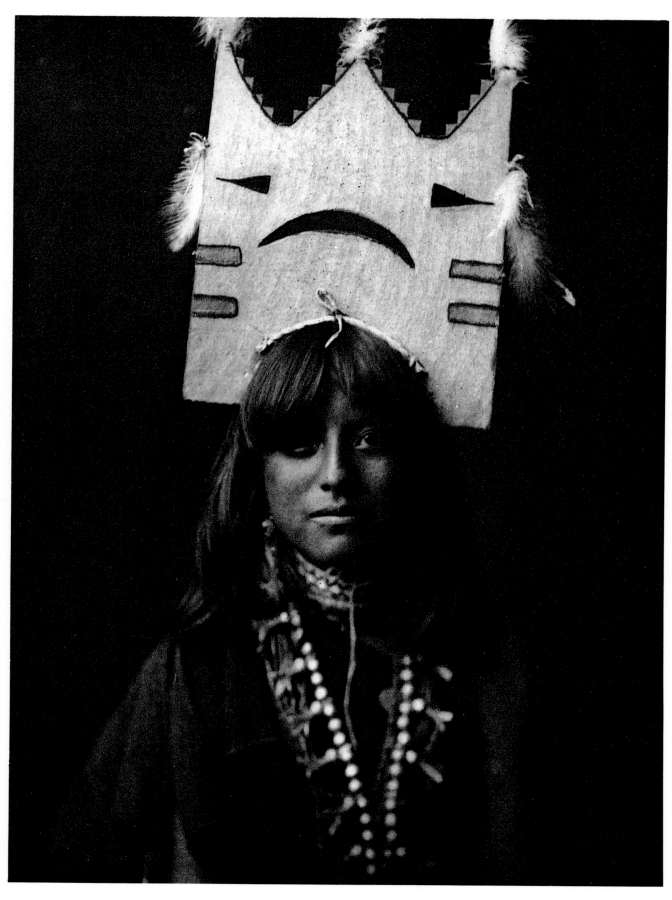

TABLITA WOMAN DANCER—SAN ILDEFONSO, 1905.

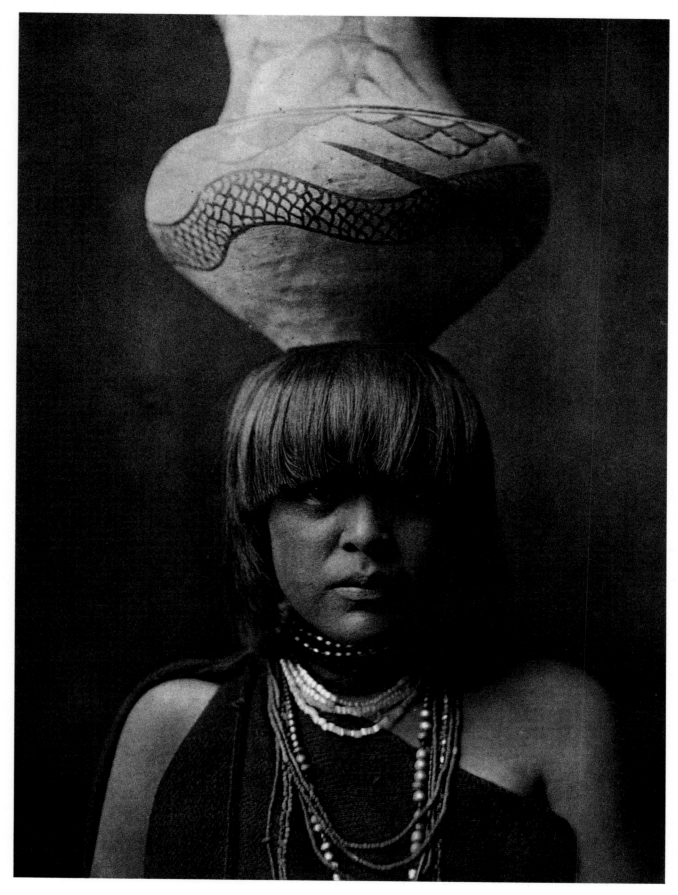

GIRL AND JAR—SAN ILDEFONSO, 1905.

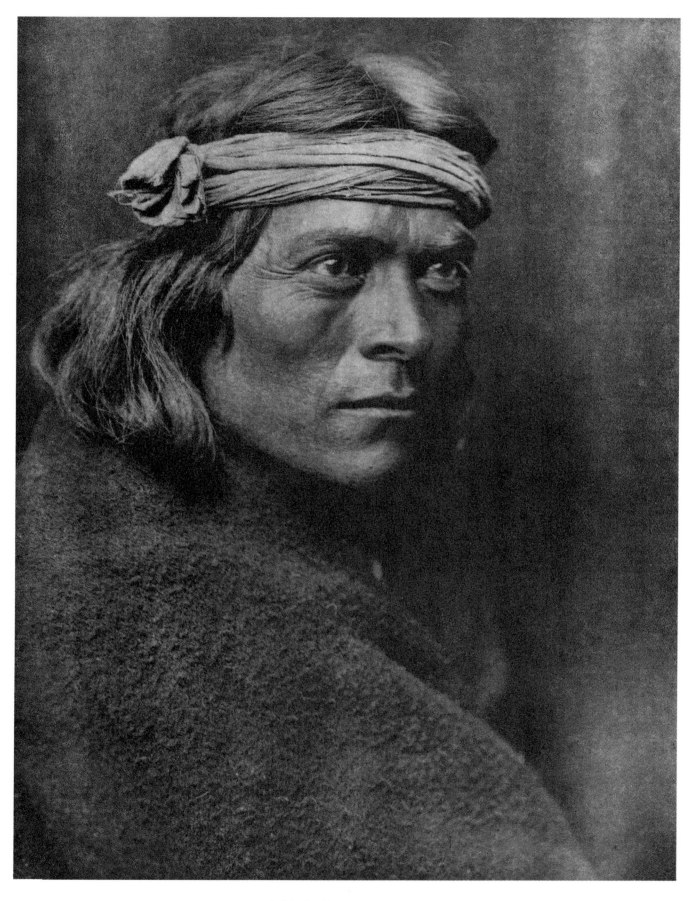

A ZUÑI GOVERNOR, 1925.

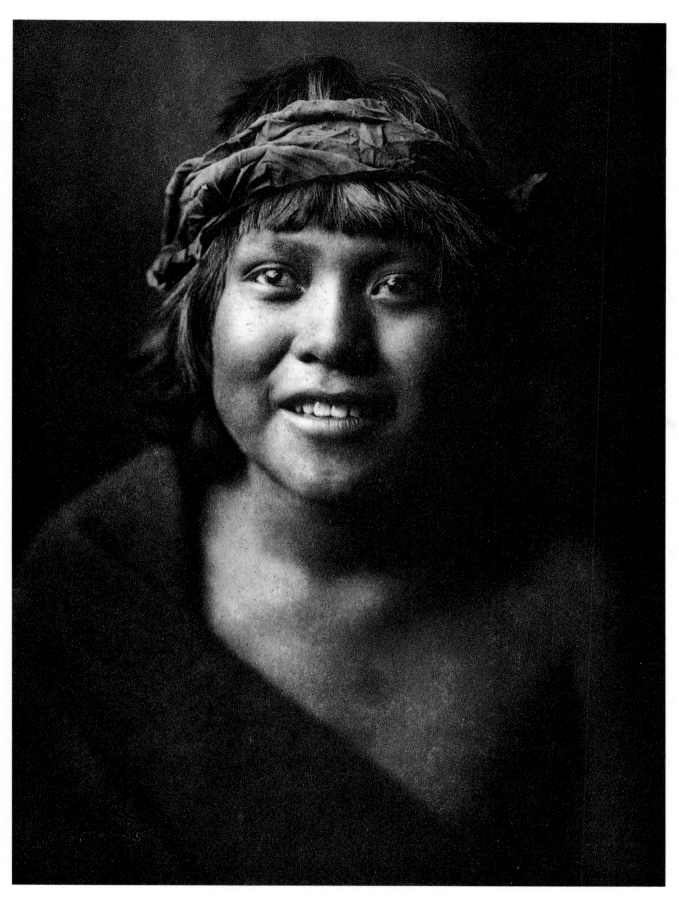

OKÚWA-T͡SIRĔ ("CLOUD BIRD")—SAN ILDEFONSO, 1905.

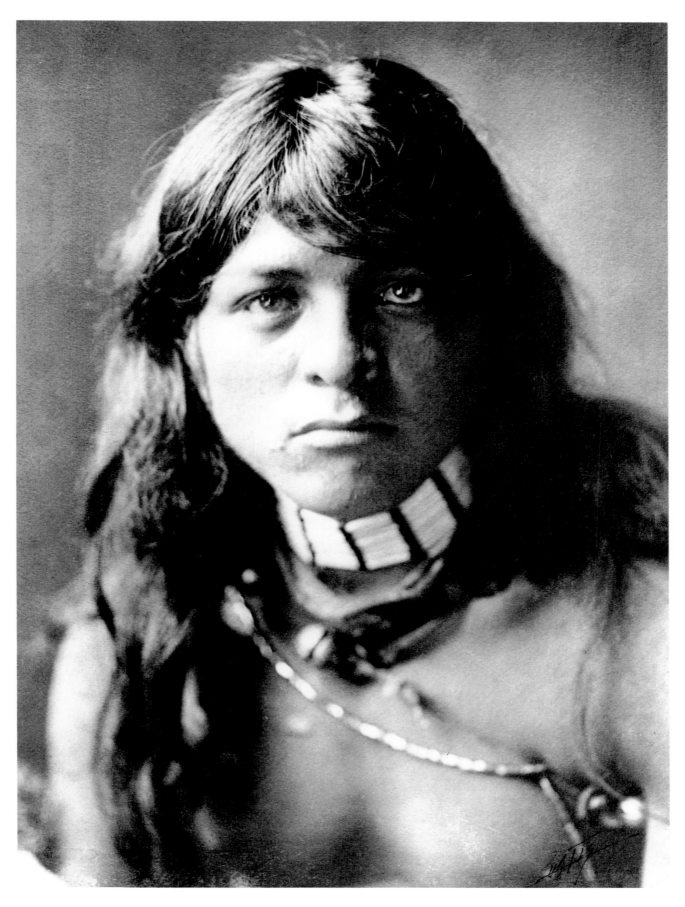

YAN-TSÍRĔ ("WILLOW BIRD")—SAN ILDEFONSO, 1905.

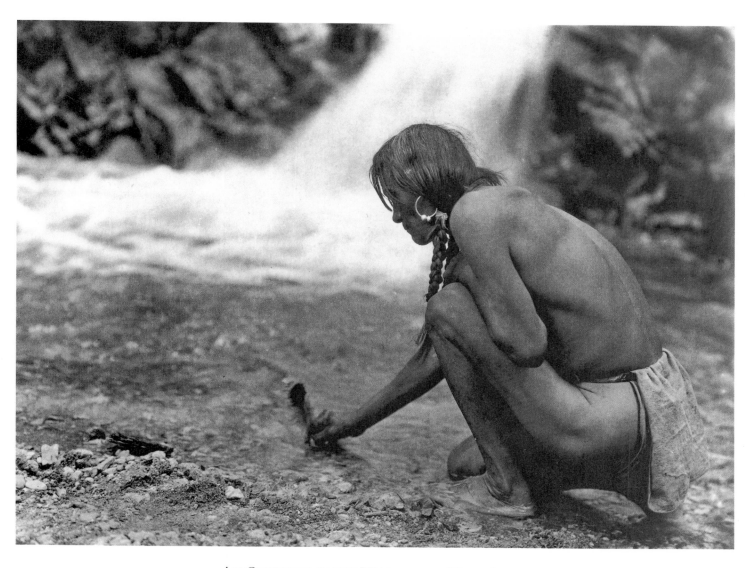

An Offering at the Waterfall—Nambé, 1925.

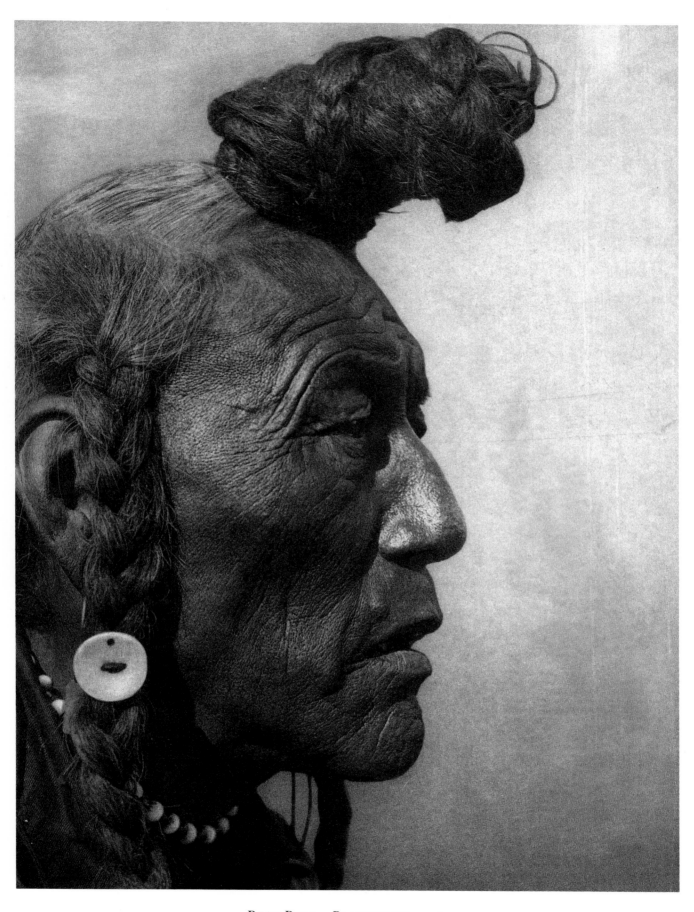

BEAR BULL—BLACKFOOT, 1926.

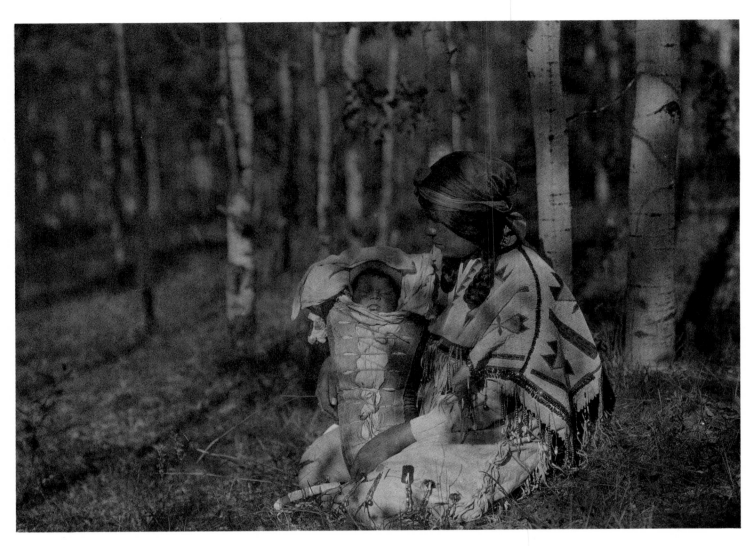

ASSINIBOIN MOTHER AND CHILD, 1926.

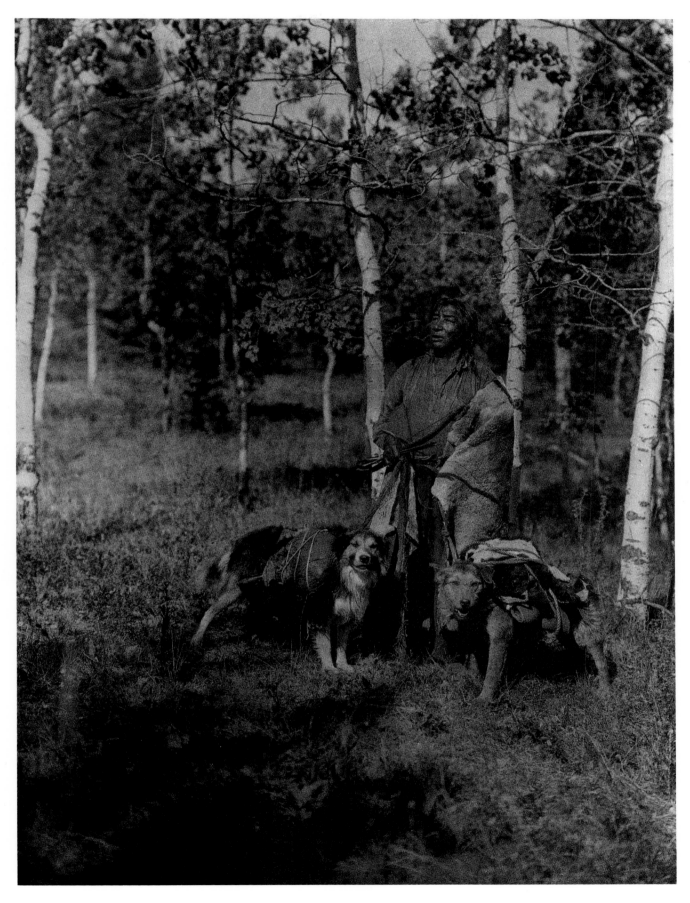

ASSINIBOIN HUNTER, 1926.

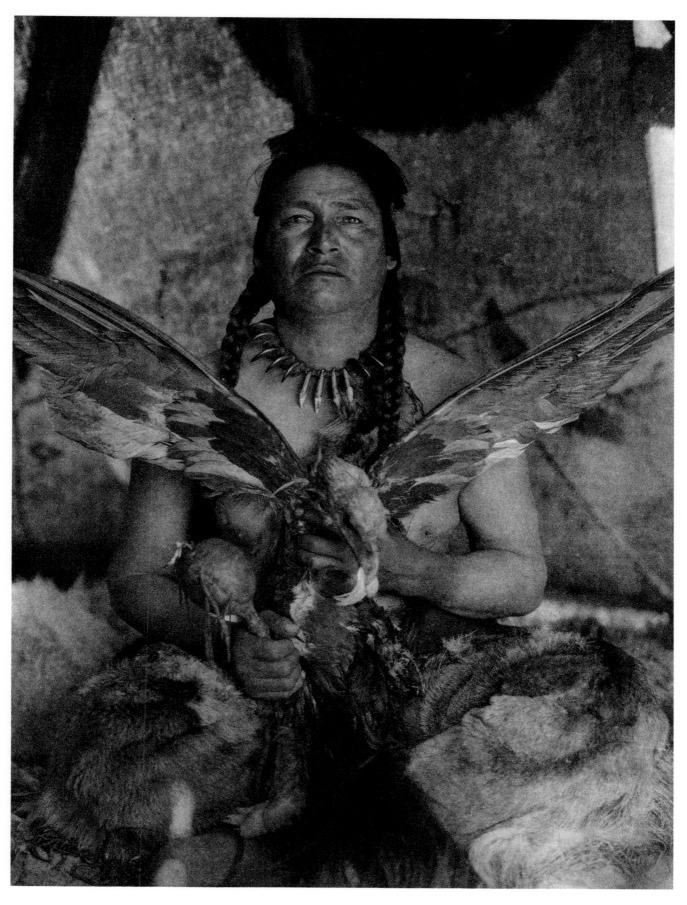

PLACATING THE SPIRIT OF A SLAIN EAGLE—ASSINIBOIN, 1926.

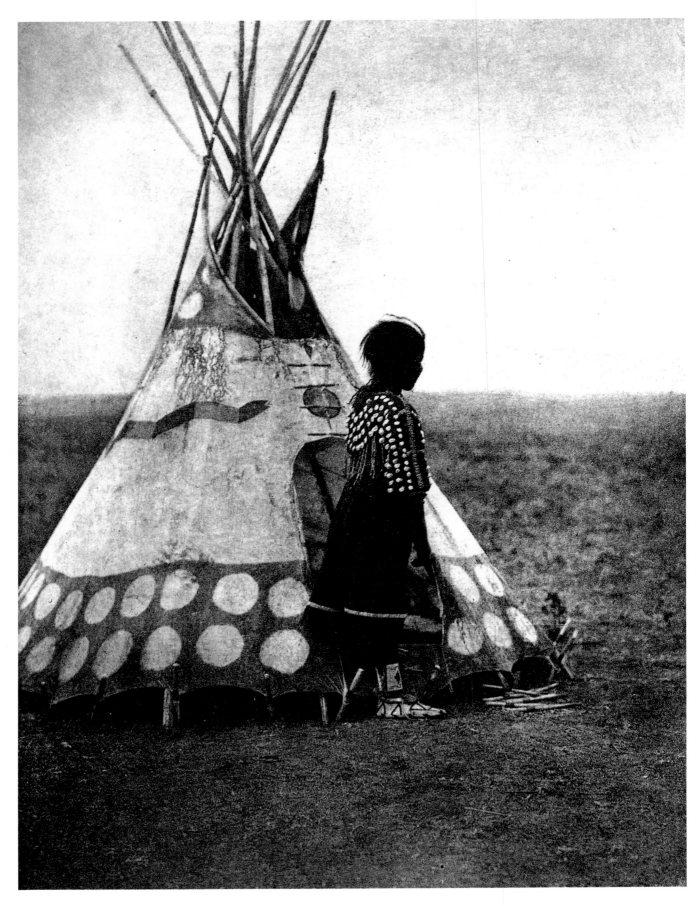

A PIEGAN PLAY TIPI, 1926.

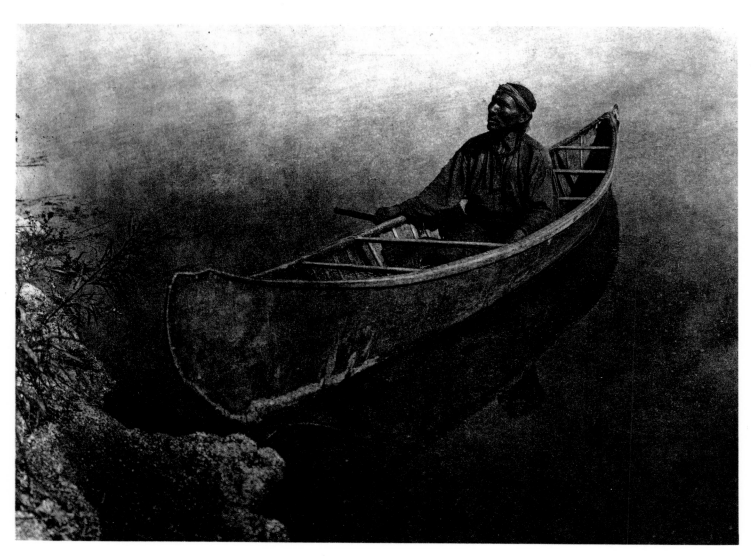

A CREE CANOE, 1926.

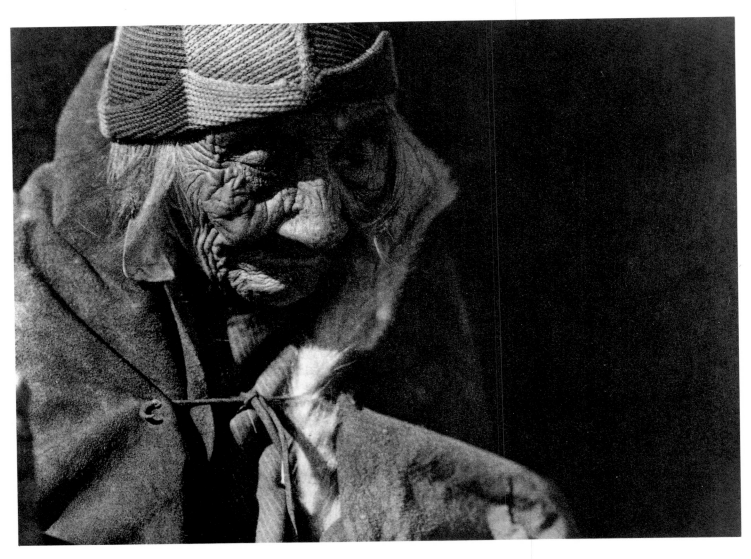

AN OLD WOMAN—BLOOD, 1926.

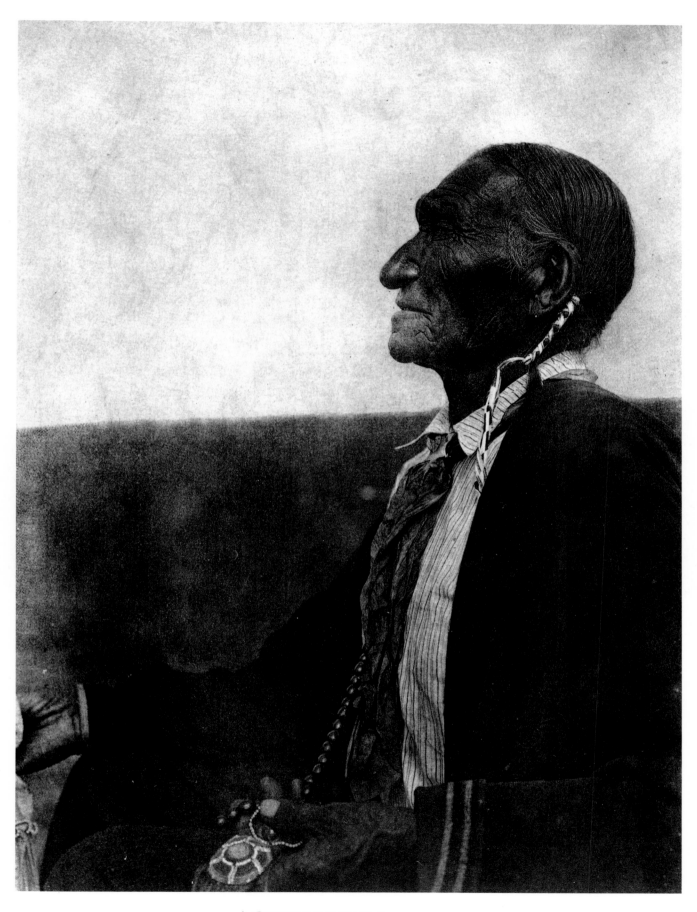

A CHEYENNE PEYOTE LEADER, 1927.

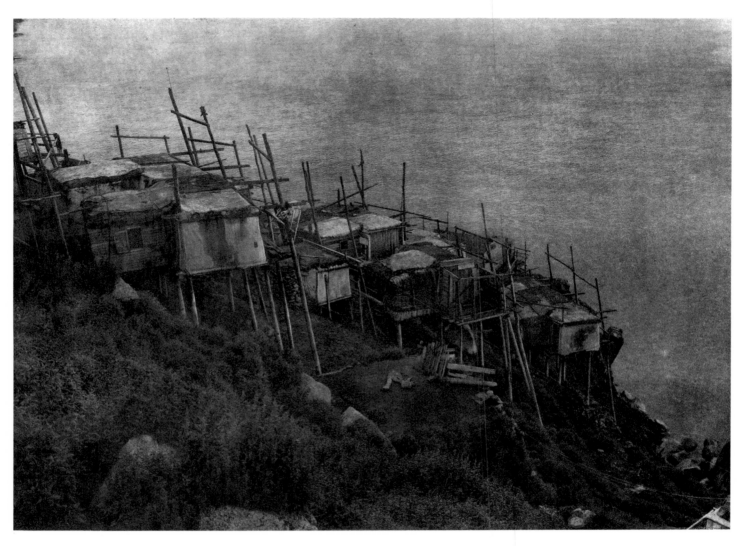

KING ISLAND VILLAGE, 1928.

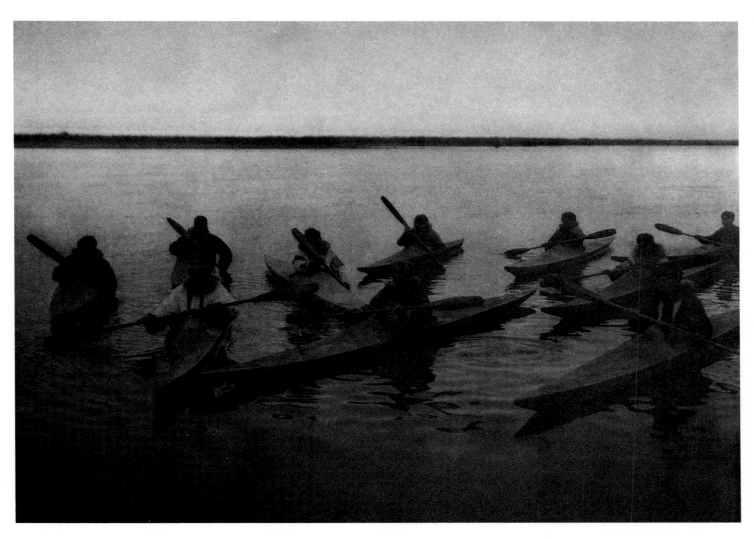

NOATAK KAIAKS, 1928.

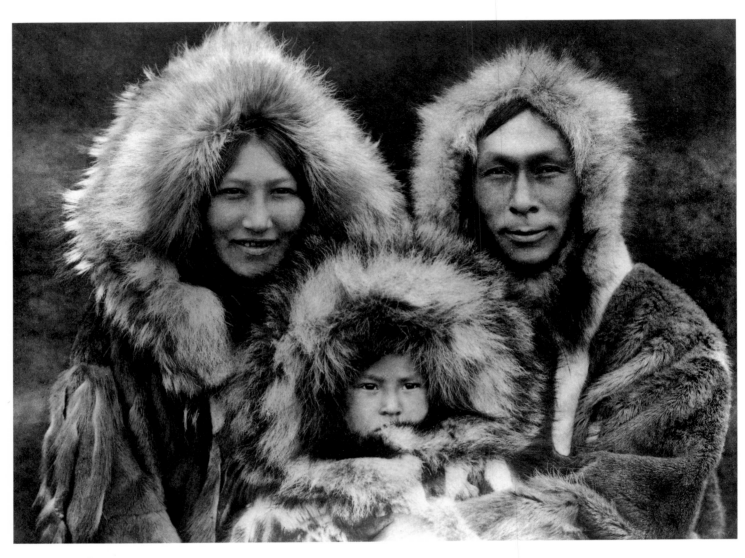

A FAMILY GROUP—NOATAK, 1928.

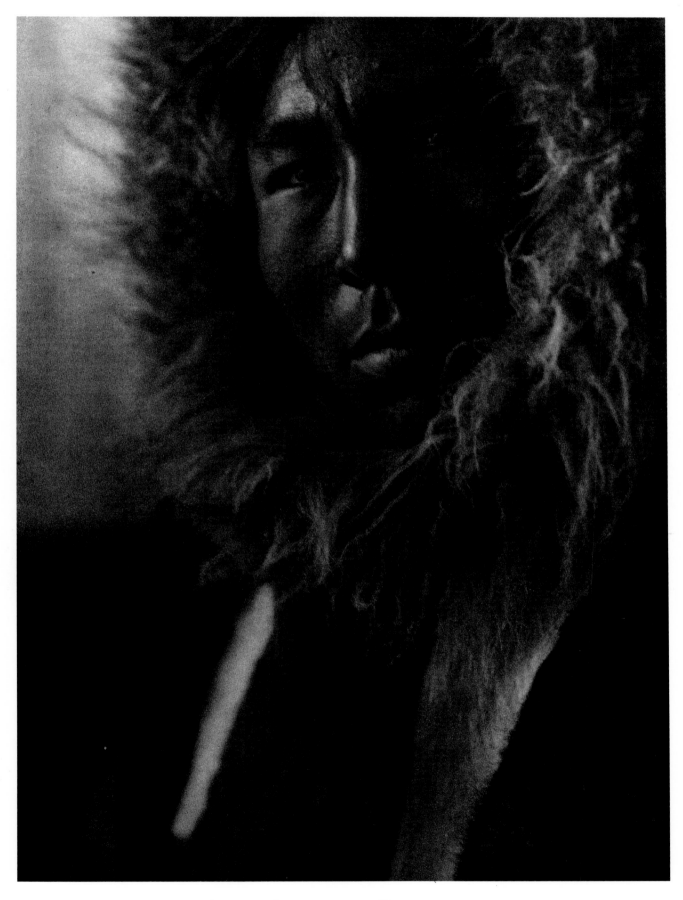

JACKSON, INTERPRETER AT KOTZEBUE, 1928.

Little is known about Edward Curtis's Hollywood work, but current evidence suggests that he was most involved with motion pictures in the early 1920s, when *The North American Indian* was at a standstill. After moving his studio from Seattle to Los Angeles in 1919, he worked as a commercial portrait photographer and as a cameraman and still photographer—perhaps even as a writer—on an undetermined number of screen projects. He resumed the Indian work on a limited basis in 1922, and during the next few years the Indian and Hollywood work overlapped. Eventually he returned to full-time work on *The North American Indian*. However, he is known to have had some part in filming *The Plainsman*, starring Gary Cooper, in 1936 and may have done other Hollywood work at the same time.

CHARIOT SCENE, 1923. Noble Johnson as the Bronze Man (*left*) and Charles de Roche as Rameses the Magnificent (*right*) in Cecil B. DeMille's *The Ten Commandments.*

APHRODITE, circa 1930. Blue-toned silver print, one of a series.

THE FEMME FATALE, 1923. Nita Naldi as Sally Lung, an escapee from a leper colony, in the modern portion of *The Ten Commandments*. Blue-toned silver print.

RAMESES AND MOSES, 1923. Charles de Roche (*left*) and Theodore Roberts (*right*) in a scene from DeMille's *The Ten Commandments*. Blue-toned silver print.

THE BLUE BED, 1923. A blue-toned silver print of a scene from the
modern portion of DeMille's *The Ten Commandments*. Having killed his
mistress because she gave him leprosy, Dan McTavish (played by Rod La
Rocque) begs his cast-off wife (Leatrice Joy) to hide him from the police.

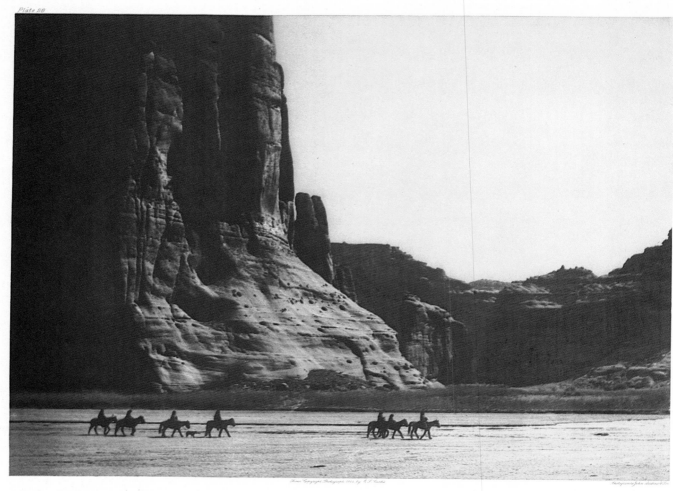

CAÑON DE CHELLY, 1904. Photograph of original gravure print on Van Gelder paper.

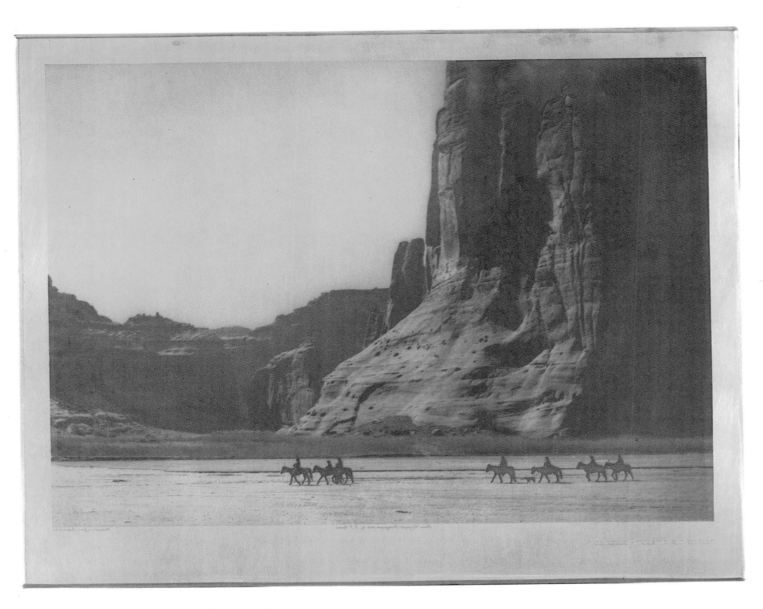

CAÑON DE CHELLY, 1904. Photograph of original copper gravure plate.

TÁṖÂ ("ANTELOPE WATER") — TAOS, 1905. Tissue print over Van Gelder paper.

OASIS IN THE BAD LANDS, 1904. Photograph of original copper gravure plate.

KUTENAI DUCK HUNTER, 1910. Photograph of original copper gravure plate.

BEFORE THE FINAL JOURNEY—CHEYENNE, 1910. Cyanotype (field print).

NOTES

Chapter 1. The Last Frontiers (pages 17-24)

1. Ralph Andrews, in *Curtis's Western Indians*, states that Curtis was born on a farm near Whitewater, in Walworth County, but according to information Curtis provided for the 1913 edition of *Who's Who in America*, he was born in Madison, Wisconsin. Birth registration in Dane, Walworth, and Jefferson counties was sketchy prior to 1907; a routine search of county records failed to turn up a birth certificate.

2. *Argus*, July 18, 1896. Pacific Northwest Collection, University of Washington Libraries, Seattle.

3. Edward S. Curtis, "The Amateur Photographer," *Western Trail Magazine* 1, no. 6, (April 1900): 379. Pacific Northwest Collection, University of Washington Libraries.

4. Edward T. Parsons, "Rainier," *Mazama*, October 1897, 25-34. Pacific Northwest Collection, University of Washington Libraries.

Chapter 2. As the West Vanished (pages 25-32)

1. Thomas Dyer, *Theodore Roosevelt and the Idea of Race* (Baton Rouge and London: Louisiana State University Press, 1980), 72.

2. William H. Goetzmann and Kay Sloan, *Looking Far North: The Harriman Expedition to Alaska* (Princeton: Princeton University Press, 1982), 71-78, 181-92.

3. Sadakichi Hartmann, "The Value of the Apparently Meaningless and Worthless," *Camera Work*, July 1903, 180.

4. Ralph W. Andrews, *Curtis's Western Indians* (Seattle: Superior Publishing, 1962), 114-15. From a reminiscence written or dictated later in Curtis's life.

5. See Christopher Lyman, *The Vanishing Race and Other Illusions* (New York: Pantheon Books in association with the Smithsonian Press, 1982), 39-42. Lyman inadvertently attributes quotes about "art sciences" and "tommy-rot" photography to Curtis. Curtis's article attributes the first quote to George Sperry, from a recent address to the National Photographic Convention, and the second to Edward Newcomb in *Photo American*, December 1900.

6. Harold Curtis kindly described his father's fascination with mining, especially with gold, when Harold was very young. Interview by Lois Flury and the author, October 1984.

7. Richard Frederick and Jeanne Engermann, *Asahel Curtis: Photographs of the Great Northwest* (Tacoma: Washington State Historical Society, 1983), 7.

Chapter 3. On the Right Track (pages 33-43)

1. Thomas Dyer, *Theodore Roosevelt and the Idea of Race* (Baton Rouge and London: Louisiana State University Press, 1980), 72-77. Roosevelt quotes are from *The Winning of the West*, vols. 10-12 of *The Works of Theodore Roosevelt* (New York, 1925).

2. "Edward S. Curtis: Photohistorian of the North American Indian," *Seattle Times*, November 15, 1903. Uncatalogued Curtis clippings, Pacific Northwest Collection, University of Washington Libraries.

3. Ira Jacknis, "Franz Boas and Photography," *Studies in Visual Communication* 10, no. 5 (Winter 1984): 2-60.

4. *Seattle Post-Intelligencer*, November 22, 1903. Clipping in Clarence Bagley scrapbook, no. 6, 65. Pacific Northwest Collection, University of Washington Libraries.

5. "Seattle Man's Triumph," *Seattle Times*, May 22, 1904. Uncatalogued Curtis clippings, Pacific Northwest Collection, University of Washington Libraries.

6. Gertrude Metcalf, "The Indian as Revealed in the Curtis Pictures," *Lewis and Clark Journal* 1, no. 5 (May 1904): 27-28.

7. "The Prettiest Children in America," *Ladies' Home Journal*, September 1904, 27-28.

8. "Sacred Rites of Mokis and Navajoes," *Seattle Times*, November 22, 1904. Uncatalogued Curtis clippings, Pacific Northwest Collection, University of Washington Libraries. Excerpts are included in Teri C. McLuhan's 1975 film, "The Shadow Catcher: Edward S. Curtis and the North American Indian," available from Phoenix Films, New York. In addition, Curtis scholar Mick Gidley has found that the Library of Congress, Prints and Photographs Division, has detailed sequences of Curtis's still photographs of these ceremonies.

9. Curtis to Edmond S. Meany, November 11, 1907, Edmond S. Meany Papers, Archives and Records Center, University of Washington. All surviving Curtis-Meany correspondence is in this collection. Additional citations will not be made unless needed to clarify text.

10. Curtis to Frederick Webb Hodge, October 28, 1904, Hodge Papers, Southwest Museum, Los Angeles. The collection contains all of Curtis's correspondence to Hodge. Further citations will be made only for clarification.

11. *The Portland Oregonian*, January 15, 1905. Clipping in Clarence Bagley Scrapbook, no. 5, 107. Pacific Northwest Collection, University of Washington Libraries.

12. *Seattle Mail and Herald* 8, no. 26 (May 13, 1905): 9.

13. "Telling History by Photographs," *Craftsman* 9 (March 1906): 72.

14. George B. Grinnell, "Portraits of Indian Types," *Scribner's Magazine* 37 (March 1905): 259-73.

15. "Noted Indian Pictures On View At The Fair," *Portland Oregonian*, June 18, 1905. This and other articles and letters are reproduced in an unpublished compilation, "The North American Indian: Extracts from Reviews of the Book, and Comments on the Work of U.S. Author," n.d. Collection of author.

16. Matilda Cox Stevenson to Edward Curtis, March 15, 1905, Curtis Vertical File, Manuscript Collection, University of Washington Libraries.

17. "Ed Curtis Back From Gotham," unidentified Seattle newspaper, May 5, 1905. Uncatalogued Curtis clippings, Pacific Northwest Collection, University of Washington Libraries.

18. "Six Weeks Among the Indians," August 1905. Clipping in Clarence Bagley scrapbook, no. 5, 110. Pacific Northwest Collection, University of Washington Libraries.

19. Theodore Roosevelt to Edward Curtis, December 16, 1905, Curtis Materials, Pierpont Morgan Library, New York.

20. Curtis may have been introduced to Morgan before their first appointment. Frank Lilly of Spokane, a mining consultant and part Chickasaw Indian, stated that he introduced the two men at the Bankers Club in New York. See Ralph Andrews, "He Knew the Red Man," *Montana, the Magazine of Western History*, April 1964, 6.

21. Curtis to J. P. Morgan, January 23, 1906, Curtis Materials, Pierpont Morgan Library. All additional Curtis-Morgan correspondence is from this collection. Further citations will not be made except to clarify text.

Chapter 4. Into the Heart of the Country (pages 45-60)

1. Curtis to Belle da Costa Greene, April 6, 1914, Curtis Materials, Pierpont Morgan Library.

2. "Edward S. Curtis Home From the East," *Seattle Post-Intelligencer*, April 17, 1906.

Notes to Chapter 4, contd. (pages 45-60)

3. Untitled, undated speech by Edward S. Curtis, Edmond S. Meany Papers. Quoted in its entirety in Mick Gidley, "Edward S. Curtis Speaks...," *History of Photography* 2, no. 4 (October 1978): 347-54.

4. "Edward S. Curtis Tells of Exciting Trip on Home-Made Motorboat on the Colorado River," *Seattle Sunday Times*, January 27, 1907.

5. Gidley, "Edward S. Curtis Speaks," 349-50.

6. Curtis M. Hinsley, Jr., *Savages and Scientists: The Smithsonian Institution and the Development of American Anthropology, 1846-1910* (Washington, D. C.: Smithsonian Institution Press, 1981), 205.

7. Charles Walcott to William Dinwiddie, April 16, 1907, Record Unit 45, Smithsonian Institution Archives, Washington, D. C.

8. Curtis to Charles Fletcher Lummis, May 10, 1907, Lummis Papers, Henry E. Huntington Library, San Marino, California.

9. Florence Curtis Graybill and Victor Boesen, *Edward Sheriff Curtis: Visions of a Vanishing Race* (New York: Thomas Y. Crowell Co., 1976) 28.

10. Curtis to Meany, August 25, 1907.

11. Curtis to Meany, September 7, 1907.

12. Adolph Muhr, "A Gum-Bichromate Process for Obtaining Single Prints," *Camera Craft* 13, no. 2 (August 1906): 276-81.

13. Adolph Muhr, "Edward S. Curtis and His Work," *Photo Era*, July 1906, 9-13.

14. Sadakichi Hartmann, "E. S. Curtis, Photo Historian," in *The Valiant Knights of Daguerre* (Berkeley and Los Angeles: University of California Press, 1978), 267-72.

15. William E. Curtis, "Curtis's Indian Books," *Washington Evening Star*, June 1, 1908. Reproduced in "The North American Indian, Extracts from Reviews."

16. Curtis to Hodge, January 14, 1908.

17. Victor Boesen and Florence Curtis Graybill, *Edward S. Curtis: Photographer of the North American Indian* (New York: Dodd, Mead and Co., 1977), 98-99.

18. Merriam to Curtis, n.d. Reproduced in "The North American Indian, Extracts from Reviews."

19. Charles M. Kurtz, *Academy Notes*, March 1908. Reproduced in "The North American Indian, Extracts from Reviews."

20. Frederick W. Hodge to Corrine Gilb, "Frederick Webb Hodge, Ethnologist: A Tape Recorded Interview, 1954-56," 99. From photocopy of unpublished transcript in the Regional Oral History Library, Bancroft Library, University of California, Berkeley.

21. Curtis to Meany, August 28, 1908. See Christopher Lyman, *The Vanishing Race and Other Illusions* (New York: Pantheon Books in association with the Smithsonian Press, 1982), 88. Lyman maintains that Meany wrote the account of "the Custer fight" which was printed in volume three of *The North American Indian*, but in fact Curtis wrote the portion in question.

22. Wanamaker and Dixon also made a film of the Crow in 1918, *History of the American Indian*. See Kevin Brownlow, *The War, the West, and the Wilderness* (New York: Alfred A. Knopf, 1979), 335-36. Joseph K. Dixon, Ll.D., was in charge of the Wanamaker Expeditions of 1908 -09 and 1913, while his son Rollin Dixon directed the film. See also Charles Reynolds, *American Indian Portraits* (Brattleboro, Vermont: The Stephen Greene Press, 1971).

23. Mick Gidley, "A.C. Haddon Joins Edward S. Curtis: An English Anthropologist among the Blackfeet, 1909," *Montana, the Magazine of Western History*, Autumn 1982, 21-33.

24. Ronald P. Rohner, "Franz Boas: Ethnographer on the Northwest Coast," in *Pioneers of American Anthropology*, ed. by June Helm (Seattle: University of Washington Press, 1966), 183.

Chapter 5. Going the Distance (pages 61-75)

1. Curtis to Walcott, May 12, 1912. Smithsonian Archives, Smithsonian Institution. Quoted in full by Bill Holm and George Quimby, *Edward S. Curtis In the Land of The War Canoes: A Pioneer Cinematographer in the Pacific Northwest* (Seattle: University of Washington Press, 1980), 32-33. Holm and Quimby published this book following their restoration of Curtis's film, now titled *In the Land of the War Canoes*, available from the Burke Museum, University of Washington.

2. Curtis to Wissler, December 1, 1914. Anthropology Department Archives, American Museum of Natural History, New York. Additional Museum of Natural History letters are from this collection. This series is also quoted extensively in Mick Gidley, "From the Hopi Snake Dance to 'The Ten Commandments': Edward S. Curtis as Filmmaker," *Studies in Visual Communication*, Summer 1982, 70-79.

3. Gidley, "From the Hopi Snake Dance to 'The Ten Commandments,'" 70.

4. Extract from annual report to the stockholders of the North American Indian Corporation, February 19, 1913, Curtis Materials, Morgan Library. A different portion of this extract is quoted at length by Douglas Ewing, "The North American Indian in Forty Volumes," *Art in America*, July-August 1972, 84-88.

5. Curtis to Greene, April 6, 1914.

6. Curtis to Greene, October 21, 1914.

7. Cass Canfield, *The Incredible Pierpont Morgan: Financier and Art Collector* (New York: Harper and Row, 1974), 153.

8. Schwinke Collection, Burke Museum Archives, University of Washington. Additional Curtis-Schwinke correspondence is from this collection. Quoted extensively by Holm and Quimby, *In the Land of the War Canoes*, 107-11.

9. Holm and Quimby, *In the Land of the War Canoes*, 29-30. Their information was obtained from Jay Ruby, Department of Anthropology, Temple University, Philadelphia. Ruby is in possession of a copy of Mrs. Flaherty's diary, which describes the visits to the Curtis headquarters.

10. Copy of Herbert Smith to Curtis, April 13, 1915, with attached letter from Curtis to Ronald Todd. July 8, 1948 [?], Curtis Vertical file, Manuscript Collection, University of Washington.

11. Undated advertising brochure for the Curtis Studio. The 1223 Fourth Avenue address (Fourth and University) dates it from 1916 to 1925.

12. This information was kindly supplied by Margaret Gaia when interviewed by the author, September 1984.

13. This was confirmed by Margaret Gaia, and by Edwin Johanson, son of the photographer in question. It was partially corroborated by Florence Curtis Graybill, who said that she never saw the goldtones until the studio was at the Fourth and University location (1916-25). However, she believes that the process was developed according to earlier experiments and instructions by her father.

14. The duplication and/or destruction of the original negatives may have led to a lawsuit. In 1920, the Curtis Studio in Seattle filed suit against W. Lennes; Nels Lennes was the retoucher who destroyed glass plate negatives after the studio had been awarded to Clara Curtis.

15. Myers to Hodge, August 5, 1919, Hodge Papers, Southwest Museum.

16. Curtis to Meany, January 22, 1922.

17. Goddard to Curtis, January 25, 1923, Anthropology Department Archives, American Museum of Natural History.

18. Myers to Hodge, April 25, 1926.

19. Curtis to Hodge, December 7, 1927.

Notes to Chapter 5, contd. (pages 61-75)

20. Substantial portions of this log are included in Victor Boesen and Florence Curtis Graybill, *Edward S. Curtis: Photographer of the North American Indian* (New York: Dodd, Mead and Co., 1977), 162-83. This book also contains many excellent photographs of Curtis and his family.

21. "Curtis, Wife on Stand in Alimony Row," *Seattle Post-Intelligencer*, October 12, 1927.

22. Curtis saw Myers only a few times following the end of the project. He eventually lost touch with him, as did Hodge, who had become Myers's close friend. Myers's personal papers have never been found, and he remains a mysterious figure in Curtis's life.

23. Curtis would later say that the Morgan family had contributed half of the total cost of the project, originally estimated at $1.5 million. Current evidence suggests that their contribution ranged from three hundred to four hundred thousand dollars. The project may have cost less than rumored, or Curtis may have exaggerated the credit due to the Morgans, by way of thanks.

Chapter 6. Out of One Labyrinth (pages 77-79)

1. Curtis to Olive Daniels, December 29, 1932, Curtis Vertical File, Manuscript Collection, University of Washington.

2. Curtis to Meany, August 13, 1934.

3. Curtis to Harriet Leitch, February 2, 1949, Curtis Letters, Northwest Collection, Seattle Public Library.

4. Indiana University owns 279 of the 10,000 recordings made during the course of Curtis's field research, and they are apparently little known outside of that university. The collection was purchased from the Charles Lauriat Company in 1956; the fate of the remaining cylinders is not known. Archives of Traditional Music, Indiana University, Bloomington.

SELECTED BIBLIOGRAPHY

Boesen, Victor, and Graybill, Florence Curtis. *Edward S. Curtis: Photographer of the North American Indian*. New York: Dodd, Mead and Co., 1977.

Coleman, A.D., and McLuhan, T.C. "Curtis: His Work." Introduction to *Portraits from the North American Indian by Edward S. Curtis*. New York: Dutton, 1972.

Curtis, Edward Sheriff. "The Rush to the Klondike Over the Mountain Passes." *Century Magazine*, March 1898, 692.

———. "Photography." *Western Trail*, January 1900, 186-88. Pacific Northwest Collection.

———. "The Amateur Photographer." *Western Trail*, February 1900, 272-74. Pacific Northwest Collection.

———. "The Amateur Photographer." *Western Trail*, April 1900, 379-80. Pacific Northwest Collection.

———. "The Amateur Photographer." *Western Trail*, May 1900, 468-69. Pacific Northwest Collection.

———. "Vanishing Indian Types: Tribes of the Southwest." *Scribner's Magazine*, May 1906, 513-29.

———. "Vanishing Indian Types: The Tribes of the Northwest Plains." *Scribner's Magazine*, June 1906, 651-71.

———. "Indians of the Stone Houses." *Scribner's Magazine*, February 1909, 161-75.

———. "Village Types of the Desert Land." *Scribner's Magazine*, March 1909, 275-87.

———. *The North American Indian*. 20 volumes. Vols. 1-5, Cambridge, Mass.: The University Press. Vols. 6-20, Norwood, Conn.: Plimpton Press. 1907-30. New York and London: Johnson Reprint Corp., 1970.

1907 Vol. 1—Apache, Jicarilla Apache, Navajo

1908 Vol. 2—Pima, Papago, Qahatika, Mohave, Yuma, Maricopa, Havasupai, Apache-Mohave

1908 Vol. 3—Teton Sioux, Yanktonai, Assiniboin

1909 Vol. 4—Apsaroke, Hidatsa

1909 Vol. 5—Mandan, Arikara, Atsina

1911 Vol. 6—Piegan, Cheyenne, Arapaho

1911 Vol. 7—Yakima, Klickitat, Interior Salish, Kutenai

1911 Vol. 8—Nez Percé, Walla Walla, Umatilla, Cayuse, Chinookan

1913 Vol. 9—Coast Salish, Chimakum, Quilliute, Willipa

1915 Vol. 10—Kwakiutl

1916 Vol. 11—Nootka, Haida

1922 Vol. 12—Hopi

1924 Vol. 13—Hupa, Yurok, Karok, Wiyot, Tolowa, Tututni, Shasta, Achomawi, Klamath

1924 Vol. 14—Kato, Wailaki, Yuki, Pomo, Wintun, Maidu, Miwok, Yokuts

1926 Vol. 15—Southern California Shoshoneans, Diegueños, Plateau Shoshoneans, Washo

1926 Vol. 16—Tiwa, Keres

1926 Vol. 17—Tewa, Zuni

1928 Vol. 18—Chipewyan, Cree, Sarsi

1930 Vol. 19—Wichita, Southern Cheyenne, Oto, Commanche

1930 Vol. 20—Nunivak, King Island, Little Diomede Island, Cape Prince of Wales, Kotzebue

———. *Indian Days of Long Ago*. Yonkers-on-Hudson, New York: World Book Co., 1914. Reprint. Berkeley: Ten Speed/Tamarack Press, 1975.

———. *In the Land of the Headhunters*. Yonkers-on-Hudson, New York: World Book Co., 1915. Reprint. Berkeley: Ten Speed/Tamarack Press, 1975.

Gidley, Mick. "Edward S. Curtis Speaks...," *History of Photography*, October 1978, 347-54.

———. *The Vanishing Race: Selections from Edward S. Curtis's 'The North American Indian.'* London: David and Charles; New York: Taplinger Publishing, 1977.

———. "From the Hopi Snake Dance to 'The Ten Commandments': Edward S. Curtis as Filmmaker." *Studies in Visual Communication*, Summer 1982, 70-79.

———. "A. C. Haddon Joins Edward S. Curtis: An English Anthropologist Among the Blackfeet." *Montana, the Magazine of Western History*, Autumn 1982, 21-33.

Goetzmann, William H., and Sloan, Kay. *Looking Far North: The Harriman Expedition to Alaska*. Princeton: Princeton University Press, 1982.

Graybill, Florence Curtis, and Boesen, Victor. *Edward Sheriff Curtis: Visions of a Vanishing Race*. New York: Thomas Y. Crowell, 1976.

Hartmann, Sadakichi. "E. S. Curtis, Photo Historian." In *The Valiant Knights of Daguerre*. Berkeley and Los Angeles: University of California Press, 1982.

Holm, Bill. *"The Vanishing Race and Other Illusions: Photographs by Edward S. Curtis* by Christopher M. Lyman." *American Indian Art Magazine*, Summer 1983, 68-73.

Holm, Bill, and Quimby, George Irving. *Edward S. Curtis in the Land of the War Canoes: A Pioneer Cinematographer in the Pacific Northwest*. Seattle: University of Washington Press, 1980.

Lee, William Beachum. *The Nature of Reality in Ethnographic Film: A Study Based on the Work of Edward S. Curtis*. Ann Arbor, Mich.: University Microfilms, 1980.

Lyman, Christopher M. *The Vanishing Race and Other Illusions: Photographs by Edward S. Curtis*. New York: Pantheon Books in association with the Smithsonian Press, 1982.

Marshall, Edward. "The Vanishing Red Man." *Hampton Magazine*, May 1912, 1004-11.

Rice, Leland. *Edward S. Curtis: The Kwakiutl, 1910-1914*. Irvine: University of California, 1976.

CONTEMPORARY PRINTINGS OF CURTIS'S WORK

Two contemporary, integrated printings from the original copperplates have made high-quality photogravures from *The North American Indian* available to the public. Available through Flury and Company, Seattle.

INDEX

Page numbers in bold type refer to
photographs.

This volume was designed by Ed Marquand. The text was set by The Type Gallery, Seattle. The plate captions were set by Accent & Alphabet, Seattle. Most of the gravures from *The North American Indian* were laser scanned directly from new prints pulled from Curtis's original copperplates. It was printed and bound by Dai Nippon Printing Co., Ltd., Tokyo, Japan.